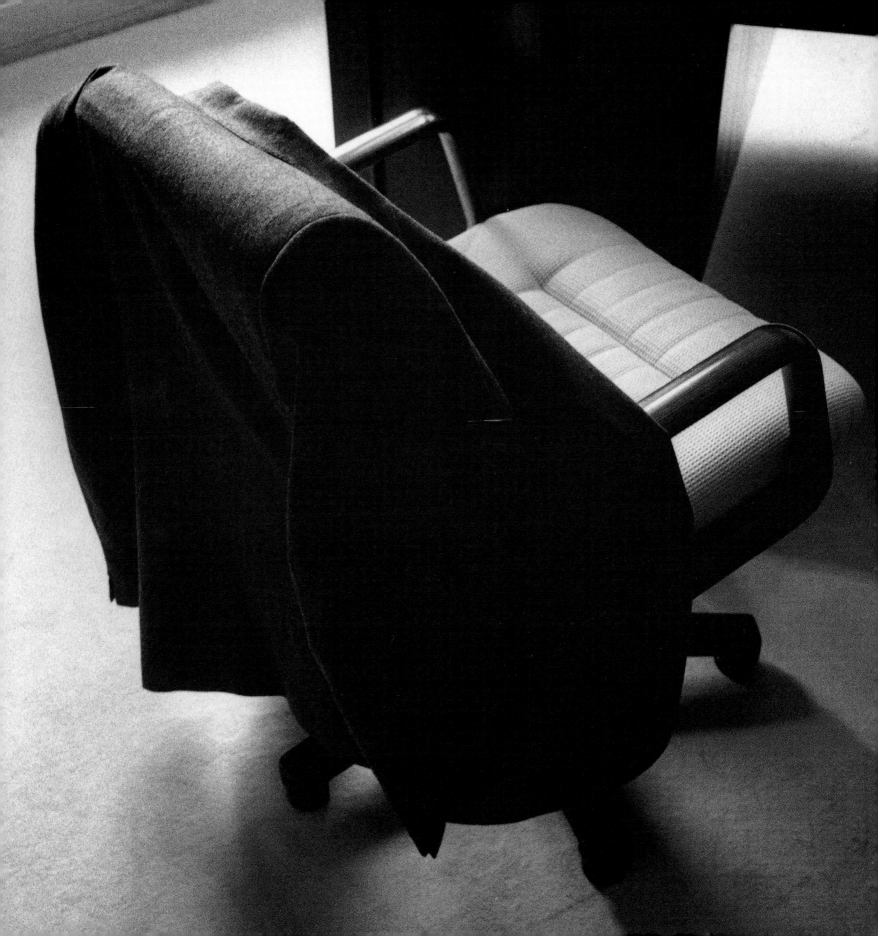

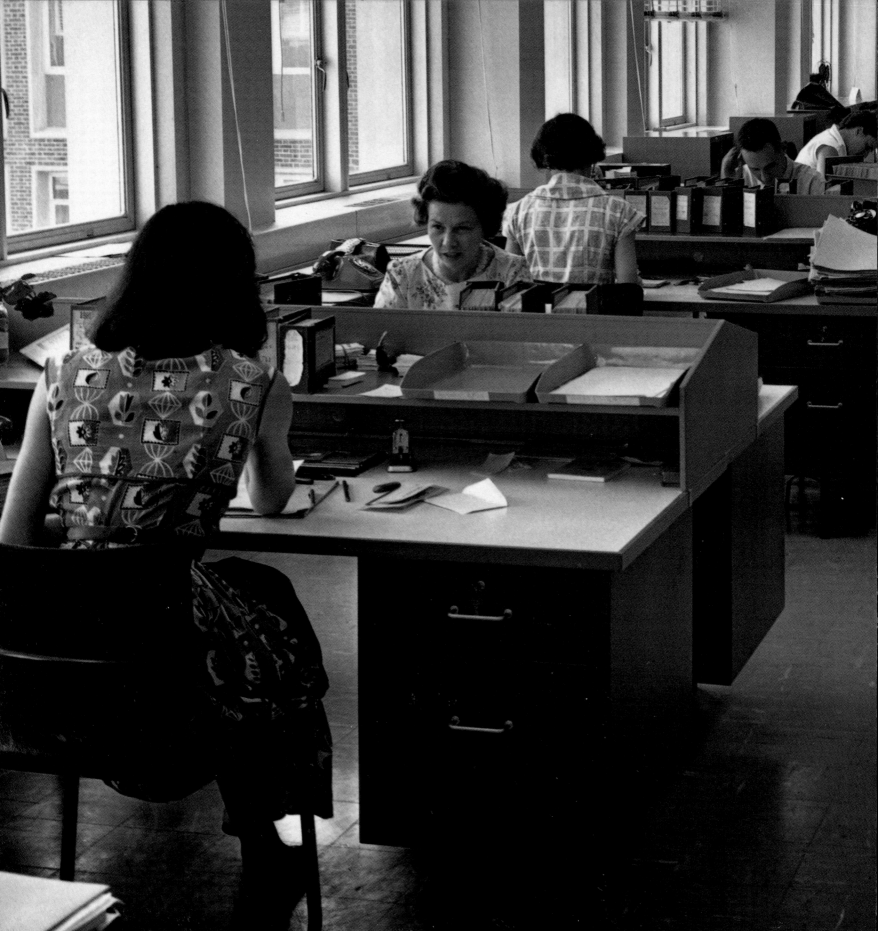

The Office

Élisabeth Pélegrin-Genel

Flammarion
Paris-New York

Editorial direction
GHISLAINE BAVOILLOT

Artistic Direction
MARC WALTER - Bela Vista

Picture Research
RUTH EATON AND
SABINE ARQUÉ-GREENBERG

English-language edition:
Translation from the French
FRANCIS COWPER

Editing
BERNARD WOODING

Typesetting
Octavo Editions

Origination
Colourscan France

Printing
Canale, Italy

ISBN: 2-08013-589-0
Numéro d'édition: 1117
Dépôt légal: March 1996
Printed in Italy

For Alain,
for Eva, Katia, Flora
and Antoine

Contents

Scenes of everyday life in the office: an emblematic office chair; the typing pool, now a thing of the past; the indispensable personal assistant; and the chaos of a newspaper office. The office is a way of life which has a history all its own (pages 1, 2, 4–5 and 6).

I have always been surprised by the fact that people seem so uninterested in the place where many of us spend around eight hours a day (and sometimes more). In most industrialized countries an office consists of little more than a table, a chair, a phone, a few shelf units, a wastepaper bin and a clothes tree. At best the décor is given a little variety by the off-white of a microcomputer and the green leaves of a couple of plants. But minor variations aside, there is no mistaking it: an office always looks like an office.

We see the office as a necessary evil. The words that are commonly associated with it often have negative connotations—bureaucrats, civil servants, paperwork, stress and so on. And yet every day millions of people set off for the office in the morning and apparently feel that there is nothing much to be said about this world which has become so much a part of the routine of modern life.

But the office is also a space for human life and interaction. You make friends there, you enjoy the satisfaction of a job well done and experience the joys of social advancement, recognition, responsibility, and other forms of self-development. The durability of the office has been highlighted by the fact that working from home, which was supposedly going to sign the office's death warrant, has been very slow in developing. For many people the idea of staying at home and maintaining only telephone or modem contact with the office seems synonymous with loneliness and the loss of social identity.

As a result, the office rarely features in representations of daily life. Once you leave the office, you forget about it until the following day. Television and the movies are happy to use eccentric apartments and luxury houses as settings, but the office is under-represented. If seen at all, it appears in one of two variants: the luxurious office of the company president, or the dismal surroundings of the humble office worker. Only occasionally will a TV series choose to show the offices of a newspaper or a police station, and here they function as locations where all human life is played out—tragedy, but also solidarity, passion, laughter and pain—in a minimal décor where people rush about and telephones ring.

The office is like a mold into which you pour yourself and then forget about the rest of life. It is a no man's land, a desert crossing that extends from around eight-thirty in the morning until six-thirty in the evening, five days a week. People sometimes make a feeble attempt to humanize the office by pinning up a poster in a corner or bringing in photographs, paperweights or bunches of flowers. How is it that people expend so much energy on decorating their houses and so little on personalizing the place where they work? The fact is that the world of work and its environment are of interest to almost no one. Who is actually responsible for the décor? More often than not, nobody has the faintest idea.

Everybody spends time in the office, but nobody ever talks about it. Is the subject somehow taboo? Works on business culture and the art of management run into hundreds, but you find almost nothing on the office as a work environment. In most countries, very little research is devoted to the office and its design. This book gives us an opportunity to rehabilitate the office a little, to take a closer look at it and to reflect on a question that concerns us all: since we more or less live in our offices, why not try to improve the quality of office life?

As an architect with a training in psychology, I have a general interest in questions relating to space and their influence on everyday life. One's surroundings are never neutral. They may be stimulating or depressing, they may encourage a work team or hinder its efforts, heighten tensions or reduce them. They may contribute to good morale among staff or to a sense of malaise. My job is to work with companies, changing the way the work space is organized in order to improve working relations between groups and individuals.

This book is not a study of the architecture of office blocks, nor of the overall conception of their layout and design (foyers, reception areas, conference rooms). Rather it is a reflection on the office itself— the space in which work is carried out, and the way in which office life is intimately linked to layout and interior design. My intention is to look at the office today. What are its origins? How has it evolved? What vision of work does it embody? How is the interior designed? This book is an exploration of the office as inner sanctum—the classic center of power. It looks at the offices of both private and public concerns, the offices of business people and writers. It also examines the kinds of offices that many of us have at home.

We have visited various types of businesses, seeking out the most innovative and original examples of office design. Our aim has been to inspire the reader, to fill them with a sudden and irresistible desire to act on the examples given here, in the hope that they may find better ways of combining work and life.

A brief history

From the medieval bure to the plank placed across two trestles, from the furniture created by great cabinetmakers to the first office buildings.

The public scribe, depicted here in a painting by L. Carabin (*c.* 1890), found himself in the roles, simultaneously, of involuntary witness and confidant (preceding double page). When he was writing he became involved in the private lives of his clients. The scribe's trade is still alive, except that today parchment, quill pen and writing-case have been replaced by the typewriter and the microcomputer.

A scribe, sitting cross-legged, with a roll of papyrus on his knees and his fingers crooked around a brush that is long since obsolete. Attentive, available and indispensable, the scribe was a proud man because "of all the human trades that exist on earth, and of which the god Enlil has named the names, he has named the name of no profession more difficult than the art of the scribe" (*c.* 2563–2423 BC).

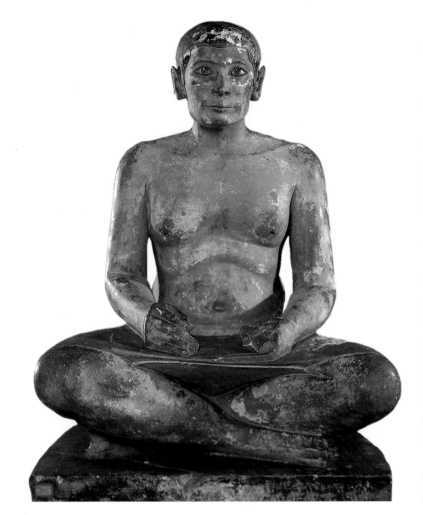

It all began in Sumer, almost five thousand years ago. The Sumerians developed a system of accounting whereby small balls were placed in clay pockets which served as rudimentary envelopes. Every operation had to be recorded, so the details of all their various transactions were recorded on these envelopes. The increasingly sophisticated graphic designs gradually gave rise to cuneiform writing. Initially the scribes used wooden tablets covered with a thin layer of wax, which could be used again, and later they introduced clay tablets. Clay was not necessarily the easiest medium, because you had to have moistened jars to hand in order to keep the clay soft, ample supplies of sunlight to dry them, and an oven in which they could be baked.

THE SCRIBE AND HIS WRITING-CASE

In Egypt, three thousand years before Christ, the scribe was a person much in demand. He was responsible for drawing up administrative and religious documents and spent his days hurrying from one place to another, clutching his lightweight materials and his writing-case. It was the Egyptian scribe, in fact, who invented the mobile office, the office of the twenty-first century. Attentive, intelligent and inquisitive, he examined and recorded, analyzed and classified, ordered and taught. His life was devoted to his work, but, if we are to believe an ancient papyrus, he got a certain satisfaction out of it: "Their works are their pyramids, their reed is their offspring, and carved stone is their spouse. The powerful and the humble alike have become their children. For the scribe rules over them all."

Resting his work on his knees, the scribe wrote in a squatting position with the aid of a small writing-case made of two pieces of wood joined by a hinge carved from horn and bone. The upper piece had a receptacle for black ink, and another to hold the scribe's writing implements. The scribe's work was varied and he even drew plans, as witness the statue of Gudia, prince of Lagash, in the Louvre, which is known as *The Architect and His Plan* (*c.* 2150 BC). The "mobile office" was born. Egyptian men of learning used to meet in the scriptorium, a communal room which was in a sense the forerunner of our present-day conference rooms.

The scribes had an enormous amount to do. Their work included drawing up documents, registering transactions, preparing inventories and composing odes to the gods. We can get a good idea of their activities

from a monthly accounting chart dating from around 2400 BC that is preserved in the Louvre, and also from the 17,000 tablets found during the 1970s in the course of excavations at the acropolis of Tell Mardiker, near Aleppo, in Syria. These, according to the authors of *La Naissance de l'écriture*, describe "an avalanche of accounts: daily, monthly, offertory, ration accounts, meat accounts, grain, fabric or draft accounts and summaries of accounts. No modern state or company could even contemplate producing such a mass of paperwork." Evidently the invention of bureaucracy predated the birth of the office, and the oldest papyruses yet discovered provide a fine example of bureaucratic paperwork.

Very soon the eternal problem of filing and storage had to be addressed. The first forms of office furniture were wicker baskets and labeled clay jars which found their way initially into temples, and then into libraries. The tablets were classified by category, and school exercises, manuals, dictionaries, encyclopedias and scientific collections, as well as proverbs and moral fables, have been found. The scribe was a man who insisted on neatness and order and when necessary he uttered dire threats against those guilty of sloppy library practice: "May Ishtar [a goddess] look with joy upon the reader who does not deface the tablet, and who replaces it properly in its holder; may Ishtar denounce with anger anyone who carries a tablet out of the Eanna [the library]."

When it became apparent that clay tablets were too fragile for everyday use, papyrus from the Nile Valley was used. This was a magical product which could be used for almost anything, from boat sails to sandals, loincloths to baskets. Light and practical, with a texture rather like that of silk, it continued to be used until the invention of parchment (or vellum), which became popular thanks to its durability and the fact that it was pleasant to use. Parchment was already competing with papyrus by the first century BC. It was very ecological, in the sense that it could be washed and reused. It was also versatile: initially used in rolls it was later made into codices. In around the fourteenth century, paper, which had been known for several centuries in China, began to be used in the West. This opened the way for the development of printing in the middle of the fifteenth century. The twentieth century saw the invention of the computer disc, an equally sophisticated development in its own way, and one to which we shall return later.

Up until the thirteenth century, when the practice of writing while standing at a lectern became widespread, the scribe would either write sitting or squatting at a low table, or else he would rest his writing-tablet on his knees.

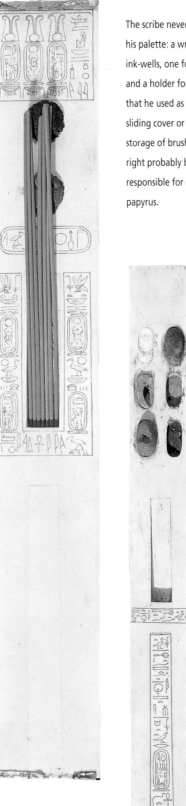

The scribe never went anywhere without his palette: a writing-case with two circular ink-wells, one for red ink and one for black, and a holder for the small trimmed reeds that he used as writing implements. A sliding cover or a simple slot facilitated the storage of brushes. The writing-case on the right probably belonged to an artist–scribe responsible for decorating the borders of papyrus.

A typical image of Saint Augustine, patron saint of theologians and printers, in a painting by Botticelli. The saint is sitting on a simple bench in an alcove. There is a pile of books to his right and the floor is strewn with crumpled bits of paper and discarded goose quills.

In 1502, in the Scuola degli Schiavoni in Venice, the Italian painter Carpaccio embarked on a series of paintings illustrating the lives of three saints. Here Saint Augustine, the great theologian of the Catholic church, hears Saint Jerome announcing his death. His large, peaceful study is that of a Renaissance humanist. The artist has lovingly detailed the books with their colored bindings, the music scores, and the small, neatly arranged bronzes (facing page).

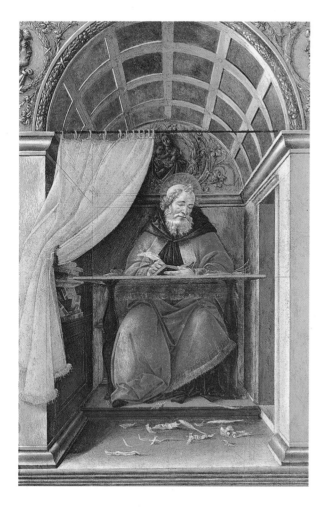

THE MONK AND OFFICE LIFE

The monk was the father of the office and it was he who gave the office its French name, *bureau*, which was derived from the word *bure* (also known in English as burel). Bure was a coarse woollen cloth which, in addition to being made into ecclesiastical garments, used to be placed on work tables under the parchment to protect it.

By now the business of writing had become the specialty of monks. They did their writing in the scriptorium, a special room at the heart of the abbey, which was heated. Their books were enormous. There was no question of carrying them around, so the copyist monks did their writing and illuminating standing at lecterns placed on large tables or pedestals. Working set hours, the monks were in a sense the inventors of office life as we know it. There were one or two differences, however: unlike the office worker the monk did not sit down to work, and the bell that summoned him to divine service sounded rather different to the ringing of the office phone.

In the fifteenth century Carpaccio painted *Saint Augustine Working in his Library, Receiving the Vision of Saint Jerome*. The saint is seated on a bench on a rostrum, surrounded by books. The scene takes place in a beautiful, high-ceilinged room with an ocher-colored floor. The furniture, as was common at the time, was fixed, and was sometimes built into the walls.

Saint Jerome was the subject of a number of rather solemn pictures. He was sometimes portrayed seated in fairly uncomfortable positions and sometimes with a lion crouching at his feet, to symbolize the mastery of the body that is necessary in order to attain intellectual excellence. One also sees him sitting or standing at a lectern. In 1456 the Sicilian painter Antonello da Messina depicted him in his study, viewed through a doorway. The scene, bathed in a warm, delicate half-light which evokes the atmosphere of Flemish painting, is dominated by a writing desk, some shelving and a portico painted in perspective. Books and various everyday objects are to hand. Saint Jerome is sitting in a comfortable seat and using a lectern. On the floor are a number of items, including a small bench.

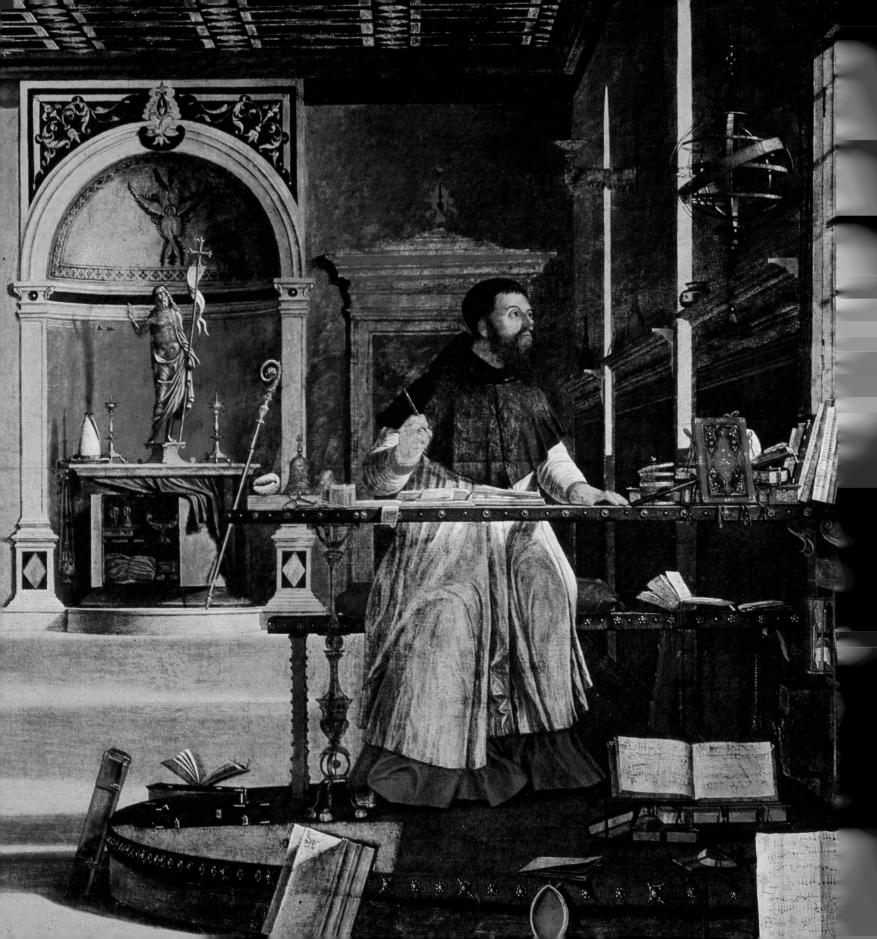

THE NOTARY AND THE FIRST OFFICE FURNITURE

In the shadow of the monk another historical figure slowly emerged: the notary. In thirteenth-century France, during the reign of Louis IX, there were sixty notaries operating in the Paris prevostship. Like the monk, the notary often worked on Sundays. His function and his moral and financial standing put him on an equal footing with the clergy, because, as the historian Theodore Zeldin has explained, he is present at the beginning and end of all things in civil life, as the priest is in religious affairs.

But the notary's life was rather more eventful than the clergyman's. He wore a number of different hats—clerk of the court, bailiff, acting prosecutor, tax collector, lawyer, businessman, and even banker. Working simultaneously for others and on his own account, he drew up all kinds of documents, transactions, purchasing orders and partnership agreements. He kept a number of different registers and was present at the birth of the first banks between the thirteenth and fifteenth centuries. He worked incessantly, and walked the streets, like the scribes before him, with a portable writing desk in his bag. But unlike the scribe (and the monk), the notary set up office in his own home, which was something new. The notary was the inventor of the private office as we know it, and he shared it with his clerks, who often also lived with him.

Since the notary was also responsible for keeping enormous cadastres, or property registers, he inevitably ended up inventing office furniture: wooden cupboards with multiple compartments, filing cabinets and bookcases. He also liked low storage units, on which were placed lecterns for consulting documents. The work table, which up until then had been quite small, now became larger in order to support the bulky and heavy registers.

Finally the administrators of the royal households came to the fore—judges, provosts, lieutenants, lawyers, advocates, king's attorneys and the like. The notaries, who possessed the skill of writing, became the right-hand men of kings and queens. In his book *Histoire et pouvoirs de l'écrit*, Henri-Jean Martin informs us that during the reign of Philip IV (1328–50) the royal clerks were responsible for the production of somewhere in the region of an astonishing 35,000 sealed letters. They were surrounded by the administrators of the chancellorship, a whole staff of clerks, notaries and secretaries. It is hardly surprising that they felt the

This painting by the nineteenth-century English painter, Erwin Eichinger, shows a jurist at work. With a goose quill in one hand, he sits at a table piled with books and papers, in a décor which is medieval in spirit. His workplace faces an open window beyond which lies a village scene.

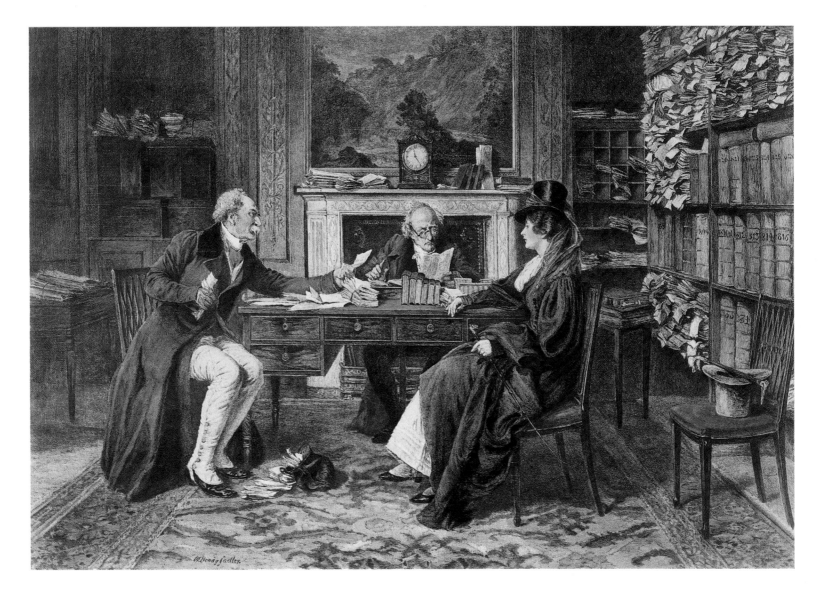

need to organize their lives, to create separate work spaces and furniture which were better adapted to their laborious tasks.

From the fourteenth century, new methods of accounting emerged among Italian merchants. Double accounting procedures were adopted. Each operation required two entries, one in the credit column and the other in the debit column. The first permanent exchanges were set up in major cities. Paper became a security charged with a variety of meanings, although paper money as such only appeared in the eighteenth century. Printing was invented and the first postal systems were organized. The nature of transactions changed and became professionalized. Up until this point, the merchants who changed coin for people (before

The artist Walter Sadler (1854–1923) was the son of a man of the law. His *Breaking a Contract with a Notary* depicts two litigants in a notary's office. The drama is played out around a flat, double-faced desk. The artist had a good eye for detail, meticulously capturing the controlled chaos of a notary's office piled high with paperwork.

This small Regency desk bears the stamp of J. Dubois. It is decorated with animals and foliage in red tortoiseshell, copper, mother-of-pearl and ebony veneer. J. Dubois, a renowned cabinetmaker during the reign of Louis XV, replaced the original legs with curved legs in keeping with the tastes of the day.

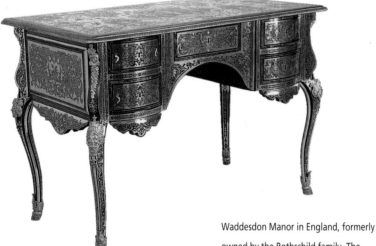

The Mazarin desk had eight legs. The first known example was made by Golé for Louis XIV in around 1669. The origin of the name is unknown, but one thing is certain—Cardinal Mazarin did not possess one. This one is decorated with pewter and amaranth marquetry and dates from the seventeenth century (below).

Waddesdon Manor in England, formerly owned by the Rothschild family. The eighteenth-century décor includes Sèvres porcelain, fine French furniture and paintings by Gainsborough, Reynolds and Guardi. In one corner of the room stands an imposing, richly decorated, cylinder-front desk which once belonged to Beaumarchais (facing page).

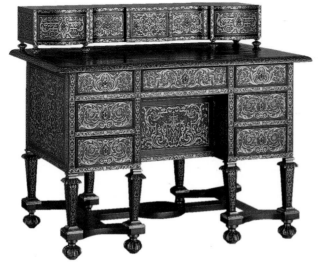

going for a drink in the tavern to seal their deals) sometimes had portable desks known as "moneychangers' desks," which were iron chests carried on a mule. Slowly the merchants handed over to the new breed of businessmen who could not draw up their paperwork sitting in a tavern. They needed privacy and space to spread out their documents, and this is how the office proper originated. However, the basic solution—two trestles and a plank—which had served as the ordinary desk thus far was not abandoned definitively: it was revived in the twentieth century, notably by the Italian designer Achille Castiglioni, who produced a modern version in 1940.

The office as we know it is the heir of all these figures. From the scribe to the notary, one finds the same concern with recording events, bearing witness, and communicating information. Appropriate furniture was invented to cater for these functions.

THE DESK, FROM THE SIXTEENTH TO THE EIGHTEENTH CENTURY

In the sixteenth century, work surfaces acquired a flat design and a standard height of twenty-nine inches. The bure cover became an integral part. The first desk had been a simple structure consisting of a plank and two trestles. It subsequently acquired four legs and became increasingly sophisticated: hinged, fold-down flaps were created and it became closable.

From then on, one no longer stood at a lectern, one sat down to work or study. To begin with, little thought was given to seating, but the desk continued to evolve. It now contained all kinds of precious items, in the form of letters, money, acknowledgments of debt and deeds of ownership, and it was felt that this should be reflected in the desk's decoration. In around 1520 desks become more ornate, with floral or rural marquetry motifs; then, as time went by, it was trimmed with ivory, shell and tin. One particularly elaborate design, the Mazarin, had eight legs, an inlaid desk-top, three drawers on either side of a central drawer and a kneehole—rather cramped by today's standards—for the user's legs.

During the seventeenth century the desk became more sophisticated and developed into the secretaire. This combined a writing surface with shelves and often secret drawers, all of which could be concealed behind a roll-down top. It was an unobtrusive item of furniture, similar to the sideboard. After 1650, the main work surface was modified to accommodate two or three small drawers. Work surfaces enlarged and the desk

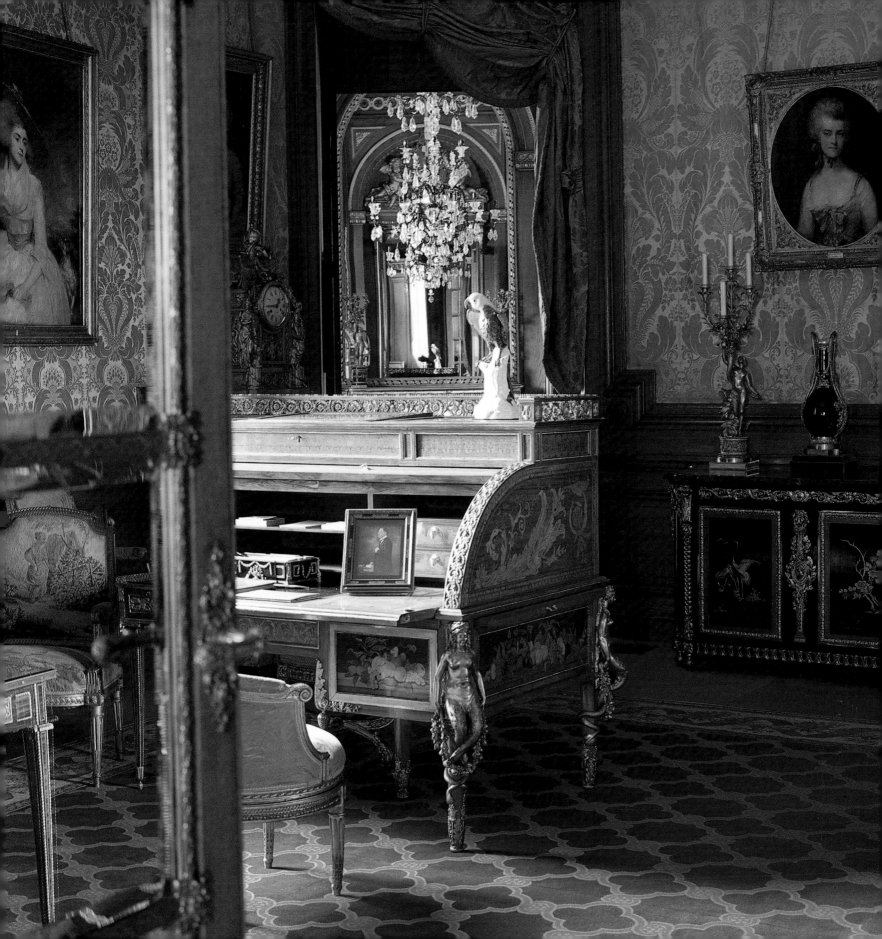

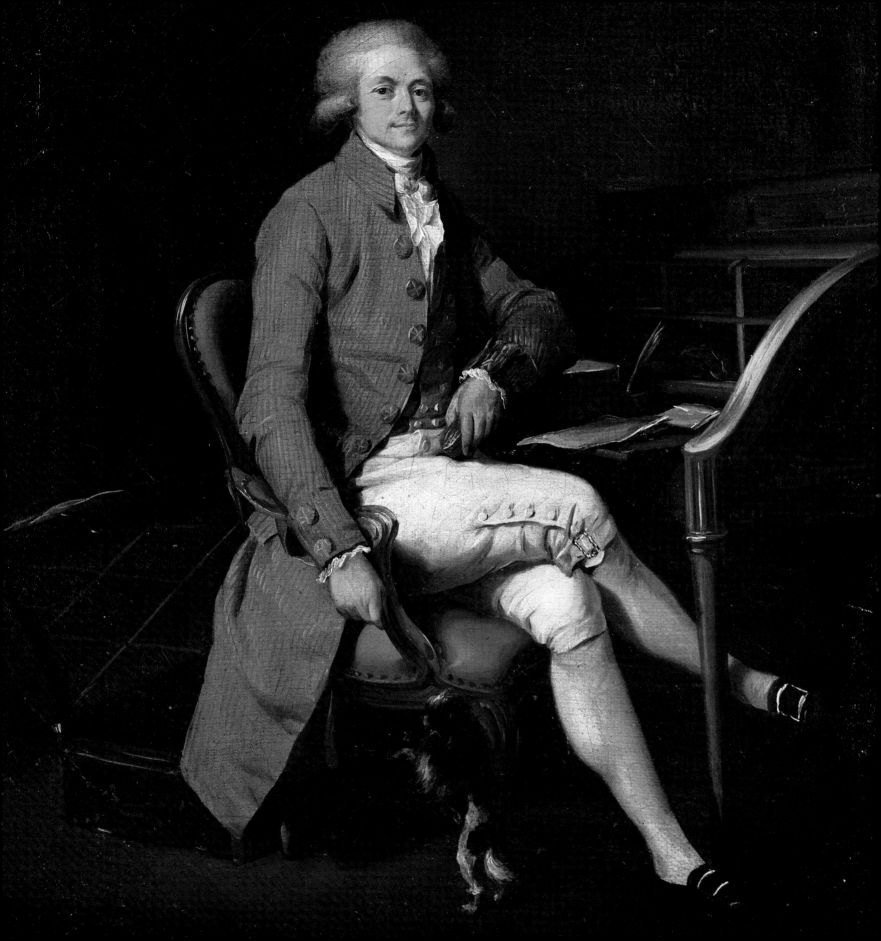

became generally more imposing, as did the room containing it, with its bookcases and sideboards. Chairs increased in size too. The décor was completed with the addition of a clock and a celestial or terrestrial globe.

Finally, a new breed of professional appeared, the administrators who managed the various affairs of the state (financial and legal). Under Louis XIV, for example, the French administration occupied a mere two wings of the Château de Versailles. The ancestors of today's civil servants in France worked at first in the house of the chief administrator; then they transferred to the outbuildings. By the end of Louis's reign, there were a dozen of them in foreign affairs alone, and by the end of the *ancien régime* there were around two hundred.

The *administrateurs* wore black woolen uniforms, differentiated by various insignia according to rank, and they performed all the functions of literate men. They had to prepare and check files, write memos, monitor events and maintain the archives. Henri-Jean Martin, in *Histoire et pouvoirs de l'écrit*, explains that "the minutes of the decisions of the *conseil*, which were to serve as a record, were written in a swift hand on single sheets of paper; provincial administrators, who only had small offices, went to considerable lengths to avoid any unnecessary paperwork."

FURNISHING THE OFFICE

From the eighteenth century onwards, people attached increasing importance to "private life" and the desire to keep private and public separate necessitated a different organization of the day's activities. The notion of privacy developed as family life was counterposed to "working life" and the business of receiving people.

Henceforth, work was increasingly confined to specifically designated places. Up until that point, people's everyday activities had been imbricated both temporally and spatially. In people's houses, a single room could support a variety of activities. However, around 1755, in well-to-do circles, the first dining rooms began to appear. This was the end of multipurpose rooms. Bedrooms became private, personal spaces, as did the toilet. Emotional life entered the home, and led fairly soon to a radical reorganization of rooms and their functions. People now expected to be protected from smells and noises, from intrusions on their privacy, and domestic servants and children were kept at a distance.

During this period the women of the aristocracy and the upper middle class began to organize salons. Madame de Tencin, who

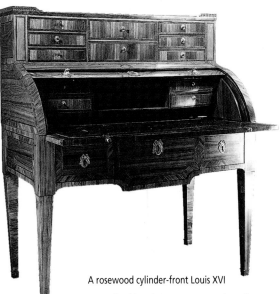

A rosewood cylinder-front Louis XVI secretaire (above). It opens to reveal small storage drawers and a pull-out leather-covered work surface.

In 1789 the portrait painter Louis Léopold Bailly painted Robespierre, one of the key figures of the French Revolution, seated at a roll-top desk (facing page). The same desk also appears in another of the artist's paintings, *La Famille Gohin*.

Thomas Jefferson, in addition to being the third president of the United States, was also an architect. He drew up the plans for his own house, at Monticello in Virginia, and also designed much of its furniture, such as this comfortable combined wooden chaise longue and desk, an ingenious and practical item that is equally suited for either work or rest.

Louis XVI-style desk set in lapis lazuli and chased gold, mounted with emeralds, one of the first commissions of the celebrated French jeweler René Boivin, who started out at the end of the nineteenth century as a goldsmith in the family workshop.

Napoleon's office–library at Malmaison, where he lived when he was First Consul in 1799 (facing page). In the foreground lies a map of the battle of Arcola in Italy, where Napoleon gained a hard-fought victory against the Austrians in November 1796. The furniture is decorated with Egyptian motifs, a fashion inspired by the emperor's campaigns in Egypt, and the décor is neo-classical.

Napoleon made frequent use of field desks, such as this fold-away desk, made by Giovanni Socchi in Florence in 1810. When closed it resembles a drum-shaped chest of drawers. Opened, it forms a complete desk, with a chair, a flap for writing and side shelves. A masterpiece of cabinetmaking, it is now on display at the Château de Fontainebleau.

entertained the writers Marivaux, Montesquieu and Fontanelle, christened hers "Le bureau d'ésprit." The desk developed in two directions. Placed in the center of the salon, it became an important element in its owner's public persona. Tucked away in a private study, on the other hand, it removed its user from public view. However, desks were only owned by a privileged few—the well-educated and the rich—and were not to come into widespread use yet.

At the beginning of the Regency period, around 1715, the design of furniture became generally more sophisticated. Following a fashion for cylindrical shapes, the desk took the form of a large table which incorporated storage space and could be closed by a sliding cylindrical wooden panel—ideal for hiding untidy habits. The visitor no longer sat facing his interlocutor, but rather next to him, implying a warmer relationship. An extraordinary desk, designed by J.F. Puteaux, appeared in the nineteenth century. Now on display in the Musée Carnavalet in Paris, it is a magnificent cylinder-front desk with a secretaire on each side, thereby enabling three people to work together while each maintained their own privacy.

Sitting at a table became the norm, a position that gradually became more or less synonymous with "work." The space allowed for one's legs varied, as did the width of the work surface, although the height remained more or less constant. Shelves, drawers and pigeonholes came and went, and the materials used differed. Various configurations were possible, but the basic principle was now firmly established. The desk had become a partner in work, an extension of the body. It had become a silent companion, functioning as a center of communication, between oneself and the world at large.

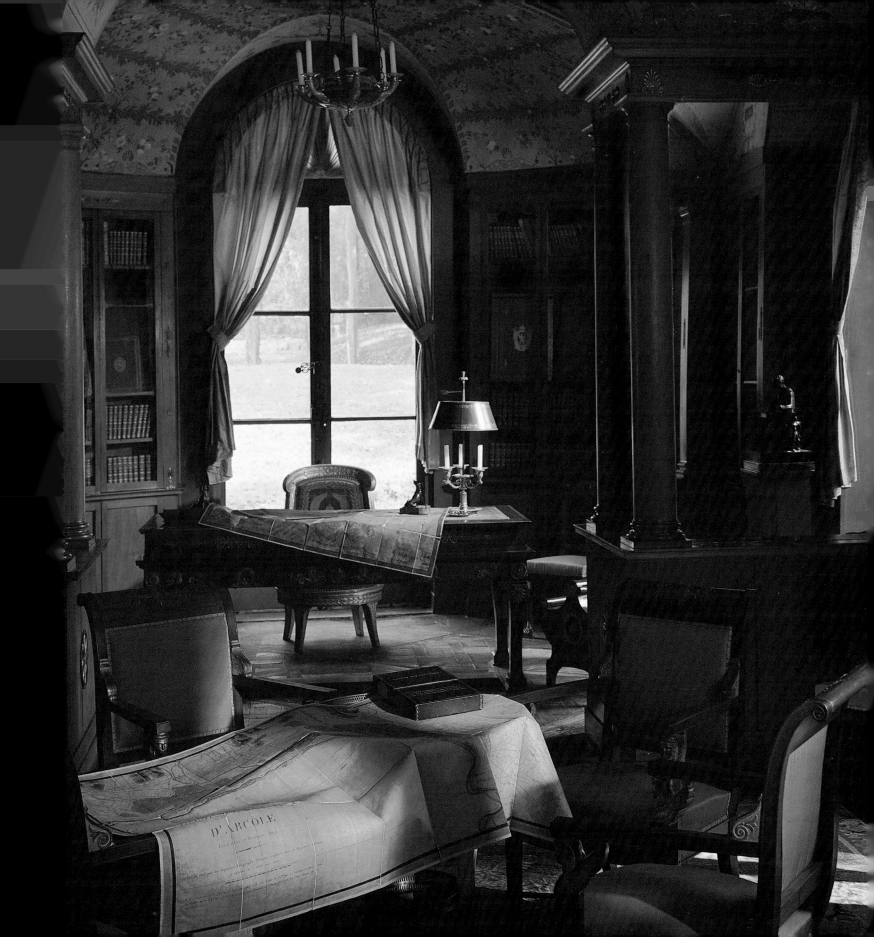

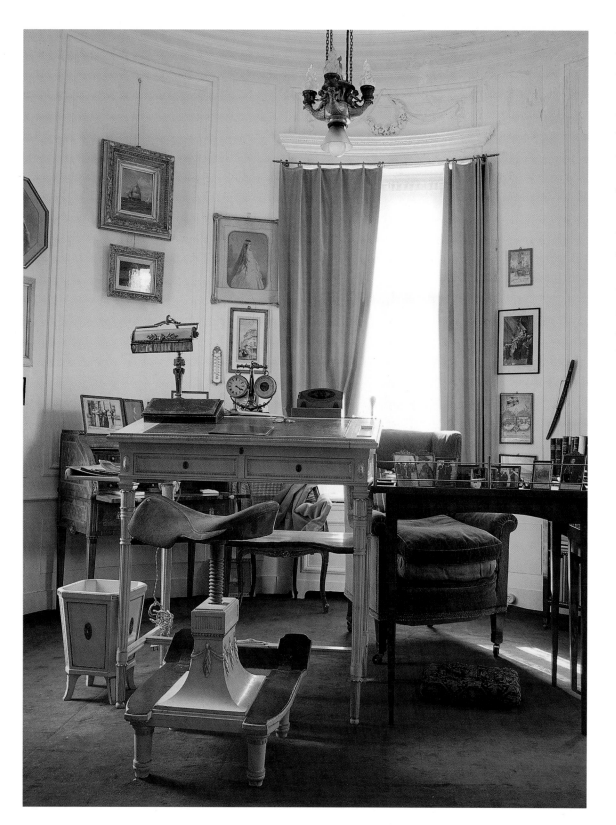

The office of Wilhelm II, grandson of Queen Victoria, king of Prussia and German Kaiser from 1888 to 1918, was a relatively small room furnished with a cylinder-front secretaire, a flat desk and a tall writing table with drawers. Note the extraordinary adjustable stool, with its saddle-like seat.

The personal study of Tsar Nicholas I. This room, designed in 1829, permitted the tsar, with the assistance of semaphore, to supervise naval maneuvers between Kronstadt and St Petersburg (facing page). Telescopes, compasses and a silver megaphone are preserved here. The walls and ceiling are decorated with superb *trompe-l'œil*.

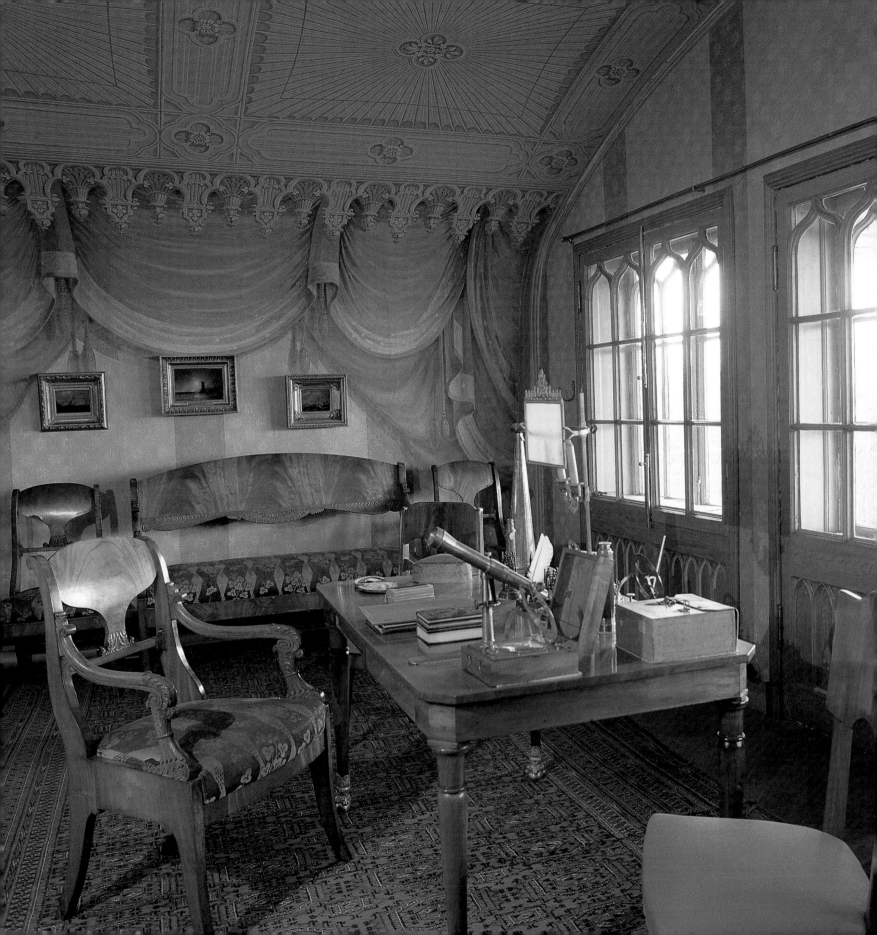

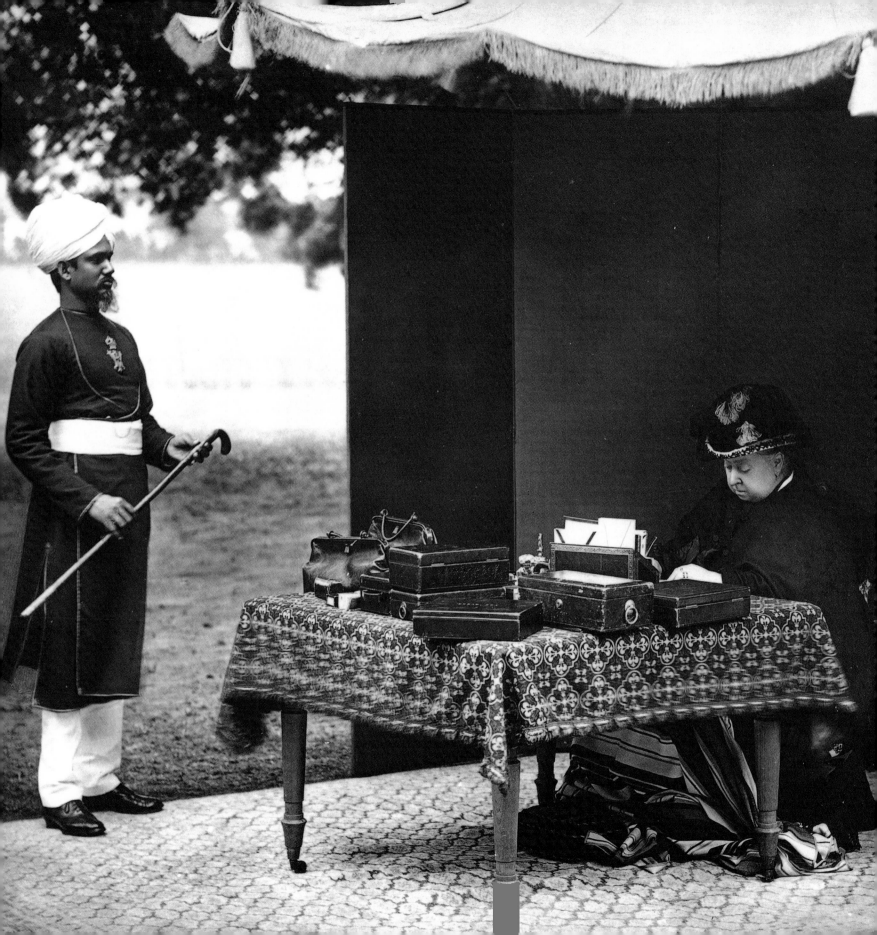

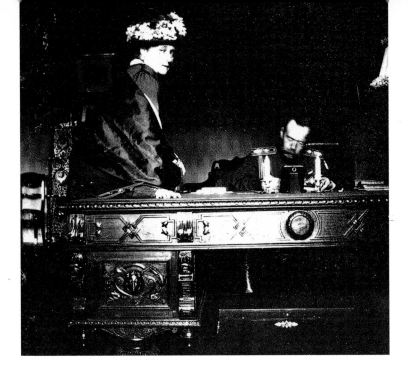

Family life played an important part in the lives of Nicholas II and Alexandra, the last royal rulers of Russia. In their palace at Tsarskoye Selo, Alexandra often came to her husband's office unannounced to share a few secluded moments.

Queen Victoria liked her creature comforts (facing page). Even in the midst of the Indian countryside, she had a large parasol, a folding screen and a carpet to provide a comfortable setting for her alfresco office. Victoria played a major role in British foreign policy, identifying herself with Britain's imperial aspirations. In this photograph, taken in 1893, she is waited on by her faithful Indian servant Abdul Karim, who stayed with her until her death.

This unusual railroad car (right), decorated with a carpet, wood paneling, and bronze fittings, has been furnished with a desk, secretaire, leather settee and chairs, together with desk lamps and fans. It was designed to facilitate work during long journeys across India and to help one forget that one was on a train in 1906.

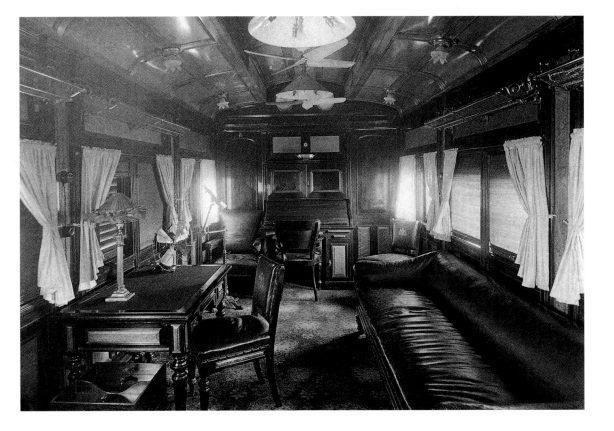

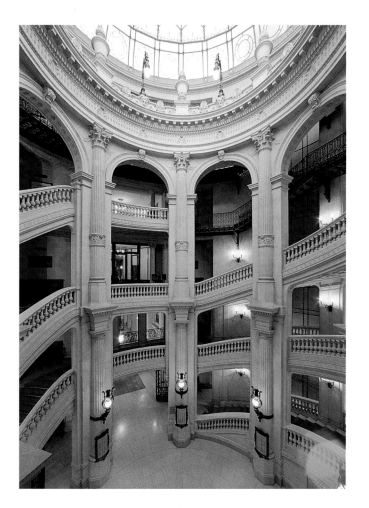

The headquarters of the Crédit Lyonnais bank on the boulevard des Italiens in Paris was designed by W. Bouwens Van der Boijen in 1876. When it was built it was the ultimate modern office building. Parisians had a new monument "which came out one day, fully-fledged, like a butterfly leaving its chrysalis," in the words of one journalist. A seventy-foot-high central atrium with a glass roof housed the first counters not fitted with grilles or glass.

This large office (photographed in 1925), with its high ceiling, parquet flooring and furniture in dark polished wood, belonged to an Italian bank (facing page). The employees sat facing each other across pigeonholes. It was a studious, all-male environment, with no typewriters or telephones.

THE FIRST OFFICE BUILDINGS

At the start of the nineteenth century, homes and offices were housed in the same building. The offices tended to be located on the ground floor and the mezzanine. Notaries and lawyers, as we have seen, practised in their own living rooms. People's office needs at this time were modest. In 1848 (according to a census by the Paris chamber of commerce), more than half of Parisian businesses involved only one person, and there were only seven thousand enterprises (11 percent) with more than ten employees.

The large banks came into existence in the eighteenth century. The Banque de France dates from 1800, and the Bourse in Paris was inaugurated in 1826. However, it was slightly later, with the development of the banking system under the Second Empire, that the organization of working space became a priority. This led to the creation of a financial district in Paris, located between the Bourse and the Opéra.

Hector Horeau, an indefatigable utopian architect who spent his time endlessly designing projects for beautifying Paris—few of which were built—proposed in 1871 the construction of an office building that would be "entirely without living accommodation," on the site of the old Opéra. His project consisted of offices linked by a battery of elevators up the front of the building, with a large glazed courtyard containing a garden. Horreau's project—technologically advanced for its time—was revolutionary. More recently, a large number of major corporations have adopted this model for their headquarters. More than a hundred years after his time, Horreau represents the ultimate in modernity.

Bankers are generally ahead of their time and were among the first to commission large buildings with extensive office space. In 1876, Henri Germain, the founding president of Crédit Lyonnais, decided to house his Paris headquarters on the boulevard des Italiens. The inauguration took place on 21 March 1878. The people of Paris had a new monument, designed by the architect Bouwens Van der Boijen—a building that was destined to become a model for the banking headquarters of the future. It featured a large central atrium, with a glazed skylight and "English-style" counters (in other words, having neither grilles nor glass). "I am lost for words to describe this vast hall, which, with its 310 gas lamps and its chandelier, would make an exquisite ballroom," exclaimed Adrien Marx in *Le Figaro*. The basement housed the safe room; the ground floor was for receiving clients; the mezzanine offered well-appointed reception rooms for foreign visitors; and the

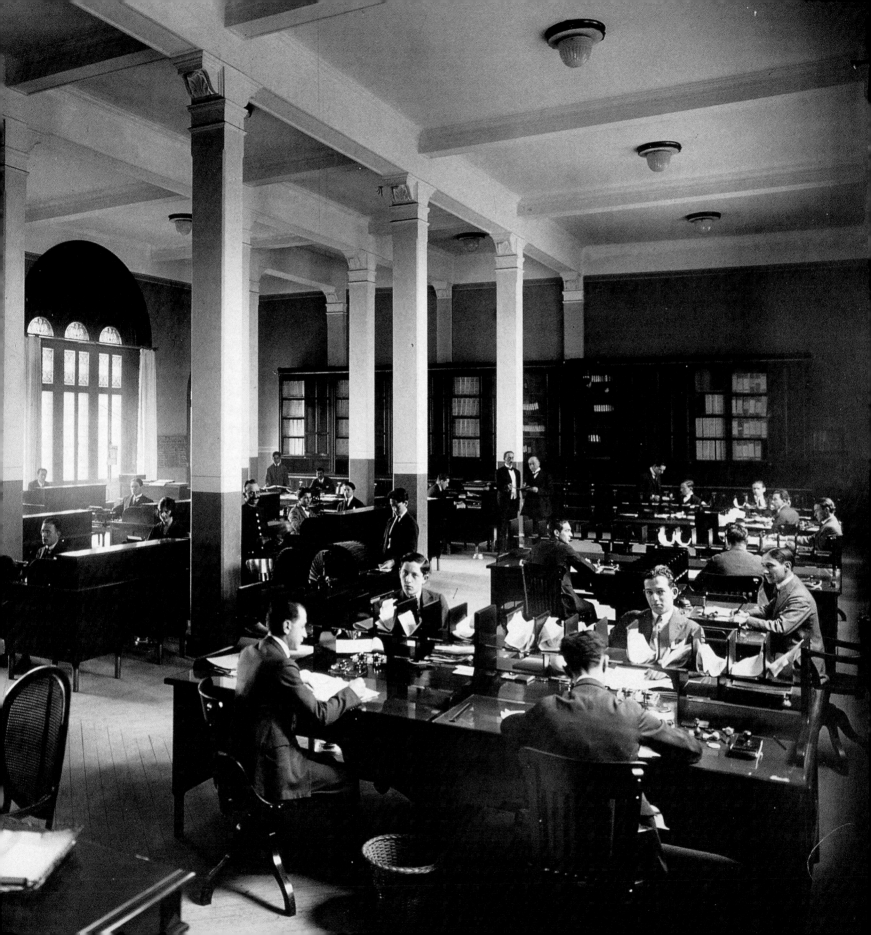

The first elevator with a built-in mechanical safety device was invented by Otis in 1853. It was electrified by Siemens in 1880. The Eiffel Tower offered astounded visitors the chance to experience the benefits of this invention. Henceforth lifts became standard installations in the stairwells of tall buildings (right).

In 1889, Gustave Eiffel's office in Paris had a unique and prestigious address: 1,066 feet up, on the fourth-story platform of the Eiffel Tower (below). The upholstered armchairs, the framed engravings and the wallpaper with its decorative frieze give this little boudoir a strange antiquated charm and create an intimate atmosphere, which no doubt enabled the engineer to forget the worries of work. It is hard to believe that this room is located at the top of the Eiffel Tower.

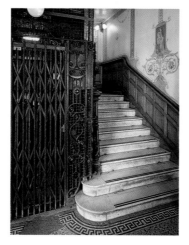

As a young office worker, George Eastman spent his evenings doing research, and in 1880 he perfected a process for making dry plates for photography. In 1888 the first Kodak box camera was launched. The Kodak offices were typical of their period, with roll-top desks arranged back-to-back so that visitors had to sit to one side (facing page).

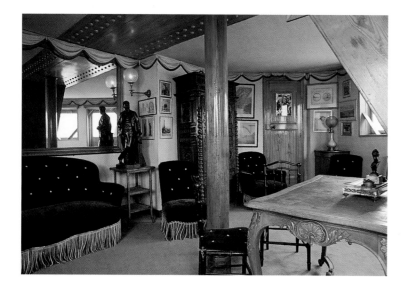

first floor was reserved for senior management. The floors higher up the building were set aside for services not involving the public. A modest man, Henri Germain had his own office up under the rooftops.

Around 1900, with the construction of buildings intended to be used solely as offices, the last link in the chain appeared leading from the scribe's writing-case to today's office. The process of office construction had begun and it was to continue unabated until around 1995, when people attempted to transform offices into apartments. That, however, is another story. Early office buildings were similar in appearance to apartment buildings, except that they had no kitchens or bathrooms. In 1905, in Paris, various shipping companies moved into a building, at 12 boulevard de la Madeleine, that was occupied exclusively by offices. Gradually office space was constructed on a particular model—the factory. This was a result of the new building techniques that were being developed. The advent of iron structural frameworks and metal girders and the invention of the elevator brought with them considerable changes in form and usage.

In Chicago in 1889, the architect William Le Baron Jenney designed a building for the merchant Levi Z. Leiter. The Leiter Building was the first pure skeleton-type building, in which none of the walls was load-bearing (such walls were subsequently known as curtain walls). The eight-story building had a cast-iron frame, which meant that for the first time large plate-glass windows could be used, separated only by fireproofed metal columns. From now on tall buildings became technically possible, thanks also to the rapid development of the elevator, another key element in the history of the office. The elevator made a commonplace of physical space, ending the separate *étage noble*, mezzanine and servants' floor. Each story had the same ease of access, and was therefore equal in value, with the exception of the upper, and in particular the top stories, which assumed a symbolic dimension as the location of power. As a result of the construction of tall office blocks served by elevators, the office of the twentieth century came to be characterized by a single open space, identical windows and uniformity of volume.

In 1889 the world witnessed the construction of the amazing 1,010 ft Eiffel Tower—a major feat of technology. It provided a model—the empty or hollow structure—which is still used today. For many years to come the Eiffel Tower set the pace, becoming a source of French pride. The French had been wise enough to build a monument and they felt no obligation to fill it with office space, except of course for Gustave Eiffel, who had his own personal office right at the top.

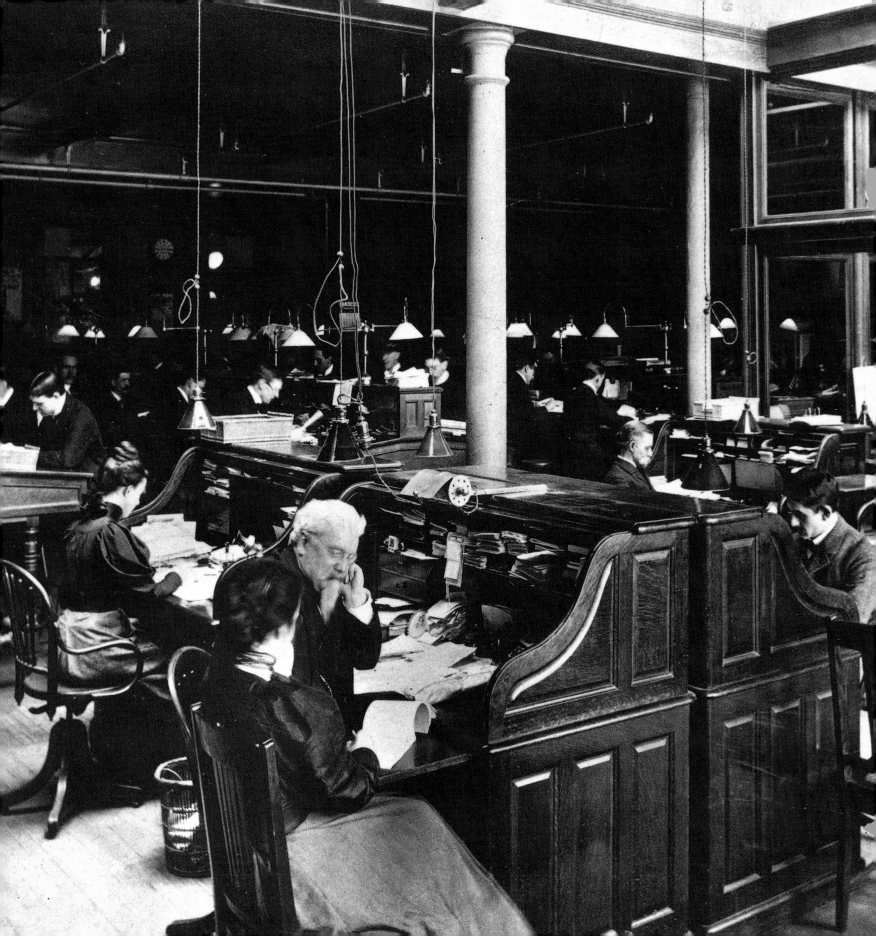

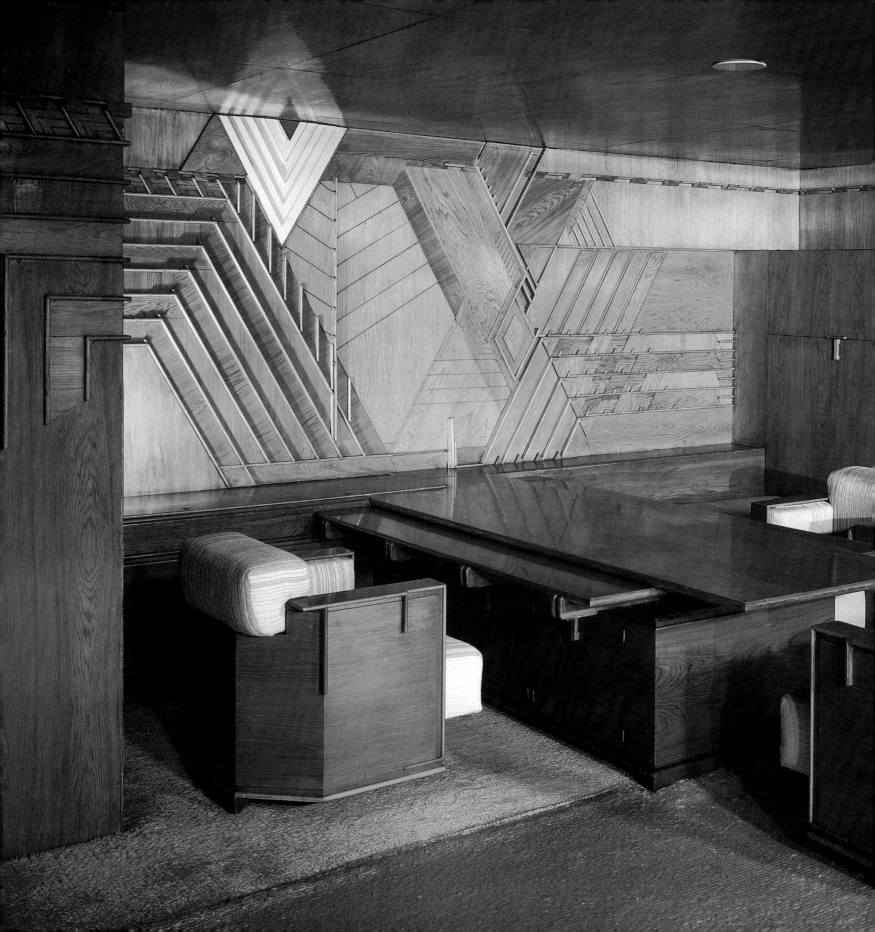

The office takes shape

Ever since Frank Lloyd Wright revolutionized the design of the workplace at the beginning of the century, architects and designers have worked together to create designs that combine form and function.

In 1937, Edgar J. Kaufmann Sr. asked Frank Lloyd Wright to design his office in Pittsburgh (preceding double page). Working with rectangular shapes, the architect produced a room that was entirely paneled with cypress plywood. The office was eventually dismantled and is now on display at the Victoria and Albert Museum in London.

An office worker as seen by a caricaturist in 1907 (above). Having read the newspaper, he has a little nap before, at some point, getting stuck into his pile of files.

In his last movie, *Mad Wednesday*, made in 1947 by Preston Sturges, Harold Lloyd played an accountant in an advertising agency (left). He is the epitome of the model employee, complete with oversleeves.

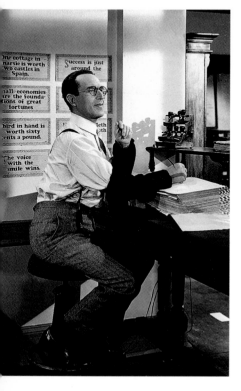

The early twentieth-century office, such as this one in the United States, was rather like a classroom (facing page). Seated behind tall desks, with pigeonholes at eye level, the employees could not see each other. There were no typewriters as yet, just papers, files and wastepaper bins. No attempt at decoration was made in this male world.

During the nineteenth century a new figure emerged who soon became the butt of endless jokes: the office worker. "Behold the office worker," wrote the *Journal pour rire* on 22 October 1853. "He arrives at nine o'clock, before his employer; he signs the time sheet and sits in the leather chair at his desk. He will stay in that chair until four o'clock. He spends seven hours there, back bent, pen in hand . . . But when you ask him in the evening what he's been doing all day, you find that he's written half a page. He takes eight days to complete a job which somebody unfamiliar with the tricks of the trade would do in a mere two hours."

In France, by 1896, the civil service employed almost a million office workers. With their arrival, a new kind of office began to emerge. The historian Theodore Zeldin noted that when, in 1848, the government was asked to publish a list of all these white collar workers, it refused, claiming that the task was too difficult.

In his novel *Les Employés* (1838), Balzac offered a striking portrayal of life in a ministry, a world which celebrated hierarchy and differences, and which used space, furniture and décor as symbols of power and of each person's place within the organization. "So the office becomes the employee's protective shell. No employee without an office, and no office without an employee . . . Where does the employee end? A serious question! Is a prefect an employee?" In 1893 Georges Courteline added, in *Messieurs les ronds-de-cuir*: "Which of these two, the office or the office worker, was the natural fruit of the other, its inevitable outcome? The fact is that they were mutually complementary. They brought each other into existence, being at once both wretched and sordid."

The creation of specific work locations gave rise to a new way of life among office workers, a daily routine which today strikes us as surprising, if not crazy. Work seemed to be the least of their preoccupations. Since they had to spend all day in these places, office workers ended up behaving rather as if they were at home. They cooked there, changed their clothes, had their hair done, shaved and penned farces or love letters. Offices were never really designed to house all these activities. The ventilation left something to be desired, as did the heating, and the chairs were hard. If Balzac is to be believed, this world was characterized by a complete lack of concern for efficiency or profitability and by the extraordinary parallel life that went on there.

In nineteenth-century offices, the furniture provided for ordinary staff looked like classroom furniture, while management had the kind

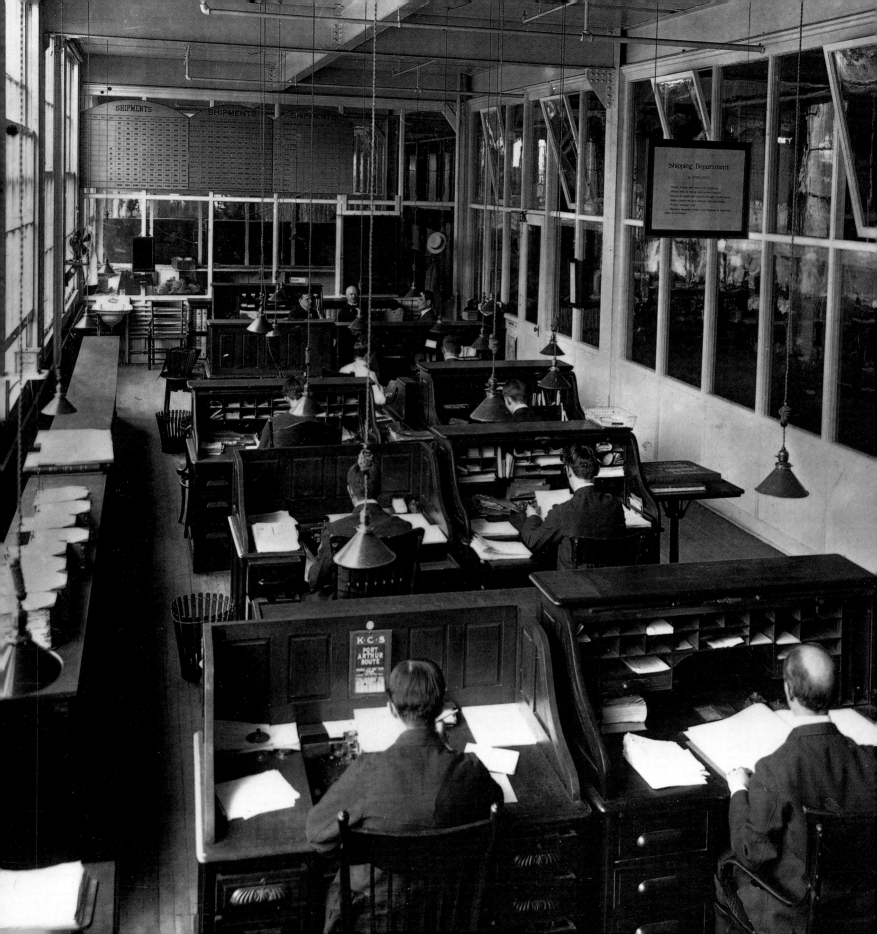

The manager's office in a British bank at the turn of the century (below). The décor includes a barometer, some handsome measuring instruments and a slightly untidy bookcase.

The offices of the *New York Dramatic Mirror* in 1899 (facing page). Actors made a point of dropping in on journalists, who were always ready to lend an ear. A few regulars feature in photographs on the wall. The cramped space facilitated the circulation of documents and news, which was essential if this weekly with a circulation of 2,200 was to go to press on time.

The movies often provide entertaining portrayals of office life. Here we see the misery of an office worker faced with a boring, repetitive task—sticking on hundreds of stamps—played by Charley Chase, a leading comic actor of the silent era (below).

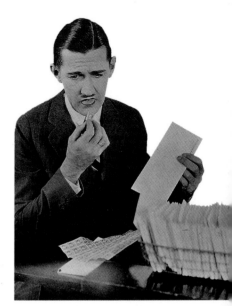

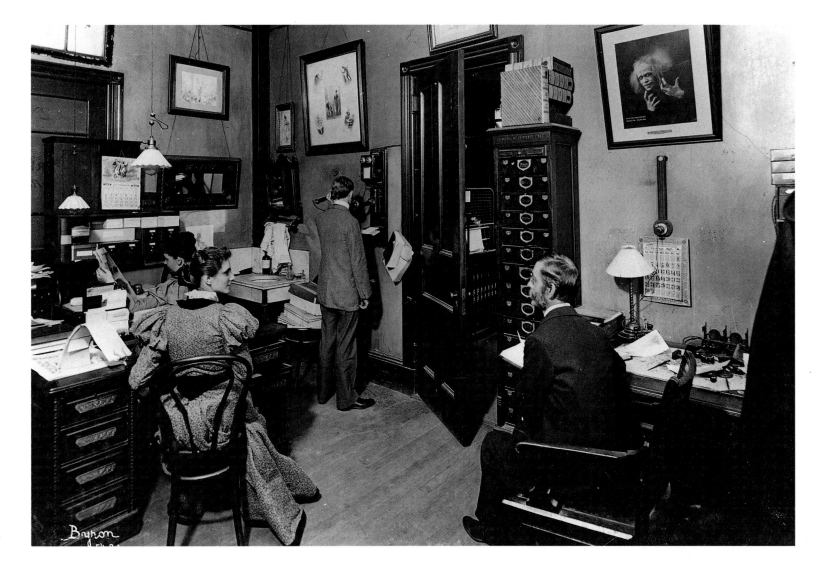

of furniture that you would have found in a middle-class home. Hierarchy was present in every detail, every item of furniture. The worker seated at his desk had few possibilities for communication, since his only available interlocutor was the person sitting next to him. "A fisherman is a God by comparison. Fishing is a passion, and the employee has no passions. He doesn't actually like his office—he merely gets used to it. He's no longer a man, he's a machine." Thus wrote the *Journal pour rire*.

Surveillance was still a prime preoccupation. Everyone was expected to be visible, to concentrate on their work and to behave correctly. Office workers were relatively uneducated and their main concern was to form the upstrokes and downstrokes of their letters properly and to keep their columns of figures straight. It was repetitive manual work, six days a week. In Courteline's *Messieurs les ronds-de-cuir* the office comes across as being a far more serious place than in Balzac's account several decades earlier. When passing an administrative building, "without realizing exactly why, you have a sense of the huge void of this barracks, and the non-life of thirty penpushers drowning within it. You sense the sinister silence of the empty offices and the paneled records-office: administrative catacombs . . . where piles of files accumulate under a shroud of dust."

TYPEWRITERS AND STANDARDIZATION

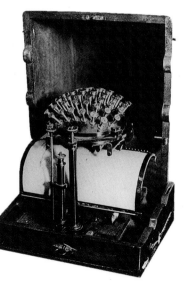

An ancestor of the modern typewriter (right). This rudimentary but rather ingenious apparatus, slightly reminiscent of a porcupine, was first exhibited at the Vienna world's fair in 1870. One disturbing detail: the machine was invented by Joseph Labor, who was blind.

Queen Mary on the occasion of her visit to the institute for young blind women at Tockenham in 1927. These girls learned how to type by means of a system involving braille (below).

A typing pool in the United States at the turn of the century (facing page). Virtually all the typists were women. Their only view was of the back of the head of the person in front. They typed by the yard and had to turn out a certain number of lines per hour.

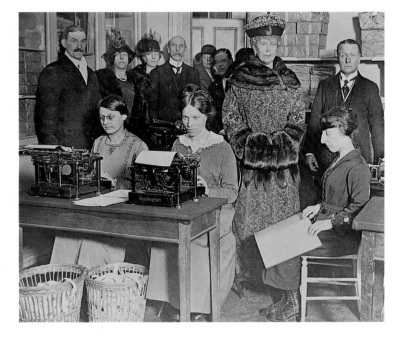

By the early nineteenth century, extraordinary prototypes of typing machines—some made of wood—were being invented. The typewriter as we know it was invented in 1868 and put into production by E. Remington and Sons, an American firm of gunsmiths, in 1873. Success was not immediate and sales were sluggish at first. However by 1878, thanks to the Remington No. 2, the first shift-key typewriter, it became possible to type in both upper- and lower-case letters. This was followed soon after by the first single-key cylinder machines. The QWERTYUIOP arrangement of the keyboard was arrived at by studying the letters that occur most frequently in the English language. The aim was to ensure that the commonest letters were not placed immediately next to each other, in case the typist mistyped as he or she built up speed. A. Navarre proposed a French keyboard (ZHJAY) in 1901 but failed to get it accepted as the standard. The first electrically operated "typewriter" was invented by Edison in 1872, becoming the familiar ticker-tape machine. The first electric typewriter as an office writing machine was invented by James Smathers in 1920.

The advent of the typewriter led to important changes in office work. It required a special sitting posture, which explains the wealth of developments in the history of the typist's chair. But above all, as the architect Le Corbusier noted, it introduced standardization: with the coming of the typewriter, letter paper took on a precise format (21 cm x 29.7 cm), which then became the commercial standard. Envelopes, mail trays, folders, files, filing cabinets—the design of every piece of office equipment was determined by the establishment of this standard and the most intransigent of individualists was forced to go along with it.

The Italian typewriter firm Olivetti produced one of the earliest portable typewriters in 1932. The Olivetti brothers, who were quick to understand the importance of image and "packaging," commissioned architects and designers to design their typewriters. In 1969 they introduced bright colors with their Valentine typewriter, designed by the Italian designer Ettore Sottsass. This red "pop" design was a huge success. IBM's S72 electric golfball typewriter appeared in 1961.

Early offices were all curiously similar in appearance. The furniture was made of dark wood and sometimes consisted of a simple table with a few deep drawers or a proper desk with pigeonholes of various

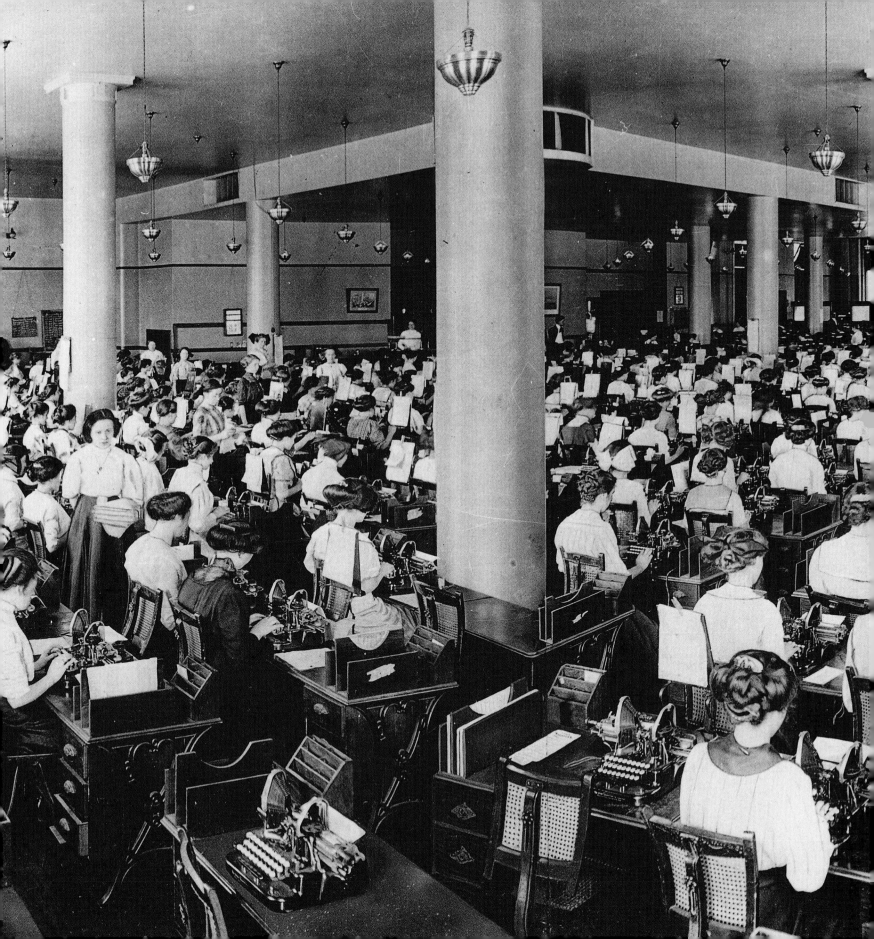

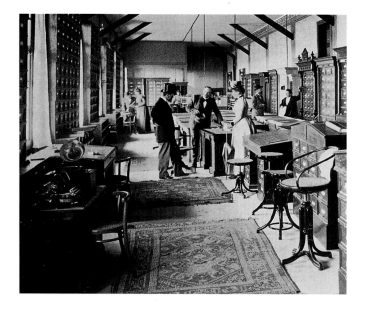

Michael Thonet set up his furniture workshop in Boppard am Rhein in 1819 (above). In around 1830 he developed a system of steambent veneers with which he was able to make complete chairs. He eventually opened factories in Hungary and Moravia, employing four thousand workers. Here we see the firm's Scholzenberg showroom, which also served as an office.

This rolltop desk was made by the Steelcase Company, American specialists in metal furniture founded in 1912 (below). With its classical lines and legs decorated with moldings, it was designed to look as though it was made of wood. The fact that it was made of metal, and therefore solid and fire-resistant, assured it a huge success after its launch in the early 1920s.

sizes stuffed with papers. In general they were still located in town houses and apartments adapted for the purpose.

What was most striking in these early collective work spaces was the arrangement of the furniture, which gave the office the air of a school—the only thing missing was the blackboard. Curiously, the blackboard has since become a standard feature of offices and conference rooms (although it is actually white). Employees sat at rather all-enclosing, almost protective desks, with eye-level shelves and pigeonholes. They all sat in rows and were not allowed to look at or speak to each other. Their only view was of the back of the head of the person in front of them. Their office equipment consisted of an ink-blotter, an ink-well and some pens, plus notebooks, ledgers and papers. There were ever-growing quantities of paper. Carbon paper, which was invented in 1890, improved the everyday routines of office workers considerably. The visitor's chair, when there was one, was placed to one side of the desk, facing into empty space. The worker's chair was made of wood, and swiveled. The storage units had dozens of drawers with brass knobs and brass label holders displaying labels lettered in elegant script. There was no attempt at decoration, no potted plants or personal objects. Maybe one or two pictures would be hung haphazardly around the place and there were black metal hanging lamps. The polished parquet flooring was dotted with over-flowing wastepaper bins. It was a world populated largely by men.

After the invention of the typewriter, a number of other inventions arrived on the scene, transforming and simplifying office life further. Not all of them were spectacular. Have you ever wondered, for example, who invented the paper clip? It was the Norwegian Johan Vaaler who, in 1899, invented this simple but very ingenious device, made of a single piece of metal wire which was bent into a shape reminiscent of a trombone. During the Second World War, when Norway was occupied by the Germans, the paper clip, a typical Norwegian product, became a national symbol, and people wore it on the backs of their lapels, as a sign of resistance. The paper clip has all kinds of emotional and psychological ramifications: on the one hand there is the manager who insists on stapling a batch of papers together, because he believes that good office practice means never using a paper clip. His secretary, on the other hand, knows that using paper clips is a discreet sign of courtesy. Whatever the case, archaeologists in the fourth millennium will certainly puzzle over this bizarre object.

The French pneumatic dispatch system was set up in 1865 and the Banque de France microfilmed its archives in 1875. At the end of the nineteenth century, stenotypy was invented and 1900 saw the pioneering invention of the rotary duplicator (ten years after carbon paper). The use of the stenotype for dictating letters had important consequences for administrative staff. From that point on, long periods of the day no longer needed to be spent in copying up notes. Male copyists were replaced by female shorthand writers and typists (the two jobs were originally separate).

In 1907, Édouard Belin made the first telephoto transmission (the first transatlantic transmission was made in 1921). However, Telex was not to develop until 1930. In France it was inaugurated in 1946 and by 1950 it was being used by about 100 subscribers, rising to 1,000 in 1956 and 135,000 30 years later.

In 1913, Steelcase Company, a major American office equipment manufacturer, produced a metal desk painted the color of wood. A fear of fires and the efficacy of the *trompe-l'œil* effect guaranteed it a huge success.

In around 1920, filing cabinets and shelving began to invade offices. Metal filing cabinets arrived in France from America and were very popular because they were the only ones that were fire-resistant. This was also the period of the height-adjustable typewriter table. Kept in a corner, it could be used by several people in turn.

In 1930, Scotch tape, marketed by 3M, came flooding into offices. It was followed, much later, in around 1985, by yellow Post-it notes, which became multicolored soon after. There are two myths of origin surrounding the Post-it. It is said that Art Fry, an engineer with 3M, used to sing in church every Sunday. In 1974 all the page markers fell out of his hymn book onto the floor. Divinely inspired, he worked on finding a formula for sticky papers that could be moved from one place to another. It took him ten years to convince his company of the usefulness of his invention. There is also another story: an anonymous engineer was researching glues. He made one particular glue which, unfortunately, came unstuck all the time. However, he soon realized that his glue had possibilities . . . Whatever the story, today Post-its are to be found on desks all over the world. They have become an important part of office life. To cater for the Japanese, with their top-to-bottom writing, they are also produced in a vertical format. How did we ever manage to combat forgetfulness and absent-mindedness before they were invented?

An early Dictaphone in use in 1926 (below). The invention of the Dictaphone, like that of the typewriter, transformed the everyday routines of the office. It worked on the same principle as the

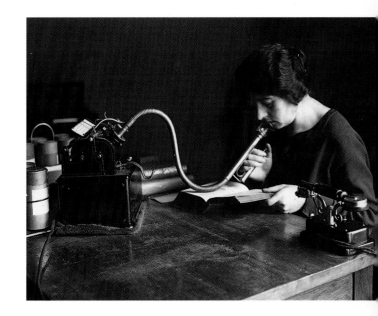

phonograph. Sound vibrated a membrane connected to a needle, which scored a groove on a rotating cylinder.

This round wooden desk tidy made of solid maple was designed by Jean-Pierre Vitrac and made by Edwood. This novel and indispensable accessory is a neat way of storing Post-its, paper clips, pens and visiting cards.

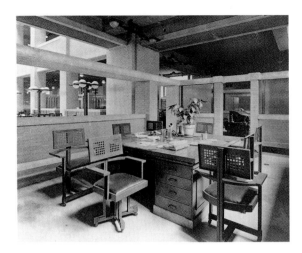

The first painted metal desk, and its matching swivel chair on casters, designed specially for the Larkin Building in 1903 (above). In another version, the chair and desk were joined by an adjustable arm. Wright always configured his office furniture in a number of "systems," which could be adapted to the specific needs of the user.

Frank Lloyd Wright in his private office at Taliesin, Wisconsin, in 1956 (below). He was by this time a famous man (the Mayor of Chicago had designated 17 October as "Frank Lloyd Wright Day"). After a lifetime of designing, he was now writing his autobiography, which was to appear the following year. The architect used his favorite materials for his private office—stone and wood.

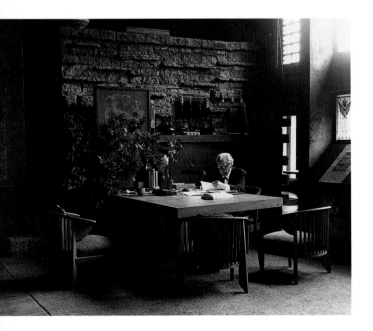

FRANK LLOYD WRIGHT, PIONEER OF OFFICE ARCHITECTURE

An American architect of genius was to revolutionize the concept of the workplace. In 1903, Frank Lloyd Wright (1867–1959) designed his first office building, the Larkin Building in Buffalo, Ohio. The light, air-conditioned interior was arranged around a central aisle with a skylight. Wright also designed the first painted steel desk, which had a built-in swivel seat on casters. You could either work sitting down, or push the chair away and work standing up, as at a drawing board. The typewriter (a tall piece of equipment in those days) was built into the desk. A shelf unit above the work surface gave the worker some privacy and enabled him or her to file paperwork. The unit had three drawers under the work surface and three drawers down one side and there was a panel to hide the user's legs. This kind of desk is still very much in use today. For the same building he designed a handsome office chair on casters, in leather and metal. Like some other examples of the architect's work, this building was wrecklessly demolished in 1950. Nevertheless, it was this creation that made Wright famous.

In 1936, Mr. Johnson, president of the S.C. Johnson & Son Company, was planning a new administration building at Racine, Wisconsin. He had already picked his architect, when, as in a fairy story, his daughter Karen suggested that he choose Frank Lloyd Wright, of whom she had heard so much, to design something really extraordinary. Mr. Johnson agreed, giving the architect an entirely free hand. The result was a remarkable building. Wright wanted his structure to give work the kind of impulse that a cathedral gives to religion, and he succeeded. Everything fits: the architecture and the furnishings complement each other splendidly. This matching of the internal and external aspects of a building was a feature of Wright's work, but it is rare for an architect to be entrusted with designing both the building and the furnishings. The desk Wright designed prefigures the office systems of the 1980s (in other words, it is made up of a combination of elements that one can assemble, like a giant jigsaw puzzle, according to need). The several hundred employees worked in a single, huge, remarkably light space. However, this was nothing like the traditional typing pool. The desks were all well spaced out, one of the factors which ensured that there was no hint of that oppressive school-like atmosphere. The office was open-plan, the landscaped office not yet having been invented. In effect Wright created an office that could be adapted to meet the users' needs.

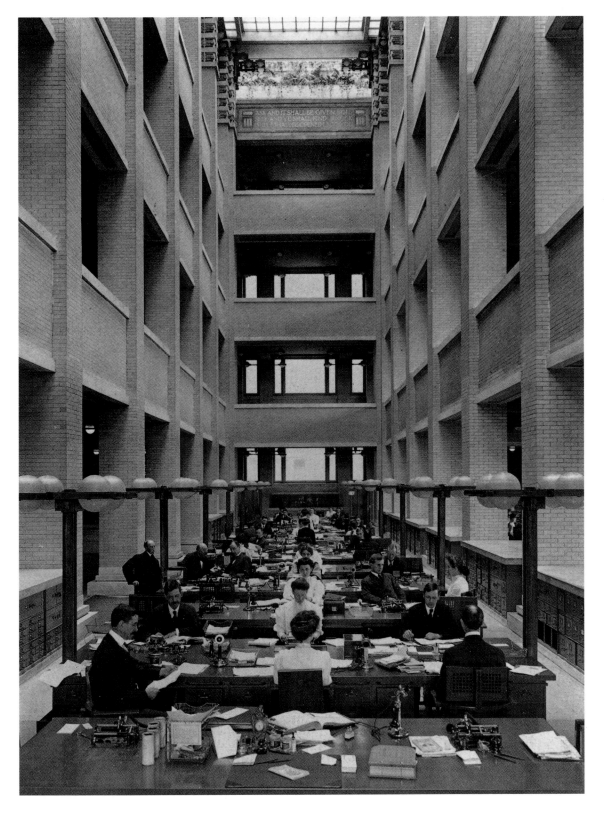

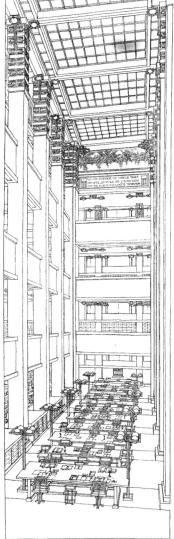

The Larkin Building in Buffalo, demolished in 1950. Wright created an open-plan architecture around a light, airy, central atrium. Wright used to say that one had to "create spaces, not design façades," and he put this philosophy into practice. Here the employees worked in groups of four or six at a time, sitting at long desks. The metal filing system was built into the brickwork. Low-level lamp stands gave this high-ceilinged space a human scale.

With his design for the S.C. Johnson & Son Company Administration Building in Racine, Wisconsin, in 1936, Frank Lloyd Wright brought about a revolution in the organization of work space. As with the Larkin Building, Wright created a vast, light space. The desks are arranged around slender columns supporting large "lily pads" (right).

Everything was designed with the comfort of the user in mind: the desk created by Frank Lloyd Wright for the building has three working surfaces in walnut, arranged at different heights, with swing bins for drawers. The frame is made of red lacquered steel. The rounded lines of the chair echo the curves of the desk, which is currently available from Cassina.

The architecture of the S.C. Johnson & Son Company Administration Building is characterized by the subtle matching of interior and exterior (facing page). The "Cherokee" red of the furniture echoes the brick used and the rounded forms of the outside are echoed internally. This extraordinary building, which is constructed around a huge open office area,

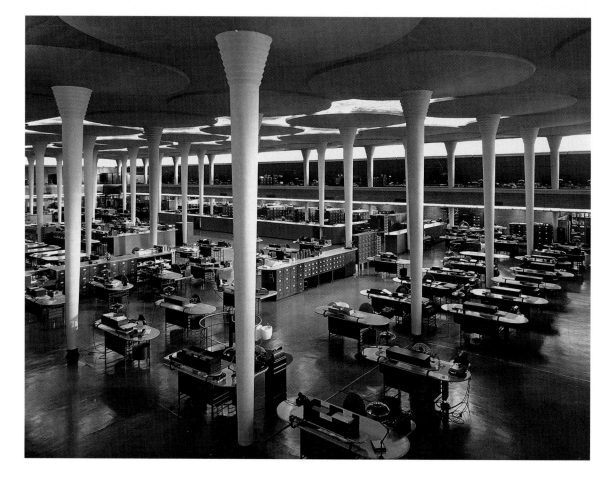

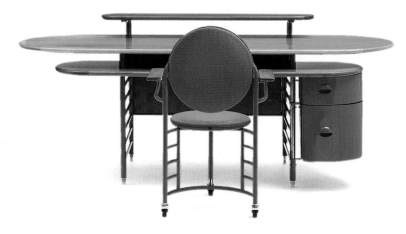

demonstrates that Frank Lloyd Wright, who designed numerous distinguished houses, was equally at ease designing large buildings.

Frank Lloyd Wright's remarkable furniture has been brought back into production today. The "Cherokee" red specified by the architect echoed the brick used, and the rounded forms of the desks and chairs echoed the "lily pad" columns and the curves of the light fittings. Wright's desk had nine possible configurations according to the requirements of the work situation and the needs of its user. The typewriter was incorporated into the desk and could be tucked away inside it; the filing trolleys were easily maneuverable; and the chair was designed specifically for use with the desk.

Wright's scheme was the first serious attempt at an overall office design. Throughout his career his work remained consistently true to the ideal of "utility and beauty," and the S.C. Johnson & Son Company Administration Building provides a striking demonstration of this. It still stands today, just as Wright designed it, which is a remarkable fact in itself.

In a completely different style, and working in Europe, the Belgian architect and designer Henry Van de Velde (1863–1957) also gave a fresh

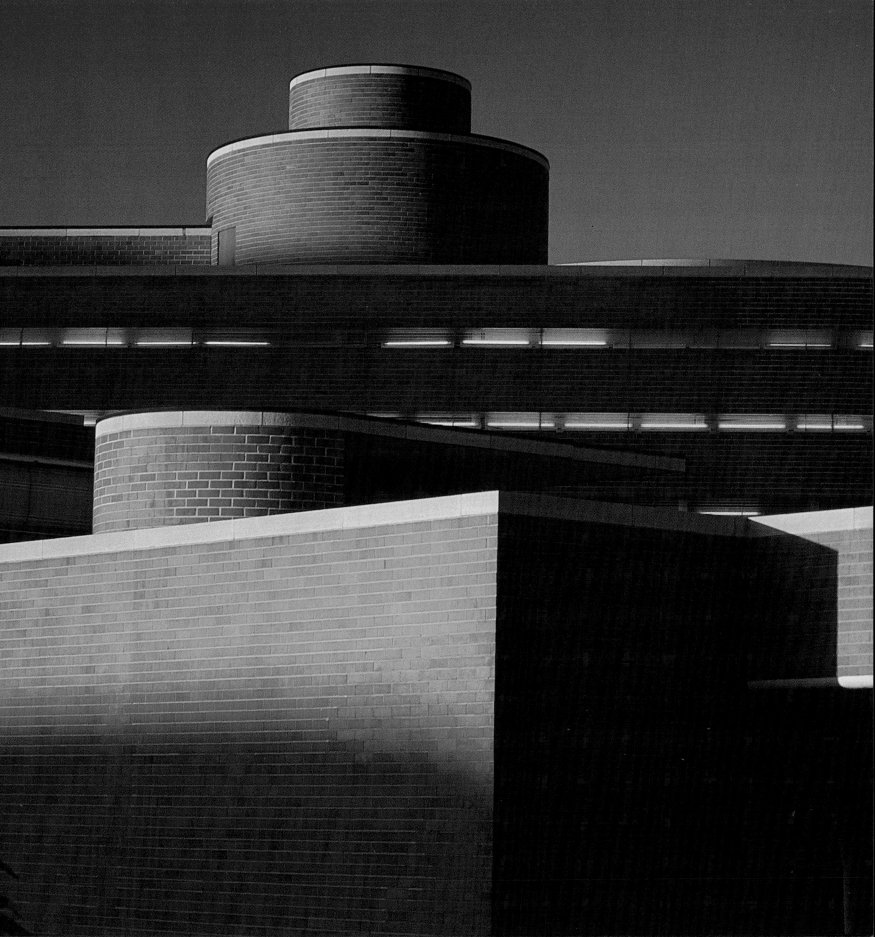

look to the desk. In 1896 he designed a wonderful bean-shaped desk, which soon became emblematic of his entire output. This imposing and exuberant piece of furniture, with its elegant curves, had a number of original details. The built-in shelves at either end helped reduce the impression of bulk and provided space to stack books and papers. It is a handsome yet functional desk. Its designer explained in 1897: "We start from the principle that particular shapes and ornamentation are totally ruled out if they cannot be manufactured or reproduced by modern machinery. We also work to identify the essential elements of each piece of furniture and each object, and we make sure that everything we design is easy to use. In that way we are able completely to renew the appearance of things."

This creator of extraordinary furniture, architect and interior decorator was widely imitated. His ideas and his work had a considerable influence on the Bauhaus. In 1902, he was already attempting to bring the artist, the craftsman and the industrialist together in an "Arts and Crafts Seminar" held at the Weimar school of art and architecture. Several years later, the Bauhaus school, the most famous of the twentieth century, was to build on this initial experiment. Its courses were also run by a team which brought together artists, architects, craftsmen and industrialists. The Bauhaus was founded in 1919 by Walter Gropius. Initially oriented towards the craftsman, with an emphasis on the individual, the school evolved more towards industrial design after 1925 (when it moved to Dessau), with a greater emphasis on materials. The Bauhaus played an important role in the development of design and was the first school to teach it as a discipline. Some of its best-known teachers, such as Marcel Breuer, began as students there. The school was closed by the Nazis in 1933.

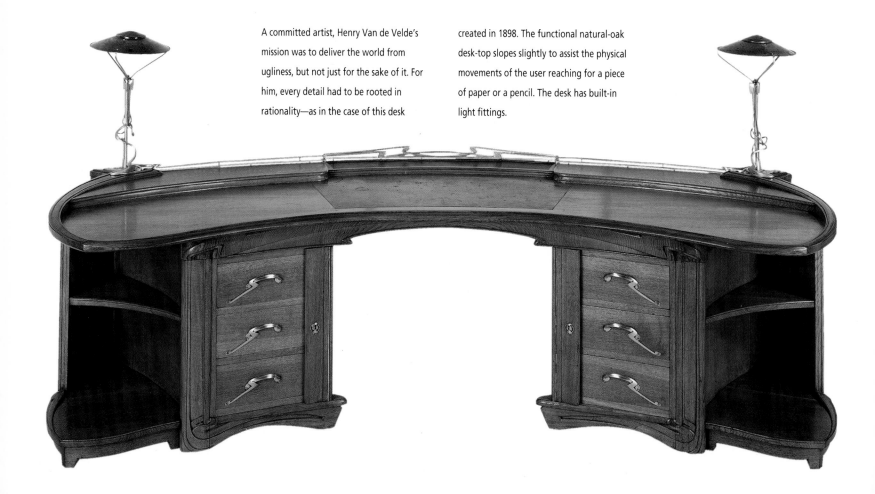

A committed artist, Henry Van de Velde's mission was to deliver the world from ugliness, but not just for the sake of it. For him, every detail had to be rooted in rationality—as in the case of this desk created in 1898. The functional natural-oak desk-top slopes slightly to assist the physical movements of the user reaching for a piece of paper or a pencil. The desk has built-in light fittings.

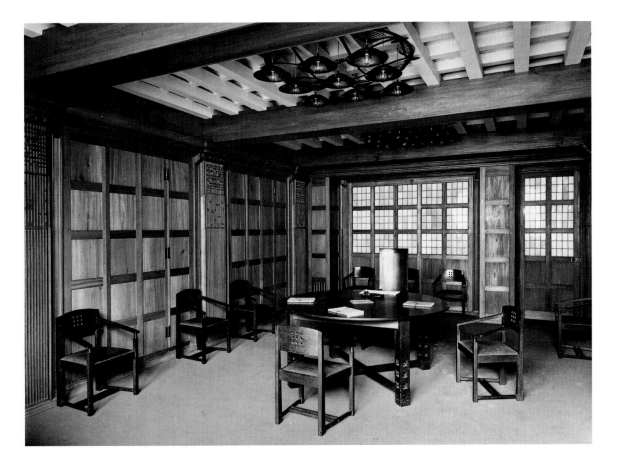

The Glasgow School of Art (left), designed in 1899 by the architect and designer Charles Rennie Mackintosh. It was his magnum opus. Here in the board room, the furniture is offset by wood-paneled walls and a white carpet. On the ceiling, white beams reflect the light produced by wrought-iron chandeliers with copper reflectors. This room is today used as a showcase for Mackintosh's furniture.

This armchair made of stained oak, with its rigorous lines and simple openwork decoration, reflects Mackintosh's preoccupation with squares (below, right).

In 1857 Thonet began mass production of the famous No. 14 chair, which was made of six separate screwed elements and could be taken apart. Here we see an office chair created in 1866, in bent beech, stained for a mahogany effect (below, left). The company listed 1,400 different chair designs in their 1920 catalog.

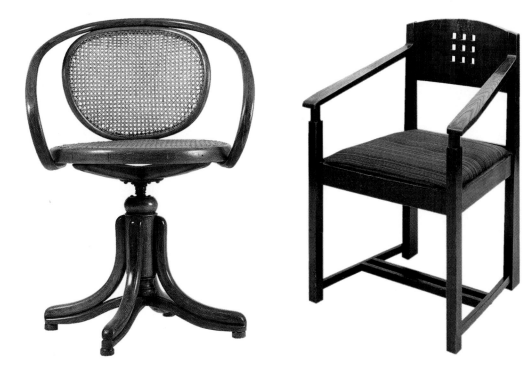

The office of the French industrialist Pierre Levasseur, a devotee of aeronautics, was designed by the interior designer André Frechet in 1919 and is today displayed at the Musée des Arts Décoratifs in Paris. It is built from exquisite dark Macassar ebony, highlighted by a marquetry frieze in copper and red amaranth. The overall impression is one of order, calm and distinction.

In 1925, Erté, the fashion illustrator and designer of extravagant costumes, created a studio-office in his Parisian apartment (below). The décor featured a curved ceiling with a tasseled frieze, a checkerboard floor and cushions with geometric patterns. The simplicity of the desk contrasts with the curious box-like form of the chair.

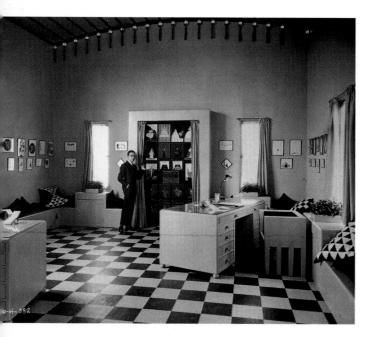

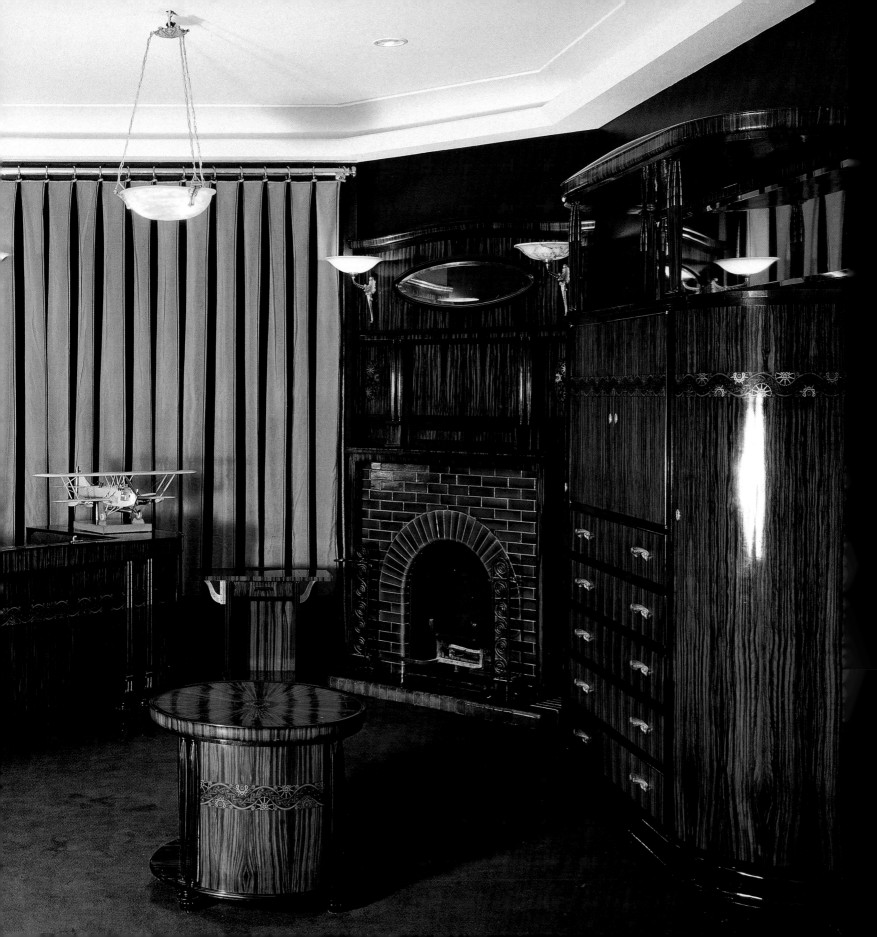

Walter Gropius's Polo-Populär table lamp, which he designed in 1931, is a perfect illustration of his philosophy: "A thing must serve its function perfectly. In other words, it must do what it is designed to do, it must last, and it must be both economical and beautiful" (below).

In 1936 Walter Gropius collaborated with Duncan Miller on the office–library of the house that the English interior designer was building for a client in Sevenoaks in Kent (right).

Marcel Breuer, who had joined the Bauhaus as a student in 1920, took over the running of the school's joinery shop in 1925. He designed a number of chairs which combined tubular steel and sewn canvas or leather. The best known of these was the Wassily chair, designed in 1925 for his friend the painter Kandinsky. A pure functionalist, he preferred simple unadorned forms (below). The Thonet brothers, known for their bentwood furniture, also became interested in steel in the early 1930s. In 1929 they bought up the Standard Möbel company, founded by Marcel Breuer and Stephan Lengyel. This 1931 brochure provided information on the complete range of office furniture designed by Marcel Breuer (below, right).

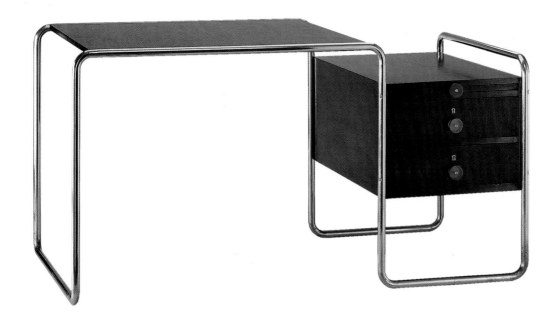

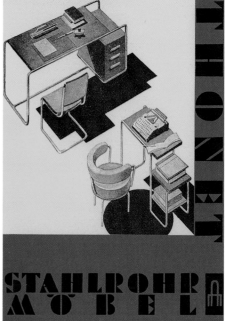

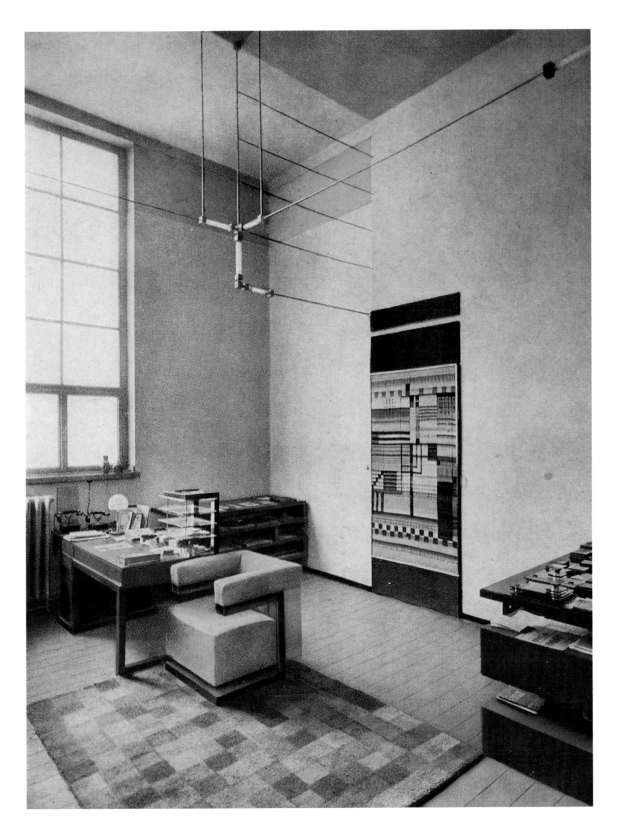

This steel table lamp was designed in 1924 by Wilhelm Wagenfeld in collaboration with fellow Bauhaus student Karl J. Jucker (below). Wagenfeld designed two versions, one clear and one opaque.

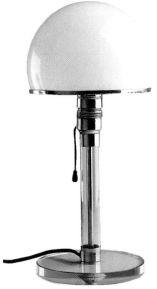

The director's office at the Weimar Bauhaus, designed by Walter Gropius in 1923, was a showcase for Bauhaus principles (left). The founding purpose of the school, which ran for only thirteen years, was to unify art and technology and eliminate the distinction between craftsman and artist. A rigorous geometry governs everything from floor to ceiling. The original lighting system consisted of fluorescent tubes mounted on slender metal supports.

"Chareau, Jourdain and Mallet-Stevens have collaborated closely, and have created a setting of which we shall rarely see the like again. Chareau was responsible for the library–office. What we have here is a work that is complete, ordered and conceived by the artist for himself—in other words with love and attention to detail." So wrote the journalist Marie Dormoy after her visit to the Exposition Internationale des Arts Décoratifs et Industriels Modernes in 1925. It featured an ingenious system of pillars and shelving, beneath a cupola which can be opened or closed by means of palm-wood slats (below).

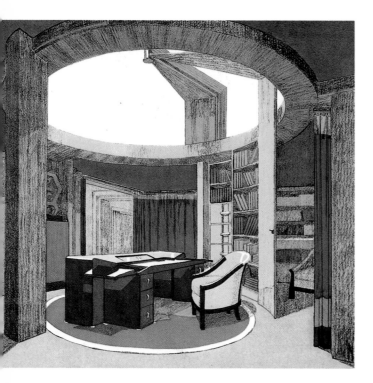

This desk was designed by Pierre Chareau in 1926 (facing page, above). The broad desktop has sloping ends which conceal four neat built-in drawers. Made from mahogany and African bubinga wood with metal legs, it has a sober, streamlined appearance. The metal desk lamp was designed by Jacques Le Chevalier.

This Macassar ebony desk exhibited at the Exposition Internationale des Arts Décoratifs et Industriels Modernes of 1925 is a good illustration of Chareau's taste for rational, architectural forms (facing page, bottom). The sloping surfaces discourage one from amassing piles of books and papers and enable one to "maintain the tidiness and rectitude which are the essence of modern life," as Marie Dormoy put it.

THE HEYDAY OF ART DECO

Henry Van de Velde's work prompted a number of other architects and designers to take an interest in office furniture. They were young, often worked in teams, and brought fresh thinking to the realm of office furniture and décor.

Francis Jourdain (1876–1958), the son of Frantz, the architect of the La Samaritaine department store in Paris, was a French painter, sculptor, architect and interior designer. Born in Paris in 1876, he was fiercely opposed to Art Nouveau. "I said to myself that a table was essentially a plank on four legs, and that this was what we had to create first; decoration could follow after, if there was space," he explained. In 1920 he exhibited a study which was the direct precursor of the office with the integral meeting room so favored by office managers today. The comfortable chair he designed had a reclining back, and a pivoting stand put the telephone comfortably within reach, a feature which was subsequently widely copied.

The French architect Pierre Chareau (1883–1950) brought a breath of something new into the world of office furniture. In 1931, for example, he created some remarkable pivoting, cylindrical cabinets, with sliding shelves, for the Maison de Verre (House of Glass) in rue Saint-Guillaume, Paris, which he designed for Dr. Dalgace and his wife. The desks he designed were equally inventive. They are ingeniously arranged, with complex systems of shelf units which, when opened, frame the person sitting at the desk. This mechanism was designed to conceal untidiness and provide some privacy.

Chareau was the first designer to build lighting into partitions, which he did in an ingenious fan arrangement, or directly into the furniture. He always prioritized line over volume and never cluttered his designs with ornamentation. Ahead of his time, he was using metal for his furniture several years before most of his fellow designers. The desk he designed for his friend and colleague Robert Mallet-Stevens in 1924, included a telephone shelf with a built-in lamp. It had pure lines and was unencumbered by storage space except for a suspended shelf to one side of the work surface.

In 1925, for the Exposition Internationale des Arts Décoratifs et Industriels Modernes, these two versatile designers, Pierre Chareau and Francis Jourdain, joined forces with architect Robert Mallet-Stevens to work on a project for a French embassy. The design created a sensation. The press spread the word of their collective endeavors.

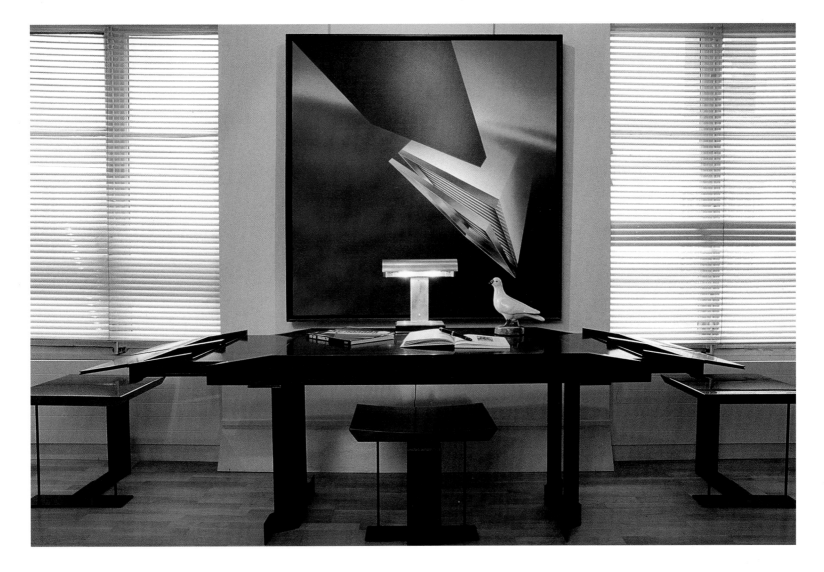

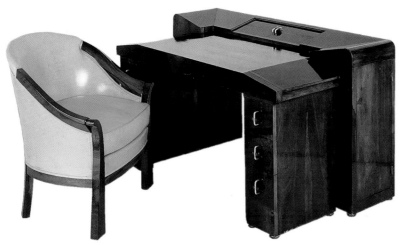

Chareau was responsible for the office–library, which had extensive shelving and paneling in close-grained palm-wood. A central cupola served "as a reflector for a lamp at its center. Since this cupola only serves as an artificial light reflector in the evening, it can be closed during the day by opening out its palm-wood slats like a fan by means of an ingenious device concealed in one of the pillars." The desk was positioned beneath the cupola. It had sloping surfaces in order to prevent "the user amassing piles of books and papers," a simple device (and one that has been forgotten today), intended to introduce a bit of order and discipline to the desk.

Many architects like to design furniture. The large number of international exhibitions gives them the opportunity of displaying

The Paris office of the former French soccer player and art lover José Touré contains an impressive collection of designer furniture. Two Le Corbusier chairs face a superb 1930s walnut veneer half-moon desk. A dial phone sits on a fan-shaped wrought-iron stand designed by Pierre Chareau. The art deco effect is completed with a Jean Perzel floor lamp, a Jumo lamp in black bakelite, and a carpet designed by Eileen Gray. The odd one out is the contemporary Solaris, designed by Shiro Kuramata.

Between 1927 and 1930 Jacques Le Chevalier designed around twenty different lamps. The base of this original desk lamp, which is made from aluminum and ebonite, has slots for pens and pencils. It has a simple semi-cylindrical shade (below).

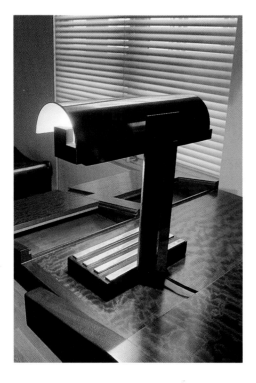

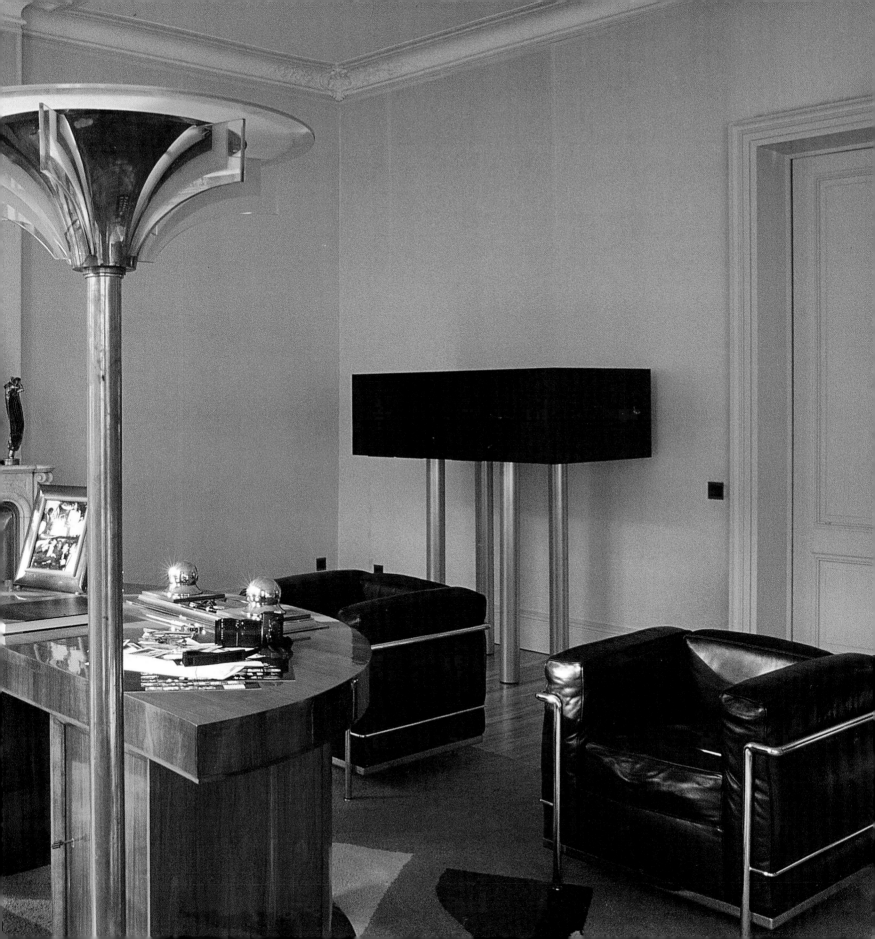

A small desk in leather-covered mahogany, intended for a woman's bedroom. It was designed by Mallet-Stevens in the 1920s (below).

A chair made from tubular metal with leather upholstery, dating from 1928. The architect Robert Mallet-Stevens had several of these chairs in his private office at his house in Auteuil.

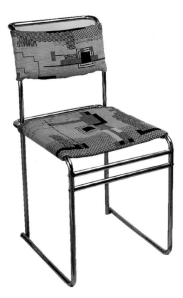

It was not unusual for Mallet-Stevens to ask friends to design furniture for his own projects. He liked this tubular metal chair (created in 1924 by Marcel Breuer) so much that he had several in his house (above). Mme. Mallet-Stevens had them upholstered in embroidered material.

their designs to the public in suitable surroundings. Charlotte Perriand worked closely with the architects Le Corbusier and Pierre Jeanneret and they put their names to numerous joint projects. On the question of designing furniture, Perriand observed: "The problem has to be rethought each time, and each time in new terms." For her the designer had to answer the following kinds of questions: How do people work? What sort of desk do they need? What is beauty? The three met as young architects. They shared their knowledge and expertise, and put a lot of effort into getting their creations known. Major magazines published articles on them and they exerted an important influence on design. Several of them, notably Chareau and Jourdain, opened showrooms to display their creations; others set up mail order services. In 1929, on the instigation of the architect René Herbst, Mallet-Stevens, Le Corbusier, Perriand, Jourdain and Chareau, together with Louis Sognot and Charlotte Alix, formed the Union des Artistes Modernes under the slogan: "Beauty in utility." The UAM was a way for them to assert their independence: it gave them a banner to exhibit under at the various shows and assured them of a higher public profile.

In 1930, Le Corbusier, Charlotte Perriand and Pierre Jeanneret designed their famous desk made of aircraft tubing and a sheet of glass, with matching leather-upholstered swivel armchairs. This creation is still many executives' dream desk today.

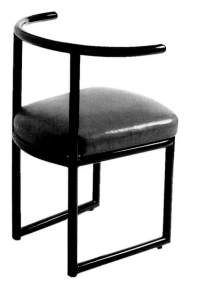

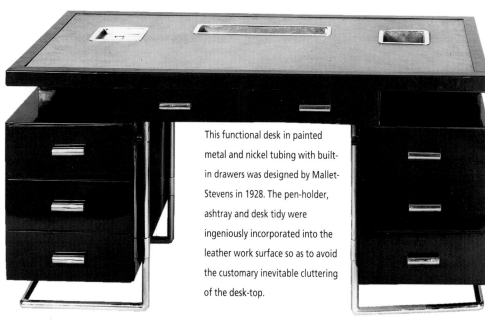

This functional desk in painted metal and nickel tubing with built-in drawers was designed by Mallet-Stevens in 1928. The pen-holder, ashtray and desk tidy were ingeniously incorporated into the leather work surface so as to avoid the customary inevitable cluttering of the desk-top.

In the same year the Frenchman Michel Dufet (1888–1985) designed a magnificent desk for the Asturian mining company. Michel Dufet was a multitalented man, an architect, designer, painter, critic and journalist. The futuristic look of his desk created a sensation. It was made entirely of zinc, a material rarely used in furniture at the time. The worktop incorporated a flat, sliding semi-cylinder, which opened up to reveal the writing surface. It was exhibited at the Salon d'Automne in 1929, framed by two huge, zinc, bowl-shaped lights mounted on cubic feet, and armchairs upholstered in zebra skin. Shortly afterwards he replaced the polished zinc shelves with shelves in red lacquered metal. Michel Dufet was an extraordinary person: "We have only one desire, one aim: to express in everyday objects the mood of our times." Thus he rejoiced when women stopped wearing constricting corsets because it made possible the creation of new kinds of furniture, notably low chairs and tables.

As the artistic director of the leading furniture store Au Bûcheron, Dufet had an excellent showcase for contemporary furniture. It was also a showcase for modern painting (notably works by Vlaminck, Utrillo, Van Dongen), because an art gallery, "Le Sylve," was set up in the store. In 1930, at the Salon d'Automne, he exhibited an original study, designed for a man. It featured a desk which had an oval work surface lined with leather and metal, flanked by two oval storage units on one side and three vertically arranged discs serving as shelves on

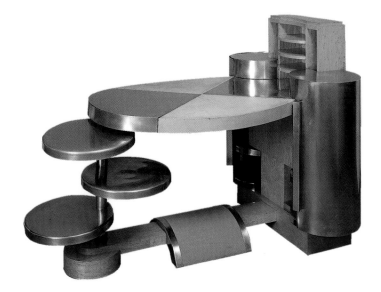

Michel Dufet designed this desk in the 1920s, which combines maple, polished zinc and leather, and used it until his death (above). This complex-looking design is in fact both ingenious and practical. Nothing is left to chance: the desk has conveniently placed pigeonholes, a footrest, and three swiveling shelves.

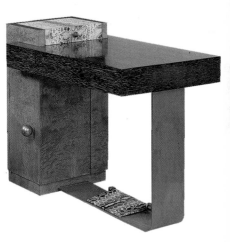

This little desk is another creation by Michel Dufet, marketed by the Au Bûcheron company in 1930 (above). The unusual asymmetrical composition combines fabric, metal, palm, ash and python skin. The desk is further evidence of Dufet's constant concern for both comfort and storage space.

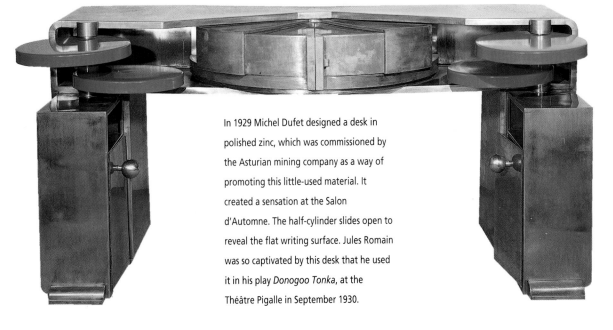

In 1929 Michel Dufet designed a desk in polished zinc, which was commissioned by the Asturian mining company as a way of promoting this little-used material. It created a sensation at the Salon d'Automne. The half-cylinder slides open to reveal the flat writing surface. Jules Romain was so captivated by this desk that he used it in his play *Donogoo Tonka*, at the Théâtre Pigalle in September 1930.

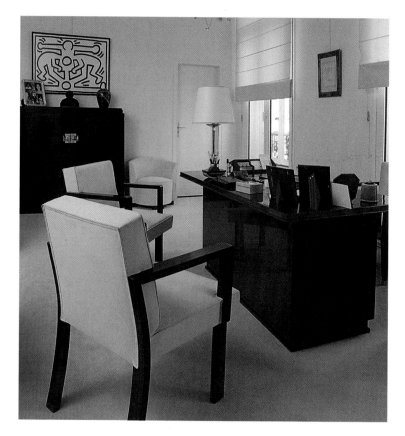

White walls, carpet and upholstery create a serene atmosphere in the office of the auctioneer Viviane Jutheau, a specialist in Chinese snuffboxes and furniture by the Leleu family (right). Her desk, topped with sharkskin, was designed by Jules Leleu and dates from 1936. On the wall hangs a painting by Keith Haring.
This small desk is attributed to Albert Guénot and the chair was designed by Louis Sognot (below). It was said of the latter that he "designed like a logician, and created like a poet."

The antique-dealer Thierry Couvrat-Desvergnes has a half-moon desk made from parchment and Oregon pine, with leather-lined storage spaces set into the work surface (facing page). This simple desk, which makes refined use of materials, was designed by Paul Dupré-Lafon, a designer who has often worked on projects for Hermès.

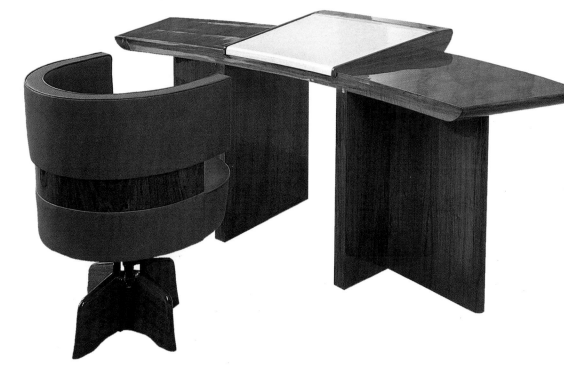

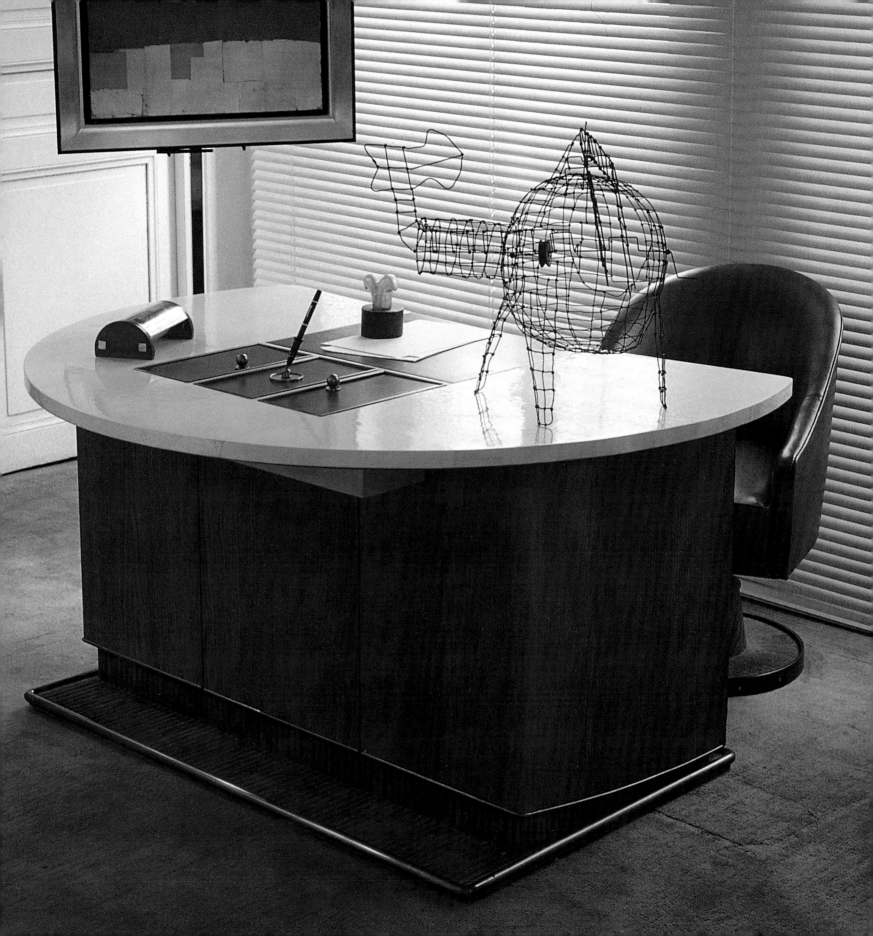

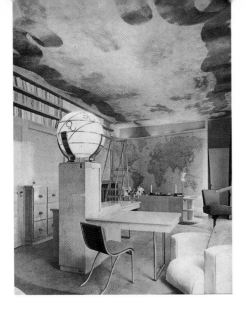

The reception area and office of the owner of *La Tribune des Nations* was designed by Michel Dufet in 1937. Dufet was responsible for both the furniture and the décor. A huge canvas map of the world covers one wall and the L-shaped desk is topped by a globe. The chairs are today marketed by Écart International.

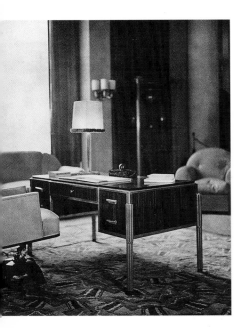

This flat Macassar ebony desk with fluted legs, a sober, functional design, was designed by Jacques-Émile Ruhlmann and exhibited at the Salon des Artistes Décorateurs in 1926 (left). Following the Exposition des Arts Décoratifs et Industriels Modernes in 1925, where he exhibited a décor for the famous Hôtel du Collectionneur, Ruhlmann emerged as a major figure in the art deco movement.

A cabinetmaker trained in his father's workshop in the Faubourg Saint-Antoine in Paris, Eugène Printz always gave wood pride of place without however abandoning ornamentation and a taste for opulence. Here we see an extraordinary desk in red lacquer on gilded bronze legs. It dates from 1943 and is the fruit of a collaboration with the lacquerer Jacques Dunand and the metalworker Raymond Subes.

the other. He designed a desk in elm for Maréchal Lyauey, exhibited at the Exposition Coloniale in 1931, which had "two drum-shaped pedestals with rounded doors and storage niches. The thick work surface is lined with red Morocco and supported on four balls of polished steel." The maréchal came to loathe this desk, because he injured a knee one day when he banged it against a door that had swung open! This desk, a one-off piece, unfortunately no longer exists.

The work of Alsace furniture designer Jacques-Émile Ruhlmann (1879–1933) epitomizes the 1920s. He had an astonishing career. He began his working life in the family firm in Paris, which sold paint, wallpaper, mirrors and lamps. He soon began creating extraordinary furniture in wood, which were masterpieces of joinery. His elegant desks in Macassar ebony were a great success. At the Salon des Artistes Décoratives in 1929, he exhibited "a crown prince's apartment," which included a large semicircular desk in black lacquer; the telephone was hidden away underneath and the desk had a built-in lamp.

René Herbst, born in Paris in 1891, was an architect few of whose projects were ever built. He was a militant modernist. His first desks were made of wood and were combined with solidly built bookcases. On the side where the user sat they had drawers and on the visitor's side shelves for housing objects and books. In 1929 he exhibited an engineer's desk, made from bent sheet metal. In his view the desk's two functions—work and the storage of files and books—were indissolubly linked. For Herbst, the office must be practical and comfortable. Like Pierre Chareau, he had a passion for designing lamps.

Although architects addressed questions of use (through carefully designed shelving, for example), they tended to confine themselves to the classic style of desk, and, with few exceptions, rarely looked at the problems of people working at typewriters or accounting machines. As yet ergonomics was not an important consideration, although there was

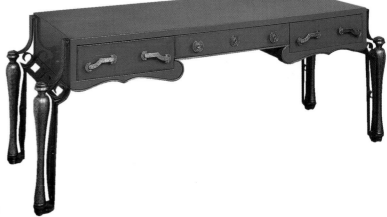

one notable and highly practical example with the invention, in 1931, of a chair that moved along a rail, which enabled the user to switch from typewriter to calculator without having to get up. It was only later that flexibility and movement began to be seen as important, when the theories of the American engineer and economist Frederick Taylor on the "scientific organization of work" emerged from the factories and workshops and began to penetrate the world of the office. From that moment, the design of office furniture was carefully analyzed so that it could be better adapted to the needs of office workers, most of whom were women. As yet, however, there was no particular interest in the general office environment, just a preoccupation with adapting the man to the machine, or the machine to the man.

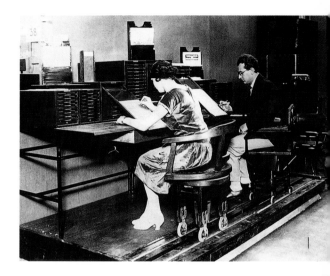

An example of the rationalization of office work in 1931, with chairs mounted on a rail (above). Note the sloping metal surface for the perusal of documents and the way the drawers have been placed within easy reach.

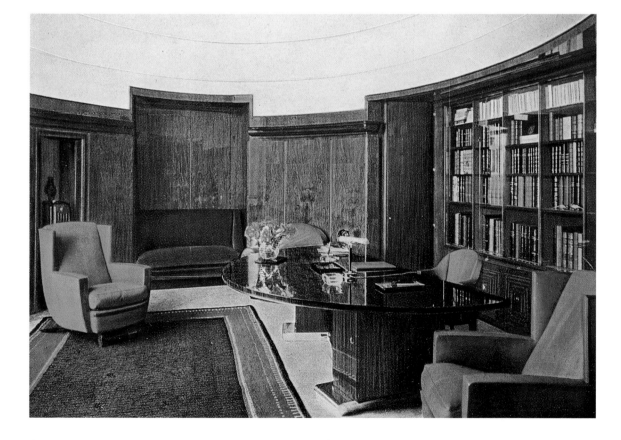

This office designed by Jacques-Émile Ruhlmann has rounded walls paneled in burr walnut, an imposing half-moon desk made of Macassar ebony and armchairs upholstered in red calf (left). Ruhlmann had a taste for precious materials such as amaranth veneers and amboyna or mahogany inlaid with ivory or shell.

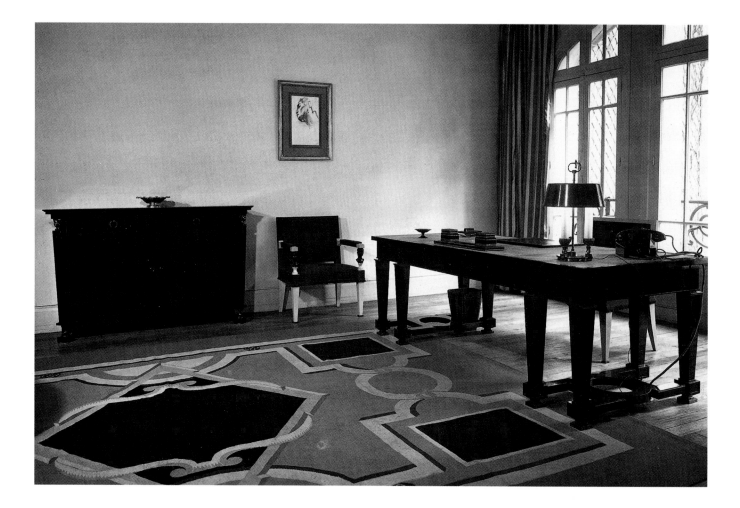

The son and grandson of cabinetmakers, the interior designer André Arbus had a reputation as a creator of prestige furniture. In 1945, the Mobilier National commissioned him to design a desk for General Harriman, in ivory-cream wood decorated with gilded bronze. Here we see a variation, with eight legs linked by mahogany braces (above).

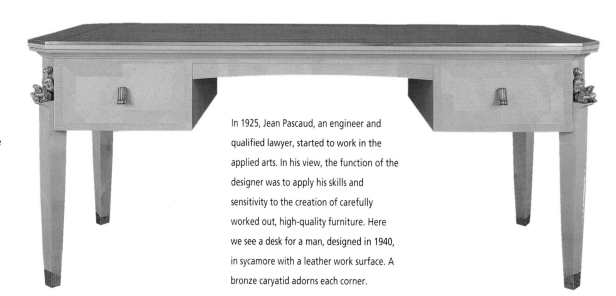

In 1925, Jean Pascaud, an engineer and qualified lawyer, started to work in the applied arts. In his view, the function of the designer was to apply his skills and sensitivity to the creation of carefully worked out, high-quality furniture. Here we see a desk for a man, designed in 1940, in sycamore with a leather work surface. A bronze caryatid adorns each corner.

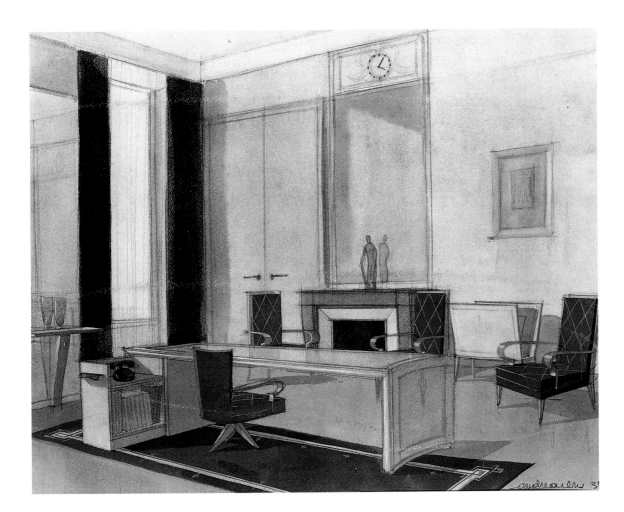

This desk, typical of the pure style of the 1940s, was designed by the interior designer Marc du Plantier in 1938 (bottom). Entirely lined with parchment and trimmed with bronze, it stands on simple spindle legs.

The light produced by this ingenious lamp, made from chrome-plated steel and blue-tinted opaline glass (below), can be softened by lowering a piece of frosted glass.

A sketch for a proposed office interior designed by André Arbus (above). "You need to sit at this desk, to feel the welcoming grace with which it comes towards you and places shelves and useful objects within easy reach, unlike the strict, dry economy of American furniture." Purity of line and discreet decoration were hallmarks of Arbus's work.

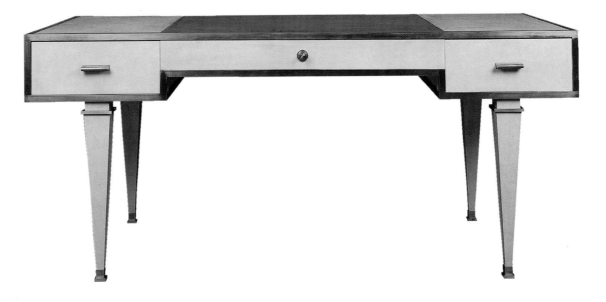

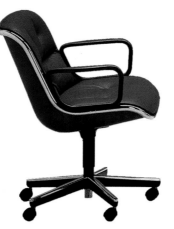

By the 1950s the office chair had become the object of research. New developments in plastic injection molding and plywood stimulated designers and manufacturers alike. Forms became more rounded and the seat and the back were often combined in one piece. Here we see an office chair based on a shell module, designed by Charles Pollock in 1965 and marketed by the American firm Knoll International (right).

A chair which is as suited to the office as it is to the home (below). This perennial steel wire lattice design was created by Harry Bertoia for Knoll International in 1952.

A reconstruction of the office of industrial designer Raymond Loewy, which he designed in collaboration with Lee Simpson, at a 1934 exhibition at the Metropolitan Museum of Art in New York (facing page). The lines are simple and streamlined and the use of white and metallic finishes gives the room an almost clinical feel.

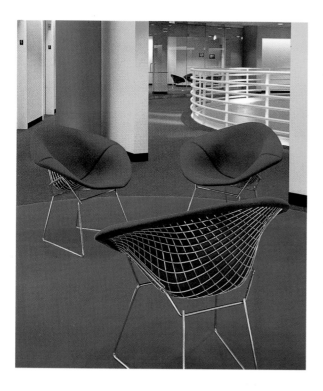

ENTER THE DESIGNERS

By the 1950s another profession was beginning to take an interest in the office: designers. Their concerns mirrored those of the architects. They were interested in creating things that were beautiful and suited to their function. Their work covered not only furniture, but also everyday objects in both the house and the office. The word "design" implies the creation of both concepts and forms. The French designer Sylvain Dubuisson, in an essay that he wrote for the book *Industrial Design, Reflection of a Century*, described how design brings meaning to things that in themselves have little meaning. However, it is clear that design makes signs before it makes meanings.

It was the metamorphosis in the design of the humble office duplicator that signaled the birth of industrial design in the office. Up until that point nobody had given much thought to the aesthetics, or even the practical aspects, of office machinery. It was all left to chance and necessity. By 1929, competition and the onset of economic crisis was to shake the world out of its complacency. The American Raymond Loewy (whose autobiography *Never Leave Well Enough Alone* was published in 1951) was one of the first industrial designers. In 1929 he was asked to redesign the duplicator made by Gestetner Ltd. He concealed the hardware inside a sleek, sculptural, bakelite shell, thereby transforming a banal machine into a work of art. At the same time, he improved, or rather simplified, both its manufacture and its use. The Gestetner Model 66 duplicator was an immediate success and remained in production until after the Second World War. The evolution of even such a modest object as the office chair—on which the average office worker sits for over 1,700 hours every year—is also full of resonance. The advent of typewriters stimulated the design of new types of chair: made of wood or metal, they were generally hard and could be adjusted for height; they rested on three feet and swiveled. As typewriters developed further, special typists' chairs began to appear. Shortly after the Second World War, British designers attempted to improve their comfort.

Before too long the science of ergonomics descended upon the humble chair. Curiously, only typists' chairs and managerial chairs were thought worthy of interest. They were fairly easy to distinguish from each other. From the 1930s through to the 1960s, people were becoming aware of the damaging effects that an unsuitable chair could have on one's posture.

Since before the war, the office chair (or at least its supporting frame) had come increasingly to be made of metal, and was looking less

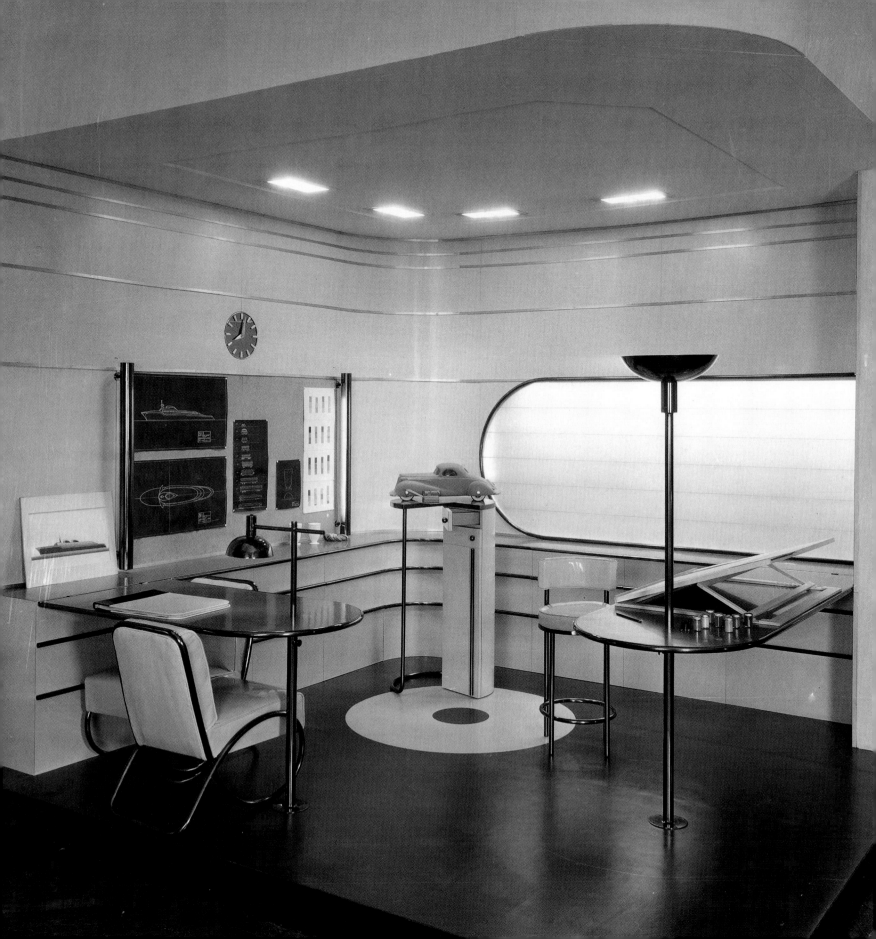

A futuristic vision from the 1970s (right). This cosy module in white plastic was rainproof and could be erected equally well on a building site or in a garden. Inside, there is no pilot's seat or electronic gadgetry, just a phone, a television and three seats.

An extraordinary shell-like desk designed by the sculptor Maurice Calka in 1969 for the Leleu company, which was experimenting with new materials. Manufactured in white fiberglass, the desk and the "pilot's" chair form a single unit.

This integrated work station by Comforto was presented at SICOB (Salon d'Informatique, de la Communication et de l'Organisation du Bureau) in 1972. The ergonomically designed chair with its built-in Dictaphone was designed to minimize fatigue.

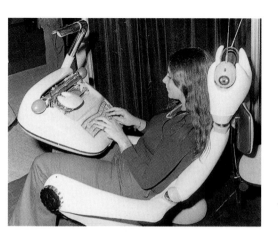

and less like a school chair or a kitchen chair. In the 1960s it was upholstered and in the 1970s it was fitted with casters and five feet.

In the beginning, the shape of the chair tended to follow the shape of the human body as closely as possible, but people very soon realized that there is not just one way of sitting, valid for eight hours at a stretch, but numerous postures. Today chairs have become more flexible and they can be adapted to suit different bodies and different postures. The seat and the back adjust to the user's posture: the chair locks in the chosen working position, and unlocks as soon as the user moves and the pressure of their back or body is lifted. "Too pronounced a curve of the seat increases pressure on the buttock muscles and discourages changes of position," we are informed by a handbook on ergonomics.

From this time on, people worked on chairs which looked more like the seats found in aircraft or racing cars, but without the safety belt. In many companies the kind of chair one has is still a sign of the place one occupies within the hierarchy. The executive often has a fashionable chair in black leather, while the secretary's chair might be upholstered in brighter colors, such as lipstick-red or azure blue.

A small revolution in offices took place in 1946. An American designer, George Nelson, invented an L-shaped desk that incorporated a "typist's return." This was an important development which was copied all around the world. It was also Nelson who, in 1947, first invented the partitions which were to play such a key role in the layout of open-plan offices in the years to come. They offered enormous flexibility in terms of the organization of space.

For the first time experts began to take an interest in people's individual work spaces. As a result all kinds of functions were brought closer to hand. In 1955, for example, Charlotte Perriand created a semicircular desk, the "bean" desk. All these developments led directly to the "systems" with which Wright had already experimented in 1939, in the S.C. Johnson & Son Company Administration Building.

A major office furniture exposition, "Tomorrow's Offices," was mounted in Chicago in 1950. This was the first exhibition entirely devoted to the office and was a forerunner of SICOB, which is held in Paris every year. It attracted 33,100 visitors, who could admire the wooden desks on display (metal was in short supply after the war) and consider the merits of the desk of tomorrow, which was presented under the slogan "Working becomes a dream." This was the last word in technology: it featured a radio built into the drawers, a Dictaphone and a slide rule; the seat was adjustable.

In 1964, a team comprising the theoretician R. Propst, George Nelson and Herman Miller exhibited the first "Action Office," the result of a multidisciplinary research project. The desk was no longer an object, but a combination of elements, a defined space, a place of inter-action. It became the object of research on the part of designers such as Sylvain Dubuisson, Andrée Putman, Michele de Lucchi, Giancarlo Piretti, Richard Sapper, Florence Knoll, Jean-Michel Wilmotte and Philippe Starck. In France, furniture design enjoyed the support of the state, in the form of financial aid, commissions and contemporary design competitions. In 1970 the designers Agam and Pierre Paulin redesigned the interior of the apartments in the Palais de l'Elysée.

In 1978 in Paris, Andrée Putman, who started out as a journalist before becoming a fashion designer and later an interior designer, set up Écart International. The company brought the famous names of the past—Le Corbusier, Eileen Gray, Rietveld, Mallet-Stevens, Herbst and Hoffmann—back into production at a time when they had been almost forgotten, while at the same time supporting the work of contemporary designers. Together with others, in 1982 she worked on designing an extraordinary office–study–library in a sepia laminate and metallic-gray epoxy for the fashion designer Karl Lagerfeld.

The following year, Jean-Claude Maugirard set up the VIA, the Comité pour la Valorisation de l'Innovation dans l'Ameublement, which was to play a crucial role in the creation and popularization of new designs in France. The VIA supported and encouraged young talent, helped designers to manufacture their designs, and ensured that they were known both in France and abroad, by organizing shows of their work.

Finally, French designers such as M. Held, R.C. Sportes, P. Starck, A. Tribel and J.-M. Wilmotte became known to the greater public through commissions for the Elysée in 1983 and through two competitions organized by the Ministère de la Culture—in 1982 for office furniture and in 1984 for office lighting. The winner in 1984 was Sylvain Dubuisson.

In 1983, Pierre Sala created his famous Clairefontaine desk, which mimics a spiral-bound notebook—you write on the pages—perched on four well-sharpened pencils.

In Italy, the Memphis group, founded in Milan in 1981 by the designer Ettore Sottsass and the industrialist Ernesto Gismondi, set out to subvert conventional assumptions, asking questions such as: why should tables have four identical legs? Why should the shelves of a bookcase be straight? They had a prolific output, using plastics, colors and forms to suggest visual references as diverse as totem poles, ancient Egypt and Elvis Presley.

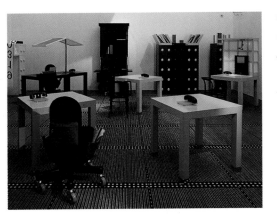

In 1989 Rolf Fehlbaum, president of Vitra, commissioned Frank Gehry to design the Vitra Design Museum in Weil am Rhein, Germany. The museum has a huge collection, housing more than 1,600 artefacts. This room is devoted to the playful, colorful furniture of the Italian designer Ettore Sottsass (left).

A desk in molded plywood, with a glass work surface, designed by Carlo Mollino in 1950. In a period when many designers were turning to plastics, his favorite material remained bentwood. The table legs, inspired by the bentwood wings of the first aircraft, bear witness to his passion for flying.

The famous Pipistrella ("bat") lamp, designed in 1963 by Gae Aulenti, is made from stainless steel and molded plastic (left). Still in production today, it is marketed by Martinelli.

A kidney-shaped desk in silver birch, designed by Jasper Morrison and marketed by Néotù. Minimalist in spirit, this English designer's work combines economy of form with the use of unusual materials.

The architectural practice of J.-M. Wilmotte is housed in the Faubourg Saint-Antoine in Paris (right). The transparent partitions allow natural light to reach corridors while preserving the privacy of the president's office. The latter is stripped to the essentials, with the exception of a canvas by Claude Viallat.

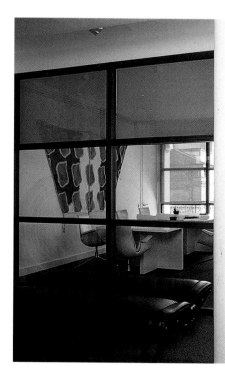

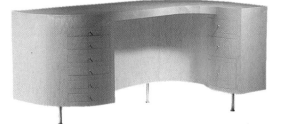

The famous zebra-stripe table, designed by Gio Ponti in 1937 for the office of the president of Ferrania in Rome, combines humor and imagination (left). The matching wall is one of the more extraordinary designs of this designer, who was the founder of the design journal *Domus*.

The architectural theorist Charles Jencks designed the interior of his "thematic house" in 1980 (facing page). The postmodern décor is set in a nineteenth-century building organized round a grand central spiral staircase. Here we see the library. On the desk are obelisks and pyramids in agate and onyx, which Jencks collects and often incorporates into his furniture designs.

The designers Antonio Citterio and Glen Oliver Löw designed their Ad Hoc system for Vitra in 1995 (above). It included a new syle of desk, with integrated lighting and perforated colored panels. Here flexibility is the order of the day. The various elements can be rearranged easily, thanks to a clever system of reversible panels.

The offices of Classic FM in London, designed in 1993 by the architect Stanton Williams (below). A composition of light colors highlights the interplay of volumes and levels. The furniture is arranged in an ordered way and the lighting is skillfully designed.

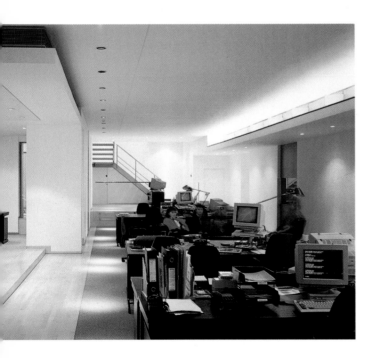

THE OFFICE OF TODAY

The first electronic, digital computer was built by the American physicist John C. Atanasoff between 1937 and 1942. The first general-purpose electronic digital computer was the ENIAC, which was completed in 1946. Up until 1970, computers were used for handling figures when they began operating with strings of characters—in other words, letters. Thus, imitating the history of the birth of writing, they went from numbers to letters and then on to information. The first computers took up a lot of space, but in 1970 the invention of integrated circuits made miniaturization possible, leading to the revolutionary era of the microcomputer. They did not arrive in the office as such straight away, but occupied specific rooms: style was scarcely considered. Prices started coming down and an increasing number of small firms were able to computerize their operations. This created important new management needs.

In 1977 Apple launched the Apple II computer. It was not originally conceived for the office, but was pitched at a public of programing enthusiasts. It was the invention of spreadsheet programs, followed by word processing software, which guaranteed the microcomputer its place in the office. Questions of form and use were addressed. The microcomputer was not much larger than a typewriter and was by now portable. However, it did not look like a typewriter and thanks to the invention of the mouse, men were able to sit at the keyboard without giving the impression of having taken their secretary's place. The mouse was a revolutionary development, marking a move away from the binary system towards a more human and playful relationship with the machine, thanks to the use of icons and symbols. Then the microcomputer was linked into networks. The evolution did not stop there. The 1990s have seen the global spread of multimedia computers and information highways. With the increasing miniaturization and complexity of computers, the world of work has been totally transformed.

Offices now occupy specific buildings. What is particularly striking is the layout of the rooms, with hundreds of little boxes strung out along a corridor. Everyone sits at a wooden desk, with drawers to left and right. The desk-top may be made of a white laminated material. The table is L-shaped, with a side table for a telephone. A green plant and a desktop computer fight for space in the corner of the desk. The visitor's chair faces the table. In the corner there is a clothes tree and one or two imitation-wood cupboards. On the wall hangs a framed reproduction of a bunch of flowers or a Monet painting. There are few personal touches,

except perhaps for a framed family photograph on the desk, or a few greetings cards. The walls are light gray as is the zigzag patterned carpet. A bottle of mineral water stands on the window ledge.

The open-plan office is a common variation. A number of work positions are set up in one large room. The impression of density is increased by the presence of mid-height partitions, designed to give each person a degree of visual and acoustic privacy. There are plenty of storage units, files piled everywhere and light gray fittings. Everything is flexible, everything is within easy reach. Tomorrow the configuration may be different, because the office can be dismantled and rearranged. There is little or no decoration. The color scheme is usually limited to black, the gray of the computers and the pale splashes of the wooden desk-tops. There are a few plants dotted here and there.

When seen in photographs, this office world seems devoid of any human presence: large deserted areas of space, empty wastepaper bins, no files on the tables. It is a rather cold environment, more suggestive of the pictures in the catalogues produced by office equipment manufacturers than a snapshot of the kind of place where many of us spend eight hours a day. There is, however, much more to the office than meets the eye.

Borek Sipek, the Czech-born designer, has said: "I always try to create a bit of anarchy in a project. Why cut the wood in a straight line when lasers allow you to cut it any way you want?" This desk in whitebeam ply and enameled metal was designed for Vitra in 1992. With its baroque lines, it is the very antithesis of the classic desk.

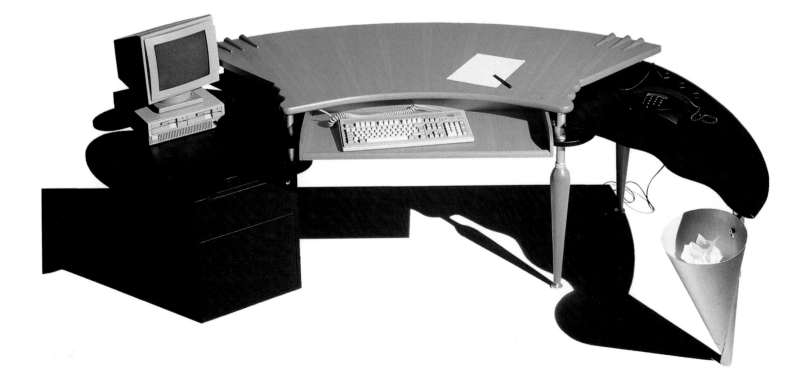

69

The expression of hierarchy

From the personal
offices of people in
power, designed to
impress visitors and
staff alike, to the
functional, communal,
open-plan office,
company hierarchy is
carefully codified.

A banker in New York, photographed by Cartier-Bresson in the 1950s (preceding double page). There is a strange contrast between the busy boss and the bored secretary, with her shorthand pad balanced on her knee. The image encapsulates the rigid hierarchy of office life during this period.

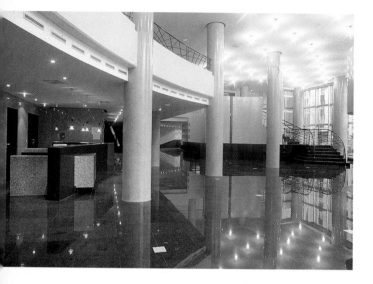

The lobby of the headquarters of Auguste Thouard Immobilier at Levallois-Perret, designed by the architect Tessa de Saint Blanca (above and right). Unusually the two directors of this company share the same office. The reception area is decorated in warm colors, the walls are hung with Chinese silks and the columns are coated with Venetian stucco. American wooden blinds soften the light coming through the totally glazed façade.

The offices of the Chiat Day public relations agency in Venice, California, are an intelligent compromise between the open-plan and the cellular office (facing page). The individual work spaces are entirely white, in contrast with the communal circulation areas, which are clad in wood. Privacy and communication here go hand in hand.

The descendant of town houses and factories, there is more to the office than first meets the eye. It is a place where hierarchy is expressed in subtle ways.

In the view of some commentators, the history of society is a long history of hierarchical relationships: the landowner and the peasant, the lord (representing the authorities) and the clerk (representing knowledge), the middle classes and their domestic servants, the foreman and the factory worker. In France, the relationships between them have been marked by a typically Gallic mixture of revolt, insubordination or submission. Hierarchy is the systematic marking out of the relationships of command and subordination which exist between people. In companies hierarchy and the codification of space becomes concentrated and can be read like an open book.

SPACE IS WHAT MATTERS

We do not usually choose the environments we work in. They do not belong to us and we have absolutely no say in their design. The important thing today is whether you have a job at all (ideally somewhere accessible by public transport), and not whether you have this or that kind of office.

However, space is never neutral. It influences people and the ways in which they behave. We would not behave in the same way in a church as we would in a shopping mall or a café. We all adapt to the particular space that we are in and behave accordingly. A given space transmits messages which induce appropriate attitudes and forms of behavior. For example, a grandiose foyer impresses not only the visitor but also the staff. It generally incorporates a discreet but efficient system for checking on people's comings and goings, which is obviously a security measure but also a form of surveillance. Glass-partitioned offices and a certain transparency in spaces that are open to visitors show a company's efficiency, its strength in the marketplace; it is a way of saying (without actually saying it), "We're the kind of people you should be doing business with." A space that is gloomy, slightly tatty and poorly lit suggests, "We work hard here, we don't waste our money (or yours, either), we're not here for the fun of it."

The way space is organized in a company creates a mold which engenders different kinds of relationships. People's behavior and the way they interact with each other are different in an executive office from what they are in a corridor or in an office shared with several colleagues.

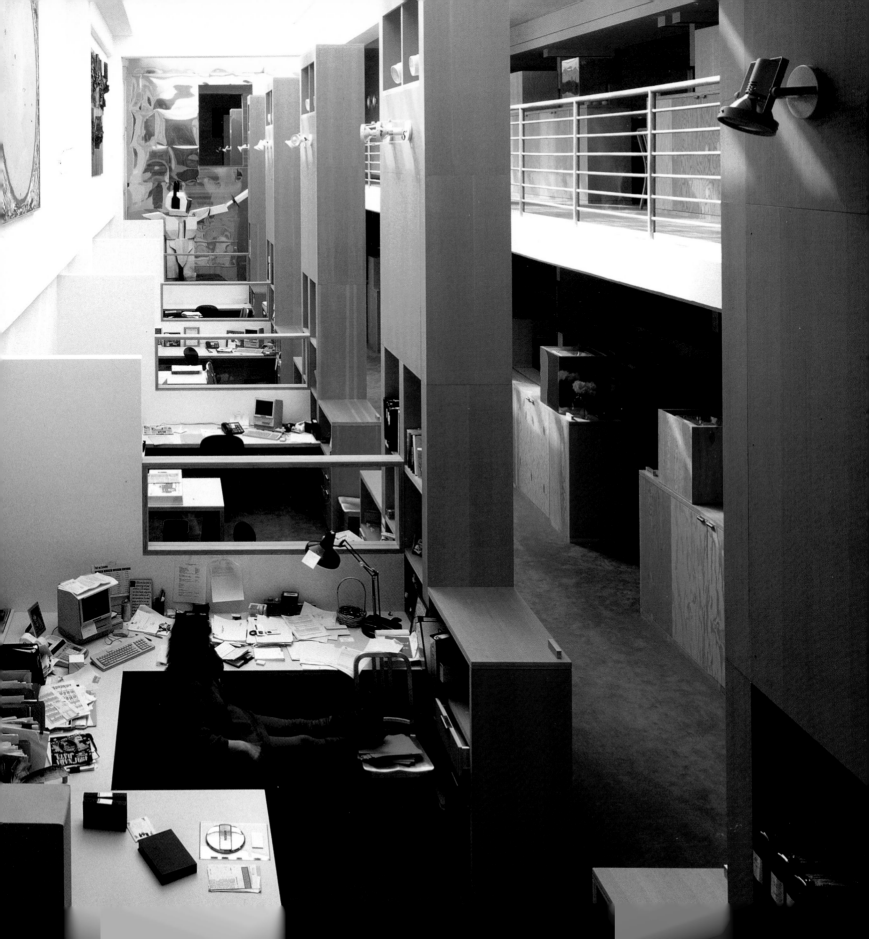

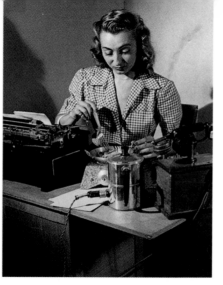

A glimpse of the private life of a secretary during her lunch break. A small stove, a kettle, a phone and a typewriter are all grouped together perilously on the corner of her desk. The typewriter seems rather archaic next to these early electrical appliances.

Each individual is allocated a given space: your place is here, and not anywhere else. Of course, the notion of being confined, of having an allotted place, has somewhat softened since the nineteenth century. What we have now is not the panopticon as described by Michel Foucault in *Discipline and Punish*, which made it possible, in the factories of old and, still, in today's prisons, to watch over the entire workforce or prison population from a single vantage point. Today, methods of surveillance of people and goods are more discreet and increasingly sophisticated, with a growing use of identification badges and computerized control systems.

In the office, almost no decoration is permissible, apart from a few small personal touches (putting up a framed reproduction, bringing in a flower vase, for example). It is a hierarchical environment. Today you are here, but tomorrow you may go up a grade, maybe even a whole floor, and perhaps you will get an extra window. Do not worry, though, there is an elevator. There is a system in operation here, and the quality of your office space and your furniture will vary according to your status. As a rule the president or managing director enjoys at least forty square yards and a good carpet; directors have thirty-six square yards; executives have to make do with twenty-four square yards and perhaps a good quality carpet; and two secretaries will share eighteen square yards between them and perhaps a plastic floor. Obviously, these standards vary from company to company, but if you want more space there is generally only one way to get it: promotion.

Finally, the existence of permissible areas has a corollary: areas that are out of bounds. Your freedom to come and go in a particular part of the premises depends on your grade and status. Only senior management and cleaners have the right to go everywhere—although obviously not at the same times of the day.

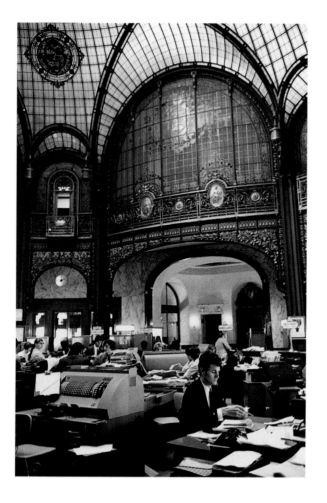

Systems have been developed for the utilization of space. These are based on distance, as has been outlined in a remarkable study by the American anthropologist Edward Hall. When you walk across a large, impressive room and then sit in a chair that is a bit too low, your nose level with an imposing executive desk, you are in the distant mode of social contact, and a certain type of relationship is immediately established. If you sit facing your interlocutor around an ordinary table for a small impromptu meeting, you are in the close mode of social distance (between four and seven feet). If, however, you prefer to sit next to your interlocutor, you put your relationship into the personal mode, which may be close or distant, depending on you. The risk that you have to watch out for is

An open space that is soberly furnished with desks and identical leather chairs, this office shows discreet signs of status (left). American bankers, like this one photographed in Houston, Texas, in 1956, do not willingly shut themselves away in closed offices.

The central hall of the Parisian headquarters of the Société Générale, by J.J. Hermant, built in 1905 (facing page, bottom). This was one of the first buildings to combine reinforced concrete with iron and glass. The hall is lit by an art nouveau glass dome seventy-seven feet in diameter. Precious woods are used for the counters. Polychrome mosaic flooring and cast and chased bronzes by Christofle add to the luxurious atmosphere.

This turn-of-the-century office, with its rows of desks, is reminiscent of a classroom, an impression accentuated by the studious air of the office workers (right). The division of labor meant that the women dealt with paperwork and typewriters while the men were responsible for the filing. Note the useful system of pull-out flaps to make the desk larger or to rest one's elbows.

Tony Hancock in the 1960 British movie *The Rebel* (below). Like robots, the movements of these office workers bent over their calculators are perfectly synchronized. Only the name-card on the corner of the desk relieves the impersonal atmosphere of this office.

An overhead view of the world of an office worker who is gradually becoming engulfed in piles of files and ledgers. In front of him are an ink-stained blotter, bottles of ink and some pens—all indispensable office tools at the turn of the century (facing page).

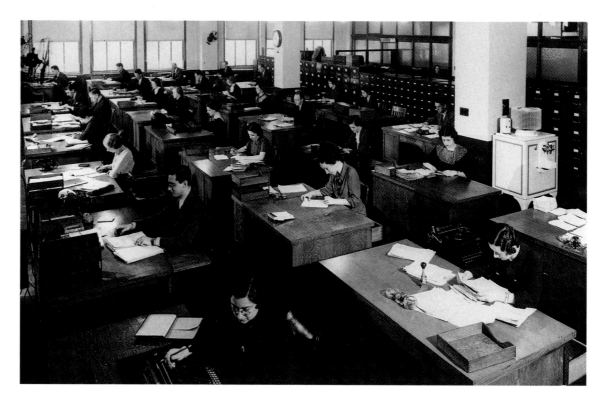

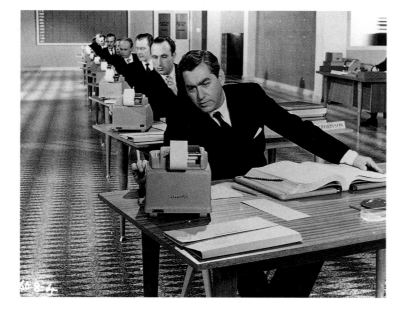

that of encroaching on your interlocutor's personal space, which Hall calls the "bubble"—a space which has definable limits for each individual, but which may not be immediately apparent. In France, an office furniture manufacturer made a study of the phenomenon for the Ministère de la Justice. The specific problem was how to establish the "right distance" between the judge and the defendants or witnesses that he had to see. It should be close enough to inspire confidence but at the same time distant enough to maintain the respect appropriate to the judge's status.

The "bubble" is a personal territory which is both physical and mental. It corresponds roughly to the immediate area of one's work surface and chair, and includes a surrounding "invisible space," which varies from person to person. Any incursion into this space may be felt as an aggression, a lack of respect. The need for privacy is as important in the office as it is in the home. Many conflicts in over-populated offices stem from the fact that the layout has not taken account of these secret codes—although people rarely blame the organization of space for such problems. Furthermore, this "bubble" exists whether the individual is static or moving. One's ability to move from one place to another depends on numerous factors: one's freedom to come and go; the "objective" congestion of space; but also factors that are more

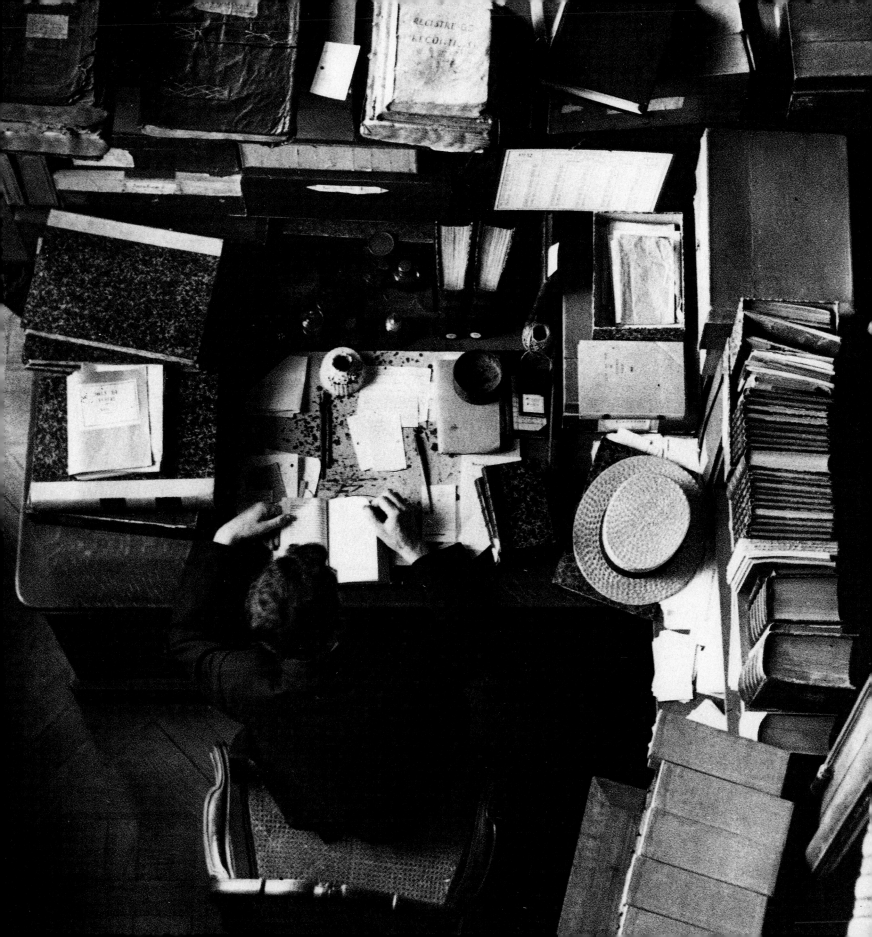

At the Ministère de la Justice, the clutter of small, shared offices contrasts with the spacious splendor of the ceremonial rooms. An Empire-style side table is piled with files. On one corner of a Louis-Philippe desk stands the indispensable bottle of mineral water (below).

This office in the École Militaire, which was built in 1751 and designed by Gabriel, was where Maréchal Joffre, commander-in-chief of the French armed forces, wrote his memoirs (facing page). This cavernous room is decorated with Verbekt woodwork, paintings by Le Paon, Caffieri bronzes, a chandelier with crystal pendants and Versailles-style parquet flooring.

subtle and personal. Visual clutter, for example, apparently has an effect on people's attitudes and behaviour.

This highly personal relationship with space depends on one's sex, culture and personality. An American, a German, a Japanese person and a French person each perceives space differently. The Japanese tend to be particularly keen on visual privacy, but are not so worried about noise levels. For Germans the reverse is true. Americans tend to be used to working in open spaces and like to develop small areas of privacy. A French office worker might complain frequently of difficulties in communicating with his colleagues while at the same time shutting himself away in his office because he is very attached to his personal space. The French do not always make the connection between the layout of work space and the quality of communication.

THE LEGACY OF BOURGEOIS APARTMENTS

Hierarchy is far easier to "read" when companies set up their premises in apartments and large private houses dating from the last century. Here we find a strong correlation between company hierarchy and the hierarchy of space: important people get a lot of space; mid-ranking people get shared space; and the least important people get little space.

Architecture has an influence (whether conscious or unconscious) on the company's policies and fortunes. These kinds of building, with their gilt plaster moldings and air of opulence, are classic expressions of power. In France, executives' offices in older buildings are generally furnished with Louis XV-style furniture. Occasionally one encounters striking contrasts of style, with a very modern type of office set within a much older décor. In this case the other offices will be an odd mix of rooms, with nooks and crannies, secret creaking staircases, narrow and inconvenient corridors, cupboards under stairs and cellars. It is a varied environment, which offers numerous spatial options, rather like an ordinary house.

As the philosopher Gaston Bachelard put it, "The house is a shelter for dreaming, the house protects the dreamer, and the house is what permits us to dream in peace. So the places where one has dreamed this dreaming tend to recur in new dreams. The fact that the memories of old houses are relived like dreams explains why the houses of the past are always with us in spirit." A house and an office are different, but the creak of parquet flooring or a simple dormer window may be

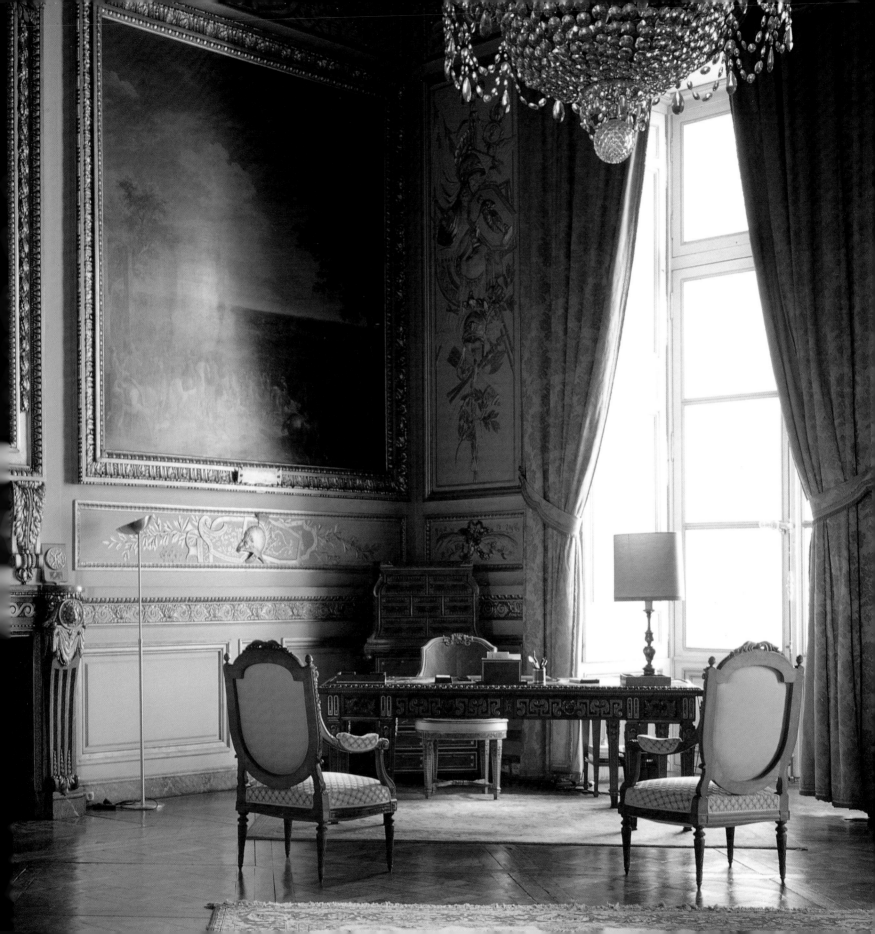

The designers of this modern office located in a Venetian *palazzo* have been careful to respect the existing interior. The discreet lighting designed by Ingo Maurer leaves the superb ceiling and its painted beams untouched. The days when one could build false ceilings in listed buildings with impunity are long gone!

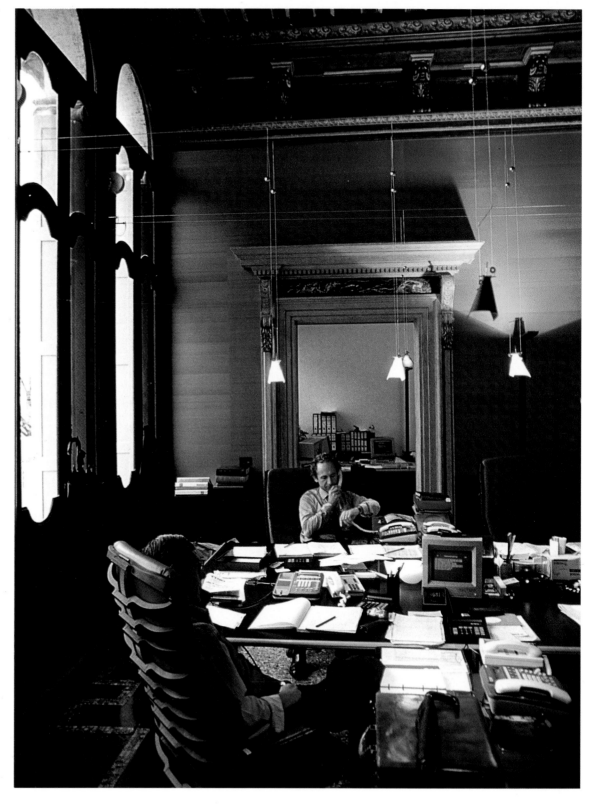

enough to trigger a flight of the imagination and are symbolic elements that are totally absent from modern office blocks.

Old buildings can occasionally be an inconvenience, for example when it is necessary to put in cables to connect up computer networks, or when a new secretary has to be housed in a cubbyhole somewhere. However, the variety of space allows for more conviviality and can help to make hierarchical differences more acceptable. In these kinds of building, open-plan offices never become inhuman. There are always load-bearing walls which ensure that spaces never become excessively large. Having large numbers of employees in this kind of building is something to be guarded against, but the diversity of space can make overcrowding more bearable.

Some companies go to great lengths not to spoil old buildings, concealing much of the modern technology required to enable them to function. Others, however, are happy to conceal old moldings and paneling behind false ceilings and partitions. The result is often disastrous: the charm of the place evaporates and a modern look is not even necessarily achieved. Some companies try to adapt their work environment to the way they function, and not vice versa, so that the best rooms go to the "sedentary" employees, while the smaller rooms go to staff who spend more time out of the office.

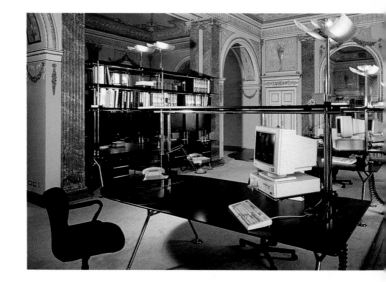

Architect Sir Norman Foster's hi-tech Nomos office system and the Empire-style décor of the Saporiti building in Milan is a successful marriage of old and new (above). Foster's design was influenced by aeronautical engineering. The archways accentuate the room's high ceilings.

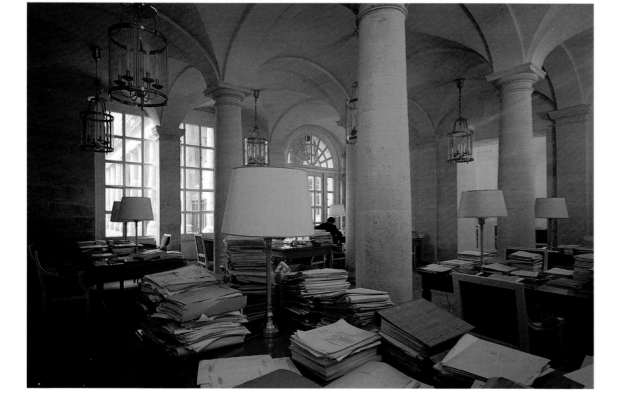

Members of the French Conseil d'État do not have individual offices; they work either in the library or in this vaulted ground-floor room at the Palais-Royal (left). The room, a warren of desks piled high with files, has a monastic atmosphere. This is where the *conseillers* prepare their assessments of the four hundred legal bills that the French government introduces every year.

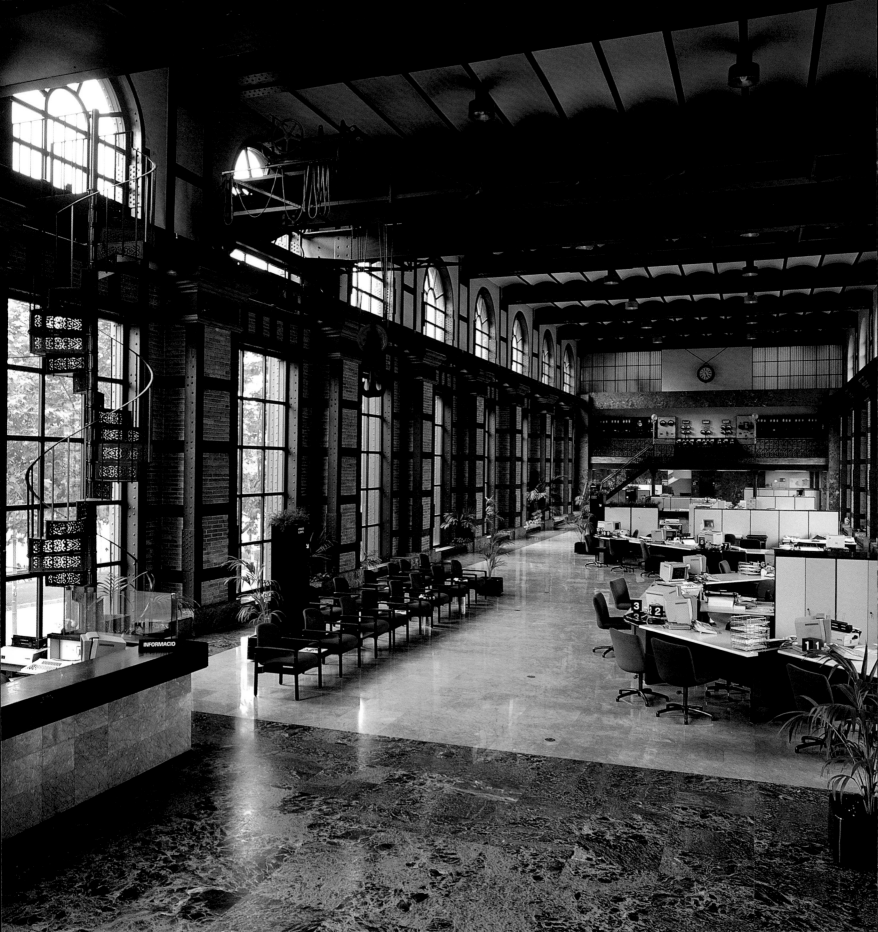

THE LEGACY OF WORKSHOPS
AND FACTORIES

The traditional factory, with its high perimeter wall and distinctive smoke-stack, has largely become a thing of the past. Industry has moved to new locations—notably the industrial park—and today many of the old factory buildings have been taken over by offices. They are usually rather austere places, covered in a certain patina caused by use and the passing of time. Such locations provide companies with premises which may be unostentatious but very spacious. The external architecture, the outer shell of the building, is frequently unexceptional. Such spacious buildings, however, provide each person with a degree of privacy, as well as convenient meeting rooms. The space is suited to a certain idea of work inherited from a time when people's needs in terms of communication and social interaction were not the same as they are today. These are work environments that are rational and reassuring, with no surprises. The offices tend to be partitioned off, on the classic model, with rooms arranged on each side of a corridor, but since the 1960s one also finds offices with open-plan layouts. The floor space allocated to each office is related to its function. Everything is codified—the surface area, the furniture, its type, quality, positioning and quantity, even down to the number of chairs for visitors. It is a system that is rather rigid and typically French, one that conjures up a vision of captains of industry striding through the company, galvanizing their troops with military rhetoric.

The Ministère de l'Économie et des Finances building at Bercy in Paris is a typical example of this tendency. The interior has been laid out in a classic way and there is a preoccupation with uniformity (and therefore also depersonalization?) which has been carried to extremes. Here you have rows of offices along endless corridors, all with their doors shut. If you are a visitor, your main problem is the fear of getting lost. You look in vain for landmarks. You have to search to find the way out. You are almost tempted to leave a trail of pebbles behind you. The subtly nuanced hierarchy is not apparent at first sight because of the uniform décor and furniture, but here the mere fact of having one, two or three desks in the same room is immediately indicative of status. You find yourself counting the number of windows, and then the number of tables. And anyway the "real bosses" are elsewhere, with the minister.

Yves Liétar, who worked with architect Paul Chemetov on the project, explained the team's thinking thus: "We wanted to give the office workers 12 square meters apiece, compared with the current

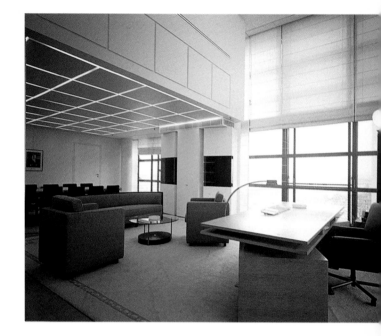

The converted machine room of the Catalonian electricity company, founded in 1896 (facing page). One of its wings has been turned into a landscaped office. Changes to the structure have been kept to a minimum and no attempt has been made to hide the building's industrial origins—even the original instrument panel at the end of the hall has been preserved.

This study was created by Écart International in 1985 for Pierre Bérégovoy when he was Ministre des Finances (above). The aim was to create a décor that was "serene, calm and anti-design." The grid of the window frames is echoed by the panels on the ceiling. The spalt oak desk-top sits at an angle on a pedestal containing drawers.

This lamp, made from sand-blasted glass and metal, was designed by Isabelle Hebey, who has won numerous government-sponsored competitions for the interiors of the Ministère de l'Équipement and the Ministère des Finances (left). Inspired by the Grande Arche at La Défense, it was designed for the new Ministère de l'Économie et des Finances building at Bercy.

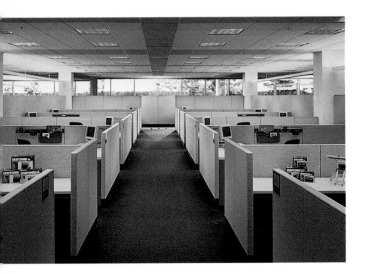

average of 8 square meters. We began with 14 kilometers of office frontage, taking a 90-centimeter pace as our basic module, in order to plan the space in three dimensions. In an office the height from floor to ceiling is 2.70 meters. At the start, we were looking at 824 offices of 12 square meters for 1 person, 860 offices of 18 square meters for 2 people, 300 offices of 24 square meters for 3 people, and 200 offices of 30 square meters for 4 to 5 people." It makes you dizzy just to think of it.

THE LANDSCAPED OFFICE: ITS LIFE AND TIMES

Should the office be open-plan or cellular? The debate has raged in France since 1960. The first landscaped office was created in Mannheim, Germany, in 1958. The Schnelle brothers, consultants in office organization, suggested this revolutionary layout for the Bohringer company. For the first time the office layout was designed to symbolize relations between people, rather than the power of the company.

The Schnelle brothers began by studying how information was circulated within the company and proposed appropriate layouts. The

Compartmentalized offices, or shoe boxes, as you prefer (above). These cubbyhole offices on a rectangular grid were built in 1992 for the Sears department store at Hoffman Estate, Illinois. This office interior is remarkably similar to the one that

director Jacques Tati created as the office of the future, twenty-five years previously, in his movie *Playtime*. It has, at least, the merit of providing its users with some privacy.

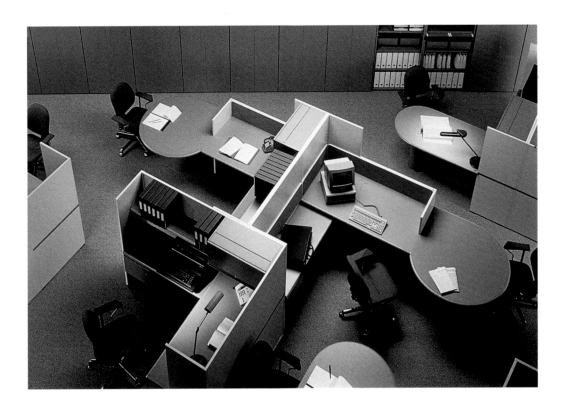

Il Pianeta Ufficio ("the planet office"), designed by Mario Bellini in 1975, has contributed greatly to the success of the company Marcatré. Designed as a set of building blocks, this was the first scheme to incorporate circular meeting tables. The system is a combination of simple elements, enabling the user to tailor the system to his or her needs.

originality of their approach lay in the way they took as their starting point the nature of the work carried out, putting to one side all the symbolic aspects of power and hierarchy. The idea was that by removing partitions and opening up space one eliminates problems in communication. The landscaped office which they came up with was not a miserable, empty work space, devoid of partitions and furniture. What they produced was a large, pleasant space, with solid blocks of greenery and modern, practical furniture which provided each employee with an area of privacy.

This system caught on immediately in the United States and then, from 1965, in France, particularly in insurance companies, where large numbers of people were employed. Landscaped offices continued to flourish up to the end of the 1970s without fundamental questions being asked. What was attractive was the idea of a new relationship with "nature." The term "landscape" is not neutral. It implicitly suggests a new balance between office work and quality of life. What was even more attractive was the speed with which a landscaped layout could be installed.

Furthermore, this kind of office fitted well with the idea of rationalization and its related notions of space-saving, although these were not yet major preoccupations. As the landscaped office crossed the Atlantic and the Rhine, however, it became increasingly cramped. Where the Americans worked on a basis of thirty square yards per person, the French had to make do with eighteen, which then shrank to fourteen, and sometimes less. Because the designers greatly underestimated the requirement for storage space, landscaped offices became increasingly cluttered with cupboards and side desks—while the blocks of greenery slowly reduced to the infamous potted plant on the corner of the desk. The initial philosophy had been forgotten. The arrangement of work spaces, which was supposed to be carefully thought out, gradually became the product of chance and the exigencies of the moment.

The real opposition, however, came from the users. They complained of a lack of privacy, of tiredness due to noise and continual movement, and of the lack of visual privacy. Aspects of human relations which normally would be inconsequential began to take on exaggerated importance. In an open-plan office, when you look up, you meet someone else's eyes. In other words you "surprise" someone and you become an aggressor, before, in turn, being "surprised" yourself by someone looking at you. You can respond with a nod, a gesture, or, for the hundredth time in a day, by a grimace. The open-plan office spoils the quality of everyday life by making spontaneity difficult and by forcing everyone to wear a permanent mask.

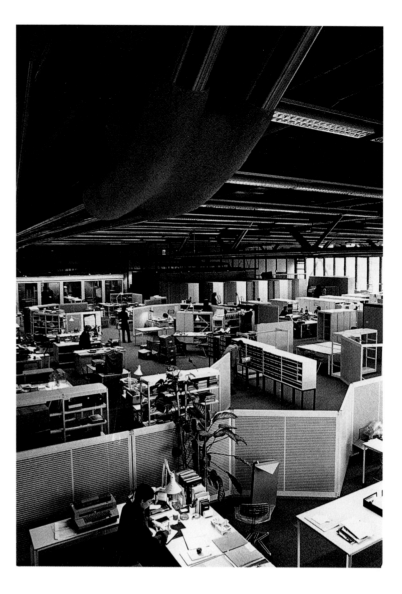

The open-plan offices in the Centre Georges Pompidou, designed by Piano and Rogers in 1973 (photographed by Robert Doisneau). This "naked" office environment, with its exposed cables and pipes, is structured by storage units and metal partitions in apple green, a fashionable color in the 1970s.

A sketch by the art director Alexander Trauner for Billy Wilder's movie *The Apartment*, made in 1960 (right). Trauner, who won an Oscar for best art director for this movie, which was shot entirely in a studio, wanted to emphasize the solitude of the main character by making the office where he works a vast and soulless place.

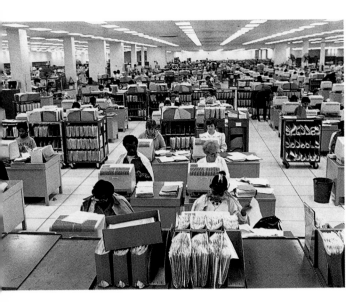

These office workers in Philadelphia in 1987 spent their days checking innumerable tax declarations against the figures on their computer screens (above). The vast, open-plan layout of the office does nothing to relieve the tedium of the work. This type of office is becomingly increasingly rare today.

The landscaped office prevents conventional forms of politeness and civility. How do you knock on someone's door if there isn't one? How do you pop your head round the door to say hello? Why get up in order to give someone a message when you can just shout it across the room?

The failure of the landscaped office in France has been due to the way it has degenerated and the specific difficulties that the French have in adapting to the style of life that it presupposes—there is no such thing as a whispering Frenchman. In Germany, the development of the open-plan office was a natural consequence of interest in efficiency and the desire to improve informal communication. In England it tends to be the nature of the activity which influences the choice

between open-plan or cellular offices, and when the choice is for the latter, it is often designed with visual openness in mind. In the United States, designers now tend to partition large office spaces, most of the time to head-height, in order to preserve private areas.

The advantages of transparency and communication were undermined because it proved impossible for office workers to have visual and acoustic privacy. Overcrowding makes it difficult to concentrate and tends to generate noise. The landscaped office implies a particular way of living in group situations. If everyone complies with the various unspoken rules of courtesy, it offers numerous advantages. But if one person ignores the rules, things can quickly get out of hand.

In the landscaped office power is expressed through subtle but identifiable differences. The question is no longer whether you have a carpet or not, or a better quality of furniture than your neighbor. Now the question is how close you have to sit to your neighbor, or whether you are tucked out of the way, sheltered by greenery, at a distance from everyone else. It is whether you have a more sophisticated telephone or a more powerful computer. The companies where management also share landscaped offices can be counted on the fingers of one hand. Yet the landscaped office continues to be held up as an ideal model. It is often used as a setting in movies, because it symbolizes American efficiency and a certain collective and resolutely modern dynamic in action.

MODERATION FOR EVERYONE

The offices of Écart International, the company founded by Andrée Putman. The black and white décor is spare and simple, in keeping with Putman's work. Her distinctive style of design left its mark on the 1980s. For this eminent designer, "It is timelessness, not fashion, that counts. More and more people are becoming aware of this."

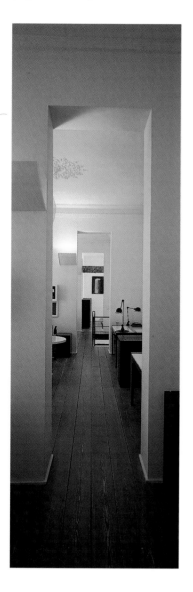

The delightful Monsieur Hulot, the character created by Jacques Tati, in *Playtime*, made in 1967 (facing page). The movie, a derisive caricature of modernity, follows the adventures of a group of tourists in an ultra-modern and impersonal Paris. In this scene, a confused Monsieur Hulot searches for someone in a labyrinth of offices.

The Michelin company claims that on its premises moderation applies to every employee and we are informed that the president sets an example in this. An article published in *Monde Initiatives* in 1994 was entitled "François and his Wooden Chair." In order to emphasize that the president of Michelin is just a person like anyone else, he is not given a surname: "François" will do. We are told that he has a very small office, "not particularly fancy," with a simple "wooden chair." But it is hard to check this information, because very few people can boast of having actually entered the president's office. You cannot even get a photograph of it. Apparently it is located on the ground floor of an old building, and not on the top floor. Is François the doorman of his own company? Not exactly, because signs of power, albeit modest signs, are still very much there. There is a system to protect this key center of power—an intercom. Apparently the room includes a small kitchen as part of the office. What is its purpose? Does François cook for himself? We are not told. One member of staff, who, despite twenty years' service with the firm, has never entered this sanctuary, was reported as saying: "They're always telling us that he has a very modest office. If it's true, it's a pity. When the head of a world-class company receives visitors, he should do it in proper surroundings." In fact, in this case the office does not have an important role to play because clients are received in reception rooms, but this does not prevent the staff from fantasizing about what this secret office looks like.

Michelin is the best-known example of this trend, perhaps because it is the most mysterious. Thousands of smaller firms also operate along similar lines. In keeping with a certain austerity linked to a particular view of work, company presidents like to cultivate a reassuring image of simple, modest work environments: a corridor, a few offices similar in size branching off it and fairly uniform office furniture. The executive simply has a larger office and slightly more luxurious furniture. The presence of a lounge corner is distinguishing mark enough. The wastepaper bins and slightly tatty wallpaper give off a faint air of poverty. The carpet in the corridor, with its stains and holes, suggests a certain stinginess.

Sometimes, by chance, there is a particularly nice room in a building. Needless to say, this goes to the boss. But it may be too luxurious for him, in terms of his self-image and the image of the company. So he may decide to have the same décor and the same office furniture as his staff or alternatively turn it into a conference room. He may even choose to move in with his personal assistant or a close colleague. Then

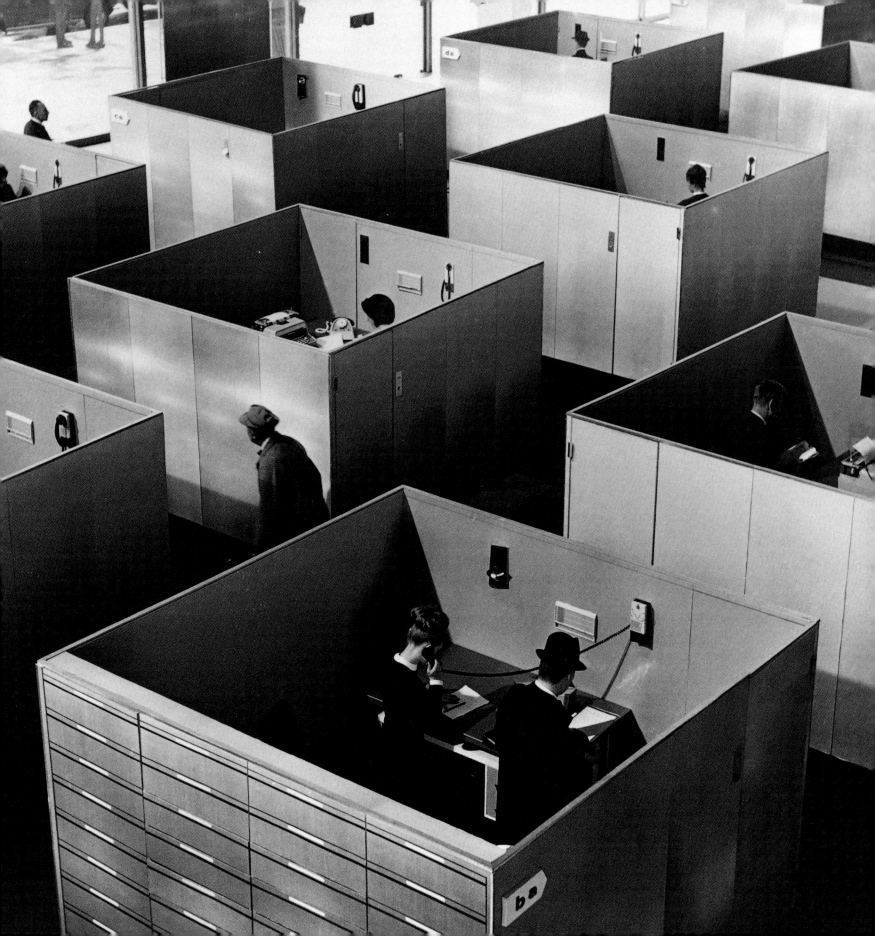

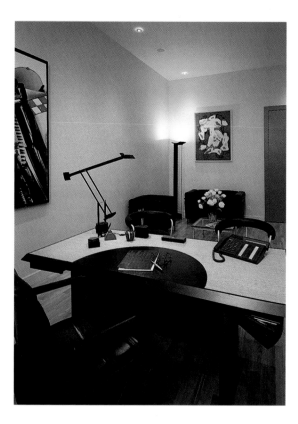

An executive's office, designed by Isabelle Hebey (above). The bright, rather austere décor sets off a handful of carefully chosen objects—a Tizio lamp and seating by Le Corbusier. "She makes everything seem effortless," said Hebey's friend, the philosopher Henri Lefebvre, summing up her work.

The office of the president of the Century Pacific Investment Corporation in Westwood, California, designed by Sam A. Cardella (facing page). This spacious room combines a classic office and a lounge arranged around a glass table. This is more than the office of a busy executive, it is a room to be lived in.

the office takes on a quite different significance. It may still be the biggest room, to be sure, but now it offers two work spaces. This is a clever way of blocking demands for more space from other members of staff. The company boss sets the example by working on the same terms as his colleagues. In these circumstances it is impossible for an employee to come and request a small sign of power and recognition.

MODERATION FOR NEARLY EVERYONE

This is by far the most widespread tendency in France, but it is more the result of habit than of deliberate choice. Whether the building is new or old, management usually occupies the top floor, preferably in south-facing rooms. Noise is muffled by the presence of a thick carpet as soon as you enter the corridor and the general décor is rather more elaborate than elsewhere: there are framed reproductions on the walls and the lighting is more intimate. At the end, a double door gives access to the inner sanctum—a handsome, luxurious space, which is immaculately decorated. Nothing is too good for the visitor or client, for all this is for his or her benefit. Management lays great stress on the company's public image. Apparently it is not because the president has a taste for luxury that his office is laid out like this: if we are to believe him, he would be just as happy with a monk's cell.

In more modern offices, where the building tends to impose a certain uniformity on the interior, the problem of creating differentiation between work spaces is more complicated and requires a degree of ingenuity. The first issue is the allocation of space: the president tends to get three times more space than any of his colleagues. Skeleton construction, which removes the need for load-bearing walls, permits a more flexible use of space. In the president's office lighting is not provided by ceiling lights, as in the other offices, but by discreet halogen lamps. Walls tend to be covered in fabric and windows have blinds. The office furniture tends towards luxury. But how can you truly highlight the greater importance of a company president with a ceiling eight feet high?

Be that as it may, a visitor sometimes feels uneasy when faced with great variations in space and décor. Should they happen, by mistake, to go down an ordinary corridor, decorated with drab colors and cluttered with cupboards, or to catch sight of some cramped offices, they will have a sense of having been a little indiscreet and of having unexpectedly seen another side—but perhaps the true side—of the company.

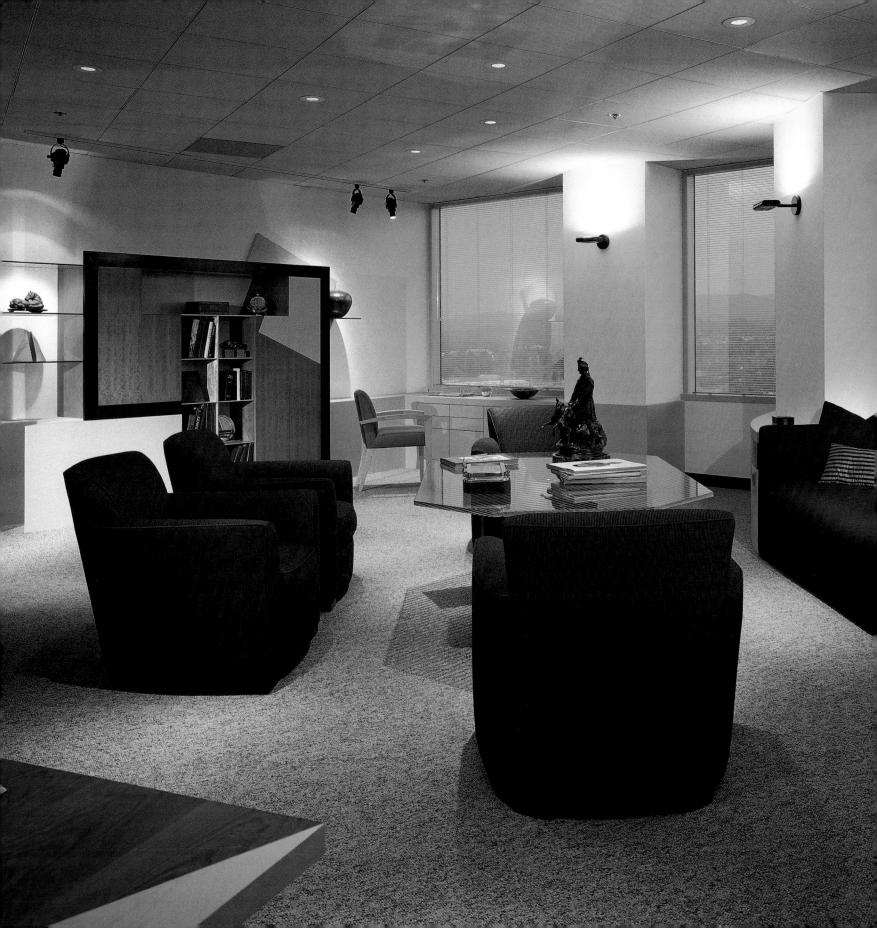

A LITTLE LUXURY FOR EVERYONE

A few companies take exactly the opposite stance, cultivating an appearance of opulence for everyone. The most famous example of this approach is the Centraal Beheer office building in Holland, designed by Herman Hertzberger.

Since it was built in 1974, this building has become a place of pilgrimage for visitors from all around the world. The architect's aim was to create "a working environment where everybody feels at home. A house for one thousand people." The building was designed to a human scale and constructed around a central core. The interior consists of a subtle interplay of transparency and individual privacy. The offices look like conservatories, or play spaces, with large paper animals for decoration. There are well-tended communal spaces and a cafeteria on each floor. It is impossible to guess the status of any individual employee merely by looking at the place where they work. Curiously, the approach adopted in the Centraal Beheer building has not been imitated by many other companies.

A more recent design was the headquarters of the Bouygues company at Saint-Quentin-en-Yvelines, just outside Paris. Much has been said about the architecture of this building, which has something in common with the Château de Versailles. The imposing buildings are arranged in a double horseshoe around an atrium, with white concrete colonnades set in the midst of huge French-style gardens, and a reproduction of the Marly horses which decorate the Place de la Concorde. Here everything is strictly controlled: even cars are kept out of sight. The building arouses strong feelings—people tend either to love it or hate it. One thing is certain, it is a building you cannot ignore. It is unusual to find office buildings arousing strong emotional responses, even if the responses are contradictory.

Each company in the group maintains its image and its logo within the greater entity and it is the organization of space—the common mold—which gives it all cohesion and an overall sense of identity. The architecture is designed to serve the Bouygues company culture and ethos. Kevin Roche, the architect, explained: "The Bouygues company struck me as being like a family, so that is why their headquarters are structured like a house, with large spaces designed partly for work but also for communication, to give people working conditions in which they can be happy." This is not a house in the sense that Bachelard understood it, with an attic, a cellar and creaking stairs. It is rather the dry clicking of heels on marble that is a bit too shiny. Only members of senior management have

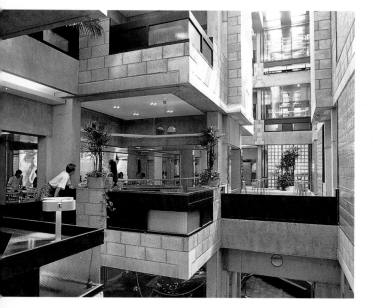

The architecture of the Centraal Beheer office building, designed by Herman Hertzberger, broke with traditional office building architecture. In this experimental project, everything has been done to help the one-thousand-odd employees feel at ease. Loggias and recesses provide everybody with the possibility of a personal space.

The central hall of the headquarters of the Bouygues company in France (facing page). This atrium serves as the village square. It has everything one could need: a hairdresser, a travel agent, a bank, a library, a video shop, a mini-drugstore, a gymnasium, a communal hall and, of course, work spaces. It is like a modern version of a traditional department store, transplanted to Saint-Quentin-en-Yvelines.

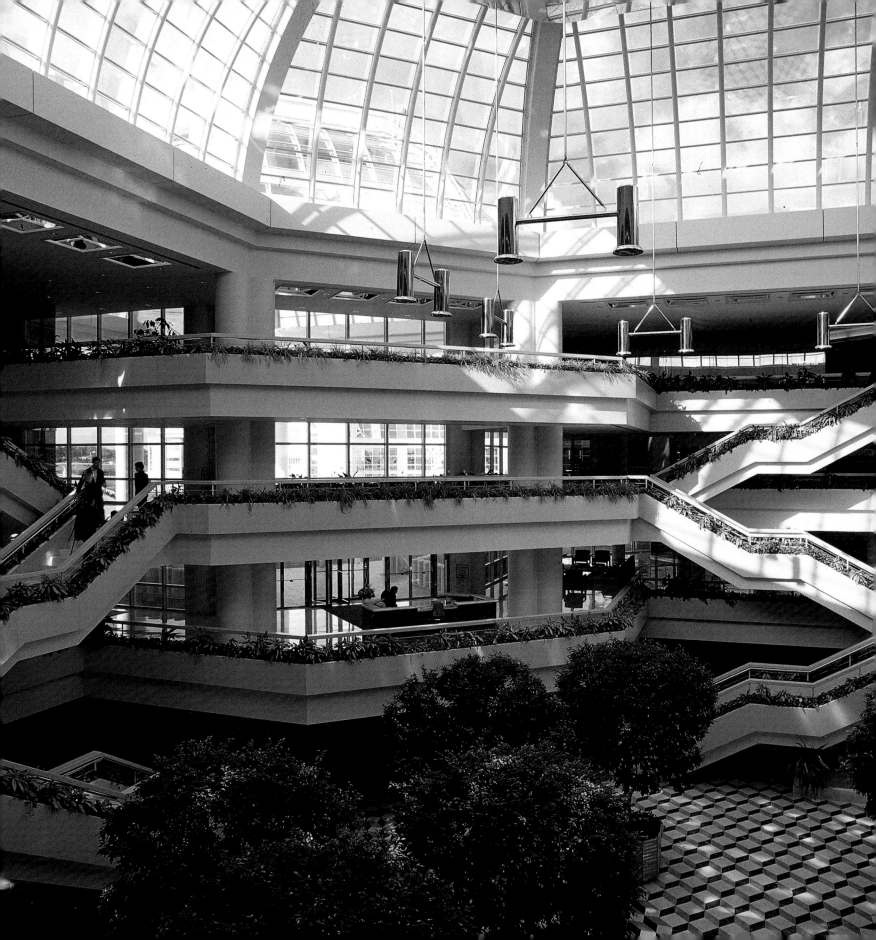

THE EXPRESSION OF HIERARCHY

The Central Beheer building is an attempt to provide its users with privacy without sacrificing the transparency of open-plan offices. The interior is dotted with plants and large, multicolored, papier-mâché figures—rather an unexpected feature in a serious business concern. This photograph of an employee at Central Beheer was taken by Marc Riboud.

Since 1992 the advertising agency CLM/BDDO has occupied a building which is slightly reminiscent of an ocean liner, anchored off an island at Issy-les-Moulineaux in the Paris suburbs (facing page). The building was designed by Jean Nouvel. The center of the building is a large atrium with a roof that opens. The offices are reached via gangways. The monitors display the company's latest advertisements.

personal offices. Other members of staff have comfortable, pleasant, open-plan offices, within an overall environment that is rather rigid. Various communal services are provided, including banking, insurance, hairdressing, shops, a movie theater and sports facilities.

In Finland, Digital Equipment provides another illustration of this tendency. The company chose a downtown location for its new premises. As space was at a premium, it was not possible to give each of the sixty-odd employees their own office. The solution was to make the building rather like a house, with a sitting room furnished with soft, comfortable armchairs and a dining room which could serve alternately as a meeting room and a cafeteria. Each employee has their own mobile desk, on casters, and their own cordless phone; they choose a corner to work in, which they can change according to need or mood.

In France, the first companies to put into practice ideas about eliminating hierarchy and creating different ways of organizing work were advertising and public relations agencies. The company BDDP was a pioneer in this field. The extensive use of glass and huge bamboo plants make it possible to arrange pleasant, private corners for conversation, thereby encouraging the exchange of information, and the work spaces are simple and identical for everyone. Every effort is made to safeguard people's privacy, either by the use of walls with only the upper part glass-paneled, or by the careful arrangement of desks, which never face passages.

The company Corporate, both when it was located in Levallois, and today, with some variations, in its new headquarters in Boulogne, has applied the same philosophy of space as BDDP. The office environment here is identical for everyone, from the secretary to the president. The offices are of an average size and are not fitted with doors. The furniture, which is white edged with pale wood, is placed against walls and windows in order to provide a degree of privacy. The atmosphere is one of openness, warmth and conviviality. The trained eye, however, can identify the offices of the managers, because they each have an extra little round white table!

In another Parisian public relations agency, CLM/BBDO, there is no hierarchy as such, but rather a recognition that different jobs need different kinds of furniture. Personal assistants have the usual classic office furniture; other staff use a new type of desk designed by Jean Nouvel, the building's architect. Meetings are held in the same room, around circular tables or on bright red sofas. Finally, if people need peace and quiet, there are tiny "booths" where they can go, although unfortunately these are about as comfortable as the polling booths used by voters. Senior

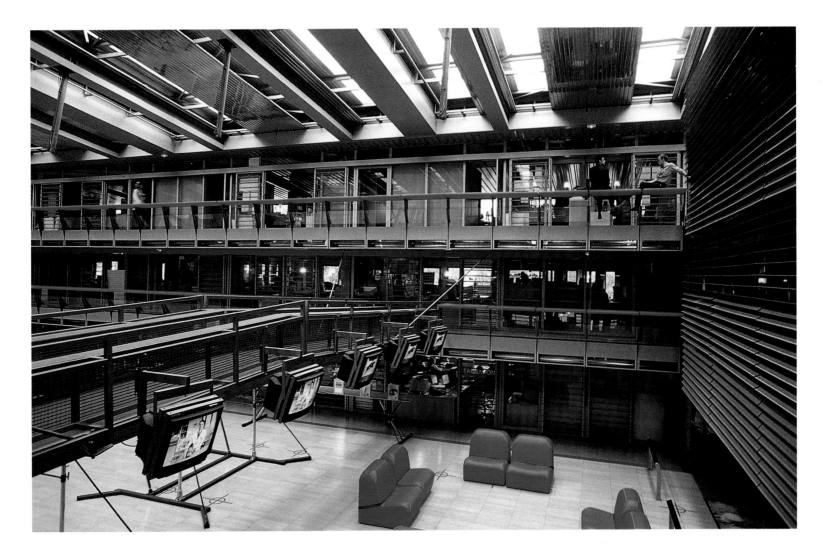

managers have average-size private offices, laid out in the same style as those of their colleagues. The almost total absence of hierarchy of space is not experienced by everyone in the same way. While the senior executives are proud of the originality of their approach, they can see that the glazed offices may have drawbacks. For example, if there is a heated discussion between two of them, everybody can see it, leading to comments on their behavior or the length of the discussion. The staff appreciate this absence of hierarchy without necessarily being fooled by it.

Paradoxically it is often in fields where the variation in salaries is widest (in advertising, for instance) that space is used in order to say: "We're all the same." Hierarchical differences will also be expressed in other ways—in the amount of free time one has or whether one has a portable phone or the use of a company car.

In more traditional companies, too, there is an increasing tendency towards layouts which put little or no emphasis on differences. Here economy is a key factor: it is easier and cheaper to buy a large number of identical items of furniture and a single kind of carpet. And such layouts support the claims of managers that everybody in the firm, at whatever level, is part of a team. Such claims are usually rather hypocritical, as management always seems to get more space than anyone else.

Nonetheless, this apparent uniformity makes it easier to integrate people within a group and makes employees lower down in the hierarchy feel more valued. Further up the hierarchy it may be less popular, but it is not easy to object, because the idea is that everyone is supposed to be on an equal footing. It is, in the final analysis, a clever way of trying to break free from traditional signs of hierarchy.

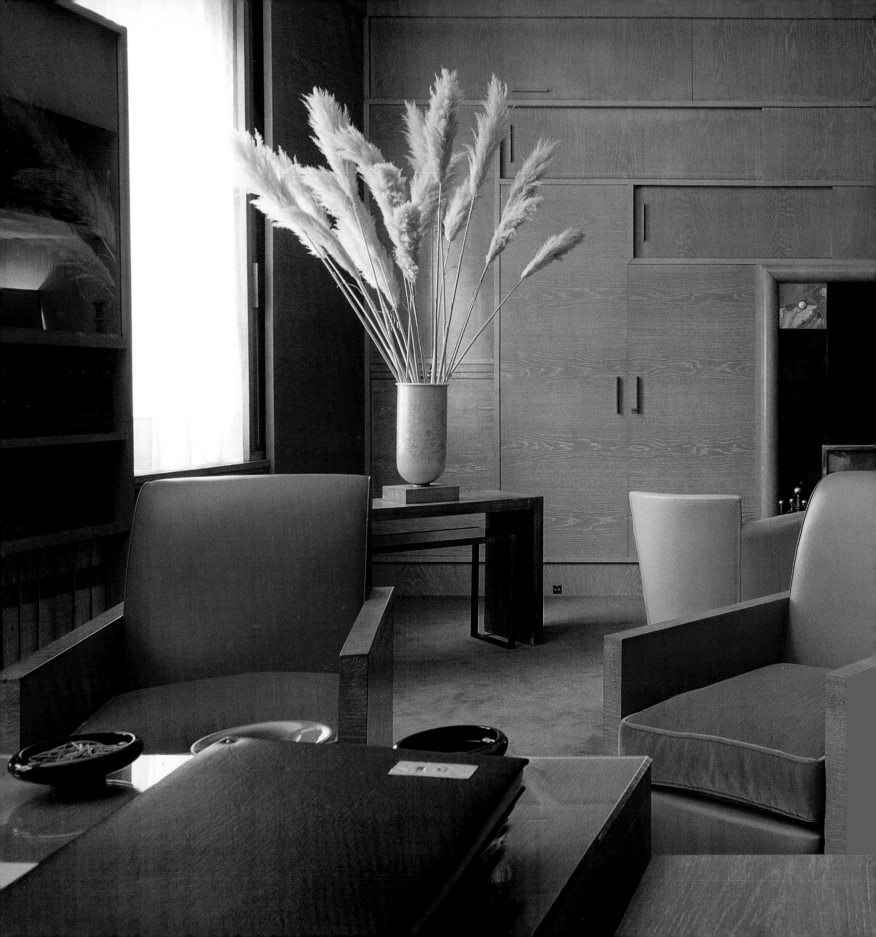

The office environment

From the snug, over-furnished offices of our grandparents to the bare steel and glass spaces of today's buildings, the office follows fashions and reveals personalities.

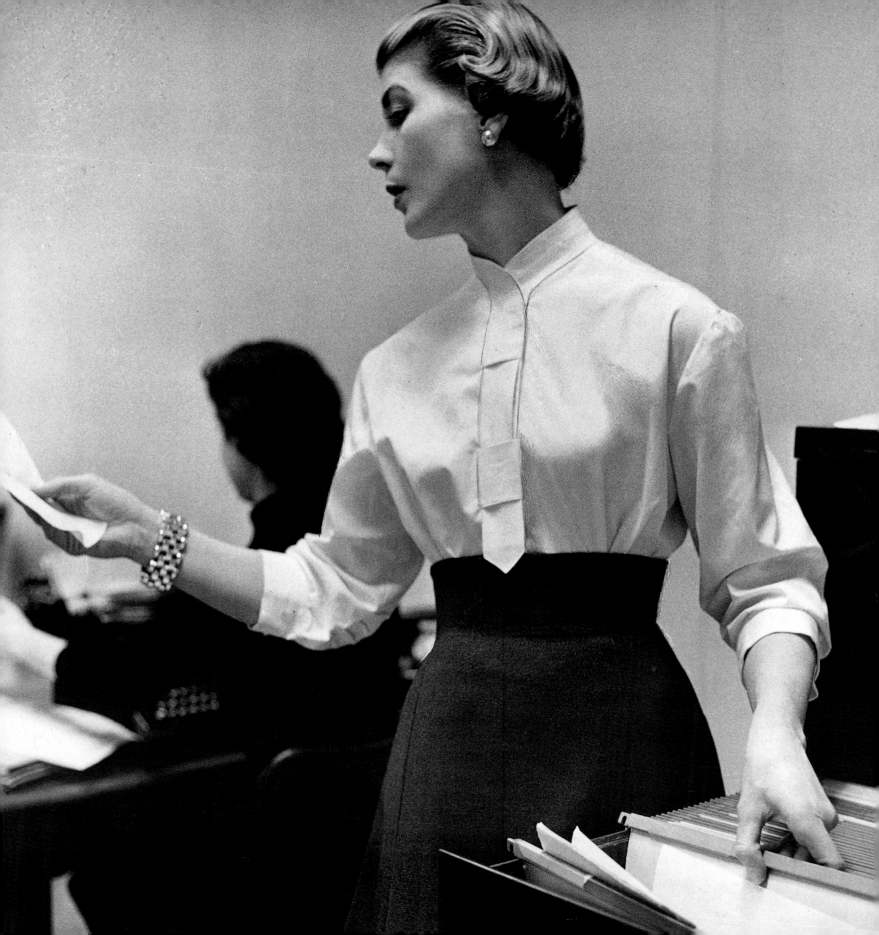

"Any woman who can play the piano well and can operate a phonograph would make an excellent typist. The work is ideally suited to women." So said a catalogue in 1880 and women—whether or not they were pianists—came flooding into the office, a world which up until that point had been the preserve of men. They came in as clerical staff, secretaries, mail ladies, and eventually, executives.

The researcher François de Singly has explained how female psychology was often invoked to explain this massive recruitment at the beginning of the century and he quotes a text from that time: "Women are more careful and more attentive than men, and they have a marvelous aptitude for the thousand-and-one needs of our big companies, which require precisely that—order, exactitude and patience."

In a provocative book published in 1914, André Bonnefoy urged men to leave the offices. Women first joined the Crédit Lyonnais bank in 1883, working in the securities department. They numbered 500 by 1898, and 1,900 by 1913, by which time they represented 40 percent of the staff at the firm's head office in Paris. In order to find room for all these women, an early solution was to put them together in a typing pool. This was a way of separating them physically from their male colleagues and of making promotion more difficult by fragmenting their jobs. "One might have thought that the fact of using a typewriter was seen as more skilled than the simple hand-copying that men had been doing in the nineteenth century. Not a bit of it!" says the historian Lisa Fine, in an article entitled "La Machine a-t-elle un sexe?" Furthermore, at Crédit Lyonnais, in the interests of morality, women employees had their own staircase and had to use a separate canteen—segregating men and women could be a complicated business.

Sedentary office jobs began to acquire a "female" image. The ideal "for a woman" was to work as a nurse or a secretary, a phenomenon that became even more widespread after the Second World War. Some 59 percent of working women in 1954 were salaried employees, and 84.1 percent in 1975, the year they overtook men (81.9 percent of the active male population). They have slowly taken over the tertiary sector throughout Europe (in France there are two women to every man). However, inequalities persist: in 1989 in France, women's earnings were on average 31 percent lower than those of men.

While their work has changed with computerization, women still tend to perform office jobs which require little or no qualifications. In France the public sector is largely female, representing two thirds of the staff in municipal administration and one half of all government employees.

Jourdain, Chareau, Sognot and Adnet worked together on the restoration of the Collège de France in Paris. In 1938 Jourdain was commissioned to design the administrator's office. The wood-paneled walls feature an ingenious arrangement of shelves and cupboards. In the evening, panels can be slid across the windows, creating an intimate space for study. The décor has been preserved just as Jourdain designed it (preceding page).

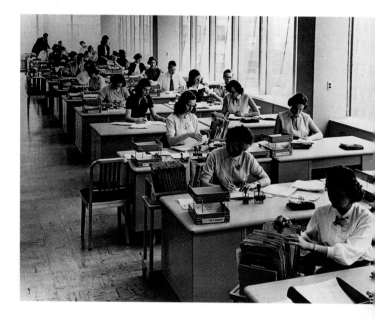

The stereotypical image of the perfect secretary is one of elegance and charm (facing page). This indispensable assistant must be constantly available and ready to tackle what may sometimes be thankless tasks, such as filing and typing.

General view of an office on Park Avenue, New York, in 1952 (above). The desks have been placed next to the windows in order to gain maximum benefit from natural light.

Packaging for a typewriter ribbon. Secretaries had to wait until 1961, when the famous IBM golfball typewriter appeared, before they were spared the unpleasant task of changing inky typewriter ribbons.

A department head and his secretary (below). Middle-aged, he exudes respectability, while she is young and charming. Under his slightly paternalistic gaze she diligently takes down shorthand.

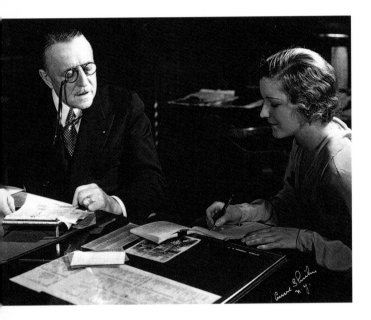

In Arthur Pierson's movie *Home Town Story*, made in 1951, Marilyn Monroe made a brief appearance as a secretary opposite Jeffrey Lynn (facing page). By contrast with Monroe's usually more sensuous portrayals, in this scene she plays the role of the attentive, efficient office worker.

Before the microcomputer, there was no such thing as a secretary without a typewriter. The first black Remington dates from 1873. In that same year Thomas Edison tried to develop an electric typewriter, without success. It was not until 1933 that the first electric IBM typewriter appeared.

THE INDISPENSABLE SECRETARY

Perhaps the archetypal office employee is the secretary—and not just any secretary, but the company president's secretary. The one whose office connects directly with the boss's and who speaks with him several times a day. The one who sees all the files and carefully guards the ones which are confidential. Her desk is cluttered, whereas the president's is empty. She organizes his diary and she is the only means of access to the inner sanctum. She spends a lot of time on the phone arranging his priorities and often has to move into top gear to organize urgent meetings. Her hours may be heavy, but her role is recognized. In the words of one president, "If my secretary's off sick, I can't do a thing."

The secretary and her boss are a symbiotic couple. She complements him. The authors of *Sur les traces des dirigeants* give a none too flattering sketch of their personalities: he is taciturn, whereas she is warm and exuberant; he is "too kind" and open, while she may be a bit of a dragon. They are united by their mutual esteem and most of the time she follows her boss up through the ranks of promotion. He cannot live without her and she cannot live without him.

This image of the female secretary—devoted, loyal and strong, as well as being vaguely in love with her boss—has inspired a number of movies and is still largely current. Movie directors have shown her varnishing her nails, doing her hair and applying lipstick while all the time talking on the phone. She wears high heels and silk stockings and has a wasp waist. Jane Fonda reacted against this image by producing the film *9 to 5*, at the end of which she called for the secretaries of the world to unite.

The stereotypical portrayal of the daydreaming secretary sitting at her typewriter goes hand in hand with another image—the cunning personal assistant who takes charge of things in order to protect her boss from all kinds of traps, a role played by Fanny Ardant in François Truffaut's movie *Vivement Dimanche!*

The PA introduces an element of seduction, gentleness, availability and discretion into the office. Her qualities are appreciated and she enjoys a very personal relationship with the boss—"We spend our time making time for them," as one PA put it. The fact that she is permanently at her boss's shoulder makes her something of a power behind the throne, but while she may take care of everyday business she has no place in the public representation of power. Her position between the top executives and their colleagues, and her privileged access to

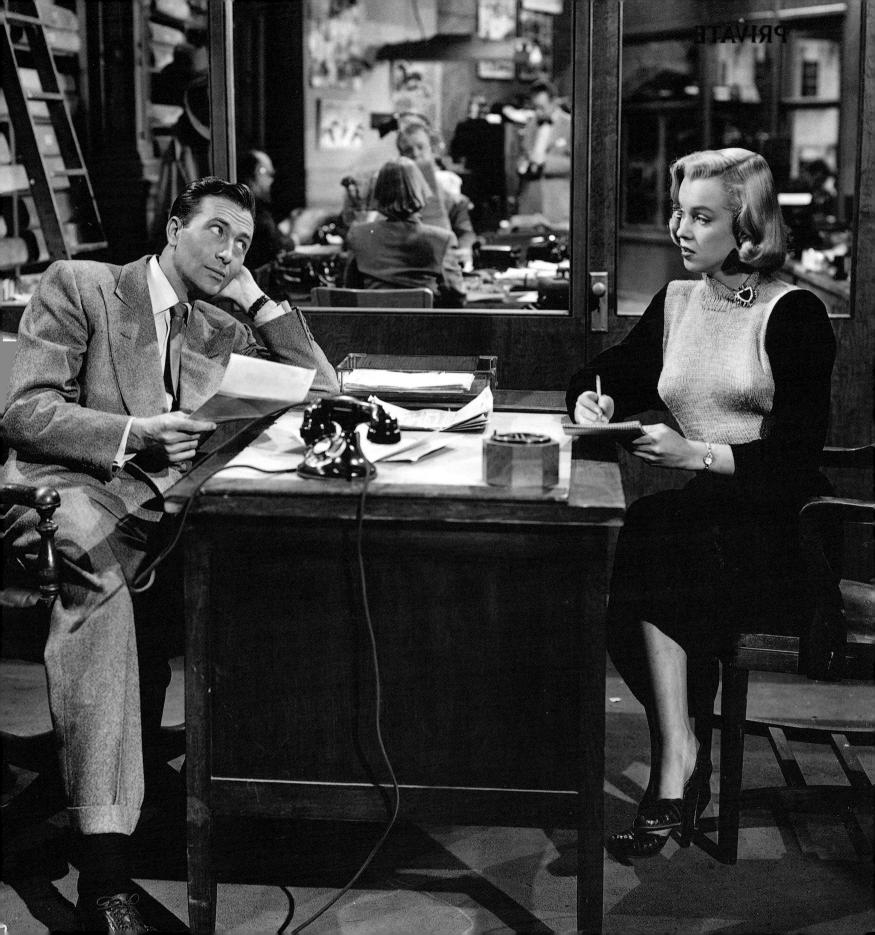

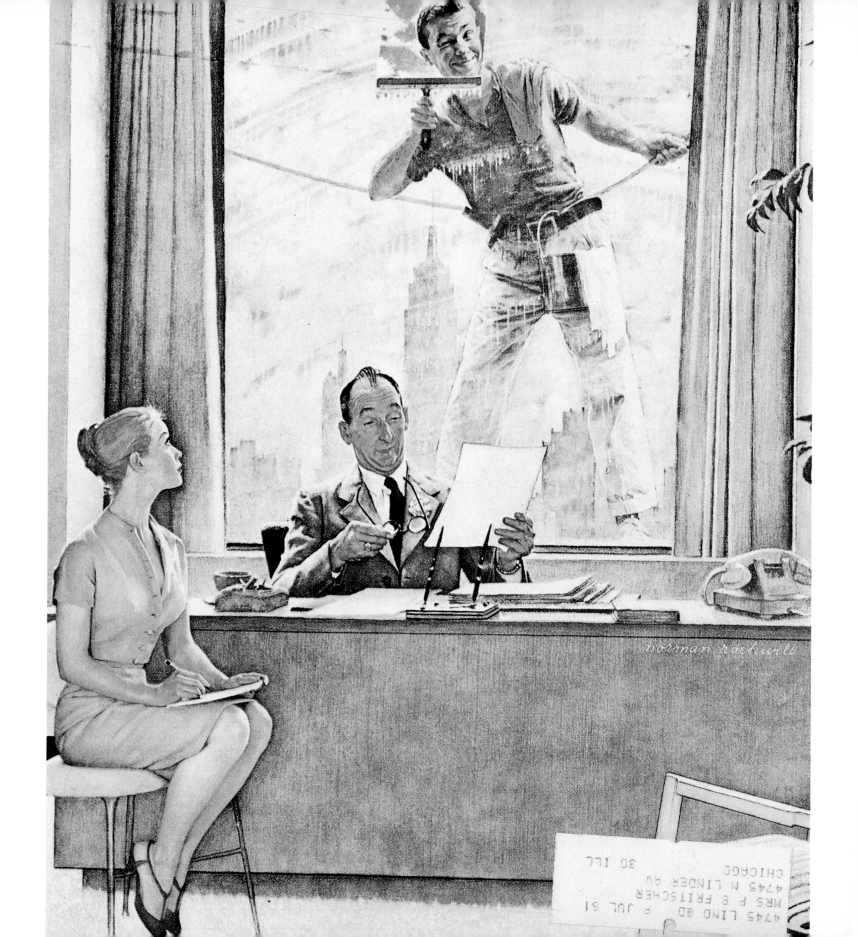

Spencer Tracy and Katherine Hepburn in their first screen encounter, *Woman of the Year*, directed by George Stevens in 1942 (left). She played a political correspondent and he a sports columnist. They marry and of course things start to go wrong, mainly because she has a career with a higher profile than that of her husband.

Putting one's feet on the desk is a pleasure reserved strictly for the boss. In the thriller *V.I. Warshawski*, made in 1991 by Jeff Kanew, Kathleen Turner plays the part of hard-boiled private eye V.I., sharply caricaturing the usually male role of the detective.

A wink of complicity from the *Window Cleaner*, in a painting by the American artist and illustrator Norman Rockwell (facing page). In this scene, a pretty secretary is distracted from her shorthand by a mischievous window cleaner—a small interruption in the often intense relationship which exists between a personal assistant and her boss.

information, have made the executive secretary an office archetype. Today she still represents a social ideal for some aspiring girls.

At the start of the 1970s women executives began to appear. They immediately adopted a masculine approach to work, as if to say: "Just forget that I'm a woman." Hence the briefcase, the constant availability, the smile at the suggestion of an impromptu meeting at eight in the evening and the inevitable tailored suit, which became more or less a work uniform. In the United States a chain of stores called Career Woman opened with her in mind. But gradually things began to change. Research showed that after a number of years, young female executives were proving so efficient that they were disrupting the customs and routines of the male executive world. Their way of being more direct and down-to-earth, and less attached to the symbols of power, disturbed the hierarchical rituals. Is it really so important to have a slightly bigger desk, or one window more or less, or a more sophisticated telephone or microcomputer? On the other hand, women executives attach more importance to questions of general atmosphere, décor and working relations.

FROM LOVE TO STRESS

Before women arrived on the scene the office was run like an army. Today, the office is a mixed-sex place and emotions and feelings are expressed more openly. To what extent is this tolerated? How do emotions translate in terms of work space? Does the décor of the office play the same role as the stage set in the theater, creating a world for the emotions and feelings of the actors? Women's magazines are always full of stories about love in the office, stress and problems with the boss.

Let us start with love in the office, a steamy and slightly dubious subject. People invoke it as a way of covering up for the difficulties of everyday social relations. They attribute all kinds of amorous or sexual adventures to their colleagues in order to spice up an everyday routine which has nothing exotic about it.

The American painter Edward Hopper, among others, treated the theme of love, flirtation and ambiguity in the office, where the archetypal relationship is that between the boss and his secretary. Hopper portrays situations that are disturbing and full of anticipation.

Love is very much present in the office, statistics prove it. Some 12 percent of French people met their partners in their place of work. A number of companies encourage family connections by hiring husbands and wives, and then perhaps the son-in-law. At IBM, in the United States, the reverse is true. The IBM employee has only one family: the company. Couples are banned. A story about Bill Gates, the president of Microsoft illustrates this tendency. One day he met one of his employees on her way home looking hard-pressed after a twelve-hour working day. Gates inquired ironically whether the woman was now working part-time.

True to tradition, France turns a blind eye to its employees' love affairs, on condition that they are kept discreet. The Americans are less appreciative, as Barry Levinson's movie *Disclosure* showed. The plot is based on an inversion of the usual scenario: here it is the high-powered woman executive who harasses one of her male colleagues. In the United States, light-hearted banter and flirting have less and less place in the office. The risks are too great. These days, when male and female colleagues need to stay late for a meeting, the doors are usually left open, or a third person will be there to act as chaperone! No less than two hundred cases of sexual harassment were dealt with in 1994 by a specialist firm of lawyers in New York. However, there are American researchers who say that "sexual attraction between colleagues,

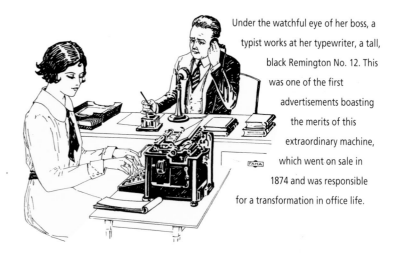

Under the watchful eye of her boss, a typist works at her typewriter, a tall, black Remington No. 12. This was one of the first advertisements boasting the merits of this extraordinary machine, which went on sale in 1874 and was responsible for a transformation in office life.

"Well, my dear, if you didn't manage to get it all down, I must have been speaking too fast." That seems to be the message of this 1907 photograph (below). Shorthand was not easy to learn. It was probably invented by the Greeks and Xenophon used it for recording the utterances of Socrates. From the seventeenth century onwards, the methods became more sophisticated although the principle remained the same.

"The picture," wrote Edward Hopper of *Office at Night*, "was probably suggested by many rides on the 'L' train in New York City after dark and glimpses of office interiors that were so fleeting as to leave fresh and vivid impressions on my mind" (facing page). Painted in 1940, the work recreates these furtive impressions. The scene seems to be filled with a tense expectancy.

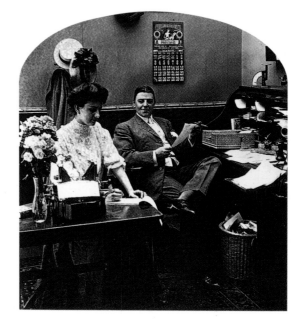

Les Nouveaux Messieurs, the last silent movie made by French director Jacques Feyder, was a satire on the behavior of politicians (facing page). Made in 1929, it was banned because of its alleged assault on "the dignity of parliament and ministers." Lazare Meerson's sets recreated the gilded splendors of the offices of power.

A scene of passion in *Disclosure*, made in 1994 by Barry Levinson, starring Michael Douglas (above). The roles are reversed in this hard-hitting story of a male employee sexually harassed by his boss, played by Demi Moore.

The office environment is not always peaceful and trouble-free. Tension, conflict and hatred are always present, but are usually kept in check. Sometimes the rules of good behavior are shattered, as in this scene from the movie *A Young Gentleman of the Old School*, where two of the protagonists come to blows.

with or without actual sexual contact, would improve productivity." In the view of researchers from the University of North Dakota, mixed work teams are noticeably faster and more creative. The Wisconsin team suggests that employees who fall in love with a colleague tend to spend longer hours in the office and tackle their work with a new fervor.

A number of firms have understood that imaginative ways of using space could be helpful in reducing aggression and nervous tension. Marie-Béatrice Baudet, writing in *Monde Initiatives* in October 1994, described the extraordinary way one company in the United States dealt with the problem of channeling aggression. In the evening, at the end of the working day, the lights were switched off, and people were allowed to throw "nerve balls"—anti-stress balls—at each other. The aim was to release aggression. Anybody wanting to get to the president's office had "to cross a waiting-room flooded with 'nerve balls,' which surround the visitor up to the waist. It is a modern version of running the gauntlet, which is physically exhausting for the visitor who is not so quick to give into changes of mood."

Aggression in the office can also lead to violence. According to *Management Review*, 8 percent of fights between employees have led to fatalities, 9 percent have resulted in serious injuries and hospitalization, 23 percent in light injuries, and 20 percent have induced post-traumatic stress.

On a more everyday level, stress is recognized as a major factor in office life. Overcrowding, accumulating files, badly designed and badly positioned furniture, a lack of soundproofing—all of these are guaranteed to increase stress among employees.

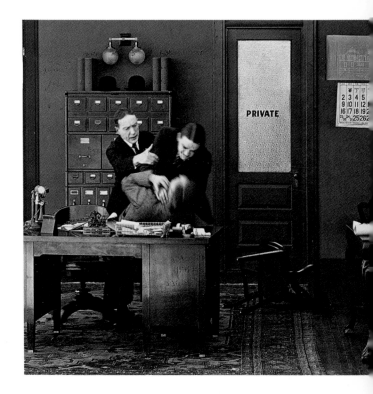

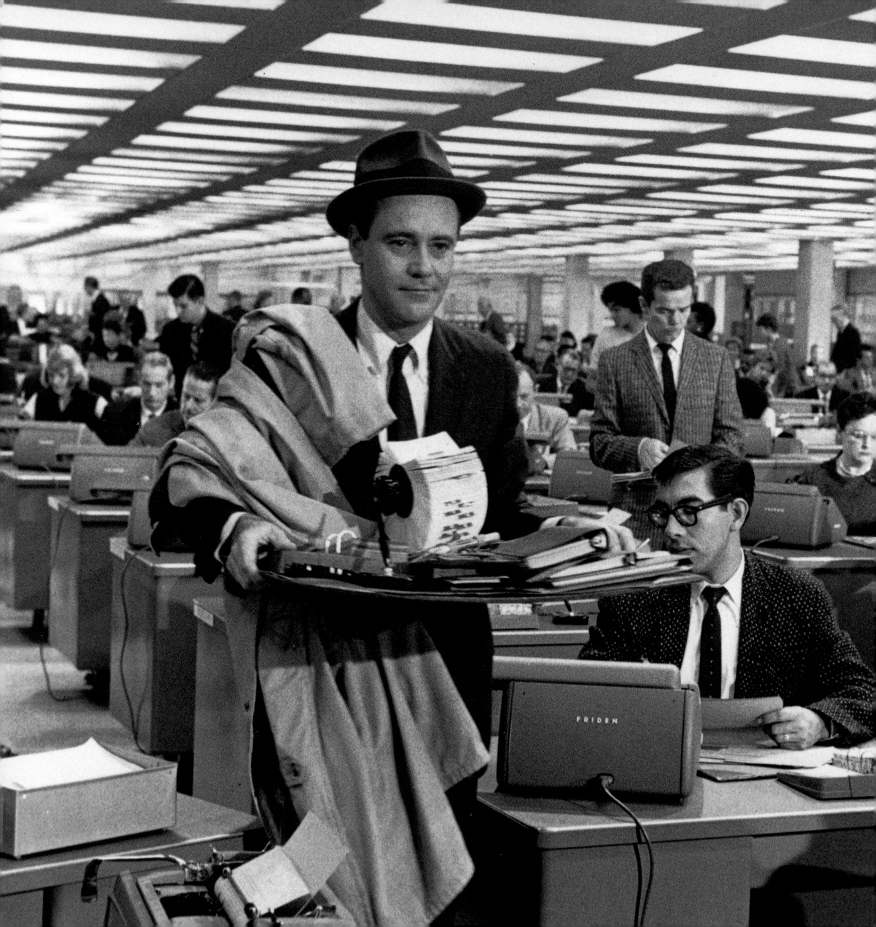

LIVING IN YOUR OFFICE

If you were to visit five identically constructed apartments in an apartment building, you would be struck by the individuality of each one, the personal touch that their occupants have given them, the imagination that had been put in. The furniture might be arranged in more or less the same way, but it would differ in age, style, color and materials. The ornaments, personal effects and lighting would be entirely different. Even the bathrooms would be decorated or equipped differently.

Nobody, however, seems worried about the idea of having an office which is identical to their next-door neighbor's, despite the fact that the office is also a place where people live, a place where they spend up to eight hours a day for a large part of their lives. People prefer not to think about it much. In addition there are a number of important constraints in the office. If you want to make even small changes, should you first ask permission? And whom should you ask? How would the boss react if you arrived in your new office with items of furniture, curtains, cushions and boxes of odds and ends?

Nowadays people are exhorted to be themselves and to develop the ego. In your personal appearance, as in the décor of your apartment, you are expected to show evidence of originality, of how you have come to terms with yourself. In short (and with the aid of a variety of specialist magazines) you are supposed to "be yourself!" This view generally stops at the entrance to the office. There is too much reserve in the world of work. A work space has been put at your disposal and you are expected to use it as a proper, upstanding member of the community. There is no question of transforming it, of injecting some originality that might seem out of place. What on earth would it look like if it no longer looked like a place of work?

When you take possession of a new office, you arrive empty-handed. Your first priority is not to mark out territory but to get yourself accepted by your new colleagues. In the beginning, you go off to the coffee machine by yourself. You know you have come through your initiation when your neighbors offer to get you a coffee. Sharing a coffee is easier than sharing one's living space. The Americans, for example, have a different conception of sharing. When a new person arrives on the block, everyone moves their desks to make room for them. This is just one way of saying "You're OK, you've been accepted." In France, however, there is no question of touching people's hard-won privileges. When he sets up his desk, the new

A scene from *The Apartment*, directed by Billy Wilder in 1960 (facing page). C.C. Baxter, played by Jack Lemmon, has just been promoted and he is more than happy to leave the anonymous world of his colleagues for a small office of his own. It is the first stage in a rapid ascent, the secret of which is known only to him and a small circle of his superiors.

This photograph by Elliott Erwitt captures a scene of everyday life in the office: a man glances at some notes, leaning over an impressive refectory table, in his large office, which, with its wooden shutters, has the atmosphere of a room in a colonial-style house.

These old warehouses near London's Tower Bridge have been turned into offices. This sensitive conversion has made the most of the original wooden floor and the beautiful beams, which have been left exposed. The desks and chairs have a 1930s feel.

A mixture of styles in one of the offices of *Esquire* magazine in New York: a glass-topped table; an anglepoise lamp in brushed metal, designed by Michele De Lucchi; two wooden swivel chairs, and a kilim carpet (below). The lounge corner by the window is furnished with a sofa and chairs by Le Corbusier.

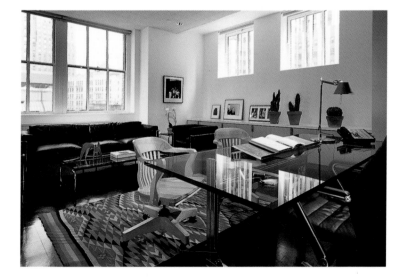

arrival has to make do with whatever space is left over.

Imagination is what is missing from the vast majority of work spaces. Usually they are too impoverished, too cramped for you to want to do much with them. For a lot of people it is almost a contradiction in terms to speak of an office lifestyle. At best this might be something reserved for the privileged few. Offices are always going to look like offices and they exist in order to get work out of people.

However, we are all attached to our everyday lives, our contact with other people. The French finally came to terms with the world of business in the 1980s, but its image has gone rather downhill since, what with economic recession and the increase in unemployment. It might seem rather eccentric to be worrying about the décor of your office nowadays, when the mere fact of having an office—and therefore a job—already seems like a privilege. Furthermore, there is something reassuring about the fact that work spaces are somehow unchanging: everyone adds touches to their own little corner, decorates it, and personalizes it by whatever means they can.

To the trained eye, no two offices are ever the same: there are always small signs that give clues to the personality of the occupant. A bunch of flowers, a cactus, some postcards on the wall, a well-used blotter, a pencil pot brought back from some Tunisian souk, an ashtray stolen from a big hotel—all these objects have meaning. They are a way of putting down roots, of resisting anonymity. Office décor is all too often limited to a plant, or perhaps a poster (which, incidentally, in shared offices, people illogically put up behind them rather than in front of them). Out of politeness, everyone tends to stick to their own corner and tries not to encroach on other people's space.

Interior design and questions of layout are rarely a priority for company bosses. Decoration is seen as somehow feminine, superfluous, irrelevant to the harsh realities of economic life and a waste of money. If you started to ask office workers for their opinion on the color of the new carpet or a possible change of layout where would it ever end? A lot of people might wonder whether the company boss did not have better things to do than worry about the décor and layout of the office. Surely he has enough on his plate already . . . However, the architect Georges Ferran insists: "Every detail is important! Nowadays the office is a place of communication and social exchange, where good management has a lot more to do with lifestyle. This means we must find appropriate ways of furnishing it, taking into account not only basic needs, but also aesthetics and what people like."

Who nowadays would want to spend their lives in the kinds of offices inhabited by our great grandparents? It was a time when people had an aversion to empty space, so each room was crammed with objects. Walls were covered with pictures and windows were hung with drapes and net curtains. Glass bookcases packed with books were topped off with marble busts and plants. The mantelpiece always had a clock in the middle surrounded by candlesticks, photos in small silver frames and ornaments. There were a number of chairs, desks cluttered with miscellaneous objects—leather folders and matching desk-blotters, bronze pen-holders and ink-wells, paperweights, an in-box for the mail, small lacquered boxes, filing baskets, yet more framed photographs, a magnifying glass, a small dish and ashtrays. And all around, there were books, books and more books.

Gradually the office began to distance itself from the apartment model, at the same time emptying of clutter. Objects became more utilitarian than decorative. More often than not they were beautiful but cold. Modern design tended to avoid bric-a-brac and the new work spaces did not really lend themselves to that kind of thing anyway.

However, all offices are decorated, or, more precisely, lived in, and that includes open-plan offices. Living in an office means more than just choosing a poster for it or bringing in an ashtray. It is also a question of leaving your mark, such as the way you leave things lying around. Various other factors contribute to making an office attractive, such as the amount of afternoon sun it gets, the kind of seating, and, above all, a pleasant décor and the general atmosphere. What began as a private office may eventually become a collective space. People sometimes club together to buy a few items of crockery or a refrigerator, and they may take their coffee breaks together. Similarly, people organize collections for a colleague who has had a baby, or someone who is leaving.

This house at Lanhydrock in Cornwall was built in the seventeenth century and was restored after a fire in the nineteenth century. It has since been transformed into a museum showing everyday life in the days of Queen Victoria. Here we see the estate office, which has been preserved virtually intact (below).

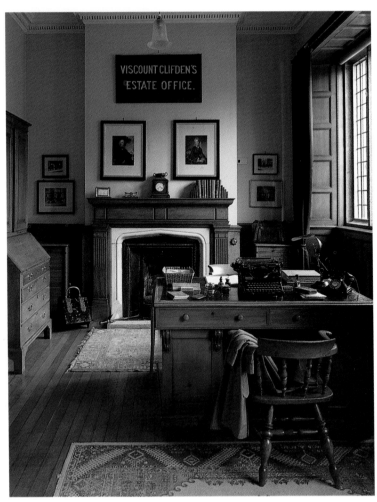

Two examples of that indispensable accessory in the offices of our grandparents: the ink-well. One is made of crystal, with a silver stopper. This intricate design has two small slots for the pens. The other is in black porcelain picked out with gold thread and dates from the late nineteenth century (right and above right).

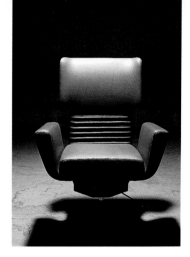

Isabelle Hebey chose a blueish-gray color scheme for Bercy. This chair, with its aerodynamic lines, was designed for the office of the Ministre des Finances et du Budget.

A hexagonal executive desk made in ebony and leather. This rather austere design dates from the 1970s. Accessories and paperwork are cleverly concealed in modules at the ends, making it possible for the work surface to be kept clear.

Today office furniture manufacturers offer a range of furnishings designed to fit standardized spaces. The names of their products are still somewhat exotic: we have the "president's" desk (70 x 35 inches), the "curved minister's" desk (82 x 35 inches), and the "half-minister" (46 x 31 inches). But what exactly is one supposed to do with a "half-minister?" They are sold with or without side extensions and may be accompanied by side tables on feet or casters. The office desk is no longer necessarily rectangular. It may be square, like the Kvadrat designed in 1988 by J.-L. Berthet and G. Sammet, with one corner cut off, or rounded and bean-shaped. It may be circular, like the desk designed by Ettore Sottsass, with its spider's-web feet and glass top; or semicircular like the desk designed by Marc Alessandri; or halfway between the two, shaped like a teardrop, with a rectangular part where you work, and a rounded tip around which you can hold meetings.

The commonest arrangement is to have the desk in the center and a lower table arranged either to left or right—not necessarily because you are right- or left-handed, but because the room dictates it. There is also the L-shaped desk. Slightly bolder is the "corridor" layout, which consists of a classic desk and a rectangular side table placed behind you. This layout is common in English-speaking countries.

Styling has become more rounded recently. The edge of a desk is no longer sharp and square-cut, but rounded, sensual and warm, with increasing use of wood. Executive chairs still look like executive chairs: black, with high backs and voluptuous armrests. Seats for visitors are likely to be more varied and are sometimes borrowed from the latest fashionable Parisian cafés. One reliable favorite is the LC2 chair designed by Le Corbusier, which is square-shaped and made of black leather, with tubular steel uprights. In 1980 it inspired a Swiss designer, Stephan Zwicky, to design a version in concrete, with an iron framework.

Color has been gradually invading the realm of office furniture in recent years. With the increased popularity of light colors, wood has tended to become almost white and pastel-colored laminates have arrived on the scene. However the ranges on offer do not always include comfortable sofas, couches and rocking chairs. Swing seats and hammocks are still forbidden. Comfortable sofas are banned (except in the offices of "creative" advertising people—to help them find the slogan that is going to make the agency's fortune, they are allowed that

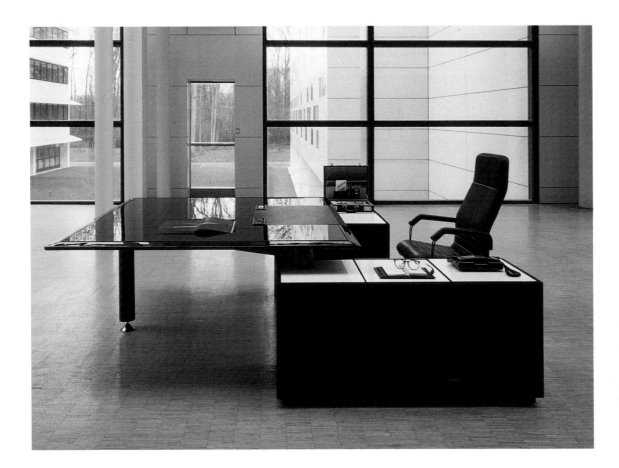

The Kvadrat desk by Jean-Louis Berthet and Gérard Sammut, manufactured by Airborne in 1988, is a shiny black lacquered square, with a streamlined edge like an aircraft wing, resting on three black satin-finish cylinders. It is a rigorous composition of contrasting volumes.

extra bit of freedom). The Americans, whose rocking chair has been elevated to the status of a national symbol, have not succeeded in introducing it into the workplace. Storage units are generally fairly ugly. Their proportions are dictated by the standardized sizes of files. You might occasionally dream of finding in your office furniture originally designed for the home, the kind one might find in a child's bedroom perhaps, such as a beautiful, tall cupboard culminating in a crocodile's head with doors in the form of scales. But would it be capable of storing ordinary A4-sized files?

The way in which furniture is actually arranged in the room also helps to set the tone. For example, when a desk is placed so that it faces the door, this engenders a certain power relationship. A desk that is near the door and perpendicular to it is generally the desk of someone who is lower down in the hierarchy. Then there is the rather rare arrangement whereby the desk faces the window, with the user's back to the door. French culture dictates that one should be able to see one's visitors coming in. Some like corners or prefer to have their backs to

This desk was designed by Carlo di Carli for the Palazzo dei Giornali, which was designed by the Italian architect Giovanni Muzio in 1940 (below). A modern version of the twin-faced desk, its large glass top offers an ideal work surface for two people.

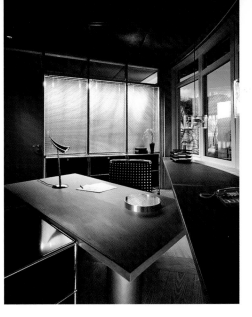

The GMP architectural practice in Hamburg, Germany. The architects have made the most of a confined space. A large work-top corrects the curve of the windows and the desk has been placed at an angle. The "graphic" décor is punctuated by a Philippe Starck signal lamp and an Antonio Citterio chair.

Two views of the offices of the Karbouw company, built in 1990 at Amersfoort, Holland. This large minimalist office is arranged around geometric elements (below). The rectilinear furniture echoes the architecture. Natural light filters through a translucent partition, which incorporates discreet shelving.

In the same building, the chaotic architecture of this work space is an attempt to go beyond the simple box. Here nothing is straight; the lines are fractured and oblique. The offices are separated by sliding screens of perforated steel. The scheme was designed by architect Ben van Berkel.

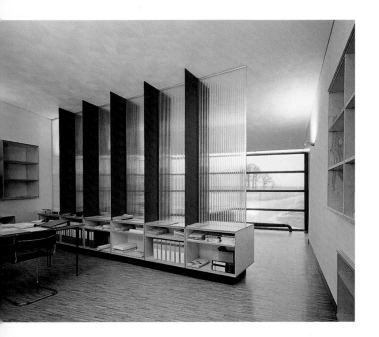

the wall. A variety of social psychology studies have been produced on this question. How does one adapt to one's space? Academics, for example, do not systematically set up their desks facing the door and they tend to leave space between the desk and the wall so that they can stretch out without banging against things.

When Americans have to share a room with other people, they tend to position themselves along the walls, leaving the center of the room free for communal activities (meetings, filing, documentation). The French, on the other hand, have a tendency to occupy this central space.

The arrival of microcomputers in offices further modified their layout. Corners began to be better used. People are more willing to sit with their backs to the door if they are facing a computer screen. On the other hand, the ideal computer table has yet to be created. You rarely find screens placed at the right distance or the right height. And when are we going to start getting furniture with a sense of humor, or a touch of the theatrical, or furniture made out of cardboard? The architect Frank Gehry was designing cardboard furniture more than twenty years ago. He created a desk and chair with rounded lines, for instance, which were made of sheets of cardboard glued together under pressure. "I can design them in the morning and produce them by the end of the day," he explained. He had another go at promoting them ten years later, but companies were not prepared to take the plunge; so he continued designing furniture made up of curved forms and inspired by traditional wicker baskets, but made of wood. The price of those, needless to say, is somewhat higher.

Finally, for partitioning off large spaces one has a choice between cupboards, medium-height storage units, glass partitions or mini-partitions covered in felt. These all enable people to protect their territory. Companies use partitions in a variety of ways. For example the former offices of the magazine *Le Jardin des Modes* have formica partitions decorated with the covers of their magazines, simultaneously providing privacy and promoting the company. Nowadays there is a fashion for openwork metal screens, but these have the drawback of offering no soundproofing. Eileen Gray produced an original reworking of the idea in perforated metal and Philippe Starck designed one in wood, incorporating photographs also framed in wood, which is a decorative element in itself. The glass panels which are popular today unfortunately provide no visual privacy at all.

Jean Perzel created imaginative lamps which were more than just reworked oil lamps or candlesticks. "I wanted to conceal the source of the light, while still using its rays. So I began looking into the relative opacity of pearl and frosted glass." He set up his company in 1918, designing geometrical table lamps, chandeliers, wall lamps and ceiling lamps. These models date from 1924 and 1930 and are still produced today.

The Tizio lamp, a modern classic, created by the German designer Richard Sapper in 1972 for Artemide. This exemplary design went on to become the best-selling lamp in the world. The screws and springs of conventional adjustable lamps have been abandoned in favor of a dynamic equilibrium achieved by swinging arms and counterweights.

LIGHT AND COLORS

Atmosphere is the result of a combination of things—wall and floor coverings, main lighting (either integrated or hanging from a false ceiling), secondary lighting, floor lamps, desk lamps, curtains and blinds. Color is important, as are textures and materials. Touch is also important: walking across a thick carpet, for example, gives a different sensation from walking on a marble or plastic floor. Visitors are also sensitive to the patina of a place, its cleanliness, the degree of wear and tear.

An interior may appear harmonious, over-stated or squalid. If the lighting is too white and violent, it may destroy intimacy. In the 1960s it was discovered that well-designed lighting had the effect of putting people into a good mood and increasing productivity: this led to a tendency to over-use light. Light flooding down from false ceilings, for example, is not very flattering for the complexion, and not very good for morale either. Nothing is better than a small desk lamp. The current favorite is the ever-popular task lamp mounted on adjustable arms, a variation of the famous anglepoise lamp. It is usually black and is fitted with a tungsten-halogen bulb. The most famous recent example is the Tizio lamp, designed in 1972 by Richard Sapper. On an airier note we have the Dove, designed by Mario Barbaglia and Marco Colombo. There has also been something of a return to the 1930s, with rather squat lamps produced in black or chrome steel, with round or bowl-shaped shades.

The classic office lamp, with its stand in the shape of a candleholder, crowned with three fake candles holding electric bulbs and topped with a green or burgundy shade, is tending to disappear, except in French ministerial offices, where it has become something of a status symbol.

Office color schemes are generally fairly uninspiring. A heavy legacy of chestnut, beige, dark gray and light gray still oppresses our work spaces. The oranges and violets of the 1970s, of which you still find traces here and there, did not develop much of a following, not that this is any great loss. The following years were very black and gray, highlighted by a streak of bright blue or canary yellow, combinations which were seen as the embodiment of design and modernity. And in recent years we have the passion for steel gray and transparent or sand-blasted glass picked out with touches of red.

Some companies have taken the opposite stance. Pernod, for example, took a bold step in 1989 in choosing mauve for the landscaped offices of their regional headquarters in Paris. The color is everywhere—on the walls and on the furniture—and is combined with

strawberry red chairs and bright yellow office fittings. But why pick mauve, a surprising choice? H. Cohen, who was in charge of the scheme at Pernod, explained: "Mauve brings warmth, calm, relaxation and restfulness. It's a color that goes well with blue. People don't talk so loudly, and acoustic tests carried out by experts have shown that we actually have the same noise levels that you'd find in an individual office!"

Color is also dictated by fashion. Today whites and pastel colors predominate. Black is disappearing. Gray is fading out, or is being mixed with pinks and greens. Wood is making an entry, with oak, beech and pale, almost white poplar being used in veneers, on walls and partitions, and for furniture. But the symbolic aspects of color, its capacity to stimulate, have not yet been extensively researched.

Each color has its own "temperature," with yellow representing absolute heat and blue absolute cold. They also have meaning. The painter Kandinsky taught a course at the Bauhaus. For him yellow was an expansive color, which broke through boundaries. It was aggressive,

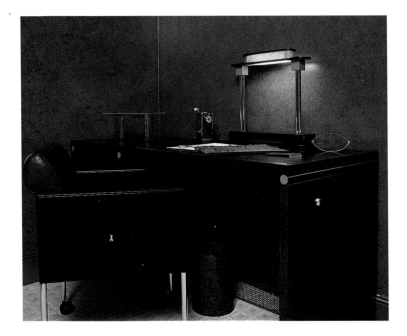

A palette of cold colors gives the office of Charles Rutherfoords in Covent Garden, London, an air of mystery: midnight blue for the walls; green light from an Ettore Sottsass lamp, and the black rigor of the club chair designed by Cini Boeri (above).

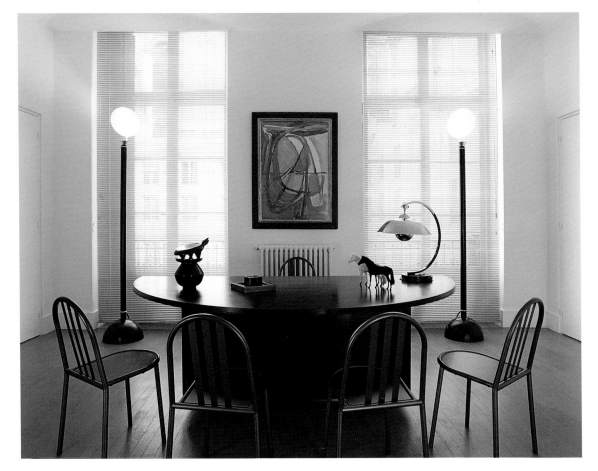

The interior designer Andrée Putman was one of the first to revive the work of Eileen Gray, Pierre Chareau and Michel Dufet. She began producing reproductions of their creations in 1978. Here we have one of her favorite configurations: Mallet-Stevens chairs around a table which she designed herself and a Fortuny lamp.

The Apple offices in New York, designed by Studios Architecture. At the end of the 1980s, architects began using color. In this corridor a palette of pastel shades highlights the interplay of volumes.

active, volatile and linked to moodiness. "It could be the color representation of madness." Blue, on the other hand, a color associated with things celestial, "draws man towards the infinite"; it is timid, passive, gentle and submissive. He went on to counterpose black and white, and, finally, green and red. In Kandinsky's view color represented a visual language which would end up by communicating feelings more clearly than verbal language.

We know that colors have a psychological effect on us and can affect our morale. Some may be too aggressive, others are depressing. For the painter Fernand Léger, "Color brings joy, but it can also make you mad." And, without wishing to turn every company into a kindergarten, one often finds oneself regretting its absence. At the beginning of the nineteenth century, Goethe said that only "savage nations, uncivilized people and children have a strong predilection for bright colors." The office has for many years lived by this precept and has neglected the language of colors.

SOME NOT NECESSARILY SUPERFLUOUS ACCESSORIES . . .

The finishing touches are provided by the various objects that one finds on and under people's desks, of which there is an extraordinary array. The following is a Jacques Prévert-style inventory: blotters, calendars, clocks, lamps, document trays, wastepaper bins, card files, pencil jars, blunt pencils, rollerball pens, felt-tips, biros that have run out of ink, scissors, folders, paperweights, desk tidies, staplers, perforators, pencil sharpeners, lighters, ashtrays, Post-its, paper clips, calculators, blotting pads, memo pads, tape dispensers. They are not all useful, or even necessarily functional, but most of them have value as fetish objects endowed with a playful dimension—like the glass paperweights which you turn upside down to see the snow fall. If you prefer something more unusual, you can have a piece of meteorite or moon rock suspended in a perspex parallelopiped.

These objects really are part of one's work, as Adrien, the hero of Albert Cohen's *Belle du Seigneur*, confirms: "Seized with remorse, he toyed dreamily with his secret teetotum, then clicked his cornelian marbles, and then, staving off his melancholy by operating his stapler in slow motion, without any pleasure, because his idleness was torturing him, he tried to find some justifications . . . Finally, seized with an insane

desire to work, he put a pencil into a large-size Brunswick which Octave was supposed to turn . . . 'Three hundred and fifty,' he announced, because he was counting the number of pencils that he had sharpened since his entry into the general secretariat of the Society of Nations."

A blotter on your desk, for example, is a sign that you have classic tastes. It shows that you are a serious person, assuming that it is made of leather and not polyurethane. On the other hand, letter trays and files in bright colors and simple lines, like those designed by Enzo Mari for the Danese company, may be interpreted as a sign of your dynamism. Objects in red or black perforated steel give a young "handyman" image. Perspex ornaments, on the other hand, are tending to go out of fashion and are being replaced by wooden ornaments with rounded forms that are inviting to the touch and which emphasize your sensual side. You can now find wooden pencil pots, paper bins, desk tidies and, the ultimate luxury, a glasses case in solid maple. In the same range there is also an adjustable table mirror, the function of which is not specified. Then there are the perennial favorites—office accessories produced in black plastic with "designer" styling. Be bold with color, but beware of fads and fashions. If funds are limited, err on the side of items produced in cardboard and covered with pretty pastel-colored Kraft film. And beware of compact objects which house all of your bits and pieces in one single accessory. They are not always a wise choice.

Overhead view of a walnut desk designed by Iréna Rosinski and manufactured by Macé (above right). Pure, elegant forms inspired by older styles of furniture, have been used to create a configuration which would look as good in the home as it does in the office.

A selection of elegant accessories for the office made by the Cassegrain company, founded in 1919—a desk pad, a diary, a blotter and a red leather pencil-holder (right).

This office desk tidy designed by Jean-Pierre Vitrac for Edwood combines the sobriety of maple with the sensuality of rounded styling.

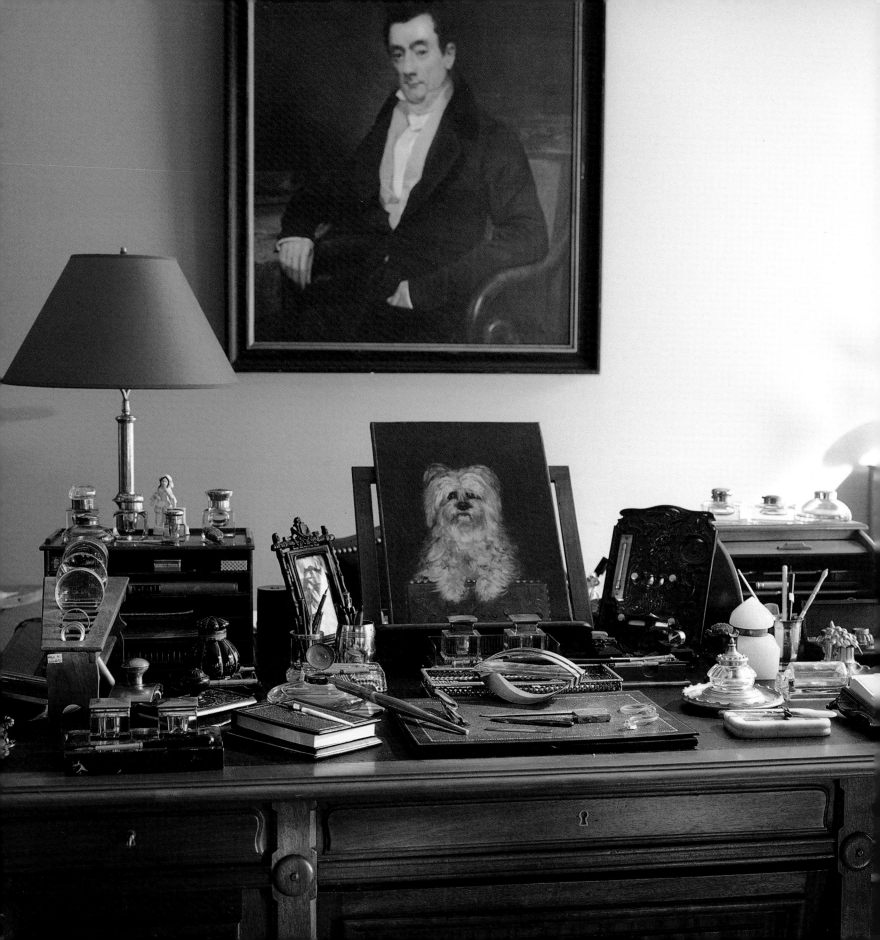

A selection of carefully chosen ornaments arranged casually on the corner of your desk enables you to control your image with greater precision. But you have to be rigorous—after all, the décor of an office is not only revealing of the work you do, but also of your personality. In short, "Be what you would seem to be," as the Duchess told Alice in Wonderland.

Those who have been admitted to the office of Madame Gomez when she was head of the Waterman company have never forgotten the experience. The office was white from top to bottom and Madame Gomez always dressed in white from head to toe; the desk was entirely bare, except for a sliver of light shining on a fountain pen—a Waterman, of course. Not everybody has the possibility of creating such a setting, or the necessary imagination.

You should be careful about your choice of desk lamp as well. A Tizio lamp offers a small but distinctive touch of modernity. You could go further and choose a Kandido lamp by Porsche—a lamp which looks as if it is about to topple over even though it is perfectly stable—or, more daringly, a lamp created by the master of Italian design, Ettore Sottsass. Or why not have a group of André Caseneuve's luminous stones in one corner?

Another important detail is the clothes tree. For at least some of the year it is not concealed under the bulk of your overcoat. In place of the conventional metal or wooden clothes tree you might prefer something more original—and certainly more expensive—for example the pyramid creation in perforated mahogany with adjustable pegs, designed by Maurizio Duranti for Morphos. Or perhaps a clothes tree with pegs in the form of red and blue pencils, borrowed from your children's bedroom, which would certainly mark you out as a nonconformist! And for those who cannot abide this particular accessory, may we suggest a more discreet version: a simple vertical aluminum stand on a flat, round base, with little hooks.

Finally, the *sine qua non* of office life is your wastepaper bin. Whether lined with leather or made of perforated metal, shiny aluminum or molded plastic, designed by a major designer or bought in a supermarket, this small item is useful in its way. It puts the finishing touch to your décor, or destroys it. If it is overflowing, it signals to your visitor that you do a lot of work, for sure, but also that the cleaning service you use leaves something to be desired. If it remains obstinately empty, on the other hand, it may indicate a major preoccupation with avoiding waste and a highly developed ecological consciousness.

And do not go and spoil everything with your ashtray. In the

A flea market is a veritable Ali Baba's cave for lovers of pens, ink-wells, writing-cases, magnifying glasses, paper knives and antique writing implements. The treasures of the Parisian market stall "L'Homme de Plume" are displayed on a desk dating from 1900. Thanks to a retractable panel, the latter can be used as a face-to-face desk or a single-person desk.

Sir Terence Conran's old office in London is a harmonious combination of pale wood and white. An architect's table, a swivel chair with an openwork back, and a beech wastepaper bin designed by James Irvine face a wall covered with engravings showing different kinds of paintbrushes. The emphasis is on simplicity, as befits the image of the founder of Habitat and The Conran Shop.

beginning the ashtray was an item of furniture unto itself. It was solidly built and usually attached to a chrome stand. In 1958 it took the form of a cube (design by Enzo Mari), and in 1973 a round one made from black plastic and cast aluminum appeared (Enzo Mari again). It later abandoned its upright support and took up a position on a corner of the desk. At this point it was made of glass, or was a solid cone-shaped affair in stainless steel (Sylvain Dubuisson). Sophisticated devices were invented to dispose of ash and cigarette butts and to prevent odors. Finally the ashtray became colorful. Then a battle between smokers and nonsmokers developed, but a peace pipe has just come on to the market: a battery-powered ionizing ashtray. It uses negative ions to wipe out the positive ions created by pollution, enabling it to deal effectively with cigarette smoke. In some companies you still find ashtrays scattered around the offices, but they are so clean that you realize straight away that there is no question of your using them. After a career as a utilitarian object, the ashtray has turned into a decorative feature.

In their catalogues, office equipment manufacturers show you pictures of managerial offices that are virtually devoid of objects. Emptiness, as we shall see, is a common attribute of the executive office. At most there will be a desk pad and maybe an elegant desk diary with a pair of glasses lying to one side. Or a desk lamp, calculator, or a newspaper. The fashion at present is for the huge table which can serve both as a desk and as a meeting table, with a magnificent desk blotter to mark the place of the permanent occupant.

Office equipment manufacturers produce different types of desk for decision-taking managers and for executives. The former are empty of paperwork and the latter are cabled, incorporating the channels necessary for a computer, a Minitel and telephone cables. Whether wired or not, the present trend is for technology to be concealed, either on separate tables, or beneath the desk-top. The desks of lower management staff are less formal, with well-designed plastic file holders, a microcomputer, a phone and the few papers that they are working on at the time.

Finally, given that manufacturers think of everything, they also produce a range of color-coordinated accessories—desk sets—ranging from lamps to wastepaper bins. Some companies manufacture re-editions of magnificent objects designed by architects and designers from the past. But there is no escaping it, these accessories inevitably evoke the atmosphere of the office.

And why not transform ornaments and furniture even further, by keeping your paper clips in an Alessi snail plate, for example? You could use a sugar bowl for your pencils, or a series of glasses illustrated by designers, like the green frosted crystal whiskey glasses produced for Daum by Hilton McConnico, with their image of a cactus picked out in gold. Use a bit of imagination, for heaven's sake!

Imagination is conspicuously absent from many offices. Sadly you rarely find Mickey Mouse chairs or a "seduction" seat like the one designed by Masanori Umeda, with its evocation of a petaled rose. You rarely see a lectern, which would enable you to work standing up from time to time, or plant holders in the form of sculptures to brighten the place up a bit. Some nineteenth-century furniture was more versatile: the same item enabled you to work either standing or sitting, as the fancy took you.

However, one household object has become a familiar accessory in every office: the bottle of mineral water. It is to be found at all levels of the hierarchy, including in ministerial offices (the latter usually also have a bottle of whiskey, although this is generally kept in a cupboard). The office would be a far more interesting place if more objects were imported from the kitchen or the living room.

TASTES AND COLORS

It is easy to produce a catalogue of today's dominant tendencies in office design. The "design" tendency can be found both in modern office blocks and in older buildings. The typical features of this trend are: modern furniture in black and metal or glass and metal; abstract paintings on the walls; electronic gadgets in every corner; a video; a computer, usually switched on; a variety of different screens; light gray walls and charcoal gray carpets; chunky staplers or perforators, which are quite likely to be gold- or silver-plated. Instead of curtains there are aluminum blinds. There is tungsten-halogen lighting and a hypermodern lounge corner with furniture designed by architects or designers. What we have here is a fairly aggressive way of proclaiming one's modernity, of announcing not only that one lives in the spirit of one's times, but even that one is ahead of them. It also suggests that the occupant is sometimes prepared to deny the importance of human relations in the interest of a striking but icy décor which affords him or her protection. However, design is not a magic wand which resolves through aesthetics the fundamental problems of organization and communication within a company.

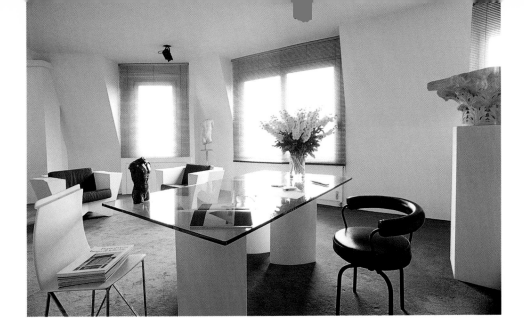

Inside the Parisian apartment of the interior designer Serge Pons, the light seems to change according to the color of the sky. The simplicity and austerity of the décor highlights a fine collection of antique ornaments, including a terra-cotta Gorgon and a fragment of a capital. Despite the rigorous approach, this is a very personal room.

André Rousselet's office at the G7 taxi company, designed by Jean-Michel Wilmotte. This spartan, almost Zen interior looks more like an art gallery than a businessperson's office. The furniture in ash and black metal, also designed by Wilmotte, contrasts with the white of the floor and walls. At the end of the room stand two Charles Eames chairs.

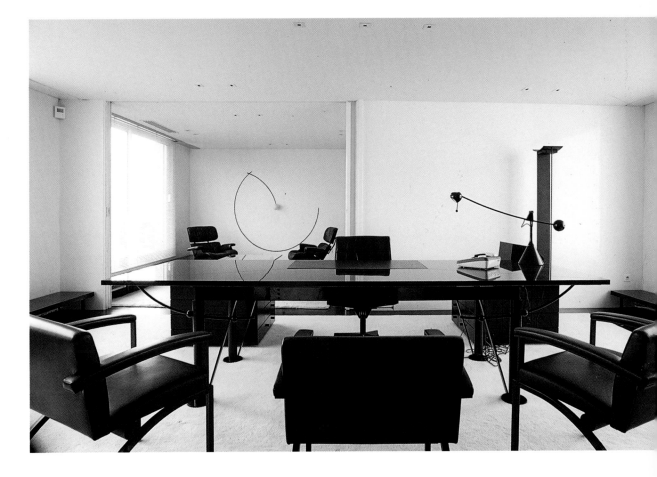

Vitra's Metropol office system. In the words of its designer, Mario Bellini, "This is a kind of archipelago, in which the table is the main island. Around this island you have a round table where people can sit, side tables for accessories, small stands for computers and telephones, and mobile units on casters. It's a kind of micro-metropolis. Hence its name."

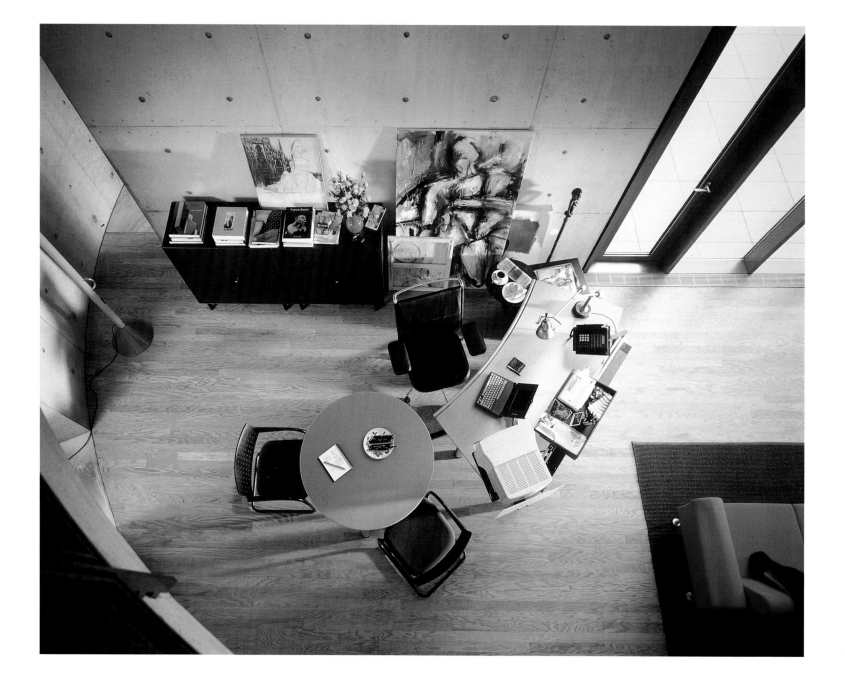

The "trendy" tendency is much rarer: modern black furniture; a lounge corner with a comfortable sofa and multicolored silk cushions, Nepalese wall hangings and abstract lithographs on the walls; a small round meeting table near the window, on which lies an expensive book, opened to show a magnificent Japanese print; background music which is a little out of place; and a large dog. All that is missing is a boldly modern fireplace with a blazing fire, even in the middle of August. The accessories in this office are multifarious, sometimes brought in from the home, and are also resolutely "trendy"—for example, a Kraft paper wastepaper bin, vaguely oriental in inspiration; a collection of valuable lacquered boxes for paper clips and staples; or a wicker linen basket for the storage of files and folders.

The "cocoon" tendency is infinitely more difficult to create in modern work spaces, but for all that it is making its presence felt in interiors that are otherwise austere and ordinary. You find walls cluttered with posters and every available flat surface covered with a profusion of ornaments and knickknacks. For example, devotees of the automobile might pin up photos and display scale models on their desks.

A more classic approach is to have pictures of mountain streams, a collection of lovingly cared for plants and, nearby, a mini-kitchen, with a coffee machine, a teapot, and cups and saucers, all carefully piled up as if on the edge of a sink—not forgetting a couple of tins for storing the sugar and biscuits. In addition there are some children's drawings, and photographs of sons, daughters, nephews and nieces. The desk is cluttered and there is a crocheted cushion on the seat, a jacket slung nonchalantly across the back of a chair, an item of clothing sitting on a case in the corner because somebody forgot to take it to the cleaner's—in short it is an office that looks "lived in."

The "collector" tendency is easy to spot. The classic "collector" pins up every holiday postcard they have ever received. Sentimentalists put up photos of memorable moments in the life of the company: the opening of the new offices, a colleague's retirement, last year's office outing and the Christmas tree. The more conventional collect files, some of which are littered with Post-its, amassing them in large stacks. This wall of files and folders says, "Can't you see that I'm pushed to the limit. I'm the only one who does any work round here." There are also those who cannot bring themselves to file anything or throw anything away. In a sense they function as "archives" for the rest of the company. You can always rely on them for finding a mislaid document. Extreme collectors will even refuse to part with an old broken chair, or a broken computer.

But there are also the real collectors—those who accumulate all kinds of curious things. In a luxury version we have the hunting trophies belonging to the president of Axa, an impressive collection of gazelles, boars and other creatures which peer at you with a mocking air. In a more modest but equally sporting version there are those who collect trophies for fencing, judo or bowls. Finally we have the totally unexpected collections, such as that of American admiral William J. Crowe Jr., whose office is lined with shelves designed to hold not books or files, but more than 900 items of headgear—helmets, sombreros, Tyrolean hats, fezes, turbans, straw boaters, kepis, borsalinos and so on.

The office of Sophie Debure at the Club Méditerranée is also filled with extraordinary hats (some with turning roundabouts and cascading fruit), but also with painted silks, jewelry and costumes. Here, however, nothing is displayed merely for the sake of it. This is not so much a collection as an accumulation of objects relating to her work: she is in charge of design for the club's various locations and her office is a cross between a storehouse and an artist's studio. However, it still has its conventional corner, with a computer, a Minitel and a phone. To one side stands the visitor's chair, which is a tall draftsman's stool. The room is like an original and unstuffy window display which shows everything that it is possible to do during a week at the club!

There is also another tendency—the "I'm not here" or the "I'm just passing through" tendency, which can be found in any office, because, by definition, the locale is of no importance. There is no sign of anybody's presence, not a scrap of paper, not the smallest object, just the bare minimum of basic furnishings. It is an empty, monk-like environment which can be taken over and used by anybody.

"IS YOUR OFFICE WORKING?"

Whatever the various trends and choices, the ultimate aim is to create a place that encourages work. There is a marvelous expression for this: "Is your office working?" Does your office make life easy for you, or does it prevent you from working? Do you feel comfortable in it? What effect does it have on your morale? If you had to write a short advertisement for it, what would you say? "Nice office, south-facing, magnificent view, beams, fireplace, fully equipped." Or perhaps: "Hole in the wall, north-facing, needs redecorating?"

Do you work in a sea of noise or in an oppressive silence? Is your working environment tidy or untidy? Too much disorder can be harmful, but too much order can be just as bad. Disorder is sometimes synonymous with activity and dynamism, but it soon tires you and may lead to a drop in energy levels. According to a recent study, every person in an office spends at least forty minutes per day either looking for or filing documents. Order sometimes gives the impression of deadly boredom and a lack of imagination, even if it guarantees greater efficiency. Office cupboards tend to be functional, austere and cold. We are still waiting for a middle way: the invention of attractive, colorful shelving units and the creation of a number of smaller rooms here and there, reserved exclusively for filing—to relieve congestion in the office.

Do you enjoy natural light or do you have to use artificial light? Are you near a window? A window is an important factor in your well-being, as is lighting and the view that you have. In short, you need air.

Two views of the Lloyd's building in London, completed in 1986 and designed by Richard Rogers. A huge glass vault caps the one-hundred-meter-high central atrium. The design reverses the usual core arrangement for office buildings, moving elevators, fire stairs and lavatories to the outside. When the project was finished the architect decided that the blue cranes that were used during construction should be retained. The building has attracted many visitors since it was opened.

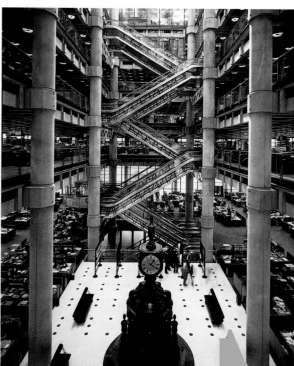

It is a gentle reminder of one of the four elements. And while we're at it, let's take a look at the other three. Is water present anywhere in your office? Why not instal a small ornamental pool in the lobby, or a fountain or a waterfall in reception, whose murmurings put you in mind of a stream somewhere, or, more prosaically, a simple drinking fountain somewhere down the corridor?

Fire, for its part, is generally symbolized by color and general tone. Finally, earth. Do you have a tatty little plant on your desk and a bunch of dusty plastic flowers in the corridor? Or do you have a luxurious jungle in the lobby? In a private residence in Montreal, the house has been extended by means of a huge glass conservatory. It houses trees, vegetation, even lianas, as well as parrots and multicolored birds, all of which serve to make the rigors of winter more bearable. Such an approach would not be viable for most companies, but many do try to introduce a bit of nature into their premises. For example, the Corporate company makes sure that every Monday it distributes small bunches of white, purple and green flowers (their "house colors") around the firm's communal spaces, for the delectation of staff and public alike. More traditional companies reserve bunches of flowers for executive offices, or for the directors' dining room. So hierarchy is also expressed in the petals of lilies and roses.

It appears that a number of Japanese enterprises have called in the services of a cosmetics company to stimulate their employees through smell—in order, perhaps, to "lead them by the nose?" In the morning you get a hint of lemon; at midday, more of a floral scent; at around three in the afternoon, forest scents; and by the end of the day, the sweet smell of mint or lavender. This apparently stimulates the workers. Is there a particular smell in your office? A smell of people at work, maybe? And does it need to be masked?

THE SPIRIT OF THE PLACE

The Chinese have always paid careful attention to the harmonious forces at work in any particular location and they take account of these before embarking on even the smallest construction project. The system of Feng-Shui combines elements of the three principal religions—Taoism, Buddhism and Confucianism—and attaches great importance to the four elements, to the direction in which a building faces and to astrological readings. This is not exactly a religion, but more a combination of

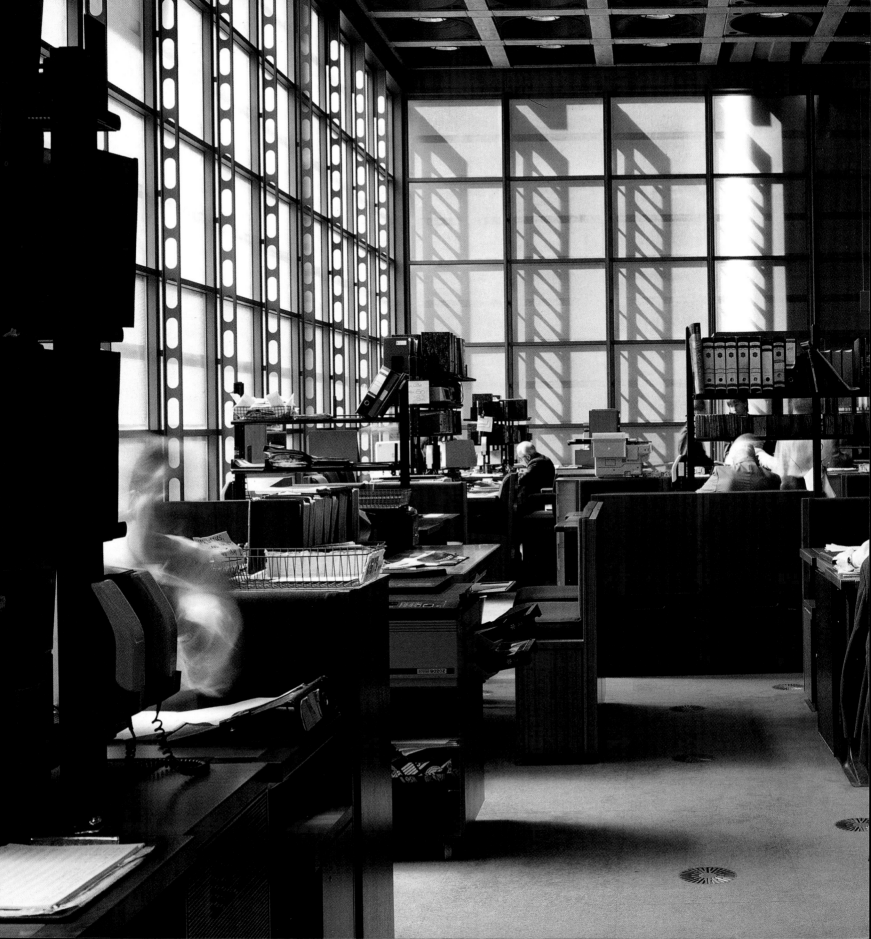

practices, a model, a philosophy designed to help in finding harmonious locations for men and their buildings within the cosmic whole. Simply looking at a site is not sufficient to identify a good location. You need the help of a special compass and the services of an expert.

In Europe, traditionally, even the smallest of farms was generally built on a south-facing slope, sheltered from the prevailing winds and out of the way of floods and avalanches. But, unlike the Chinese, we have lost these skills of location-finding.

Feng-Shui philosophy influenced the design of the Hong Kong and Shanghai Bank in Hong Kong, the most expensive and technologically advanced bank building to be built in recent years. It was designed by Norman Foster Associates and features hanging gardens, spectacular views and impressive escalators (the aim of which is to make communication as easy as possible). A master in the philosophy of Feng-Shui advised on the position of the escalators, for example. The initial X-shaped design was contrary to Feng-Shui principles, so it was modified. Bamboo was planted in parts of the building which were not "good." Feng-Shui is, in some senses, an art of management. Western firms are beginning to take an interest in it—and not only firms which employ Chinese personnel. The management consultancy MacKinsey also took the advice of a Feng-Shui master for the construction of its Hong Kong branch, and he was responsible for deciding the location of the entrance, the orientation of the offices and the décor for the foyer.

For the Chinese, the location and orientation of the president's office are fundamental. Its dominant position is an affirmation of his power. In the view of the Chinese, power generally emanates from the corner opposite the entrance. The desk should be placed at an angle to the door and facing it. If such an arrangement is impossible, a mirror placed next to you will enable you to "see" the door. Corridors are to be avoided as far as possible and glass partitions are only to be used with discretion. The interior décor may also take account of Feng-Shui. Thus, for example, a picture in a manager's office depicting mountains and water symbolizes power and prosperity, while a glass paperweight and some plants provide antidotes to bad influences. Some firms go even further and determine the ideal positioning of each employee on the basis of their (Chinese) astrological sign, name and date of birth.

The office of the manager of a lorry factory in Shanghai, photographed by Marc Riboud in 1965. The simple décor is dominated by the sayings of Mao Zedong on the wall: "A stubborn and combative spirit," "A burning class consciousness," "A rigorous scientific attitude."

The Hong Kong and Shanghai Bank in Hong Kong, designed by Norman Foster Associates and completed in 1985, is the most expensive building in the world (facing page). It is a twentieth-century Eiffel Tower, where 20,000 people work. Using the ancestral principles of Feng-Shui the atrium at the heart of the building contains hanging gardens and escalators.

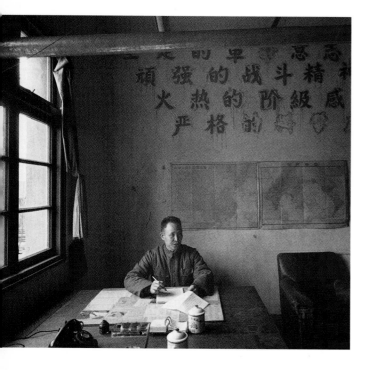

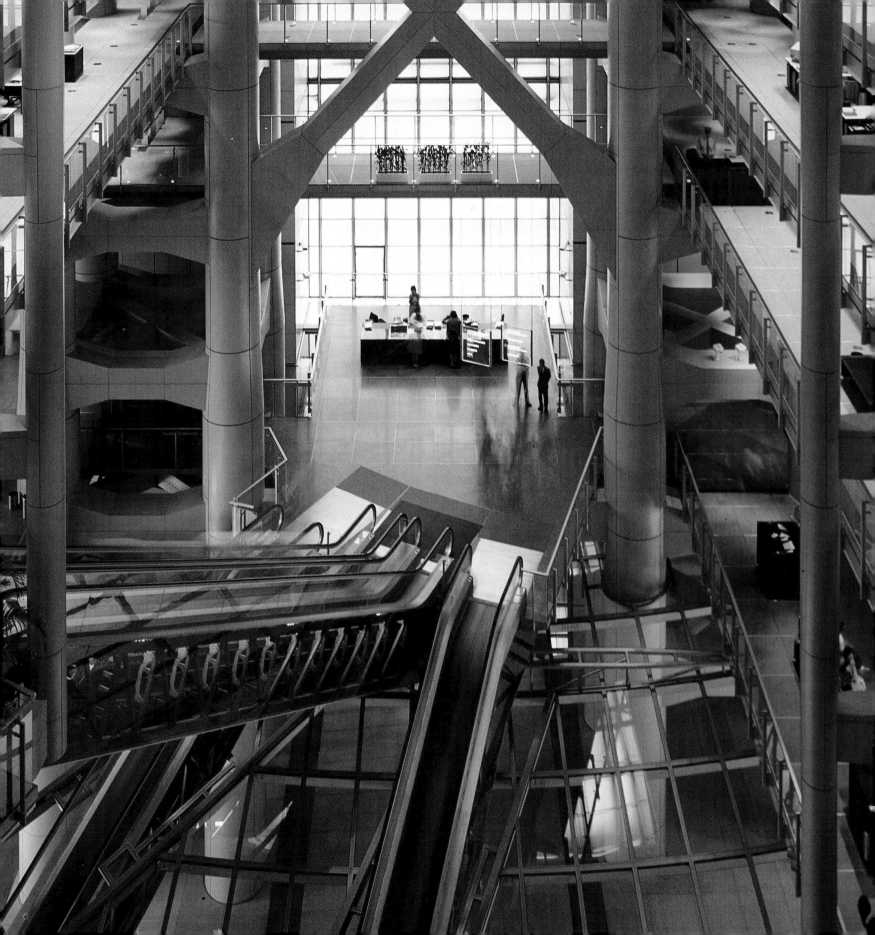

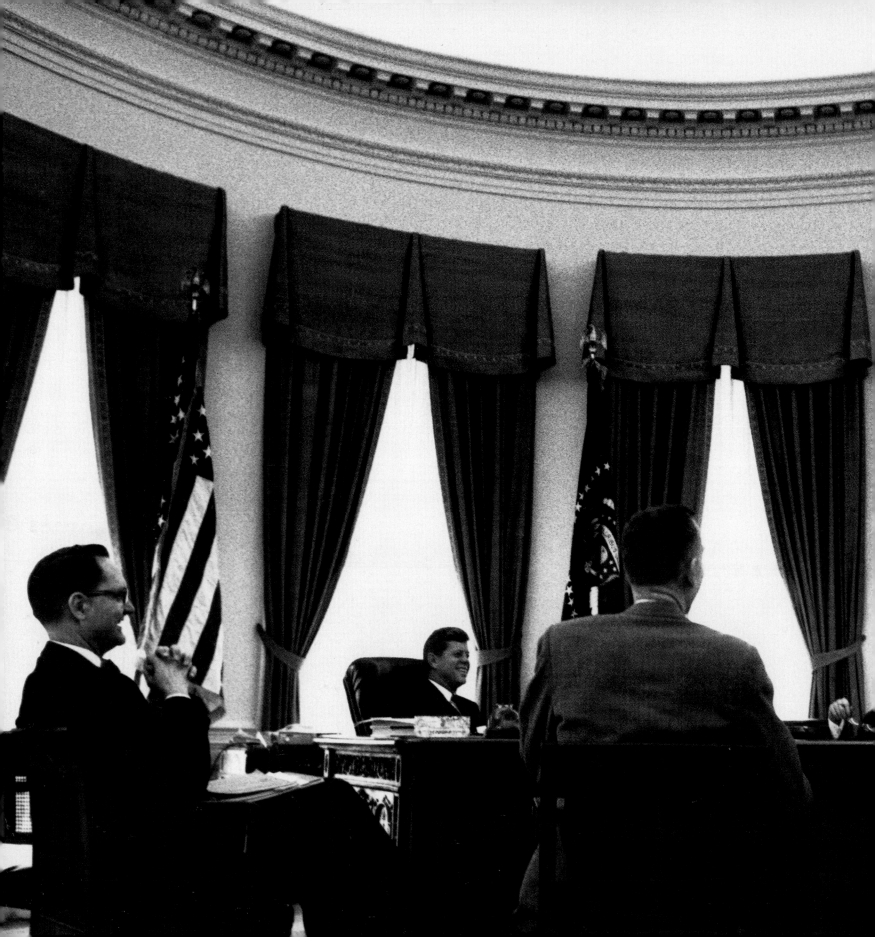

Power
offices

The offices of
world statesmen
and presidents of
major corporations
demonstrate the
choice to be made
between tradition
and modernity.

John F. Kennedy, the young and newly elected president of the United States, presiding over a meeting in the famous oval office of the White House in 1961 (previous double page). Among those present is the German foreign minister, Herr von Brentano. The atmosphere is relaxed and friendly.

The British Foreign Office, designed in 1866 by the architect George Gilbert Scott (facing page). The customary grandeur of ministerial offices is here softened by armchairs and a red leather Chesterfield sofa, which, unusually, has been placed backing on to the desk.

In 1962, John Kennedy Jr., aged 18 months, finds a novel way of exploring his father's desk. The office of an important person is rarely the place for family life. Here we have the exception that proves the rule.

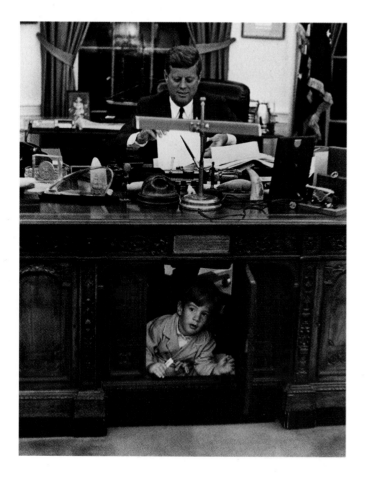

Senior politicians and corporate presidents lead somewhat similar lives and the interiors of their offices often have much in common. In the case of the politicians, however, the office remains while the occupants pass through, whereas company presidents have more scope for making their offices their own. In their amusing little *Guide du futur directeur général*, J.-L. Chiflet and M. Garagnoux give a list of useful pointers for recognizing the office of someone in a position of power: the absence of plastic plants; the absence on the walls of postcards, posters, post office calendars or metal planning charts with magnetic tags; the absence of lino flooring and desks with steel drawers; the absence of plastic blotters, Mickey Mouse telephones, office calculators with big rolls of paper and files piled on the floor or, worse still, on the desk.

In his novel *Les Employés*, Balzac described the office as follows: "Parquet flooring and fireplaces are the special privilege of office managers and heads of department, as are mahogany cupboards, desks and tables, red and green leather armchairs, sofas, silk curtains and other objects of administrative luxury." A century and a half later, this description still rings true.

A SYMBOLIC SPACE

Power is the location of desire, or so Laure Adler claimed in her book *Les Femmes politiques*: "The desire for recognition, from which nobody is entirely free." Writer and former minister, Françoise Giroud, added mischievously: "Even ministers dream of being useful to someone . . ." The role accorded to work space is crucial. This is what signifies "I'm the boss." And what does a boss do? He or she runs things. The office has to be a representation of authority. It gives the "appearance" of power and becomes one of its principal symbols. The interior designer Isabelle Hebey stresses the importance of this match between image and function. But not everything should be geared to the sole aim of impressing (intimidating?) one's visitors. The well-being of the office's occupant and the general atmosphere all need to be studied in detail. The integration of technology requires particular care and attention, for one's quality of office life depends to a large extent upon it.

Some people—rare, it is true—refuse from the outset to have an office that symbolizes their function. They make a point of letting everyone know it, sitting at a tiny desk facing the window in an unassuming room.

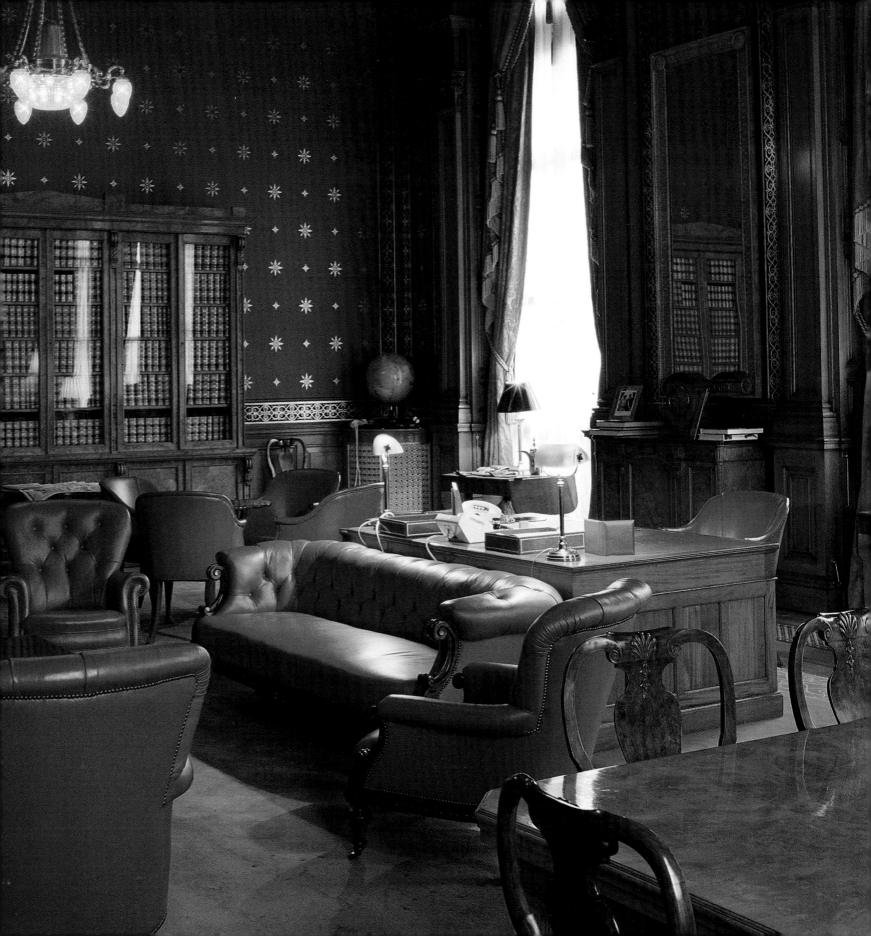

The desk of the Ministre des Affaires Étrangères at the Quai d'Orsay in Paris. The desk is a copy of the one that belonged to M. Vergennes, who was himself Ministère des Affaires Étrangères under Louis XVI. The original is in the Louvre. A classic power accessory—the gilded bronze inkstand created by Odiot—still stands on the desk, just as it did in Vergennes's day.

Twenty-five times a minister and eleven times Président du Conseil, Aristide Briand was an *habitué* of the offices in the corridors of power. Seated at a Louis XV desk, here he poses surrounded by his cabinet colleagues in 1915 (facing page). Before him stands the same inkstand which today graces the desk of the Ministre des Affaires Étrangères.

This is one way of saying: "My role is so obvious that there's no point in my trying to highlight my importance by giving myself a fancy office."

In France, power was for a long time symbolized by the Palais de Versailles. The first real government administration was set up under Louis XV in the golden splendor of this palace and in neighboring private mansions that had been requisitioned for the purpose. With the French Revolution, the new governing authorities were established in the Manège aux Tuileries and, later, in the Salle des Machines, where the Convention sat. Subsequently the Comité de Salut Public took over the ground floor of the Flore pavilion. In 1798, the Assemblée moved to the other side of the Seine, to the Palais Bourbon. The surrounding *hôtels particuliers*— private mansions—were requisitioned. This area is still the seat of power. The exception is the Palais de l'Élysée on the right bank, which was allocated to the president in 1848. Eventually, in 1882, the Palais des Tuileries, which had been partially burned by the Commune, was demolished. With it disappeared a symbol of French power.

It is no accident that successive governments were less interested in building than in taking over the offices of the previous authorities. The leaders of the French Revolution were no exception, taking over palaces and mansions. That is where power was born in France and that is where it has stayed. As a result of this curious history, the physical location of French government has become, by definition, the eighteenth-century *hôtel particulier*. These buildings, all constructed to the same basic model, were laid out around a courtyard. The street façade is treated in a formal way, while the garden façade is simpler.

Ministerial offices in France are always impressive rooms, on a par with the aristocratic opulence of the ancien régime. There is usually a grandiose entrance hall, with a marble-tiled floor and a monumental staircase. The banister is made of wrought iron with gilt inlays; the walls are clad in paneling and *trompe l'œil* imitation marble. An enormous chandelier hangs over the stairwell.

There is a dizzying succession of salons on both the garden side and the courtyard side. It seems like wasted space, totally unsuited to present-day work patterns. This emptiness contrasts with people's actual work spaces—a succession of tiny rooms tucked away behind hidden doors which have been transformed with difficulty into offices piled high with files.

As in the eighteenth century, it is still this emptiness, this apparently useless, nonfunctional space, which symbolizes power and its splendor. As a result the offices tend to be very similar in appearance.

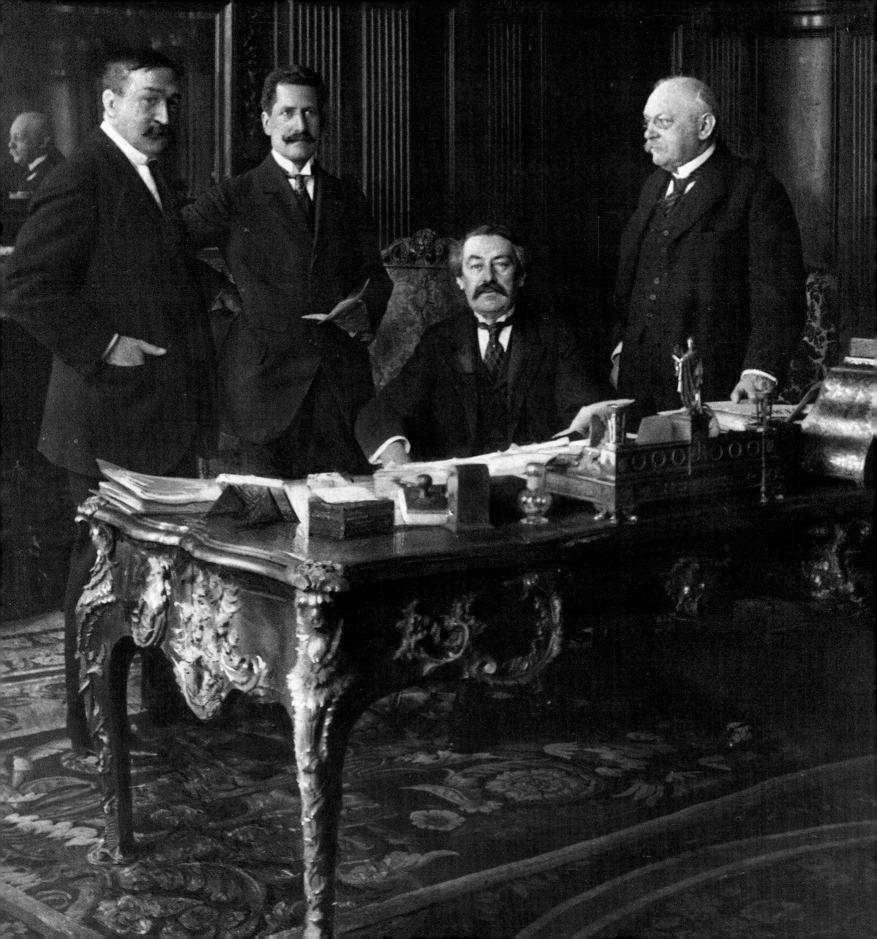

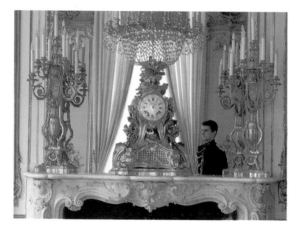

Built more or less in the same era, they obey the same canons, with abundant white and gilt woodwork, painted ceilings, overdoors, real or *trompe l'œil* marble, Corinthian columns, gilded moldings and crystal pendants. Gigantic chandeliers hang from high ceilings. On the mantelpiece stands a chunky clock surrounded by sleeping cherubs, out-of-proportion vases and voluptuous caryatids wrapped round candleholders. These rooms are used as spaces for receiving foreign delegations, or for giving interviews. People rarely stay in them for very long.

Let us go into the office, the place the French like to call the *cabinet de travail*. The word *cabinet* suggests something intimate and cosy, and slightly fusty—rather at odds with the majestic splendor of the place.

Offices like these, whether they are occupied by ministers, principal private secretaries or company presidents, all look fairly similar at first glance. They are cavernous rooms—empty space symbolizes status—with fortress-like desks which are kept completely clear, unencumbered by files. There are very few storage units—just a side table or two, a bookcase perhaps, and some delicate half-moon side-tables.

Candelabra in gilded bronze and Louis XV clocks are to be found on the mantelpieces of many ministerial offices in France, as here in the Salon des Portraits at the Palais de l'Élysée.

library (following double page). Two Louis XV work tables face each other in a pleasantly ad hoc arrangement unusual in the office of a government official.

The office of the principal private secretary of the Ministre de l'Industrie is the only room in this eighteenth-century *hôtel particulier* to have kept its original décor of white and gold rococo wood paneling, crystal chandeliers and mirrors (right).

In 1988, President François Mitterrand decided to refurnish his office at the Élysée. The president, on the advice of his wife, who had admired Pierre Paulin's furniture at an exhibition, asked the designer to create a set. His only instructions were to "bear in mind my function, and the nature of the building." Paulin designed an extremely simple table and some smaller items in amaranth (facing page).

The office of the general administrator of the Bibliothèque Nationale, designed by Henri Labrouste in 1854, is a library within a

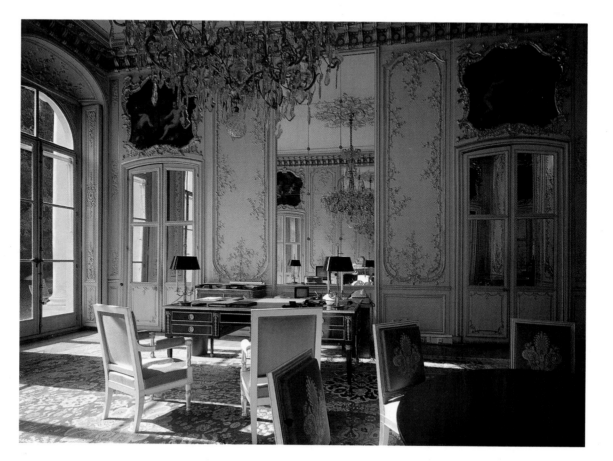

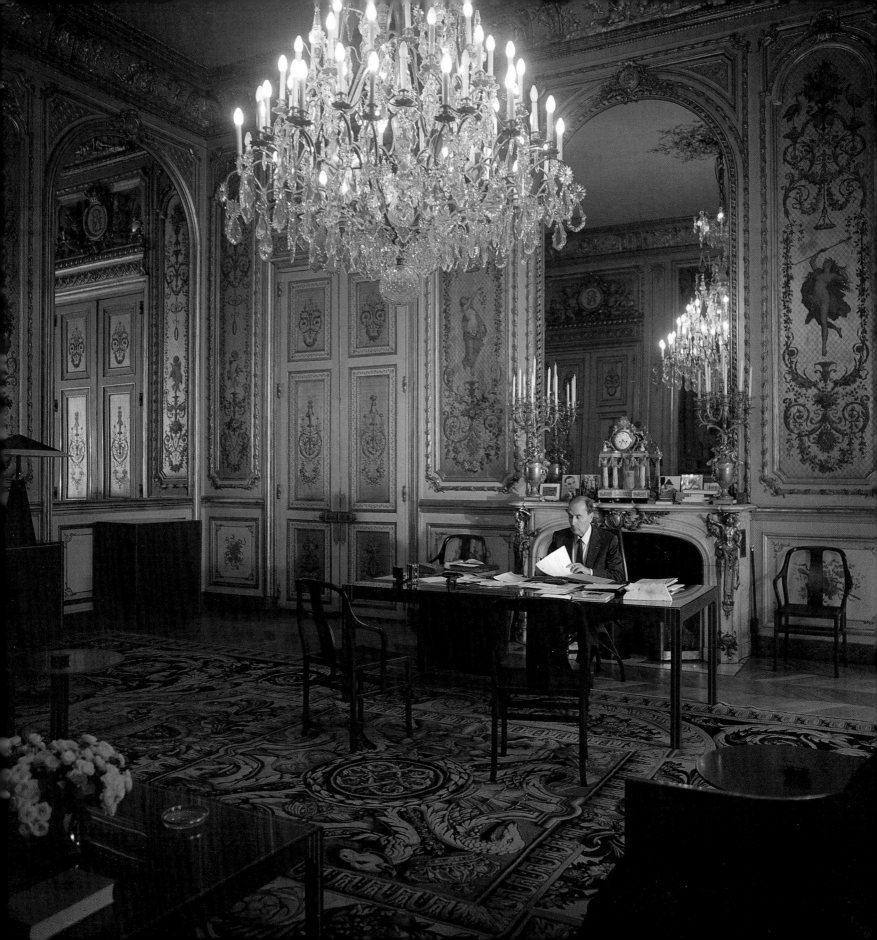

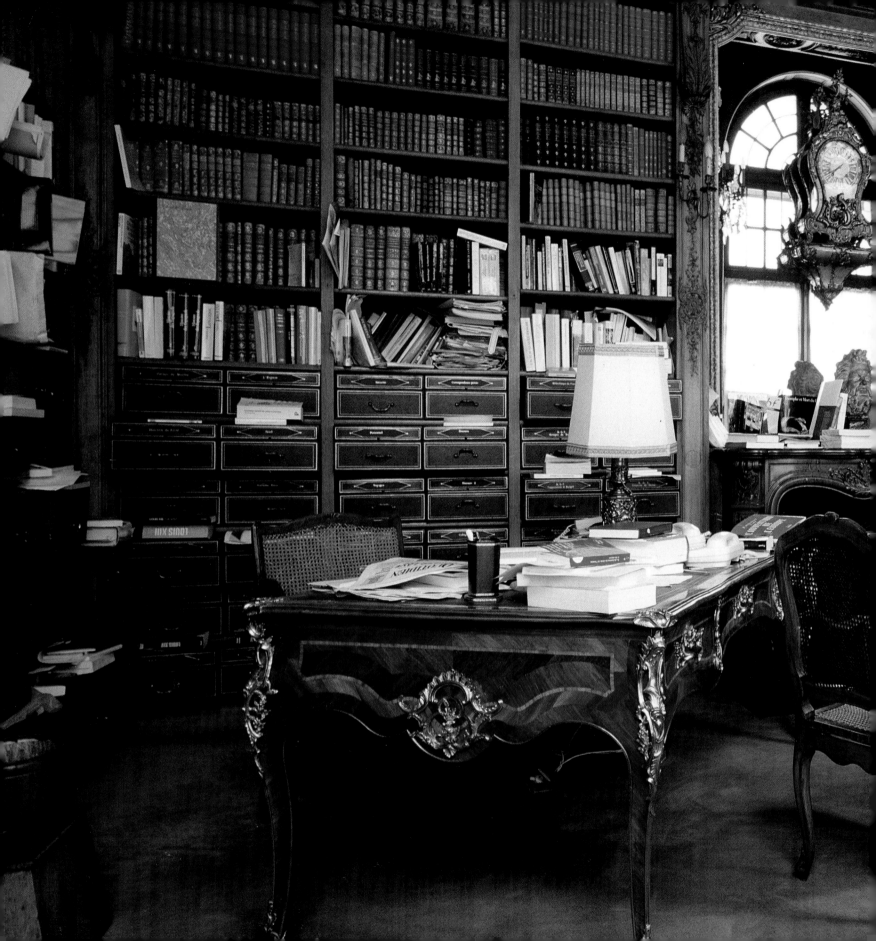

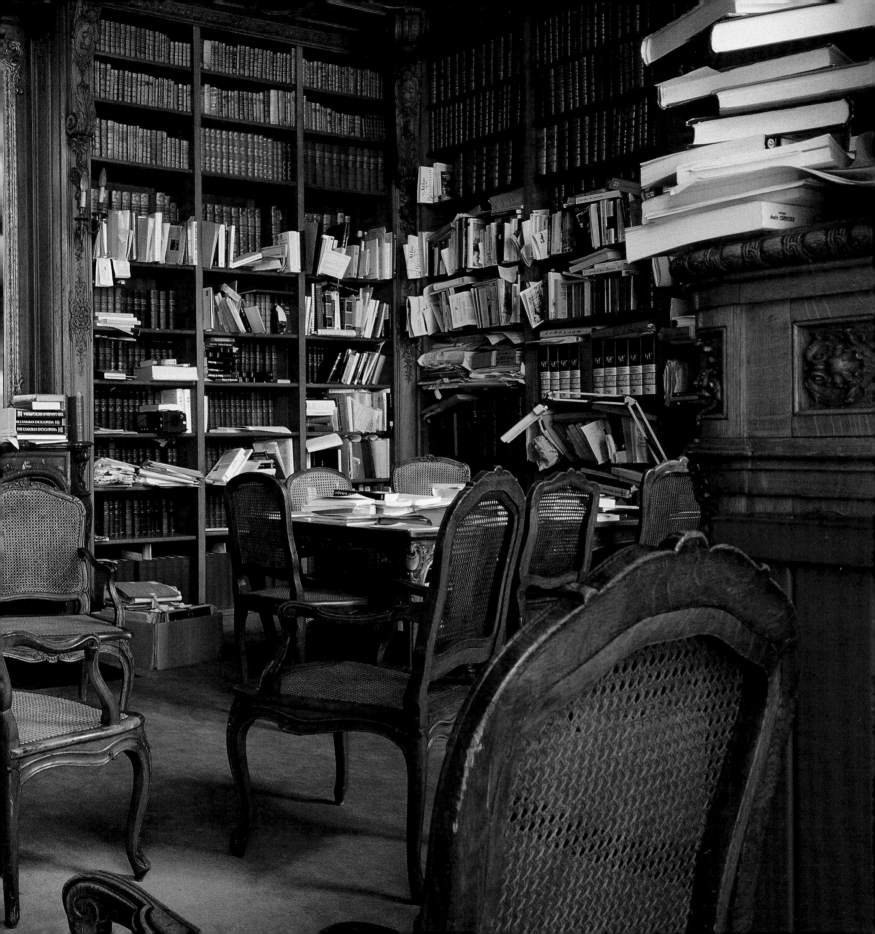

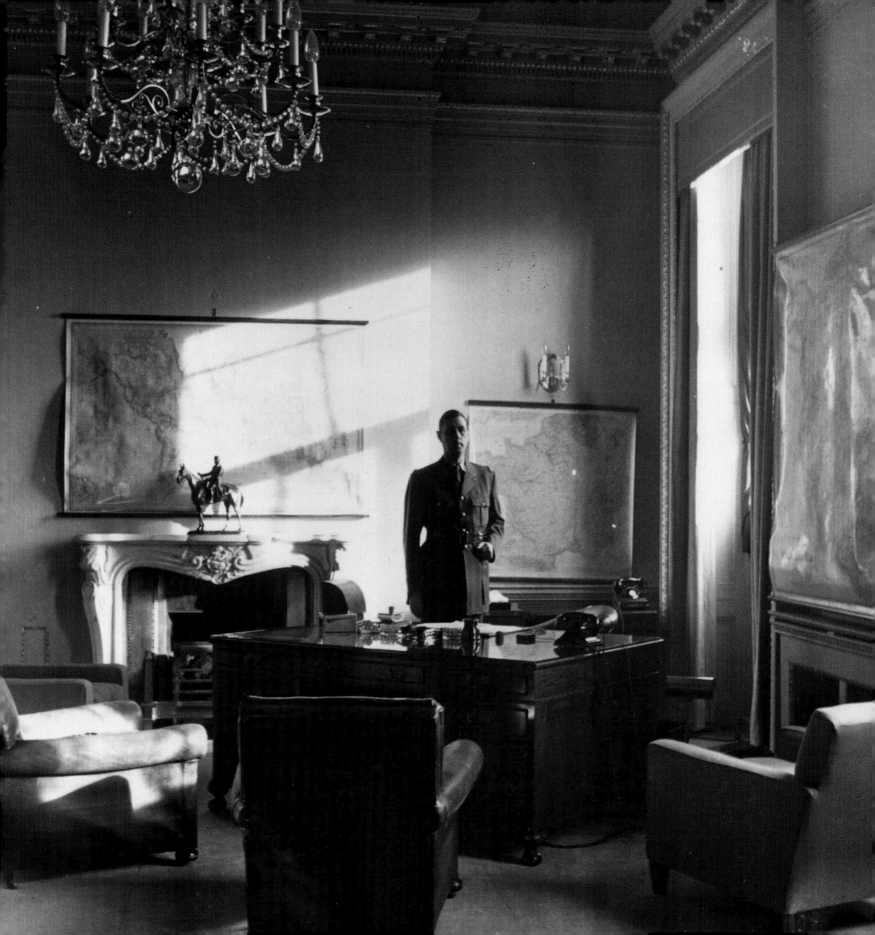

OFFICES OF THE STATE

In his *Mémoires de guerre*, General de Gaulle describes moving into his office at the Ministère de la Défense, in the Hôtel de Brienne, on the day Paris was liberated: "Immediately I was struck by the impression that nothing had changed within those hallowed walls . . . I entered the ministerial office that M. Paul Reynaud and myself had left, together, on the night of June 10, 1940. Not one piece of furniture, not one wall hanging, not one curtain had been moved . . . Nothing was missing except the State. It was my task to restore it. So I got down to work."

Are France's state offices unchanging? The chairs have changed, and the lighting too, but the chandeliers are still there, as is the desk lamp with its green shade and its gilt stand and three imitation candles. The wastepaper bin, however, has been banned.

The phone (or rather phones) still have dials. The intercom is a drab gray affair, which gives the minister immediate access, via three digits, to the exclusive brotherhood of members of the political fraternity, who are listed in a large hardback orange directory. "Good manners require that only the holders of numbers beginning with a two (fifty or so, including the members of the government) call those whose numbers begin with a four or a five . . . In France hierarchy clings to its rights," as Françoise Giroud put it in *La Comédie du pouvoir*.

The daily life of a minister in France is broadly speaking the same as that of the president of a major corporation. His daily activities are punctuated by the sound of attendants' footsteps on oak parquet or marble flooring. The rigidity of the location and its traditions can weigh heavily on its activities.

"It's so rigid, so inward-looking, that when new people arrive, even if they want to change things, they can't. Imagine a minister who decides one day that he's going to go into his ministry and change the way that everything is done. He declares that everything is going to be different and that from now on he no longer needs someone to bring him his towel. The machine is there, terribly powerful and organized, with people who have been on the inside for the last thirty years," wrote Françoise Giroud.

The timetable, protocol, custom . . . everything is laid down in the rule book. Everyone, from the humblest attendant to the highest official, knows their role and plays it perfectly, as if in a theater. However, here the actors can change, whereas the text remains unchanging, as does the setting.

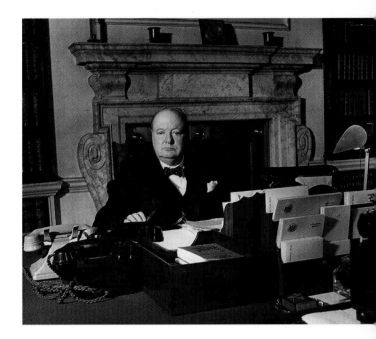

General de Gaulle posing stiffly in his London war office for Cecil Beaton. The walls are hung with military maps (facing page).

Another portrait by Beaton, this time of Prime Minister Winston Churchill, in 1940 with his famous cigar (above).

The Ministère de la Défense in Paris contains a small private museum dedicated to the memory of General de Gaulle (below). The décor has remained unchanged since the time when de Gaulle occupied it as the head of the provisional government. The Louis XV desk was also used by Clemenceau.

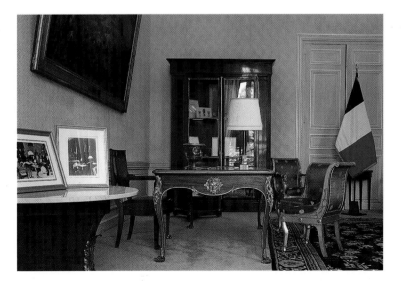

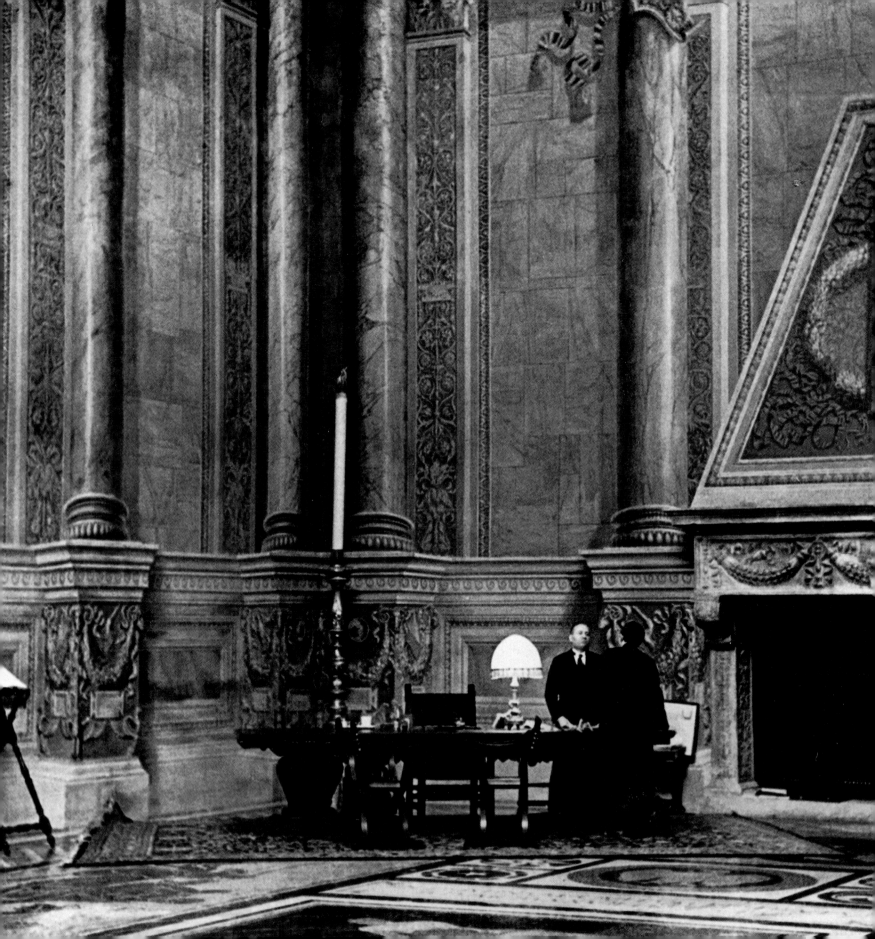

These kinds of magnificent government offices pose two particular problems: that of making a space one's own, and that of one's legitimacy. How does one set about appropriating a space that is so splendid? And how can one avoid feeling crushed by the seven-meter-high ceiling and the responsibilities that come with it?

It is essential that you find ways of signaling to your visitors, who may be in a state of shock at the size of your office, that this is your chosen workplace. It represents your function, of course, but it is also "you."

You would not have the nerve to bang holes in the magnificent eighteenth-century wooden paneling in order to hang up a favorite painting. It would even be hard to stick up a poster with Scotch tape. Fortunately, such offices are well-equipped with console tables, side tables and radiators carefully boxed in wood, so your paintings and your photos in their charming gilt frames can be displayed on those. When Michel Rocard was prime minister, there was in his office a slightly anachronistic photo of a glider amid the sculpted paneling and Fragonard fruits. It sat on a sumptuous Louis XV sideboard, next to a chessboard and a bottle of mineral water (the bottle of water is a symbol of office work at all levels of the hierarchy). For Michel Rocard, a glider enthusiast, was this perhaps a way of indicating that as well as being prime minister he was also a man capable of passion?

Françoise Giroud inquired what it is that makes ministers happy: the inflation of the ego. "The ego swells, spreads, becomes pompous, begins to swagger" in this environment, with all the services that go with it. The more the physical space of government is empty and difficult to appropriate, the more the ego has to expand to fill it. It may be that the minister will come to identify a little too closely with this physical space of which he is only the temporary occupant. "One minister went so far as to request that corridors be emptied as he went through on his way out of the ministry, in the same way that cars are removed from the route of processions."

This swelling of the ego is obviously not exclusive to ministers; it affects people in all spheres of professional life. However, ministers are more markedly prisoners of their environment and their function. The memoirs of ministers who find themselves out of government after an electoral defeat or a ministerial reshuffle are eloquent on this subject. It is never easy to return to normal life after you have known the heady delights of power. The fact of being an ordinary mortal again also involves a change of location: instead of the golden splendors of power, you have a modest office lent by a friend to help you out..

Over-inflated grandeur, as befitted the Duce. Benito Mussolini's office evoked the spirit of ancient Rome, with columns and marble (facing page). Although his desk was large, it still looked lost next to the huge mantelpiece.

The Great Dictator, Charlie Chaplin's first talking picture, came out in the United States in October 1940. The adventures of an amnesiac barber and the dictator Adenoid Hynkel—both played by Chaplin—were banned in France until 1945.

For his 1927 movie *Metropolis*, Fritz Lang created an icy, futuristic office décor (below).

CORPORATE PRESIDENTS

The presidents of classic corporations have far more freedom in the question of whether their office décor should reflect the personality of its occupant or that of the company.

There are two underlying philosophies, which extend well beyond the simple question of office décor. The first is based on the need to assert one's existence, becoming an ambassador for oneself and turning one's office into a showcase that symbolizes the wealth and magnificence of this rather special company directed by a master of management. This may be achieved with the aid of veneers in precious woods, expensive furniture, delicate paneling and thick carpets. The second philosophy is to consider oneself at the service of the company and to stamp one's workplace, which may or may not be a "design interior," with a certain austerity by creating for oneself a workplace that is functional and sober. The office of Gérard Toulemonde-Bochard, president of a publishing company specializing in books about carpets and hangings, shows immediately what business is going on, with a large bookcase (in oak, like the walls and furniture) which displays the firm's products.

A new president immediately carves out a place for himself. He takes possession of his office. Often he is in a hurry to redesign it, to leave his mark on it. Speed is of the essence. This is his way of symbolically taking possession of the company and showing that he has the power to take decisions. But he has to play his cards close to his chest. Depending on the history and culture of the company, excessive expenditure would either be looked on favorably or would be seen as a provocation. So, depending on circumstances, he will either call in an interior designer or simply seek advice from his wife (or husband if the president is a woman).

But what do presidents actually do? Anne Lauvergeon and Jean-Luc Delpeuch set off bravely on their trail and were able to offer a few helpful indications. A president is a rather special animal, endowed with considerable powers of physical endurance. His days begin before eight o'clock and finish around midnight.

People's general view of senior civil servants and company bosses is that they are gluttons for work. When they are not traveling, they are at their desks. They do not spend long there—half their time at most—partly because they spend most of their time in meetings. This is a person who, despite being interrupted by phone calls and having colleagues thrusting problem files at him, still manages to maintain his train of thought. That is the sign of the true executive! Indeed, his

An executive stretches, cat-like, during a pause in work. Surrounded by books and papers, he is clearly a busy man who spends every minute of his day battling against the invasion of files and paperwork.

William Powell, in Mervyn Le Roy's 1932 movie *High Pressure*, epitomizes the cold, haughty corporate president (facing page). With his sober, double-breasted suit, brilliantined hair and big cigar, he is an American-style caricature of "the boss."

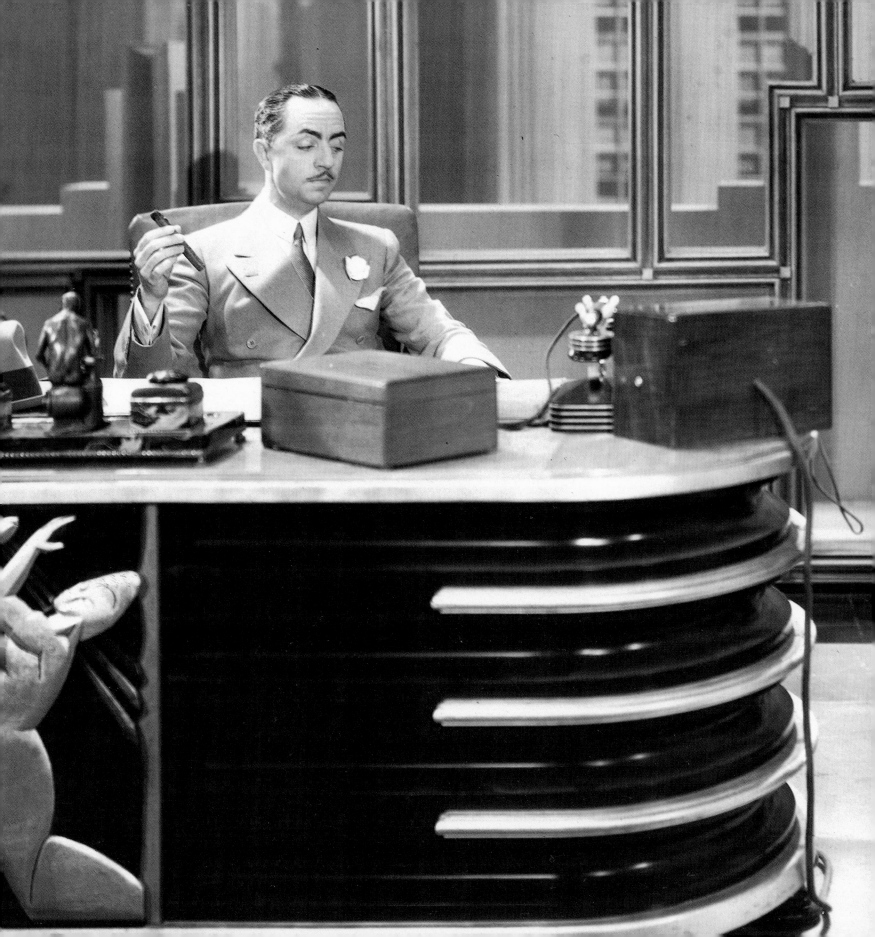

principal function is to be available. He is the ambassador for his company, and, as in the case of ministers, ceremonial duties take up a lot of his time. He has to receive visitors. Hence the care taken with his workplace. The president always officiates facing his visitors. His cult objects are a desk blotter, a desk diary and a fountain pen. Sometimes he also has an elegant signature book and a handsome in-box. Above all, he has a phone. As the journalist Pierre Voisin put it: "Calling New York, checking the Dow Jones, dictating the mail, making a note of an appointment . . . smoking a cigar. These are the liturgical moments in the celebration of tertiary-sector work." A slight caricature, perhaps.

The reappearance in recent years of leather blotters integrated into desk-tops reminds the president that the desk is intended, above all, as a place for writing. However, studies show that never have presidents written so little! This activity takes up a bare 2 percent of their time. They prefer the lounge corner or the conference table. They have between fifteen and fifty phone conversations per day: their telephones have become virtual extensions of their bodies.

Time for the president, like the minister, is fragmented and broken. He rarely enjoys extended periods during which he can think, plan ahead and decide. The place where he spends his time, on the other hand, is ample, immense and unchanging.

A scene from King Vidor's 1949 movie *The Fountainhead*, with Gary Cooper in the (romanticized) role of Frank Lloyd Wright. The movie traced the trials of a creative genius faced with the neo-classical tastes of his clients. Roark, a man of integrity, sticks determinedly to his ideas and succeeds in building the tallest skyscraper in New York. Here we see the businessman Wynand, played by Raymond Massey.

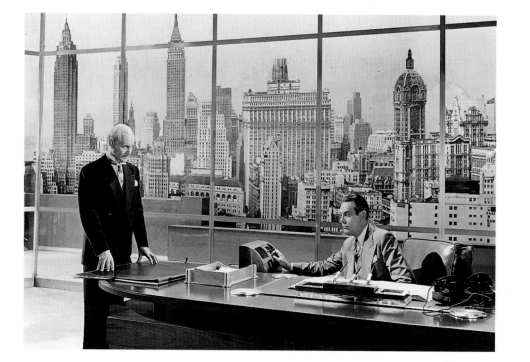

The classic image of the corporate president (facing page). He has one thing in common with his secretary—both of them spend nearly all their time on the phone. He has taken off his jacket. Facing him, as if ready for a confrontation, are two carefully positioned chairs, separated by a small pedestal table.

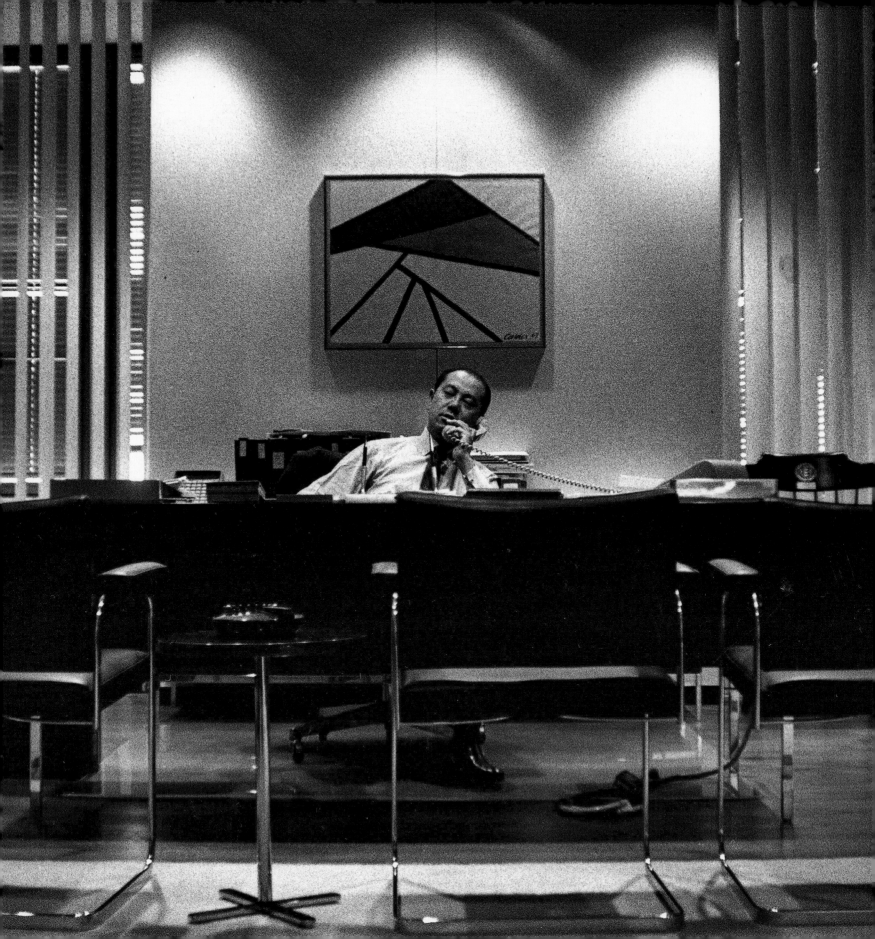

The office of the president of the Paul Le Blan textile company in Lille (above). The picture was painted in 1990 by Marie-Thérèse Le Vert, an artist who accepts commissions to paint your favorite room for you.

Barclays Bank at 160 Piccadilly, London. This austere bank manager's office has black paneling and partitions of frosted glass. In one corner stands a richly inlaid cabinet, whose motifs are echoed on the cane chairs.

The office of the Ministre de la Fonction Publique, near the Hôtel Matignon, the residence of the French prime minister, was decorated according to the design proposed by the architect Chalgrin in about 1770.

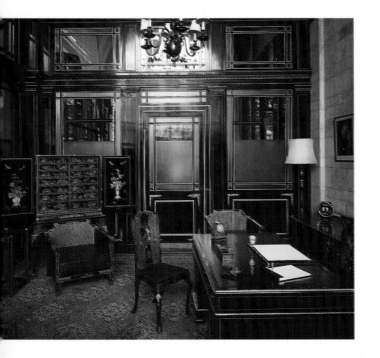

THE WEIGHT OF TRADITION

France has always been dogged by the war between the "ancients" and the "moderns." Already, in 1960, in an article in *Le Nouvel Observateur*, the journalist Mariella Righini observed: "For as long as the prime minister and his ministers are able to present themselves on television in a Louis XV setting, the public will accept living in a world of folklore. In the same way, for as long as magazines continue showing Dalida and J.-C. Brialy in their 'antique' environment, women are going to want to have a little Versailles in their own homes. The people who 'dare' to live in tune with their own times are a tiny minority in France—a handful of architects, perhaps, and students who have lived for two or three years in a contemporary setting in the Brazilian block or the Swiss block on the university campus. It is no easy matter to create a décor that is contemporary."

The state's policy of preserving existing monuments—established in the last century—and the ruling class's continuing taste for antique furniture do the rest.

In an old *hôtel particulier* or a Haussmannian apartment building, the classic risk-free solution is indeed to stick with antique furniture. Here ministers provide the most striking illustration of this, as do many banks.

The founder of the Crédit Lyonnais, Henri Germain, had an office at the headquarters in the Rhône valley in 1873 which consisted of a ministerial-style desk and matching chair, six chairs, a bookcase and a dark-colored wooden sofa, in a room that was paneled with oak and deal. On the black marble mantelpiece stood a mirror, a clock and two lamps. While it was austere, this office did not reflect so much the offices of presidents, but more the personality of this original man who was untrameled by the customs and fashions of his milieu.

Gradually, colors began to become lighter, the floor was covered with a thick patterned carpet and furniture was often neo-Louis XVI in style and made of mahogany. Then the Empire style came into fashion, thanks to its disciplined, virile image. Finally the Louis XVI style became all the rage with bankers—an infatuation which stemmed from their "aristocratic" aspirations, the influence of time, and the boundless admiration of the Empress Eugénie for Marie Antoinette.

But the problem is how to introduce technology into settings such as these. Fortunately, ministers do not usually have to spend their time on computers. However, some corporate presidents have them. In the words of one, "We need to keep up with the times." In the words of his

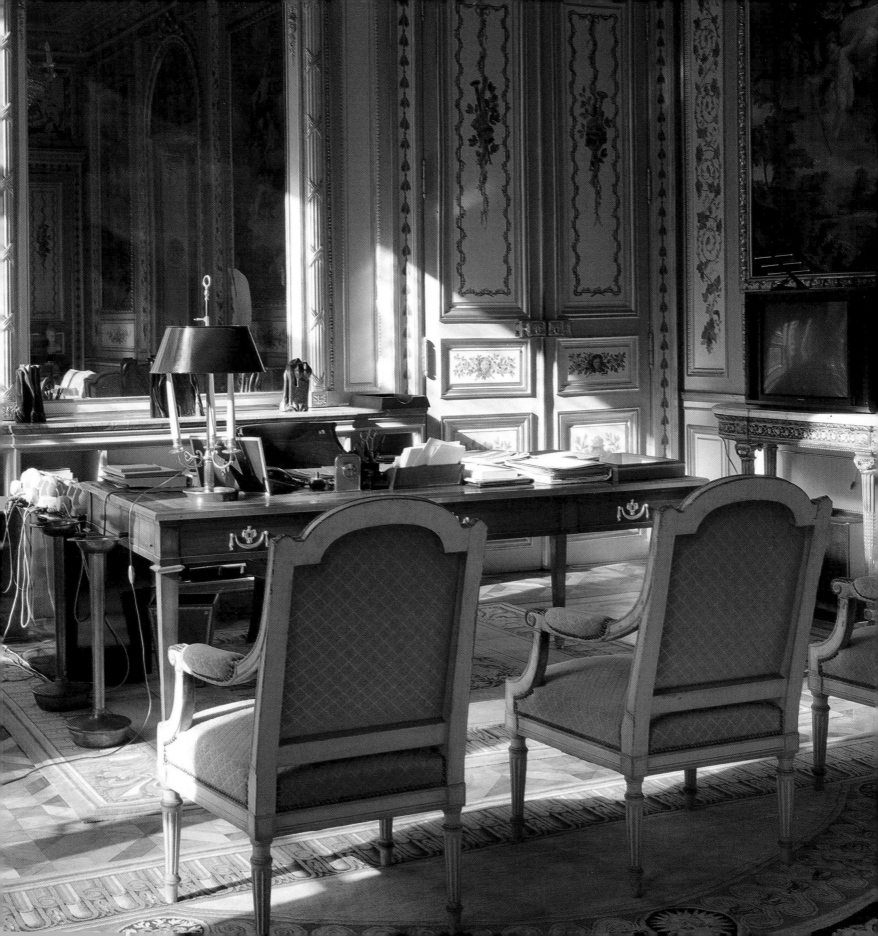

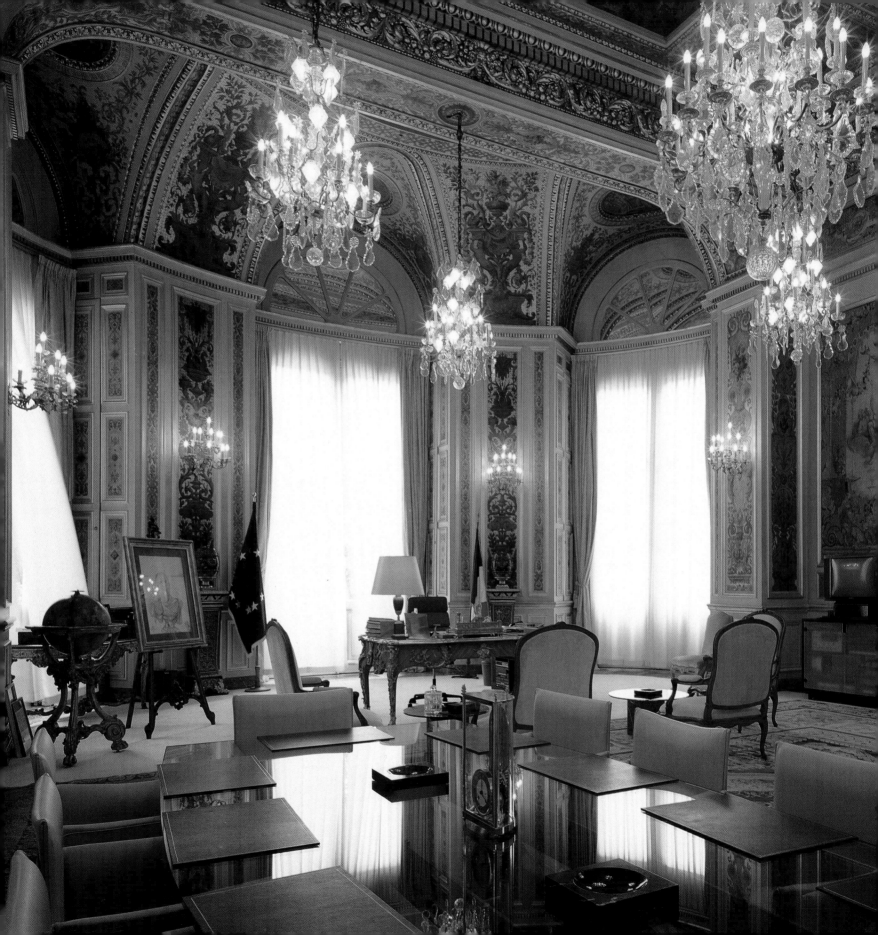

secretary: "He's bought a computer, but he never uses it." However, they almost all use televisions and video recorders, but unfortunately Louis XVI secretaires are too narrow for them. At the Ministère de la Fonction Publique in the Hôtel de Clermont, the television is placed on a fabulous half-moon console table made of gilded wood. At the Quai d'Orsay, it goes on a determinedly hi-tech stand, flanked by two delicate Louis XV chairs.

This "traditional" tendency is characterized by a quiet and—if the room is not too big—intimate atmosphere and by the antique furniture. Once again one has that impression of density and confinement which was typical of nineteenth-century offices. On the wall hang antiquated engravings in often indefinable colors, framed in gilded wood; the windows have net curtains, but also slightly old-fashioned velvet drapes; there are various items of furniture, books (with antique bindings, of course) in a glass-fronted bookcase and handsome desk accessories, with the inevitable leather blotter, a gold clock and a lamp in the classical style. These accessories may be in a variety of styles, such as traditional, romantic, Directory or Richelieu. The emphasis is always on leather. On the floor is a high-quality carpet, generally fairly worn. The gilded plasterwork has taken on the patina of time and there is a certain bourgeois legacy: the décor is opulent but in good taste. This is the style of office favored in France by ministers, presidents of large corporations founded over a century ago and heads of family concerns. The founder watches over his great-grandson from a gilt-framed portrait hanging on the wall. In ministries this role is played by a photograph of the French president, similarly framed.

What we have here is an image of tradition, of perennial values passed down from father to son. The company is one big family. Hence radical change is not one of their priorities.

A visit to the remaining offices in the building proves the point. The corporate president's secretary generally has furniture which was made recently but is very classical in style. In her office a note of modernity is provided by the computer. The president's colleagues have either antique furniture or modern furniture that is already a good thirty years old, rectilinear in form and possibly made of metal. The cupboards are solid and hardwearing, and also made of metal.

While French ministries and companies that are more than a hundred years old tend to opt for the "traditional" tendency, large-scale administrative offices and medium-size family concerns feel more at home with the "classic" tendency.

The office of the Ministre des Affaires Étrangères at the Quai d'Orsay, one of the few official buildings that was designed specifically for its function. When he first visited it, the Emperor Napoleon III, the first occupant of the Palais de l'Élysée, exclaimed: "My dear minister, you are better housed than I am!" The original chandeliers have been supplemented with a few discreet tungsten-halogen lamps. There is another deviation from tradition: a television set (facing page).

Harold Macmillan was Minister of Housing between 1951 and 1954 under Winston Churchill. In contrast to the sumptuous décor found in French ministerial offices, his office was simple and unostentatious. This photograph of him standing behind his desk was taken by Arnold Newman.

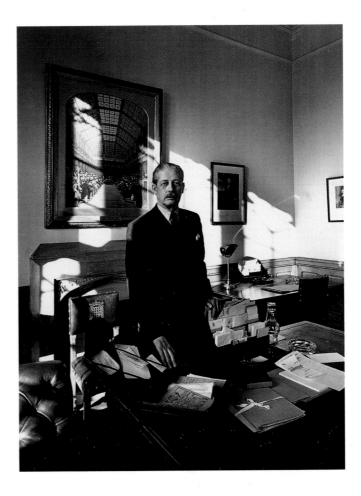

THE "CLASSIC" TENDENCY

A Parisian lawyer's office, designed by the architects Michel Seban and Élisabeth Douillet (facing page). The rounded top of the window sets the tone and is echoed by the curves of the walls and furniture. On either side of the desk stand Philippe Starck chairs. The rectilinear design of the ceiling lights provides a counterpoint to these curves.

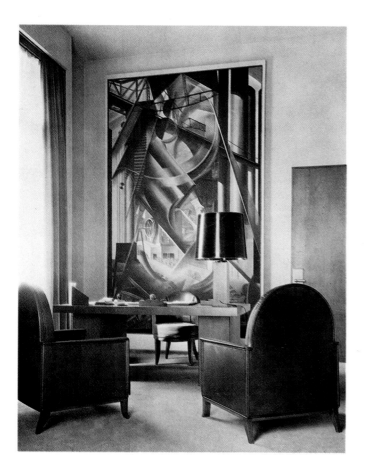

M. Haardt's office at Citroën in 1929, designed by Jacques-Émile Ruhlmann. The rectangular desk in limed oak, with its matching lamp, is dwarfed by a Cubist–Futurist tapestry. Two comfortable chairs for visitors soften the rather austere décor.

This kind of furniture is simple and functional, and bears the passing of the years gracefully. Today it is enjoying a comeback. It is hard to date it precisely. It is neither Louis XV nor Empire but of our century. Through the workings of fashion, which often honors the previous generation, it finds itself back in favor again. It is solid furniture, usually made of black or brown metal, with chairs made of leather and metal, and with predominantly square, sharp-edged lines. There are no heavy drapes here, just net curtains. There are few ornaments, just the fresh air of functionality.

On the walls hang an aerial photograph of the factory and a large picture, which can be rather overwhelming sometimes, as in the office of M. Haardt at Citroën, which was designed by Jacques-Émile Ruhlmann in 1929. The occupant had the good sense to hang his large tapestry behind him—unfortunately for his visitors. Next to it, paradoxically, the desk looked minute. The lamp, which is relatively tall, attempts to redress the balance. This layout is an example of the principles that Ruhlmann had already demonstrated at the Salon des Artistes Décorateurs in 1926. It consisted of a work table and a bookcase dominated by a huge wall fresco which left visitors speechless. Two comfortable "Éléphant" chairs and a cocktail cabinet helped to soften the overall effect.

This style highlights the values of work rather than power and tradition. The décor is austere and simple. There is no particular concern with decoration, but there is a certain presence nonetheless, thanks to the scale of the office and a few telling details: for example the padded leather doors.

Up until the 1930s, the typical industrialist's office was decorated in a style that was close to that of the nineteenth century. They were pleasant and attractive places, more like smoking rooms with the discreet atmosphere of a club or library. Deep, comfortable armchairs encouraged conversation and relaxation. The walls would display samples of the firm's products, along with framed diplomas and awards and the intimate atmosphere would be enhanced by a variety of ornaments.

Then the activities of the president changed. The captain of industry was born. He began to run his enterprise like a ship, taking decisions on his own and talking loudly in the mess-room. Office décor began to change. Objects disappeared and furniture became more functional. Since then, in order to avoid waste, there have been few changes. Not least because furniture from the 1920s through to the 1940s is extremely hard-wearing. Furthermore, an unpretentious office may be seen as an asset, given present trends in management thinking.

OPTING FOR THE CONTEMPORARY

The decision to opt for contemporary furniture in an older setting might signify "I'm not taken in by grandiose décor. I'm not scared of the ghosts who've been haunting this place for the last two hundred years. And finally, I'm not, as you may think, a man of the past. I'm quite capable of living in the present, of being interested in avant-garde artists and designers. My choice of furniture proves it."

When he took over in the rue de Valois in 1990, in the *hôtel particulier* designed by Fontaine, the Ministre de la Culture Jack Lang asked the designer Sylvain Dubuisson to design a desk for him. For this classic setting, with its gilded paneling, Dubuisson created a magnificent desk in light-colored wood, with bold forms and rounded lines. The visitors' chairs are Louis XVI.

The office of the Ministre de l'Éducation in the rue de Grenelle inherited a desk designed by Andrée Putman, commissioned in 1985 during his first period of office by Ministre de la Culture Jack Lang. Here the gilded wood paneling contrasts with the sobriety of the furniture. The light-colored wooden half-moon desk-top rests on an elongated, rounded pedestal. The chairs, with their modern rounded lines, have no armrests and are upholstered in untreated leather with ivory-cream piping. There is also a low table consisting of two hemispheres in sycamore and bronze.

A number of executives also opt for contemporary furniture within an antique décor—for reasons of personal taste, perhaps, or simply for a change of image and in order to set themselves apart from the trimmings of power. They opt for the reliable standard-bearers of modernity such as Le Corbusier and Charlotte Perriand. More rarely they commission specific items of furniture from modern designers. This makes it

Jack Lang commissioned this extraordinary desk from the designer Sylvain Dubuisson when he was Ministre de la Culture. Consisting of an elliptical surface in polished mahogany resting on a conical base, it contrasts with the more conventional décor of the rest of the room. The blotter pivots on a semicylindrical drawer.

Another desk commissioned by Jack Lang when he was Ministre de la Culture. This one was designed in 1983 by Andrée Putman and was made by Mobilier National (facing page). Today it stands in the office of the Ministre de l'Éducation. It is a simple half-moon desk in sycamore and bronze, which fits very well with the eighteenth-century interior of the Hôtel de Rochechouart.

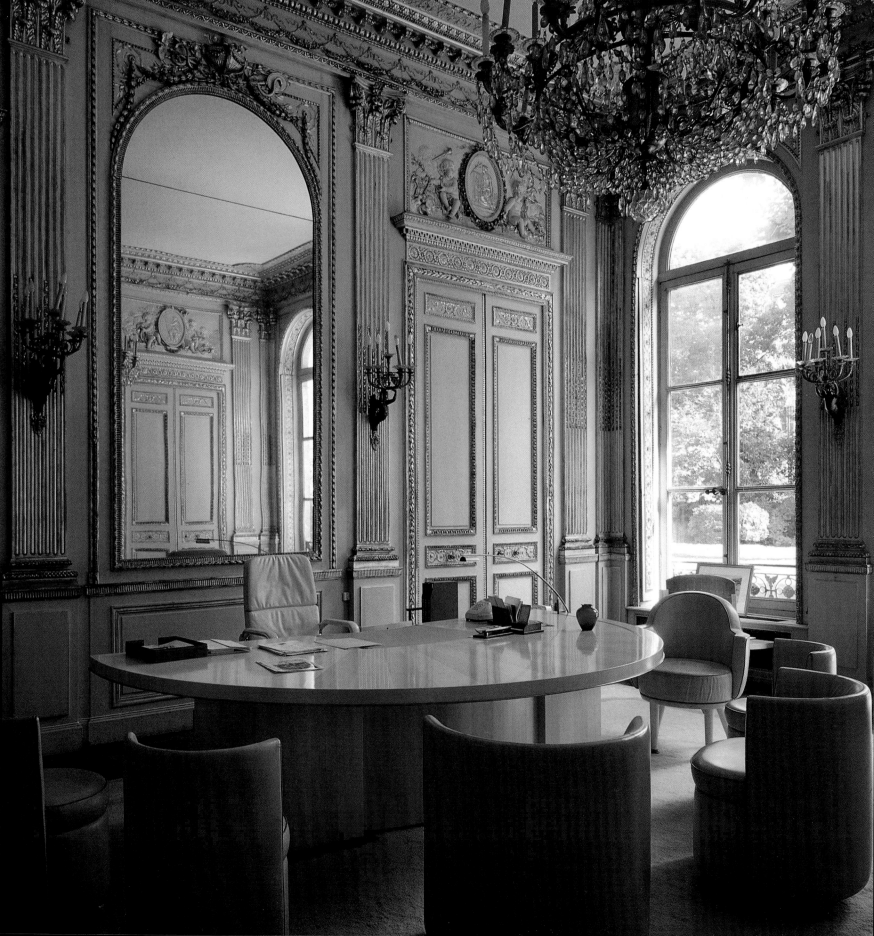

easier to incorporate modern technology. Some leaders tend to be fond of gadgets, which they handle with great dexterity: a mini TV incorporated into their desk, a retractable screen, automatic devices for opening blinds and curtains, and dimmer switches for controlling the lighting.

However, senior French politicians sometimes have an aversion to contemporary furniture and are only happy in an antique environment. Thus Michel Charasse, when he was Ministre du Budget, preferred to transfer his antique furniture from the Louvre to the brand new Ministère des Finances at Bercy, possibly in order to combat the modernity of his new work environment. He had an Empire desk and chairs and the inevitable desklamp with a green shade. A typewriter stood on a small Empire table, facing a huge bay window. The lighting was modern. The high ceiling, that made you dizzy just to look at it, heightened the impact of a huge antique tapestry.

Modern architecture and contemporary furniture are common in business circles nowadays, but it is a fairly rare combination for a ministry in France, such as the Ministère de l'Équipement, du Logement et des Transports, located in the Grande Arche at La Défense. This sumptuous office (96 square yards) on the thirty-fourth story is trapezoid in shape and is furnished with handsome furniture designed by Isabelle Hebey. The beech furniture, with its oblique angles and cylindrical chrome legs, echoes the geometry of the building. There is a lounge corner or, more precisely, a combined office and lounge space, a frosted-glass pedestal table—on which have been placed scale models of airplanes and a huge television—low, armless Le Corbusier chairs and a coffee table, also in frosted glass. The colors are warm, with light, honey-colored walls and doors, a creamy carpet and white fabric shades. The obligatory photograph of the French president stands on a side table.

Is power more easily expressed in an antique setting than in a contemporary setting? As we have seen, what counts is not the setting, but the nature of the room and the space available. With or without plasterwork, paneling and overdoors, empty space remains a constant as a symbol of power. It can be created anywhere as long as there is space available. Obviously, in an old building, the office will be given additional resonances by the neighboring spaces: the main staircase, the anterooms and the lobby. Antique desks are often relatively modest in size. Was this in order to give the occupant a sense of intimacy? And is it the case that the modern tendency of going for ever-larger desks is emerging as a counterbalance to the progressive shrinking of work spaces?

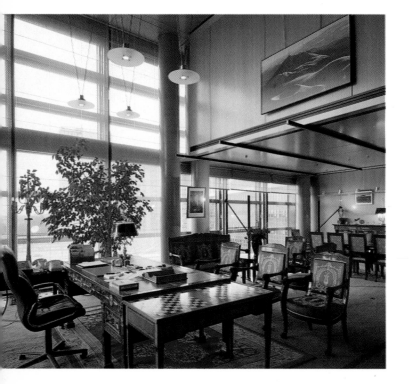

A mixture of styles. The Empire furniture of the Ministre des Finances moved from the paneled interior of the Louvre to Chemetov's modernist architecture at Bercy. Traditional "ministerial" lamps rub shoulders with contemporary lighting systems and the black leather managerial chair faces Empire-style armchairs upholstered in green and gold silk.

The 1,800 employees of the Ministère de l'Équipement work in offices located in the south flank of the Grande Arche at La Défense, a majestic cube 333 feet high, designed by the Danish architect Otto von Spreckelsen. On the thirty-fourth floor stands the minister's office, designed by Isabelle Hebey (facing page). Light colors have been used throughout, from floor to ceiling, including the beech furniture. The rigor and sobriety of the room is in keeping with the architecture.

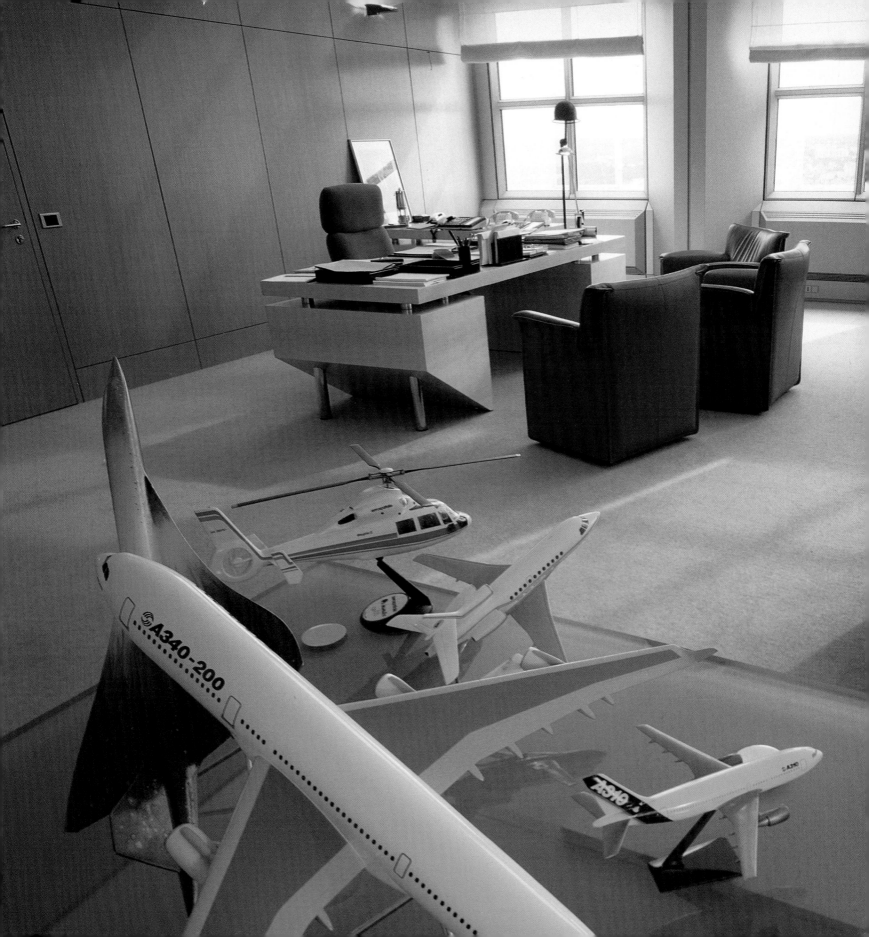

WOMEN EXECUTIVES

What kind of an environment does a woman executive choose to work in? There are still not very many of them and most of the time they tend to work in the same style of office as their male counterparts.

While they attach less importance to job titles and symbols of power, women tend to be a lot more sensitive to people's personal capacities. Most of them have not chosen to question the large uncluttered desk devoid of files, the supreme symbol of power. They are not particularly interested in their working environment and the idea of decorating it makes them shudder. They are not the company's hearth crickets. At a push, the potted plant may be replaced by freshly cut flowers or sophisticated arrangements of dried flowers. Where they deviate from the male model is in relation to their image as mothers. They are less hesitant about discussing their children, or indeed about inviting them into their office. Ségolène Royal, for example, when she was Ministre de l'Environnement, used to invite her children in on Wednesdays to watch a video. And, as Françoise Giroud put it: "When you still have to worry about what's going to be for lunch each day,

Madame Hanau, the "présidente" of the famous *Gazette de France*. When this respectable lady became caught up in a financial scandal she went on hunger strike for twenty-four days while she was in prison awaiting trial. She returned to her place behind her desk on 12 June 1930. A bouquet of flowers and a bucket of champagne were waiting to greet her on her return (below, right).

Queen Elizabeth II working on board her private plane, with the obligatory cup of tea (above). If you do not happen to own a private jet—a privilege restricted to the rich and powerful of this world—you can hire one for a few hours, complete with lounge, bedroom and offices.

A portrait of Jeanne Lanvin in her office on the rue Boissy-d'Anglas, painted by Édouard Vuillard in 1935 (facing page). This eminent figure in the world of haute couture began her working life as a young girl. She used to travel all over Paris delivering huge hatboxes. In 1889, at the age of twenty-two, she set up her own fashion house and within a few years had created a luxury industry.

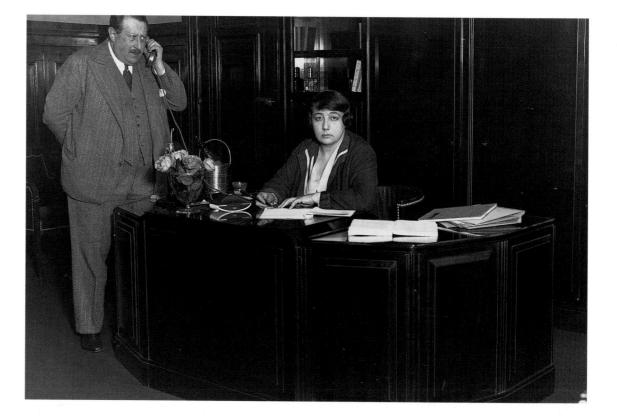

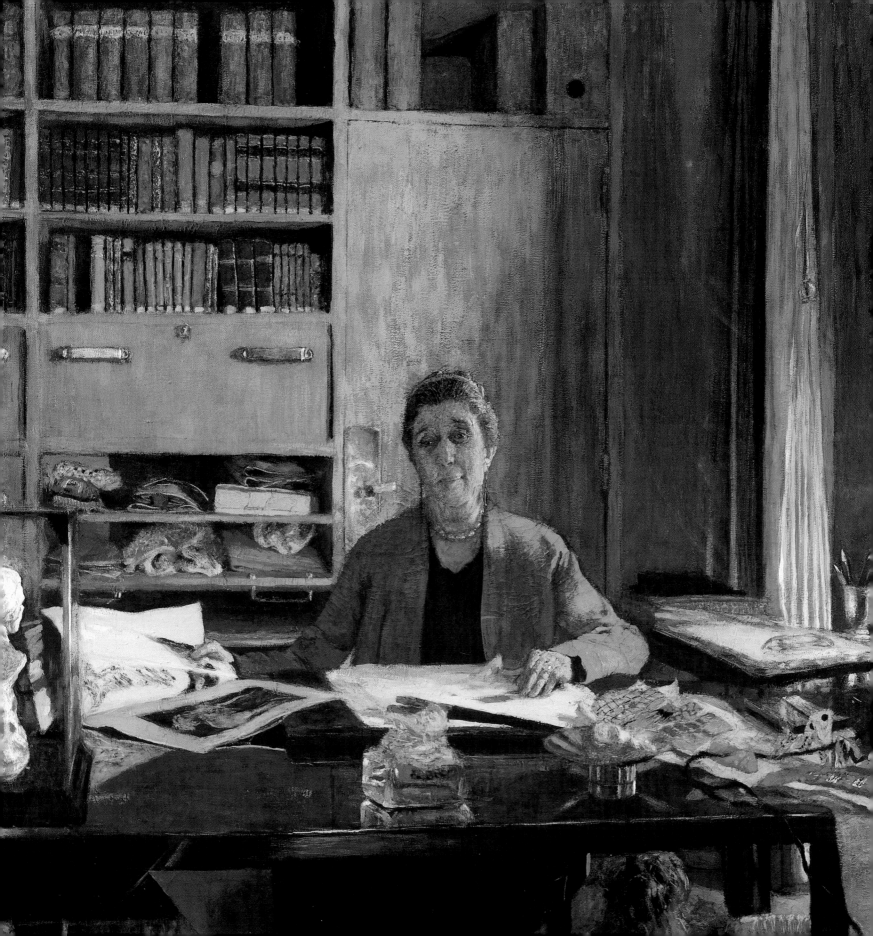

The office of the superintendant of schools in Paris, part of the Sorbonne (above). There is a personal desk in one corner—cluttered with personal objects, books and files—and spaces for holding meetings or receiving visitors.

The office of Éliane Scali, who took over the Puiforcat company in 1983. Her principal concerns were to project the image of the company and to create something new by using contemporary designers. This is a feminine décor in a handsome circular room with yellow curtains, a yellow partition, and a vase of flowers (below).

making sure that the day goes smoothly and arranging for what's going to happen with the children in the evening, it protects you from a lot of things. A woman is never completely disconnected from the everyday reality of things." Does this mean that power can never go to her head?

In the view of Michèle Gendreau-Massaloux, superintendant of schools for Paris, a woman is less "spontaneously hierarchical" and more capable of protecting her personal life from the winds and tides of power. Gendreau-Massaloux's work environment is extremely important to her. While her office may appear at first sight to be a typical seat of power, with its enormous volume, its antique furniture and its eighteenth-century paintings, it is far more than that. There is a desk modestly tucked away in one corner, piled with books, files, personal effects and statuettes. The center of the room is a socializing space, with an oval table where meetings can take place. At the other end is a more conventional space with a sofa, some chairs and a simple bunch of flowers. It is a good place for receiving visitors, a very personal world, helped by the presence of objects which you do not necessarily notice at first glance, but which all contribute to the office's flavor.

For the redesign of the offices of *House and Garden* in London, the magazine's editor Susan Crewe called on the services of young designers. For her own office, which until then had not been particularly stylish, she wanted a light décor with natural materials, a simple design which would impress visitors while at the same time putting them at ease. The designer Jonathan Reed proposed sisal flooring, wooden shutters and completely neutral colors, because he felt that the necessary color would be provided by the people working there. Particular care was taken over the lighting. Dimmers enable the light to be varied according to the time of day and the requirements of the work in question.

Their office used to be a huge living room, of 120 square yards, opening on to a garden, a handsome white-painted room with light floorboards (facing page). There are two identical desks, one in each corner for Maimé Arnodin and Denise Fayolle, the *grandes dames* of the world of fashion and founders of Nomad and Mafia. The round table in the middle of the room surrounded by Stark's Costes chairs is for meetings.

The office of the president of the Pinault company and the Compagnie Française d'Afrique Occidentale is entirely made out of wood and eschews artifice and pomp (facing page). The walls are paneled with maple; the table designed by Marcel Raymond combines maple and sycamore. On a column stands a monumental *Head* by the sculptor Kim Hamisky.

For the office of the fashion designer Gianfranco Ferré, the interior designer Christian Benais was inspired by the Louis XVI chairs which have always been part of the décor of the house of Dior. The large screen covered in tan leather is on casters and can be folded away for fitting sessions. On a Louis XVI pedestal stands a white, cast-iron, Directory-style vase.

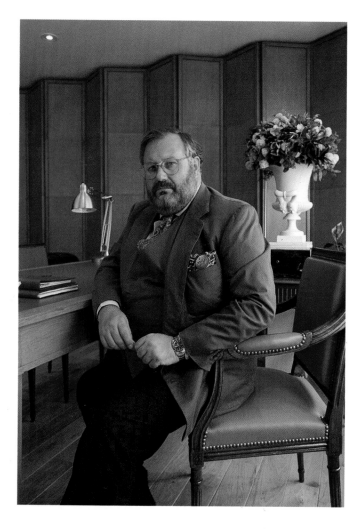

OFFICES FOR LIVING

A person's environment says more about them than they would necessarily like to reveal, and so does the way in which they organize their day. Analyzing the place where they work and dissecting their diary gives you precious insights into their style of management.

Company bosses are slowly coming out of their isolation. Their offices are no longer automatically tucked away on the top floor. They are becoming more willing to mix with their troops. The message is: "I'm just a person like you, active, dynamic and down-to-earth, and my work space shows it." These days one finds fewer and fewer of those leather-padded double doors which our ancestors adored. And people no longer instal those slightly ludicrous systems of traffic lights outside the office, which were always reminiscent of garages and train stations, and which thrilled children when they went to visit dad in the office.

True wealth, particularly in big cities, consists of space. The offices of Actimo would be the envy of any employee: forty-five colleagues working in a space of 1,800 square yards—true luxury right in the heart of Paris. All the work spaces are carefully designed and decorated. This is a prestige setting to match the image of a group that specializes in the renovation of prestige offices. The president's office is huge (sixty square yards) and houses a collection of modern art, hung on walls that are paneled in light-colored wood inlaid with ebony. The layout is classical, with both a work space and a lounge area.

With the tendency for work spaces to get smaller, corporate presidents like at least to have an imposing desk, a table for meetings, a lounge corner, a bar, a small kitchen and sometimes a private toilet. It is rather like a small student's apartment, and, like students, the president likes being able to escape once in a while—via his secretary's office, for example.

The office of Philippe Villin, when he was editor of *Le Figaro* and *France-Soir* in 1988, was a particularly luxurious example. It was a huge office, with a shower room, a bar, a conference room separated by a glass-paneled partition, a spacious lounge corner with the obligatory Le Corbusier sofas, a desk and a side table with eleven telephones and a computer. Lighting was indirect and carefully arranged and there were paintings hanging on the oak-paneled walls.

Executives are the people best placed to evaluate their style of working and then to extend their conclusions to the company as a whole. Those who have gambled on this approach offer the most original examples. Their offices reflect the fact that for them the office is a way of life.

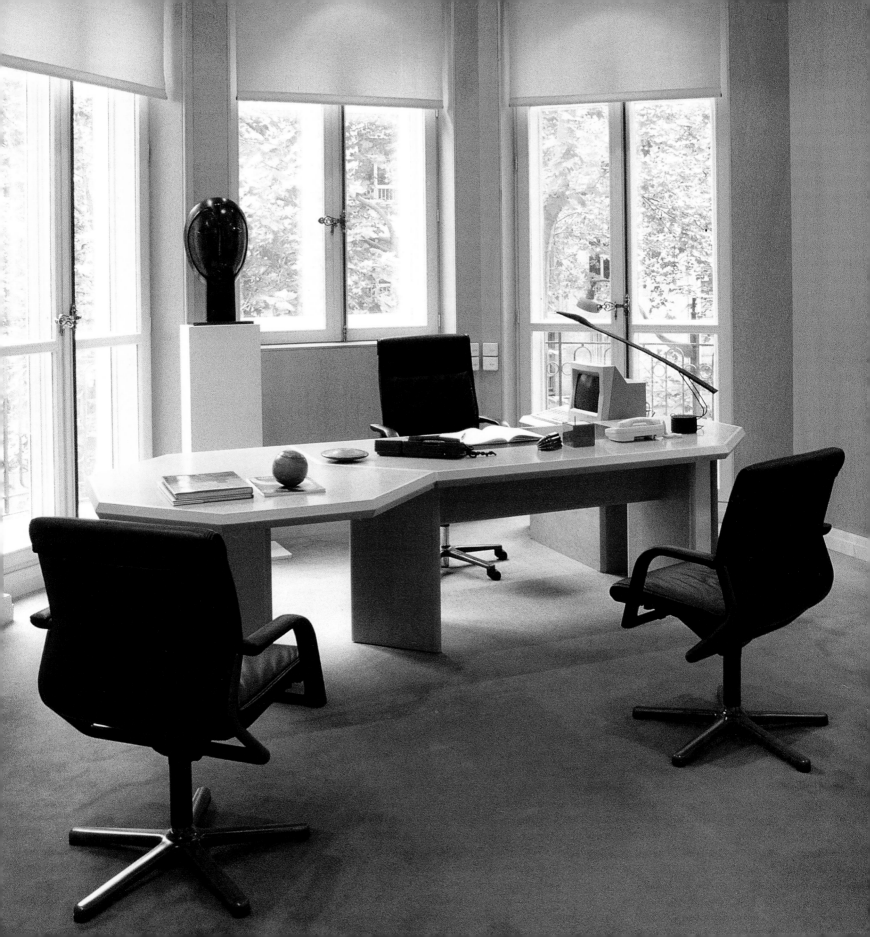

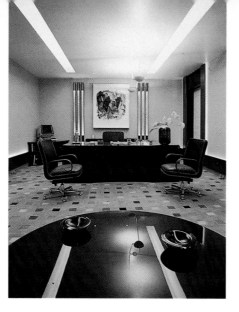

The office of Gilbert Trigano in the former headquarters of the Club Méditerranée, on the avenue Kléber, in Paris. The highly symmetrical interior, created by Alberto Pinto, features a classic layout, with a desk at one end and a meeting table at the other. A checkered carpet adds a touch of color.

The office of Alain-Dominique Perrin, president of Cartier International, on the rue Francois-Ier in Paris (below). This is a light-filled space dominated by a white and mahogany chessboard floor and art deco-inspired furniture. It was designed by the architect Jean Nouvel in 1988. On the desk stands one of Martine Bedin's Gédéon lamps.

The Catalan architect Ricardo Bofill set up both his house and his practice in an old grain silo in Barcelona (facing page). The stark simplicity of this décor, punctuated by black lines, highlights the curved walls and arched windows. The furniture is reduced to a bare minimum: deck chairs on one side and, on the other, a long table surrounded by Thonet chairs.

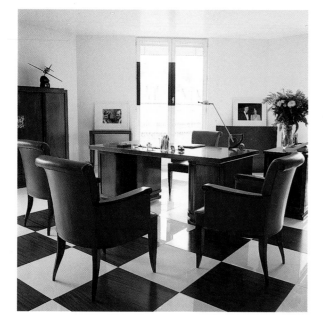

Such is the case of the company Avenir Havas Média, based in Boulogne-Billancourt near Paris. The president's office is designed in the image of its occupant, Philippe Santini. Of course he has a desk, because a person needs a desk—his is oval, made of granite on a polished aluminum base and was designed by Pascal Mourgue—but he almost never sits there. There is a television, showing an endless stream of images from around the world (this is, after all, an international multimedia group), and Le Corbusier sofas. The wall is decorated with American posters from the 1930s. A very personal feel has been achieved in an office which is relatively modest in size (36 square yards).

At Hermès, for example, Guy de Brantès, when he was vice-president in 1988, explained his choice of work surface: "In the eighteenth century, one worked on a rolltop desk set against a wall, and had a flat-top desk for receiving visitors. This was the idea that I sought to recreate at Hermès, adapting it to present-day tastes." His office had a magnificent work-top in wild cherry running along the walls, a round table designed by Saarinen, and Mies van der Rohe chairs. "The fact of sitting behind a desk has a fascist side which I don't like," he added. "A round table is more sociable. Also, on this table there is nothing—no files or personal effects—to catch my eye and distract me, so I can give my undivided attention to the person I am talking to."

Hermès' president, Jean-Louis Dumas-Hermès, worked with his architect wife Rena Dumas on the design of a number of the offices at the company's premises on the rue du Faubourg-Saint-Honoré. The first of these was a totally private corner on a mezzanine, with some books and a Peppa couch. Downstairs he has retained his father's classic desk. To one side he laid out a space for creative work (which he calls "Mimi Pinson"), which includes a folding table and some Japanese stools. "I didn't want an office that projected a false image," he says.

"I wanted an office where it would be a pleasure to work but also to live. I receive visitors and listen to people more than I work with paperwork, so I found it interesting to create a different style of office," explains Serge Trigano, president of the Club Méditerranée. Thus, he has a highly original office, with a large, round table in mottled pear-wood and black leather with a metal base (designed by Canal), and matching Mies van der Rohe chairs. You would not be able to guess the status of people from the seating. The colors—blue, celadon green and coral red—evoke the company's activities. The overall impression is one of communication and simplicity, an impression that is also found in other aspects of the firm's layout. For

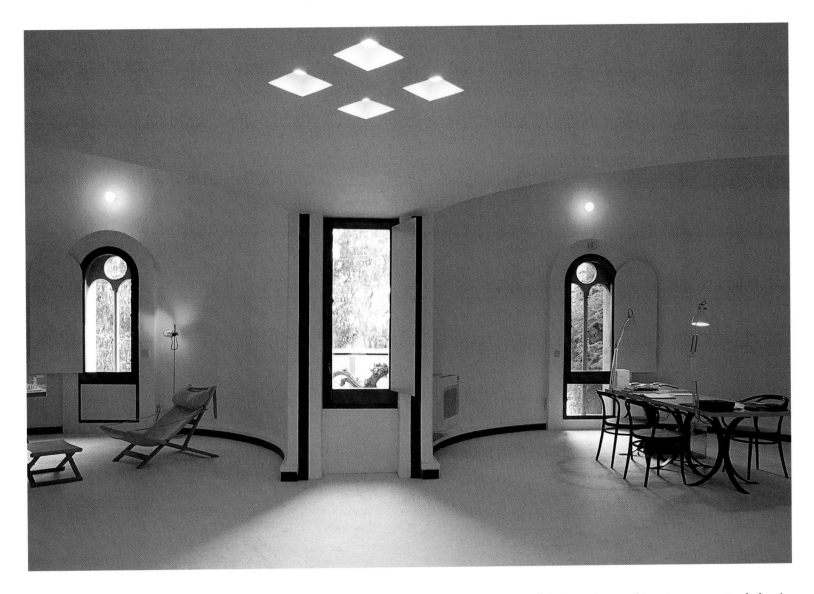

instance, a kitchen has been installed nearby, making it possible to have a snack while working.

Sometimes your office does not suit you at all—a bit like when you make a mistake in choosing a pair of glasses. When a person meets you for the first time, something about your glasses might jar, but then they get used to how you look and forget about them. Sometimes there are disturbing dissonances, such as the company president who has dusty, dated, Napoleon III furniture which suggests the study of some lonely bachelor. His small, antique desk would be perfect for writing to his sister who emigrated to Australia, but seems at odds with his speech on the subject of the company's performance and the need for modernization.

Some sculptors and designers have a thing about executive desks. An example is the granite desk designed by Pierre Digan, sculptor and stone-mason—"A heavyweight desk for the volcanic president," in the words of the magazine *Espace bureau*. It is heavyweight to the tune of a ton and a half! The thick granite work surface, which rests on a granite base, has been sculpted to incorporate reinforcements, a pen tray, a set of tulip-wood shelf units and even computer print-outs. The electrical wiring is built in. It is a striking desk, whose functions have all been carefully thought out. Those looking for something lighter might prefer the card-board desk, almost a scale reproduction of the Arc de Triomphe, which was shown at the Salon des Artistes Décorateurs in Paris in 1985.

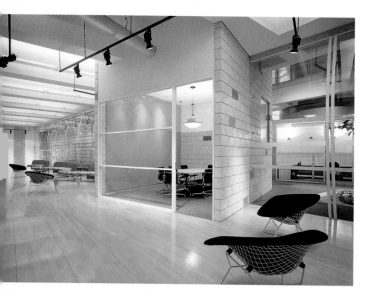

THE AVOIDANCE OF OBVIOUS SIGNS OF POWER

As Jérôme Galletti explained in his book *Aux lieux du bureau*, perhaps American executives are leading the way. The president of the Mars corporation has a landscaped office, with his fellow executives grouped in a concentric circle around him. Communication is instantaneous and essentially oral. In the offices of MacDonald's, both in the United States and in Paris, the same formula is followed: open-plan offices for everyone, including senior management. Full-height glass-paneled partitions are used for sectioning off meeting rooms.

In other American companies executives may have several offices—one close to senior management and another to maintain contact with the lower ranks. They make more systematic use of meeting rooms than the French, which means that they have smaller individual offices. It seems that some executives have been rejecting the office entirely, in preference for a lounge-bar with a sofa, computers and audio-visual equipment sitting on mobile units with casters. The president of Digital Finland found that he was using his office very little—barely two hours a day—and that he worked more efficiently if he moved around in the company. So his workplace basically consisted of a high table for his microcomputer and a bar chair. Everywhere he goes, he takes his portable phone with him.

The office of a French or American corporate president is usually a corner office on the top floor—the one with the best view. In Japan this kind of office exists too, but with a difference: it is only used for receiving important visitors. As Edouard Hall puts it, in his book *Comprendre les Japonais*, it is actually a sitting room which looks like an office. For the rest of the time, Japanese executives work in landscaped offices, in the midst of their colleagues. In their culture it is not usual for a person to have an individual office. The executive will have access to other, more private, spaces elsewhere: he has an account at a nearby restaurant, and receives his visitors in small private salons. A Japanese boss attaches little or no importance to the splendor of his office. On the other hand, within an open office space he will tend to occupy the desk that is furthest from the door. Thus hierarchy can be maintained in the subtlest of ways.

Transparency and communication are the watchwords at Apple's training center at Stockley Park in England. Designed by Studios Architecture in 1993, the meeting rooms and relaxation areas are separated by glass and the latter have light wooden flooring—a successful arrangement of work and social spaces. The colors of the famous little apple recur throughout.

This serpentine partition made of glass blocks is an elegant way of avoiding the traditional corridor (below). The simple, almost ordinary materials, contribute to an architecture that is refreshingly different and open. The same architects were responsible for Apple's offices in New York, where, once again, color plays an important role (facing page).

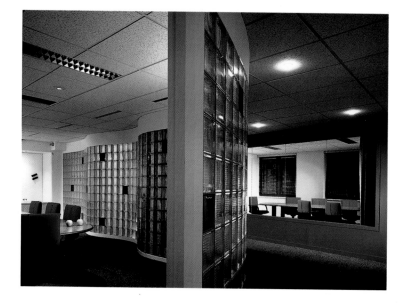

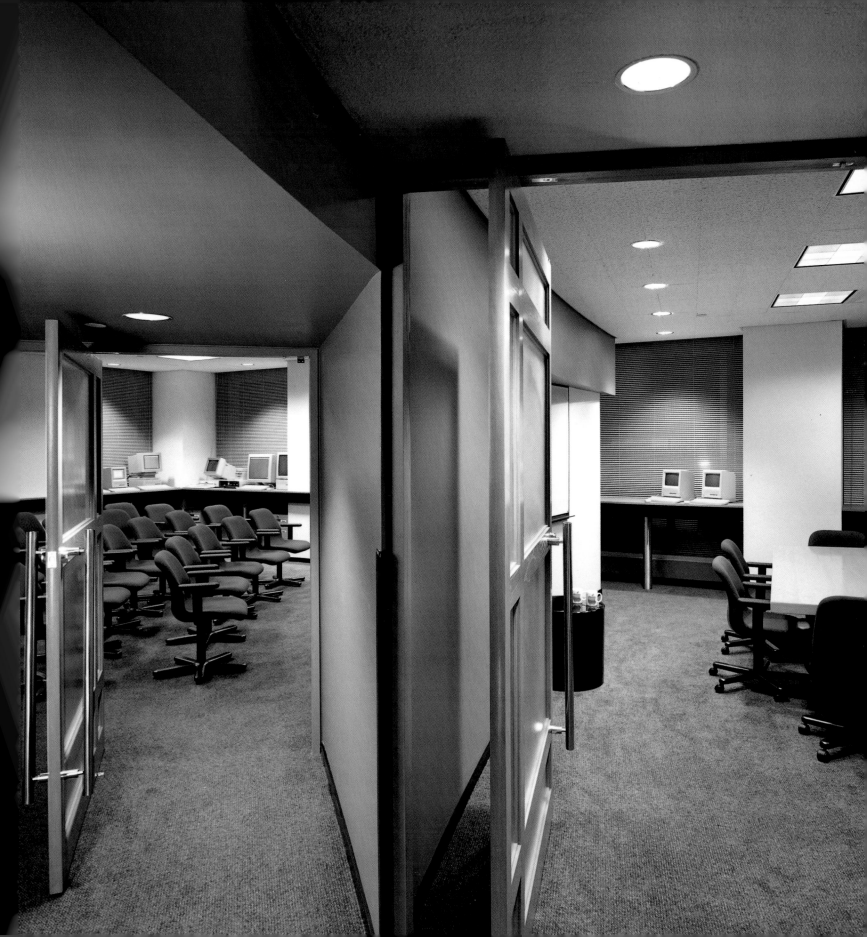

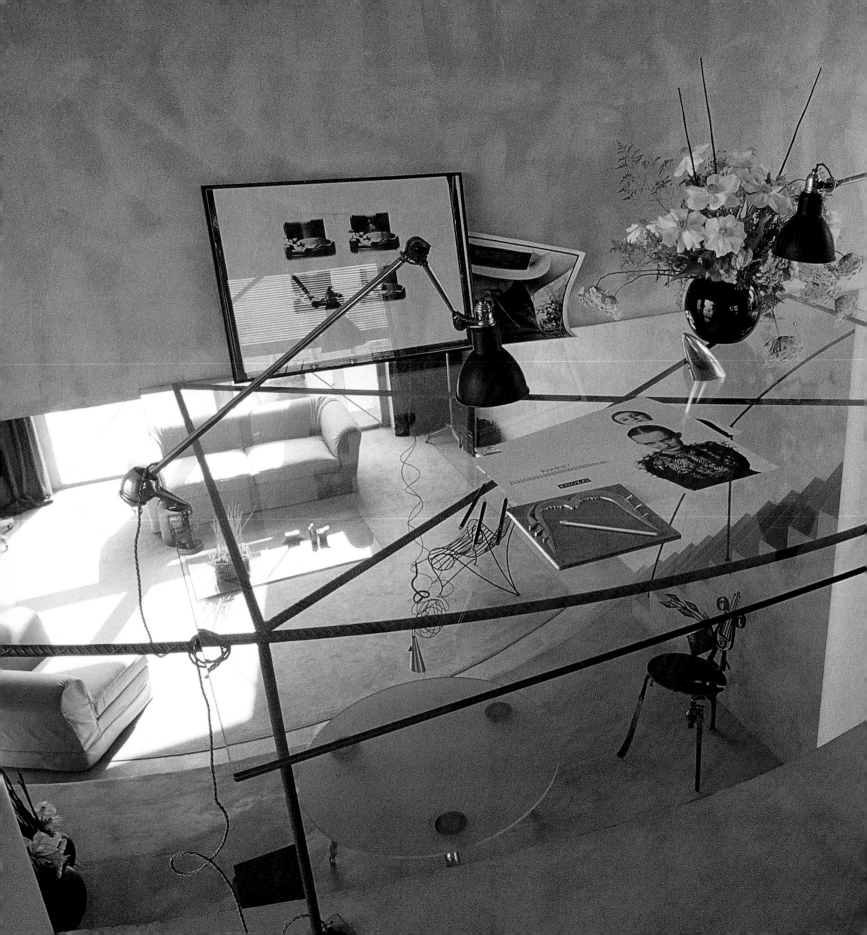

The office at home

The symbol of a degree of freedom. The highly personal preferences of lawyers, doctors, architects and writers. The choice between the rigorous and the fanciful.

A transparent almost ethereal desk in a tall narrow house on the outskirts of Paris designed by Philippe Starck (preceding double page). This work table is a simple sheet of glass supported by a metal frame over empty space, providing the user with an overhead view of the living room below.

Why not have your office in the kitchen? With your pen in one hand and a spoon in the other, it is an ideal way of doing two things at once, although it may not always be easy to concentrate with the aroma of a beef casserole wafting past your nose or to avoid getting flour all over your files.

A place of your own, with no boss looking over your shoulder, no hierarchy and no commuting—having an office in your own home symbolizes a certain freedom. You are master of your time and your work, like the architect suffering from insomnia who organizes his colleagues' work between two and five in the morning.

A lot of people would like to work from home, because it provides a way of combining all the aspects of their lives into one harmonious whole. "Working becomes a dream," to quote the slogan that accompanied an exhibition of the "Office of the Future" in 1950. Professionals who work from home might agree with this point of view, because generally they work longer hours than employees. The idea of the office in the home re-emerges periodically in the business world. The debate about teleworking is currently making it even more relevant, while the concept of the "business environment" is gaining currency. The idea is that one's company should not be merely a place of work but a place for living. It should encourage better relations through specially designed spaces which are a cross between the lounge, dining room and kitchen of a private house, while at the same time providing private work rooms.

France has about 1,300,000 people employed in white-collar jobs—doctors, lawyers, notaries, architects, accountants, and so on—and many of them work in shared offices. There are a number of reasons for this: habit, the financial advantages of a shared lease, a simpler everyday life and the fact that when they are first setting up in business they cannot afford a separate workplace of their own.

To be able to work in your own room, like a dressmaker, might seem to be the stuff of dreams, but is the office in the home really the model for the future? The reality is often more complicated. To begin with, it is not always easy to organize work time and family time satisfactorily—to make a clean break between your private life and your work. For example, there was the young consultant who was expecting his first proper clients. He tidied his lounge-office from top to bottom and then went to take a shower. But he had got the time of the appointment wrong by an hour, and went to the door in his bathrobe. Or there was the accountant who, when relaxing in the summer, used to wear a pair of threadbare khaki shorts and a tweed jacket which came down to the bottom of his shorts. His clients arrived early for their appointment and, as he was bizarrely attired, he had to position himself hurriedly behind his desk. He received them seated, but when it came to the end of the interview he completely forgot what he was wearing and got up to see them out, much to his clients' amazement.

A CONFUSION OF FUNCTIONS

Those who have offices in their own homes are more aware than other people of the messages that their office gives out, of what it reveals about them. How is one to avoid saying too much, or giving too much away? People's apartments are not always large enough for an easy division between work space and living space.

Many medical professionals use their sitting rooms as waiting rooms for patients. This means that the room cannot be used by the rest of the family during the day, and it also influences its layout and décor. The practitioner cannot just leave his books lying around, or his collection of old pipes, unless he keeps them in a glass cabinet. The video cassettes have to be tidied away. In most cases they give priority to the reception side of things, and accept the fact that in the evening they are going to be living in a waiting room. Their waiting room will have little in common with the company lounge area. Noise has necessarily to be kept to a minimum. There may be background music, and the furniture will be more comfortable and personal. Dentists have long had to live with the scent of cloves seeping through to their bedrooms. On the other hand, it is hard to imagine a lawyer or a doctor holding a consultation in an office filled with the aroma of a beef casserole simmering nearby. The entrance also has to be kept tidy. You cannot leave coats piled on a chair, or your shoes in a corner.

The office, however, still remains a place of work. Its lucky owner will be able to express themselves here with more freedom than the average office worker. They can indulge in a touch more fantasy, express their personalities more fully. But they also have to take account of the other people who live in the house and have to accept an inevitable telescoping of their everyday life. Sometimes, also, there may be a sense of dispossession. Here the office is no longer a slightly magical private place, where a person can withdraw and hide away, but simply one room in a house where everyone comes to steal your stamps, Scotch tape, scissors and envelopes. In the evenings your teenage offspring treat it as if it is their own and they amuse themselves by either using your phone or playing video games on your computer.

This confusion of functions can go the other way too. Sometimes the office overflows and invades the house. For example there was the case of the notary public who was struggling with a particularly complicated inheritance case. Because the rival litigants would not stop arguing, he ended up banishing them one by one to the waiting room, then to the

This boudoir-office in the apartment of an Avignon bullfight aficionado, designed by P. Servel and S. Taurelle, is decorated with objects from every era: a Louis-Philippe boat-bed, chairs designed by Garouste and Bonetti, and an antique Italian mirror.

This patrician villa on the border between Switzerland and France is reminiscent in design of a Palladian villa. The interior, designed by Henri Garelli, has a rustic atmosphere. The upholstery of the Louis XVI bergère matches the floral fabric used for the drapes and wallpaper (below).

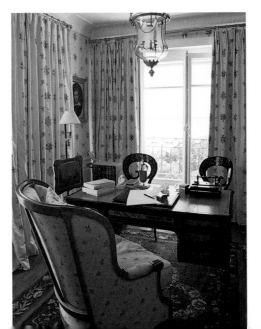

sitting room, and finally they ended up in the children's bedroom.

When a company is founded, it first occupies the sitting room and then slowly extends to take over the rest of the apartment. The photocopier is in the kitchen, the filing system in the couple's bedroom.

For colleagues who share your home office, this kind of work environment has a quality all its own: the pleasure of going to wash your hands in a real bathroom, or the gentle sound of a washing machine spin-drying the laundry while you are typing a letter. The day is structured around the sound of the children going to school in the morning and coming back in the afternoon. The children of the house have to be quiet when mum or dad are doing their consultations. There is a special kind of atmosphere in apartments where a husband and wife team of psychoanalysts both live and work. The sitting room and another room serve as waiting rooms during the day, because their respective patients should not be allowed to meet. The two offices are separated by double doors and silence reigns. The distant noise of a food mixer in the kitchen could have the effect of a pneumatic drill drilling right into the north face of the subconscious. And who knows, maybe in thirty years time these children will themselves need the psychiatrist's couch, to psychoanalyze the effect of the heavy silences of their childhood.

Having an office in the house makes relations between couples more complicated. The lack of privacy and intimacy on both sides is a recipe for endless conflict. There is the lawyer, for instance, who literally lives in his office but is unaware of the fact that he is neglecting his wife and children, because he is always there, in the room next door. Furthermore, when a man has his office in the home, he imposes a particular style of life on his family. A lot of men appreciate this system because it gives them an opportunity for a foray into the house between appointments. Women, on the other hand, find it harder to cope with organizing home and work side by side and, given the choice, they often prefer to find an office elsewhere.

Also, when you work from home (particularly in the case of professionals who have relatively few clients coming to see them), you often need an iron will to get the working day started, or to continue with what you have already begun. You have to resist the temptation to curl up with a thriller, or switch on an appliance between two phone calls, or, if the day's business proves too taxing, to go and potter about in the garage. Some people complain about this proximity, this absence of breathing space between work and private life. They may need to devise elaborate and complicated rituals to get themselves started in the morning.

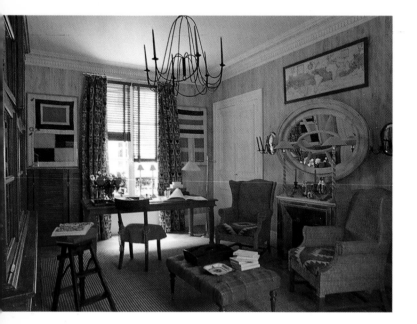

An office-library in the Parisian apartment of the interior designer Coralie Halard. The red of the large table is echoed in the red of the cushions and wall-hangings. There are comfortable wing chairs and floor to ceiling bookcases.

In the Roman home of the Italian movie director Franco Zeffirelli nothing has been forgotten: a large, multipurpose table, a rolltop desk for writing, a shuttered filing cabinet for storing paperwork and a space for relaxation (facing page). A large rectangular mirror reflects the early twentieth-century décor, giving the impression that the room is bigger than it is.

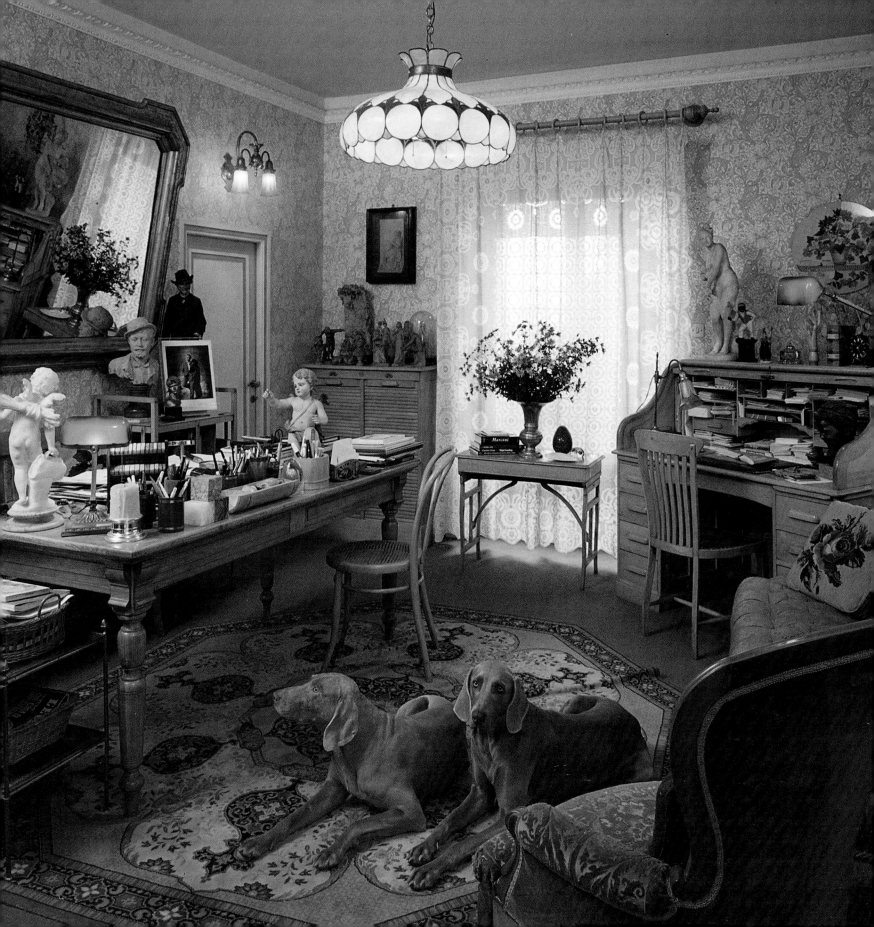

Interior designer Eva Jiricna is particularly renowned for her work for the Joseph fashion stores. At home she has a bright, colorful office filled with plants. There is a television set and, for when she is in a reflective mood, a chaise longue with Mickey Mouse ears, designed by Kita for Cassina.

Between two lamps with conical shades stands a combined desk and shelf-unit and a matching chair (below). On the back of the chair, on the table, are small bronze rabbits, a visual joke on the part of the designer, Philippe Renaud. A distinctive red-and-white color scheme enlivens this room, where Louis XVI chairs mix happily with the crisp modern lines of the desk.

The study of Jack Lenor Larsen, a leading figure in the American textile industry, in his Long Island home (facing page). This extraordinary attic space gives a feeling of purity and tranquillity. The desk was designed by Geoffrey Hollington.

A VERY PERSONAL DÉCOR

In the opinion of the interior designer Isabelle Hebey, a professional's home office should be quite the opposite of the ordinary everyday company office which each occupant has to find ways of making their own. It is also the opposite of ministerial offices, which are conceived not so much for their occupants as for their function. The office at home should take account of the personality of its occupier. This is a dream opportunity for those responsible for its design and layout—both the person designing it and the person who will occupy it. While the office's function should be borne in mind, flights of fancy are not ruled out. A doctor's premises, for example, should inspire confidence and a sense of security, and a lawyer's likewise, although the lawyer might permit themselves some theatrical touches in order to impress (and thus more easily justify his fees). A dentist, on the other hand, has to guarantee spotless hygiene, modernity, and a "clinical" lighting to match. Imagination and creativity are better received and tolerated in the offices of architects, designers and people working in the fashion industry. The public has a certain image of what the doctor's surgery, the lawyer's practice and the notary's study should look like, but other professionals are perhaps less keen to be trapped in stereotypes. You may want to conceal your youthfulness and the fact that you are receiving clients in your own apartment while simultaneously giving an image of seriousness and modest prosperity.

Then again, you might attempt to create a space that fits with your work patterns, focusing not merely on the image you want to project, but also your comfort and working methods. The office that architect Claude Parent, for example, designed for himself has a classical layout, but behind a section of wall, in an elegantly decorated area with black walls, he has a magnificent and inviting chaise longue facing the window—a wonderful spot for meditation and mulling over ideas.

A different approach was adopted by the engineer who designed his conference room as a lounge area, with comfortable sofas, low tables and pedestal tables for taking notes. The resulting space was distinctively different from the ordinary office and far more conducive to dialogue. Adopting a more classic approach, an architect stores all his paperwork and plans not in some dark corridor, but in a small and pleasant room. The raised work tables running along the walls enable him to browse through various documents and study them at leisure.

Specialists in the field of medicine have to deal with the problem of new technology, such as computers and sophisticated examination

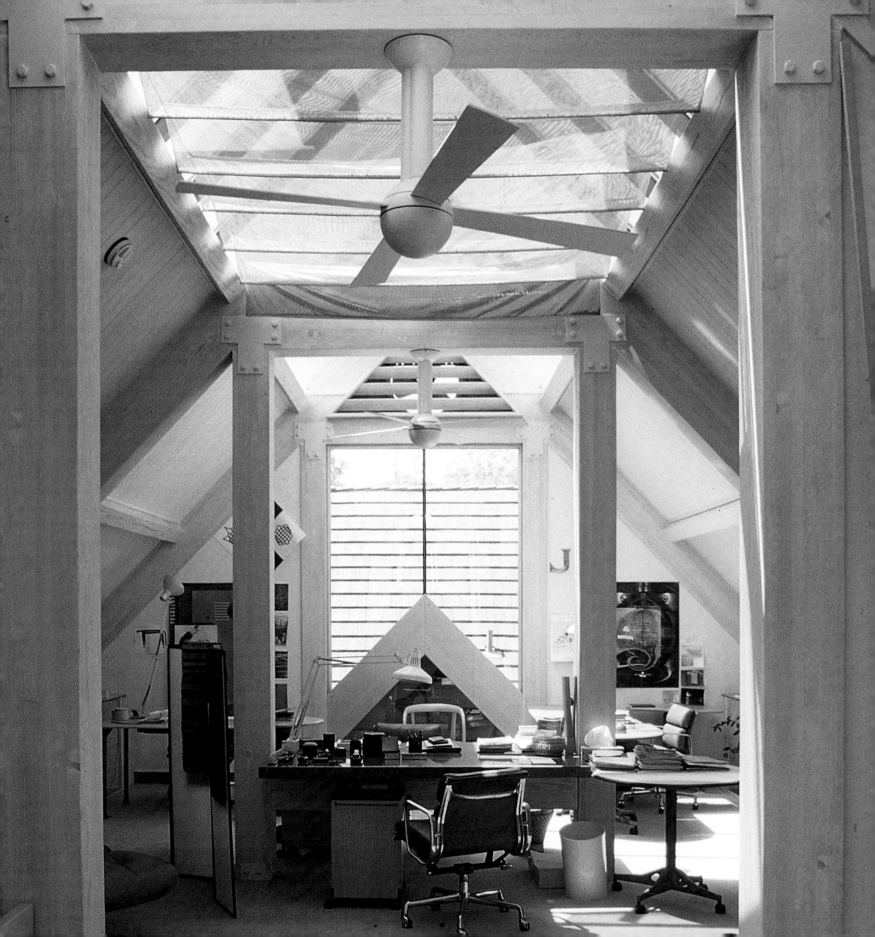

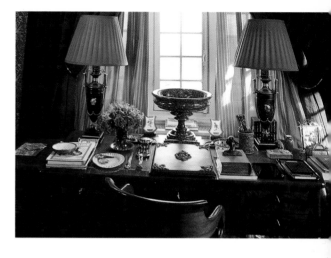

The office of the fashion designer Christian Lacroix, in the rue du Faubourg-Saint-Honoré in Paris, serves both as a tea room and a meeting room (left). He likes to have meetings over meals, breakfasting or lunching around a table which looks nothing like a desk. "I always have an idea a quarter of an hour after I've drunk a cup of coffee. It's like a discharge, and it's a system I can always rely on."

Primitive, baroque, barbarous—there has been no lack of epithets applied to the furniture, jewelry and interiors of Élisabeth Garouste and Mattia Bonetti (below). Here

A palette of pinks for the office of the fashion designer Yves Saint Laurent in his house in Deauville (above). A very sombre mahogany desk and a scrolled chair have been placed by a heavily curtained window. Two Empire-style lamps add a formal note to the décor.

we see their immoderate taste for unusual materials: animal skins and bronze for the Rodeo desk designed for the house of M. and Mme. Edelman in Switzerland.

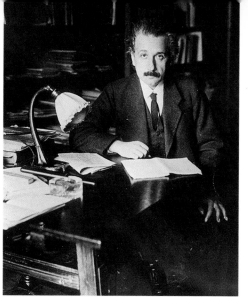

Albert Einstein, author of the theory of relativity, photographed in his office in 1921, the year of his Nobel Prize. Little thought has been given to the décor or layout of this study: there is just a wall of shelves packed with books and files and a small table lamp. The atmosphere is quiet and studious.

The two Flammarion brothers should not be confused: Camille was the astronomer and Ernest the publisher. One was already famous and the other was to become famous a few years later. Here is Camille Flammarion, scientist of genius, looking Bohemian in his office in 1893 (below).

"Despite the much-vaunted moderation of my style of life, I have sacrificed a lot for my collection of Greek, Roman and Egyptian antiquities, and I have in fact read more works about archaeology than about psychology." So wrote Sigmund Freud in a letter to the novelist Stefan Zweig on 7 January 1931 (facing page).

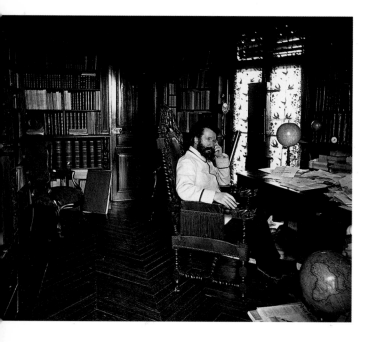

equipment, invading their surgeries. The patient's stress levels, which are already high, risk rising even further if the atmosphere is not designed in such a way as to play down this technology. Since these specialists spend a lot of time in their surgeries, the décor is likely to have an effect on their state of mind and their energy. Having a surgery at home enables them to create a comfortable setting in which a painting or two and a few carefully chosen ornaments can lessen the alarming impact of their rather chilling equipment. Dentists face a similar problem.

When you have your office at home, it is easier to give full rein to your originality and be daring with your décor. There are some amazing examples, such as the consultant whose premises are halfway between a discotheque and a spider's web. He has a large, dark-colored desk, equally dark floor and walls, closed curtains and very subdued artificial lighting coming from a painted coffered ceiling. The floor is raised and, in the middle of the room, there is a kind of sunken area with sofas. The furnishings are extremely elaborate and include palm trees made of leather. It is a sorcerer's den, where the bemused visitor wonders if he is ever going to get out in one piece.

The offices of psychoanalysts are distinguished by the presence of a soft divan with a brocade drape and some cushions, like the one belonging to Freud at 19 Bergasse, Vienna. This is the only profession which readily accepts this kind of furniture and uses it as a work tool. Engravings, paintings on the wall, intimate lighting: all these elements give the feel of a slightly closed environment in which the ghostly spirits of the previous client still hang in the air. In both his London and his Vienna offices, Freud had an impressive collection of statuettes, which stood on his desk, the mantelpiece, the large farmhouse table, and on top of display cabinets which themselves contained dozens of statues. His patients were thus given some clues about the tastes and character of this highly secretive man. He had a passion for archaeology and history, obviously; a certain concern for personal comfort, as witness the two cushions on his chair; a concern for his patients, with his comfortable and inviting divan. But he also had a certain obsession with order. You would probably have found that if you had shifted one of these statuettes a few inches, Freud would immediately have put it back where it belonged. It would be interesting to examine the question of what they meant for the father of psychoanalysis, this crowd of maternal figures permanently sitting in front of him and which he liked to stroke as he sat at his desk.

A persistent legend suggests that the use of sofas is forbidden in French lawyers' offices. After some research we discovered an old text in which

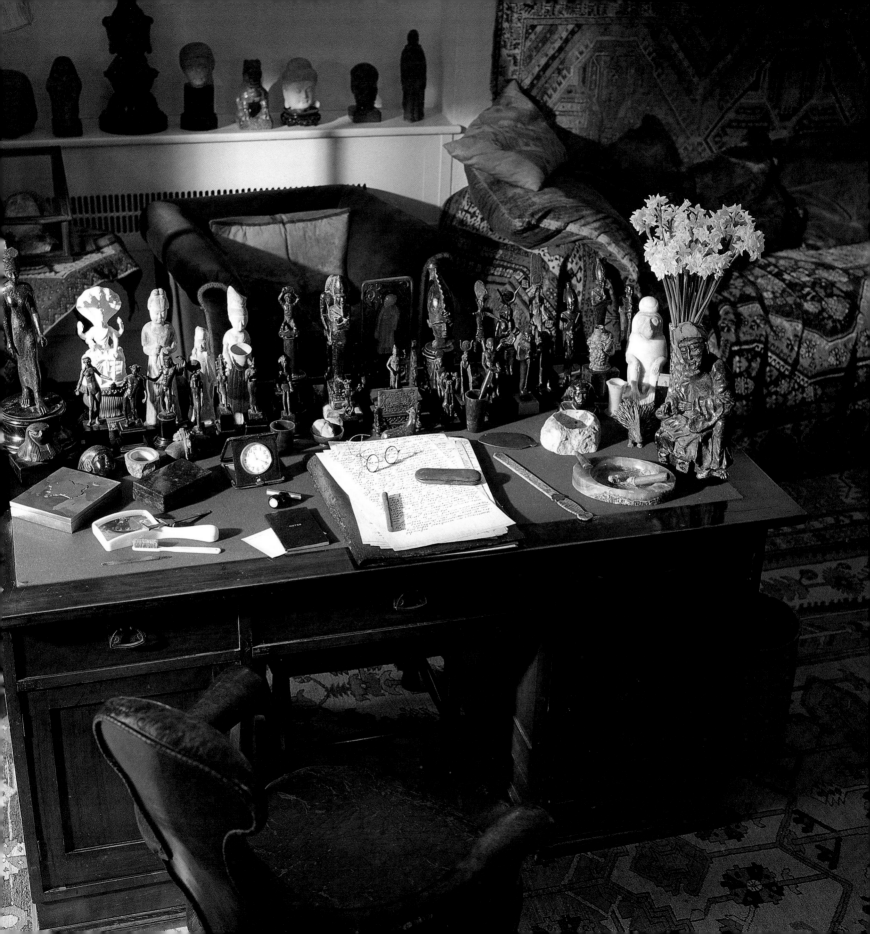

A style-conscious office in accord with the tastes of Napoleon III and the Empress Eugénie, where the bronzework stands out against black-painted wood.

A collector's office in an English country house. Family photographs, objects, busts and books adorn the mantelpiece, bookshelves and desk (facing page). Every available bit of space is filled with meticulously arranged personal effects.

The man of letters Jules Simon (1814–1896) interrupted in his work. This classic late nineteenth-century office is in a state of creative chaos, with a cluttered table and a wastepaper bin that is begging for mercy. Nearby, within easy reach, stands a strange cruciform pedestal table with shelves.

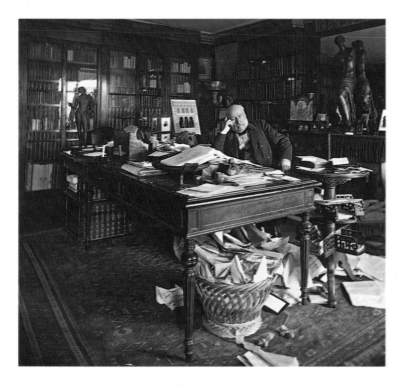

this is indeed stipulated. One is not permitted to pay one's lawyer in kind!

Some private offices are modeled on the kind of offices of power we saw in the previous chapter, as in the case of the office that used to belong to businessman and politician Bernard Tapie in the rue des Saints-Pères, Paris. The early nineteenth-century desk, with maple veneer and motifs in ebony and rosewood, was surrounded by Directory-style chairs designed by J.-B. Deray. There were no files, computers or filing cabinets. The impressive décor consisted of bas-reliefs, friezes, overdoors and paintings. On the desk stood two eagle paper-rests, some pencil-holders, a compass and a globe. The office had a rather formal feel, as if it was mimicking the offices of government ministers.

In these kinds of private offices one also tends to find antique tables rather than desks as such. They are usually placed in the center of the room, which is decorated with ornate plasterwork. On the leather desk-top there is a charming, eighteenth-century inkstand, on either side of which are bronze or biscuit ornaments.

Finally, some people go to the curious lengths of actually laying out the entire house like an office! There is a pervasive gray and black atmosphere, which you become aware of as soon as you enter. There is a huge glass table and a modern lamp and the walls are bare. There is no semblance of a personal stamp anywhere, no personal touch, no disorder, not even any files and the pencils are all properly sharpened. The occupant of such a place is likely to be an architect or a designer conducting a home experiment in pure, unadulterated modernity. The visitor, however, may have the curious sensation of having stumbled into the showroom of an office furniture manufacturer.

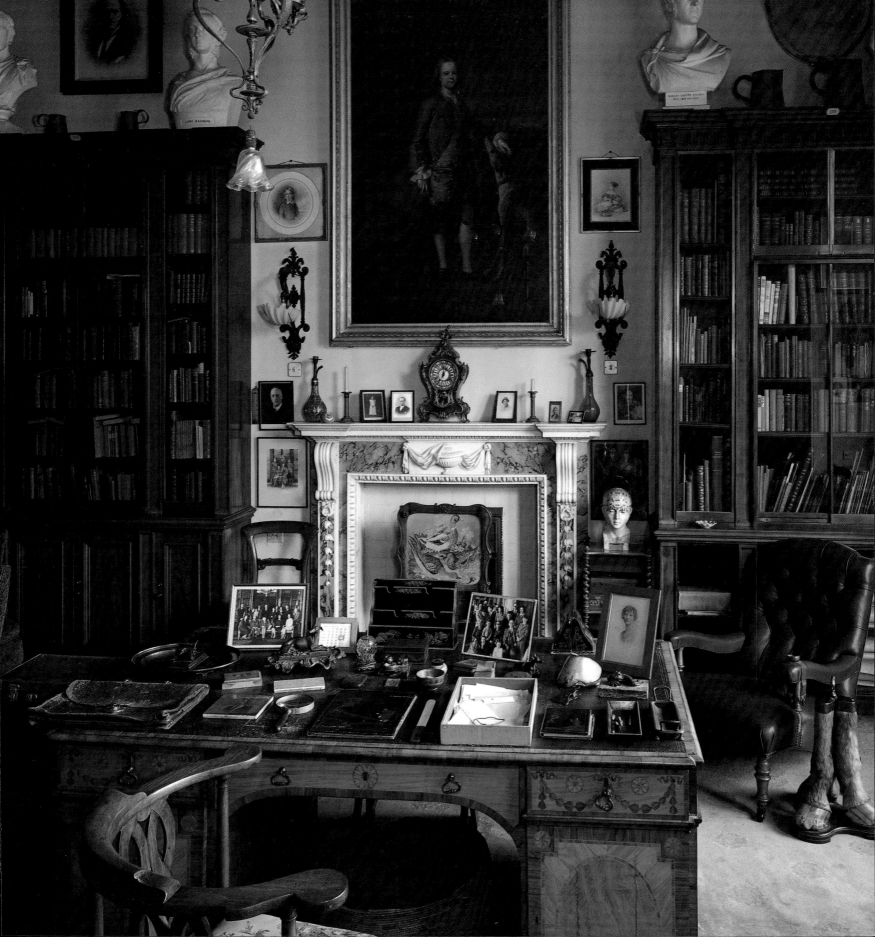

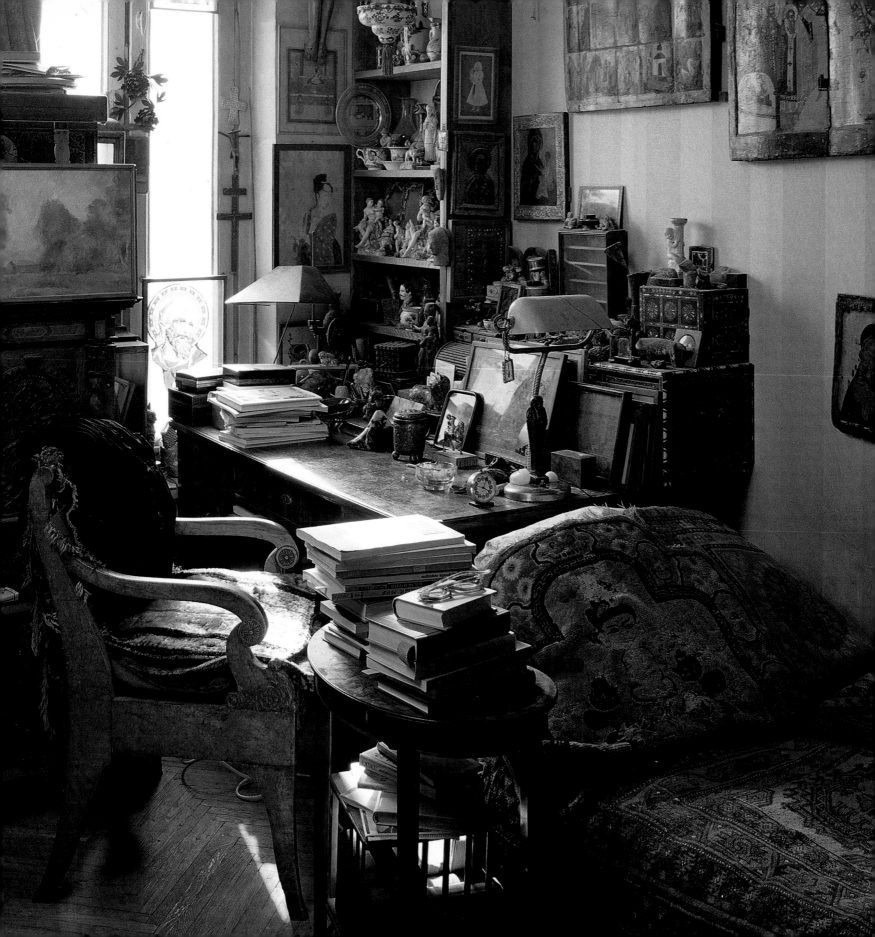

OFFICES FOR WEEKENDS
AND EVENINGS

A lot of professionals set up two work places: one in the home and one outside it, with the former tending to be more private. The office of a particular antiquarian is a case in point. There are art books everywhere and all kinds of ornaments on every available flat surface. A pretty little work table is piled high with books and ceramics. There is a bronze, a potted plant and a magnificent paper knife. There are fine antique curtains. The atmosphere is cosy and snug. There is a deliberate, organized disorder. Sometimes the room is so full of things that it is hard to find anywhere to hang pictures. One solution might be to hang them in front of the rows of books, which is fine as long as you do not need to consult the books too often.

Sometimes you begin to wonder about these charming little tables staggering under the weight of books and ornaments. There is not even room to scribble a visiting card (even commercial-size), fill out a sick note or thumb through an art book. Perhaps these desks are really just part of the stage-set, a kind of display case for showing off one's favorite objects, part of the decorative scheme of the room as a whole?

The auctioneer Maître Binoche has deliberately taken a different approach in his private office. The room is entirely paneled in light oak, with built-in shelf units which are totally invisible. There are a few books, two or three ornaments, and a huge work table, also in light oak, which was designed specially for him and which has no lamp, blotter or accessories.

The designer Christian Duc has created an office which is evocative of Japan, although actually it contains nothing that is specifically Japanese. There is a Quaderna notebook-table, a horizontal worktop and two low supporting walls covered with a white laminate with black joints, reminiscent of a school exercise book—which back on to a huge window featuring a white-slatted blind—a black chair, a lamp with a curved metal stand and round lampshade, an arrangement of four square white ceramic vases filled with plants and flowers that suggest bonsais, and a black metal perforated wastepaper bin designed by Joseph Hoffmann in 1905. The atmosphere is very conducive to meditation. It is an office which is at once original and depersonalized, a good place if you feel the need to go and sit somewhere in the morning, to think quietly for a while, far from the phone and external distractions.

A boudoir-office in a Russian home (facing page). The desk, placed by the window, is submerged beneath a plethora small objects. Cluttered with a divan covered with a Turkish rug and piles of books on an occasional table, the room itself more or less disappears under the décor. A collection of icons and porcelain figures adorns the walls and shelves.

Christian Astuguevieille's apartment is a collector's delight, a veritable curiosity shop, with all kinds of unusual books and objects. African statues stand on the mantelpiece, while one wall features rows of delicate butterflies in glass cases. Items of cord-threaded furniture, inspired by distant civilizations, stand like so many totems. Christian Astuguevieille takes everyday objects, such as chairs and vases, and braids them with cotton or hemp cord.

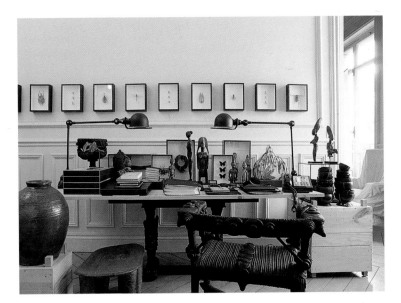

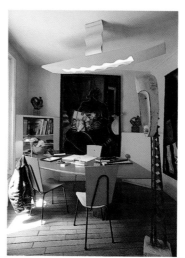

This highly colorful décor was created for the house of Paul Jacquette and Carole Duffrey at Joinville on the banks of the Marne. Surrounded by paintings and sculptures, these two artists have designed themselves an office in the style of the 1950s, with an asymmetrical red table, high-backed yellow chairs and strange light-fittings.

The office of Relka Maren in Polonezköy, a village near Istanbul founded by Polish refugees in 1850, has a calm and harmonious atmosphere (facing page).

This charmingly simple art deco-style office corner belongs to Geneviève Lethu, who was chosen best businesswoman of 1994 in France. It consists of a side table, some leather-covered chairs and architectural drawings on the wall (above).

An elegant office, in keeping with the image of Inès de La Fressange. The luxurious treatment extends to the smallest details. The timeless furniture, refined colors and simple décor create an ideal atmosphere for a relaxed cup of tea.

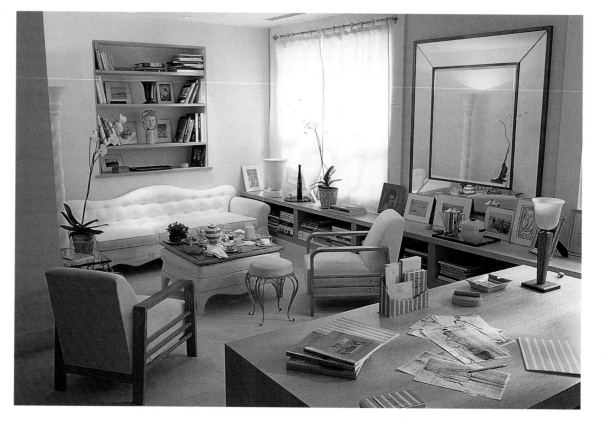

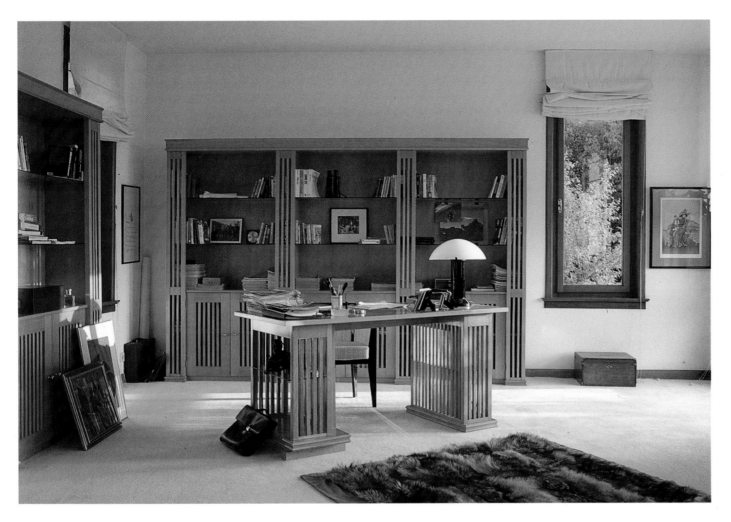

According to an IFOP study made in 1992, four out of ten French people have an office in the home, and one in seven say that they work at home at least one day a week. Which part of the house do these occasional workers choose for their work? The dining room table, after supper, perhaps? Or in a corner of the lounge on a small table facing the wall, or in one of the bedrooms, or even in the kitchen? Why not follow the example of the American actress—a devotee of the culinary arts—who got fed up of spoiling her soufflés every time the phone rang, so she decided to create a work space on the round table in the kitchen.

In order to protect themselves against being disturbed by visitors, some opt for working in the bedroom. Others show more creativity and end up in the most unlikely places—perched on a landing, perhaps, or clinging to a mezzanine, or even in their dressing room, like the architect Rena Dumas. The latter is a tiny space, as "portable" as one

of today's computers. And by way of decoration, a collection of small terra-cotta figures stands guard in a row on the window sill.

Teleworking has been billed as the miracle solution to problems of transportation and is raising the same kinds of hopes as computerization did in the 1970s. Working at home is nothing new, but working at a screen linked to a computer network is fairly recent. Technically, teleworking is not expensive or difficult to set up and yet it is not really catching on. In France there are, at present, barely 20,000 people working in this way. Many who do not may be apprehensive about taking sole responsibility for the organization of their time and worried about being cut off from the world.

The Axa insurance company launched an initiative along these lines in 1981, but it was not popular. A vast majority of the women who liked the idea opted for Wednesdays, the day when schools are closed

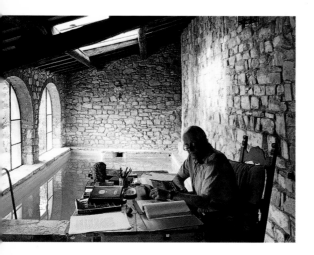

The British writer and journalist M. Flower in his villa in Tuscany. This poolside office, which would be the envy of any office worker, consists of a simple table placed at the water's edge looking out through stone arches.

in France. Teleworking and children are undeniably linked, but how many people can afford to juggle their lives in this way?

The first problem is where to work. People's apartments are not always big enough. Some women choose the children's bedroom, others the sitting room, while some take refuge in their own bedroom.

The second problem concerns the iron discipline that is required. Your family think that if mum is at home, it is because she is not working. The women who opt for this solution have to be able to work without being put off by external distractions. In France, some start on Tuesday evening, so as to be more available for their children on Wednesday. Out of six hundred people given the option in one firm, only forty decided to give it a try. Most preferred to keep the split between private life and professional life and made it clear that they were very attached to the social life of the office. People fear being isolated, stuck in front of their computers. In the words of one woman: "Two days away from the office is too much for me. I need to get out of my house, I need office life, I like coming here."

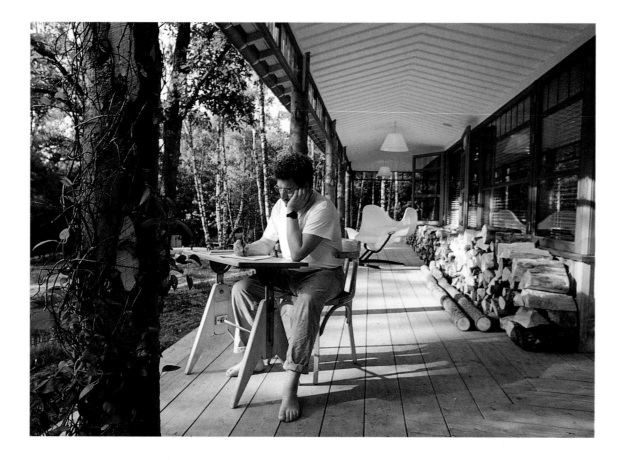

Desks can be tucked into the most unlikely of places (facing page). This one has been fitted into a space between the rafters, creating a tiny ivory tower. It is a simple flat work-top which appears to be tailor-made for the narrow space available.

A return to nature for Philippe Starck. The designer is working at a small drawing board—a makeshift al fresco office—on the verandah of the wood-and-glass colonial-style house which he designed for the Trois Suisses on the edge of the forest of Rambouillet.

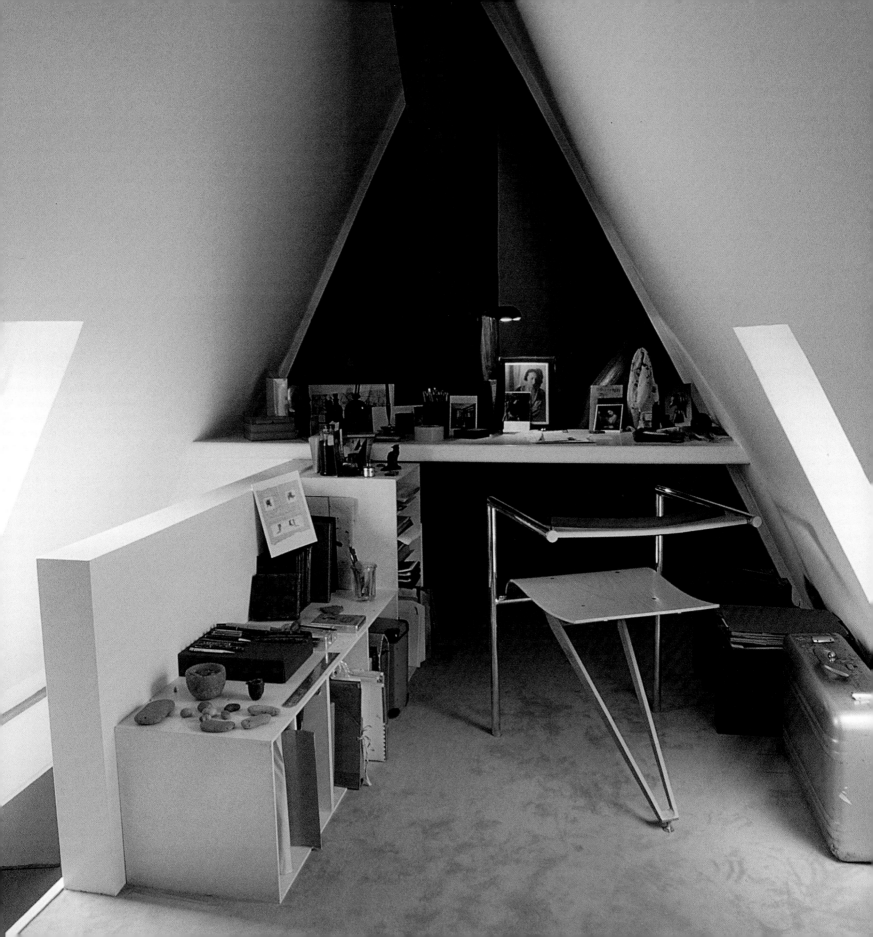

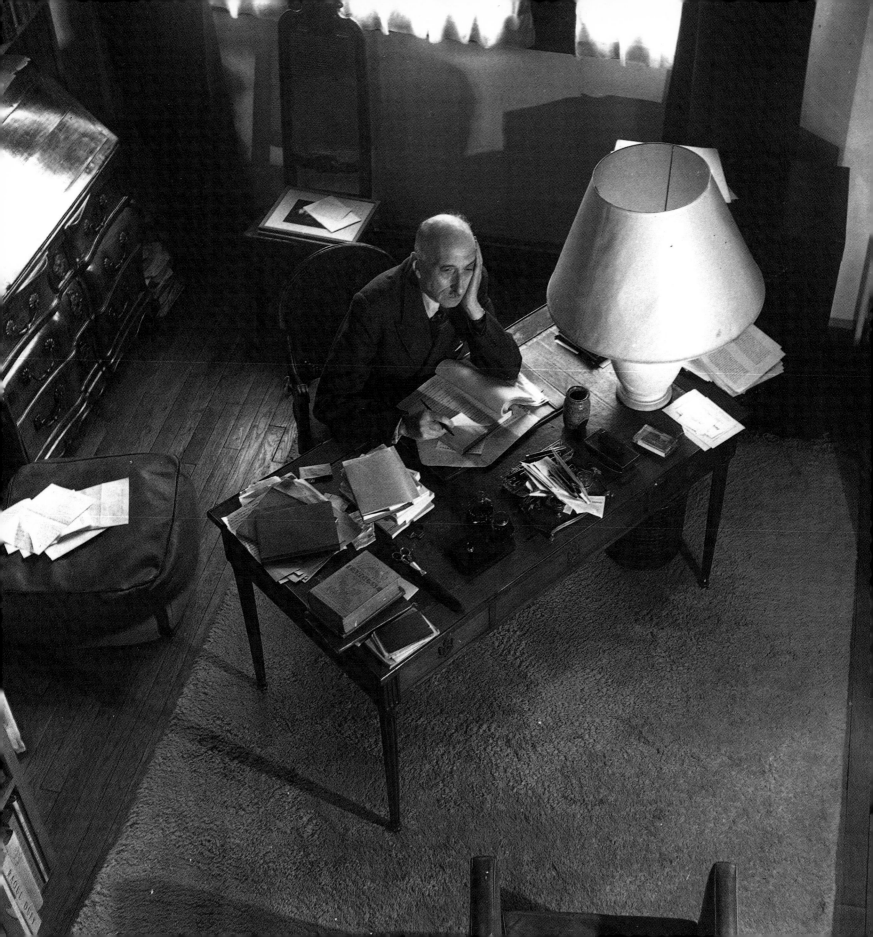

THE WRITER'S OFFICE

Writers practise their art in their own homes. Ordinary working mortals have always been rather fascinated by them and their style of life, perhaps because they seem to be the opposite of the average office worker: there is no boss on your back, fewer irritating interruptions with phone calls, no urgent files that have to be got ready for an evening meeting—just a work of creation and imagination, which brings you fame and glory—quite the opposite of ordinary people's work.

The world inhabited by writers is a world that is strange and rich. One imagines a den, a cave, a hideaway, a lot of suffering and loneliness. There is a stuffy smell of stale tobacco. An empty bottle of whiskey stands on the desk. It is a secret place, where visitors are not admitted, except after the author's death when he or she has finally become famous.

The writer's desk can be everything and anything, as authors and artists have shown, using variously their knees, the carpet, the kitchen table and their beds. However, most writers have a proper desk. "You know, even a young man tries to get himself a desk; it's one of the first acts of one's existence," said Pierre Schaeffer. A desk means a table with a chair and, generally, a typewriter. This is no longer a Remington, but an elegant portable machine which sometimes "jumps about like a frog." And now the writer has a computer too. There are two schools of thought on this: that of the hard-line writer who uses only paper and pencil and who types hardly at all, and that of the writer who has an affectionate relationship with his machine and who often writes at the keyboard. "I myself type for reasons of tidiness, morality and hygiene," said Pierre Schaeffer.

While François Nourissier moves at high speed up and down his long work table on a comfortable chair on casters, others have an extraordinary disregard for their chairs. More often than not they are badly designed and uncomfortable. There are rarely any chairs for visitors, because this is a private office—writers seldom or never have visitors. If the writer eventually manages to produce a book without too much suffering, they become superstitious and try to repeat the experience, in the same setting and with the same tools. They go to great lengths to regain that state of grace. Perhaps this explains the almost pathological attachment that some writers have to the tools of their trade. If they lose their favorite pencil or run out of their usual paper, it is a personal disaster of the first order and inspiration dries up. On one occasion Georges Simenon enacted for the cameras his "scenario" for writing. It was always the same

Surrounded by books and papers, Marguerite Yourcenar used to write sitting opposite her friend Grâce, in their house at Petite Plaisance. "The walls of a house are like a collection of memories. Documents of what one has done." They both used to work surrounded by reproductions of Hadrian. On the table stand two lamps with parchment shades, on which Marguerite had inscribed calligraphic inscriptions in ancient Greek.

The writer and journalist François Mauriac had a rather austere office (facing page). The author of *Noeud de vipères* and *Baiser au lépreux*, and Nobel Prize winner for literature in 1952, chose not to surround himself with a welter of personal effects. This was a working study with a simple Louis XVI table.

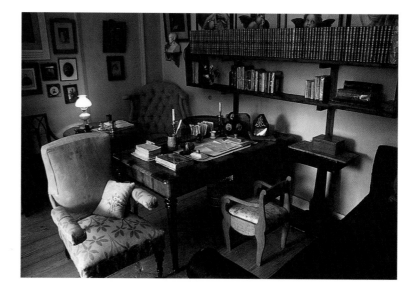

The study of the Russian novelist Leo Tolstoy, at Yasnaya Polyana, in Tula. Curiously, the small chair was not intended for one of his thirteen children, but for the author of *War and Peace* himself—a practical solution for a short-sighted man who did not like wearing his glasses.

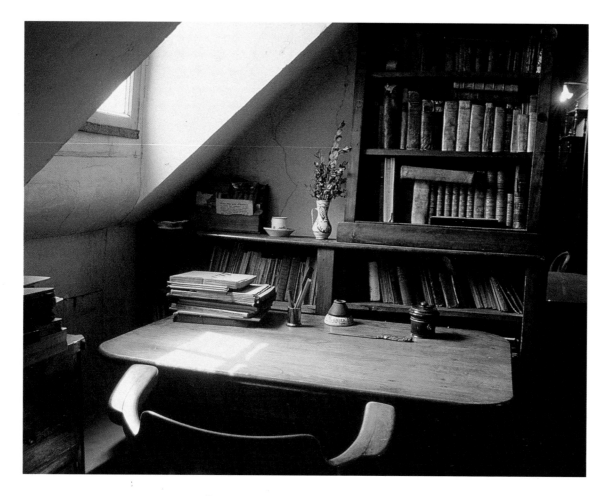

In 1913, the poet and art critic Guillaume Apollinaire left his house in Auteuil, where he had been living with the artist Marie Laurencin, and moved into an apartment on the boulevard Saint-Germain in Paris. He organized an attic retreat for himself, modestly fitted out with a simple table and a few books.

A portrait of Alphonse Daudet, the author of *Petit Chose* (1868), at his desk (facing page). Everything around him seems over-large. In order to reach his desk, he had to sit on a thick ledger. Daudet, whose work is all too often relegated to the children's section in book stores, was very popular in his time.

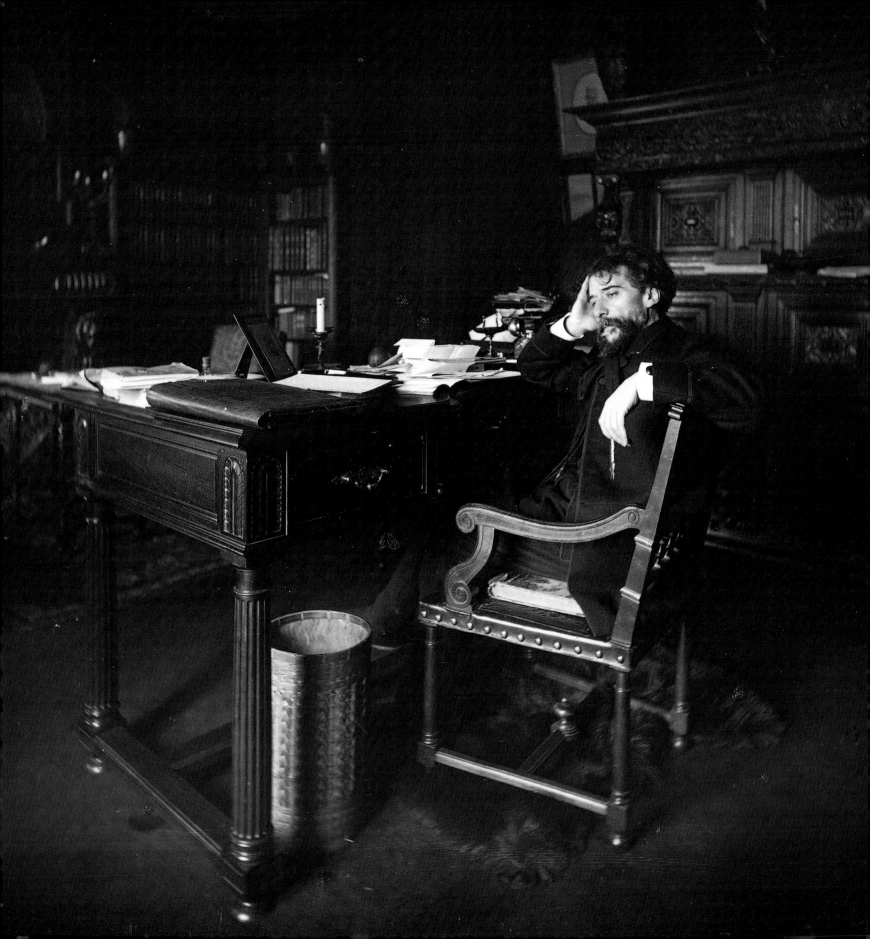

from one book to another: he would hire a hotel room, put a table in a bathroom with no window, and there set up his typewriter, his paper, his pencils and his pipes. Why change a winning system?

On a writer's table things are generally chaotic. Writers resent having to do secretarial work, given that they already spend so much time at the keyboard. There are piles of letters pending, official paperwork, documents, dictionaries and diaries. Pages written the previous day, plus that day's pages, lie in a pile on the desk. Some writers simply change desks and change rooms when the jumble gets too much for them—like Jean Cocteau: "I'm drowning, pursued by disorder. It creeps into my room like a barbarian invasion." He ended up leaving his apartment and developed a taste for hotel rooms—"A wonderful, abstract thing"—where he was able to distance himself from the "walls of the rue d'Anjou, which watch me and devour me."

Most writers hate doing housekeeping and woe betide anyone who touches their desks. But one should not give them all a bad name. They

Jean Giono was born in Manosque, Provence, in 1895. He stayed faithful to the modest house that was his birthplace and left it only grudgingly for occasional short trips to Paris, "that necessary miserable hell." Here we see his attic office, where he wrote by hand in simple spiral-bound notebooks. On the table lies the manuscript of a work in progress and various favorite objects.

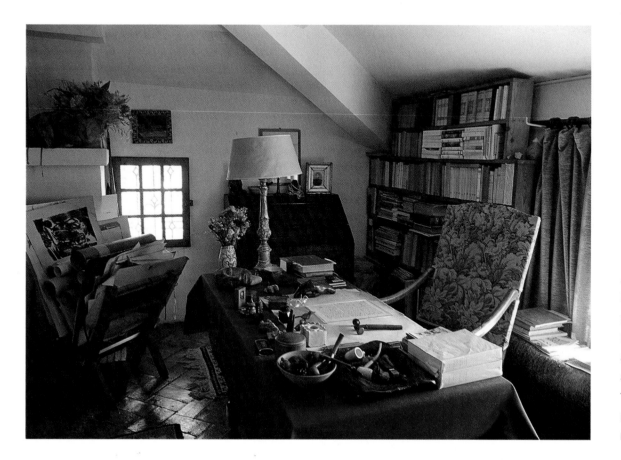

Jean Cocteau's office in his house at Milly-la-Fôret, where he moved to in 1947 (facing page). A small drawing board is piled with books and notebooks. On the wall, against a "panther-skin" background, hangs an assortment of photos, doodles and letters. There are mementos and portraits of intimate friends, including Picasso, Jean Marais and Colette.

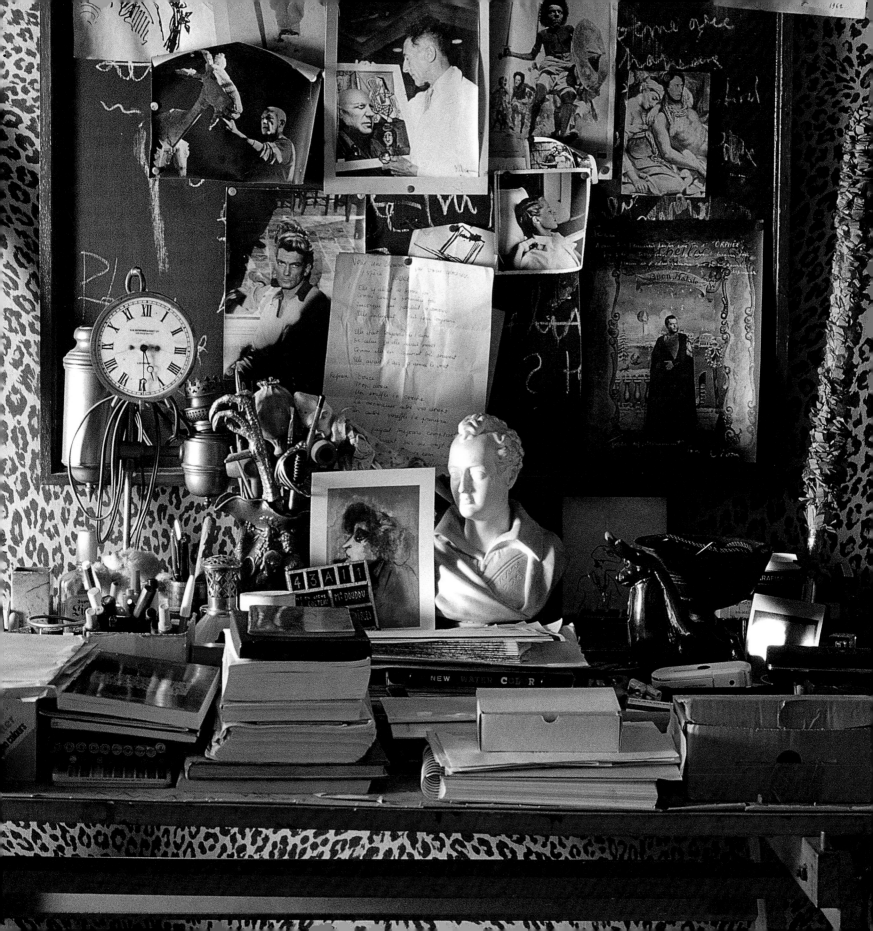

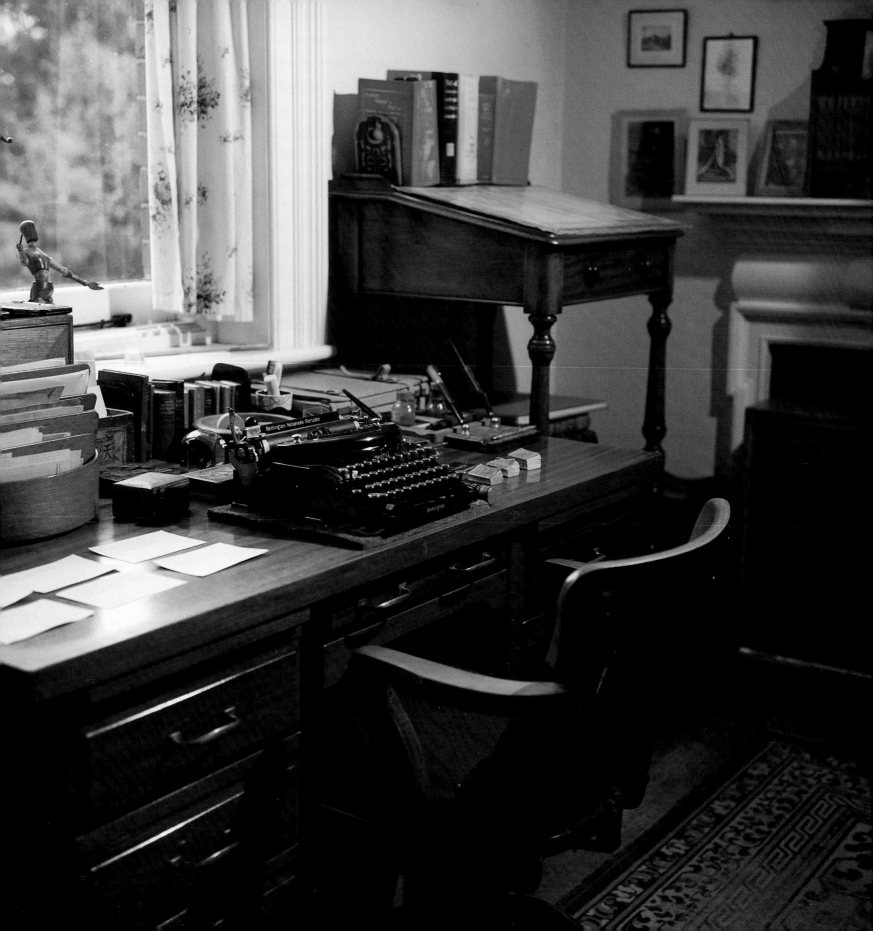

may not like housekeeping in their studies, for sure, but they generally like order in the rest of the house. There are, however, exceptions. For example, Paul Léautaud used to work in an indescribable shambles, surrounded by cats and dogs, on a small work table next to his bed. He would complain that whenever he had anyone to visit, it was hard for them to find somewhere to sit. At the other extreme there are the obsessive ones who cannot start writing until they have made their beds, dried the dishes and tidied the house from top to bottom.

When you look at the disorder in these private offices—there are not the same pressures as in a company office—you are tempted to remind these writers of a practice which is supposed to take place in England every year on 10 January: "National Clean Off Your Desk Day." Companies in St. Petersburg set aside a day for cleaning the windows. Everyone takes part and there is plenty to be done, given that the windows are all double-glazed. One office clean-out per year is perhaps hardly excessive. Einstein used to do it every once in a while and would find out-of-date cheques that he had forgotten to bank. A writer might be lucky and find the odd mislaid manuscript. In 1912 Gaston Ravisse, writing in his magazine *Mon Bureau*, offered this advice: "If you want to increase your output, put some order in your office."

Unlike most of the world's victims of offices, writers can permit themselves all kinds of excesses, and that is why they excite fascination and a touch of envy. We forgive them their manias and eccentricities if they are necessary to creativity—cats on the table, a little monkey, or perhaps, like Céline, a parrot that used to nibble his pens. Georges Conchon has three bicycles in his office. "They're my sculptures. Other people have Giacomettis and Zadkines, I have these. They are airy, they give an impression of space. They talk with me about what we're going to do, one of the three of them and me, later in the afternoon, once I've finished my work—that wretched drudgery, that prison which is the writer's world." One person might settle for a few Chinese knickknacks. Another might have pencil pots, or a collection of inkstands scattered around in a deliberate disorder which nobody else has the right to touch, as was the case with William Faulkner. The writer's lamp may be in the form of a lady sitting on a rock, or—somewhat less poetically—a design that would look more at home in a police station.

Tables come in many shapes and sizes. Geneviève Dormann prefers a large wooden table, "because I can't stand writing on cold things." Jean Vautrin has a Ruhlmann table, "a rational piece of furniture, with a lot of drawers. And on the top there's a sheet of glass under

The work room of George Bernard Shaw, the author of *Pygmalion*, at Ayot St Laurence in Hertfordshire (facing page). This Irishman and lover of nature liked to have his typewriter facing the window. To one side stands a lectern where he could consult books. He also liked to tuck himself away in the shed at the end of his garden.

In 1930, Vita Sackville-West moved into a half-abandoned manor house at Sissinghurst in England. "Her house is pleasant, has some style and splendor, but no novelty, nothing original." Such was the verdict of her friend Virginia Woolf, whose portrait stands on the writer's desk. Her first-floor office-library was an ivory tower where access was forbidden even to her children.

which I can slip photographs." Photographs of writers, of course. While most writers are happy with a board resting on a couple of trestles, others cannot live without Napoleon III furniture. More surprising is the writer who enjoys writing on oilcloth tablecloths. Each has a special relationship with their desk. "My desk and I have an exemplary conjugal life. We never argue. She puts up with everything," as one writer confided. Paul Valéry used to say: "Parting me from my desk would be like parting me from myself." And so, over a period of fifty years, every morning, "in the solitude of the dawn," he would set off "in pursuit of ideas."

In writers' apartments, the table is not placed just anywhere. Writers like attics and rooms that are out of the way (their ivory towers?). They may have to put their desks up against a wall, to avoid the daydreaming brought on by the sound of birds, or the view of trees or the street outside. In 1965 Lawrence Durrell moved into a house at Sommières. His desk was an ordinary turn-of-the-century kitchen table, painted white, placed on the verandah and facing the wall. By way of company, he had a bunch of flowers, a few sheets of paper and a portable typewriter on which he would type frenetically.

RIGOR OR FANTASY

The writer faces the same problem as the office worker: any excuse will do for ducking out of work. Going to the kitchen to make a cup of coffee simply demands rather more time than popping down to the coffee machine in the office. There are more distractions—although fewer opportunities for chance meetings—than in a business office.

Another common ground that the writer shares with the office worker is the ritual surrounding work. Writers tend to be more whimsical, less respectable. They are often as routine-oriented as people in the white-collar sector. Some can only work between given times of the day. Some need total peace and quiet, while others prefer an ocean of noise. Most tend to write early in the morning and night-work for writers is tending to become a thing of the past, although some do close their shutters and work only by artificial light. On Saturdays and Sundays most relax like the rest of us. They all have their own distinctive work routine. Some feel obliged to stick to a routine that would do credit to a civil servant. Others prefer school hours—and school holidays too. Some give full rein to their inspiration; they work twelve or

The study of the German writer Karl May in his villa at Radebeul was a celebration of hunting (above). Comfortably seated on an oriental carpet, which served as a seat, he is surrounded by his trophies—a magnificent stuffed lion and stag's head, animal skins on the floor and an arsenal of swords and rifles hanging on the walls.

Novelist, journalist, politician, member of parliament and academician, Maurice Barrès, author of *Du sang, de la volupté et de la mort*, is seen here sitting at his desk. Behind him are framed panels showing details from Michelangelo's *Creation* (facing page).

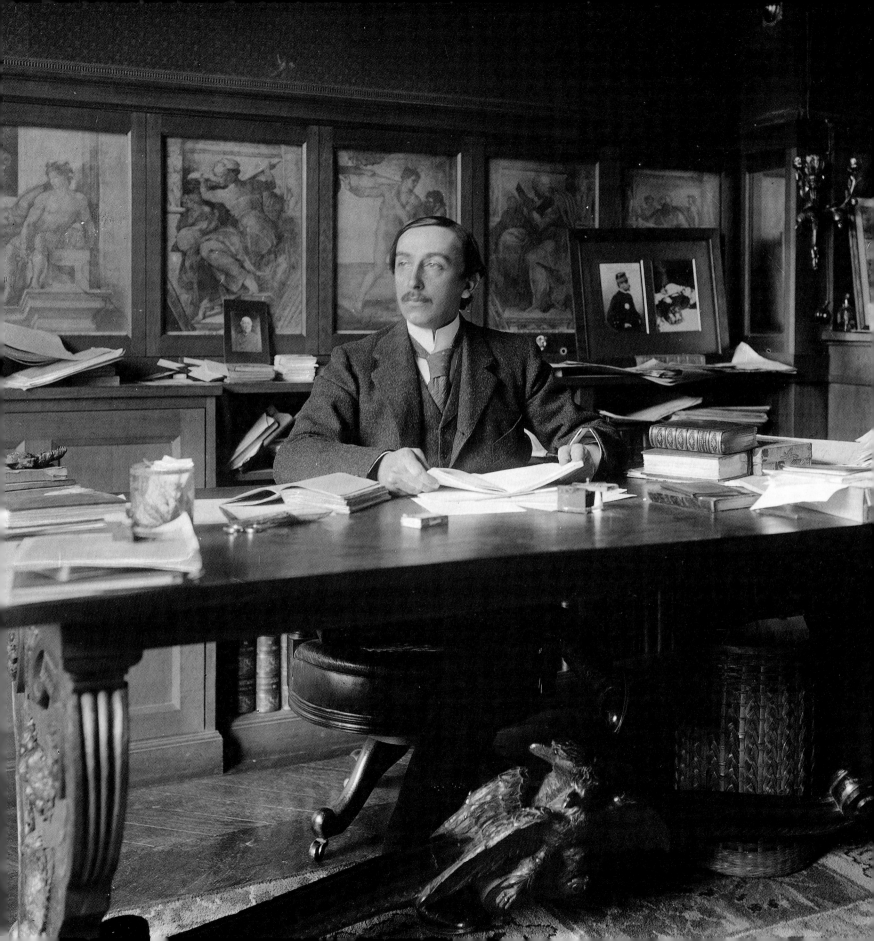

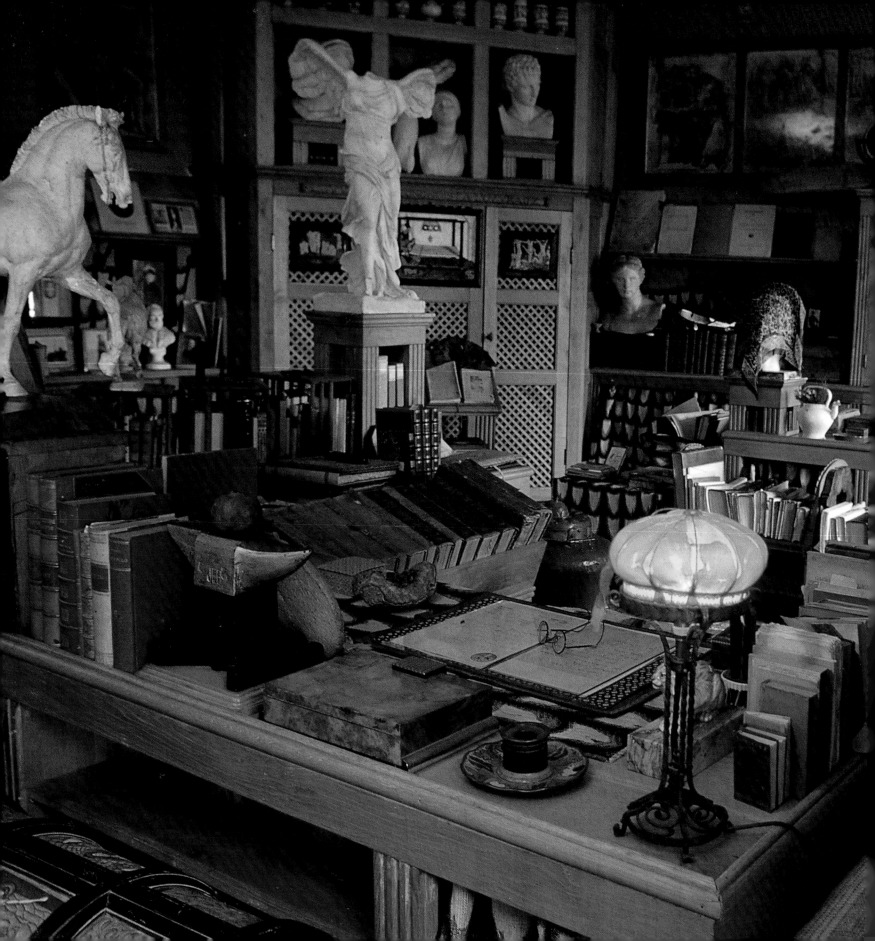

Gabriele D'Annunzio worked with a young architect, G.C. Maroni, on the restoration of his villa at Cargnacco in Italy. Beginning in 1922, he restored, modified, built and transformed it little by little into a veritable museum. He spent whole nights in his study, which was lined with books, plaster casts and documents.

Colette, "that lively woman, that authentic woman who dared to be natural" was also an actress, mime and dancer. This photograph of her was taken by Herbert List in 1949. At the end of her life she suffered from a paralyzing condition. She was confined to her bed, which became a kind of "raft," as she liked to call it, but continued to write.

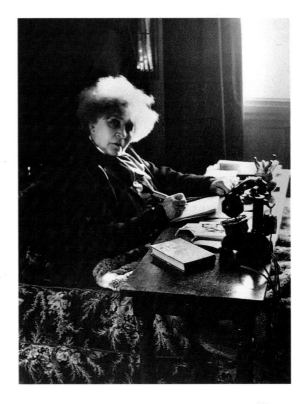

Patrick Mauriès, the writer and director of the "Le Promeneur" collection, is a great book-lover. They are indispensable to his art and he accumulates piles of them in his apartment, which has become a veritable library (facing page). In his spare time he enjoys sitting and flicking through them. When he writes, however, he shuts himself away in the kitchen to avoid distractions (above).

A 1930s style desk in the Milan apartment of the fashion designer Alberto Lattuada (below). A born collector, here he has brought together all his favorite items of furniture and ornaments.

twenty-four hours at a stretch and then do nothing at all the following day. And we would all like to have the order and discipline of someone like Le Clézio, who is capable of writing an entire manuscript in one go, all in the right order and virtually without revisions.

Pierre Bourgeade has described his visit to Michel Foucault: "I was very impressed, because on a long wooden table there was a manuscript which was visibly in the process of being written . . . You could see, for example, that Foucault had arrived at page 382 . . . The pages were neatly arranged in a pile . . . I felt rather ashamed of myself . . . I wondered what he would think if he only knew how I tend to write!"

Writers' originality is also expressed in what they wear. Here is where the ordinary office worker gets really envious. It is hard to imagine the average white-collar worker wandering through the corridors in shorts, draped in shawls, wearing a dressing gown, or even in Babygro pyjamas with big woolen booties, as does Yves Navarre. Most writers dress fairly sloppily, walking round in their socks or barefoot, with the exception of Angelo Rinaldi, who assures us that when he writes he wears a tie, "out of respect for grammar."

Others prefer to be seated, but not at a desk. "I don't like to think that I'm sitting there writing. It alarms me," explains one writer. "If I sit at a table to write, if I actually tell myself that I'm going to write, I freeze." They invent all kinds of ingenious systems: a red-painted board with a raised edge to stop their pencils rolling off, with large binder clips to keep their papers in place, resting on a deck chair, or across the armrests of an armchair, or even on footrests.

An extraordinary number of writers write lying down. In most instances it is because they have no choice—for reasons of failing health, as in the case of Colette and Proust. The latter almost never left his bedroom. *À la recherche du temps perdu* opens in his bedroom in Cambrai and ends in another bedroom, that of time regained. Proust used to write with the shutters closed, the double windows shut and the big blue curtains drawn. The only source of light was a small bedside lamp with a green shade. He used large hardback notebooks and a small rosewood table with side flaps, on which were placed his pen-holder, his pens and his inkstand. Although he was very sensitive to the cold, he also had to avoid heating because of his asthma attacks. When writing or receiving visitors, he preferred to be heavily wrapped in fur coats with otter collars edged with mink. Anna de Noailles never left her bed either. Her writing surface was a large flat book of "old-time songs for the tender-hearted." She could not stand any kind of household noise and her bedroom was padded with cork covered with cretonne.

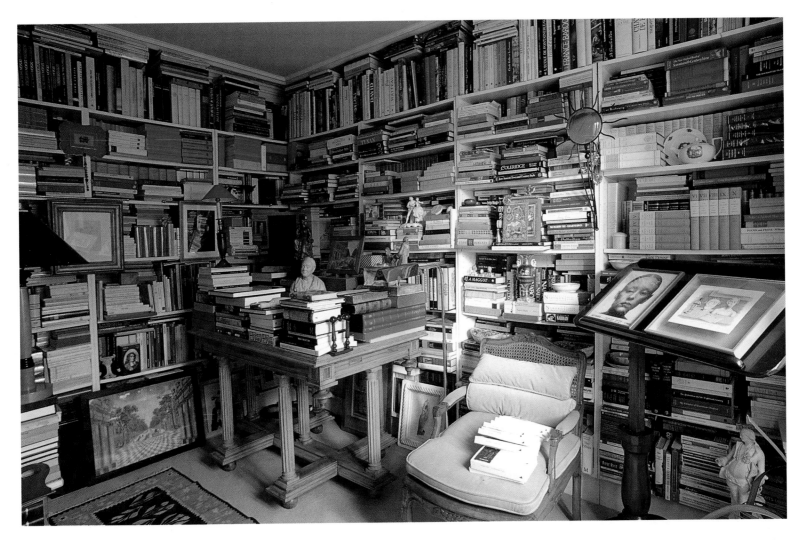

As Marie Cardinal put it, your bed is the only truly private place you have, respected by your family and, in particular, by your children. If you use the table in the lounge or dining room, first you have to clear it. Your bed, on the other hand, is always available. However, she prefers to write "not stretched out on the bed, but lying back with blankets and pillows." She also uses her typewriter in bed. Most people would prefer a sofa.

Some authors, such as François Weyergans, prefer discomfort: they cannot stand writing in apartments where there are carpets. Sometimes he sits on four telephone directories, with his typewriter on a chair. Yet another types lying flat on his belly and breaks off regularly for a round of patience. What would people think if bank employees started doing this kind of thing?

All writers have a close relationship with their work environment. Some can only ever work in the same place. Others recognize immediately the rooms in which they will not be able to write, perhaps because they are too near the family. Others seek solitude and work in sheds at the end of the garden. George Bernard Shaw, for example, had a hut which was a model of simplicity, comfort and ingenuity. It contained a desk, a Remington portable and an alarm clock to ensure that he did not miss lunch. Finally, in order to enjoy the morning sun whatever the time of year, he had a system for rotating the entire floor, like a roundabout. According to his secretary this mechanism was rarely used, presumably on account of the weight of his desk and books.

Jefferson, Churchill, Hemingway and Victor Hugo all used to work standing up, as does Henri Troyat today. Churchill designed his own

An intrusion into the private world of the
writer Georges Duhamel, photographed
here by Cartier-Bresson in his house at
Valmondois. On an untidy desk we see a
coal bill waiting to be paid, a clothespin—
symbols of the details of everyday life. All
his life he wanted to be "a friend, to help
people to live, to suffer, and to be cured."

A photograph taken by Gisèle Freund in
1962 of Jean-Paul Sartre and Simone de
Beauvoir in their apartment on the
boulevard Raspail in Paris (facing page).
The couple had a taste for "transitional"
spaces, such as hotels and cafés. The
apartment has the air of a student room: an
anonymous work environment, with an
improvised layout. The furniture consists
of essentials: a table, a chair, an inkstand
and Sartre's famous Boyard cigarettes.

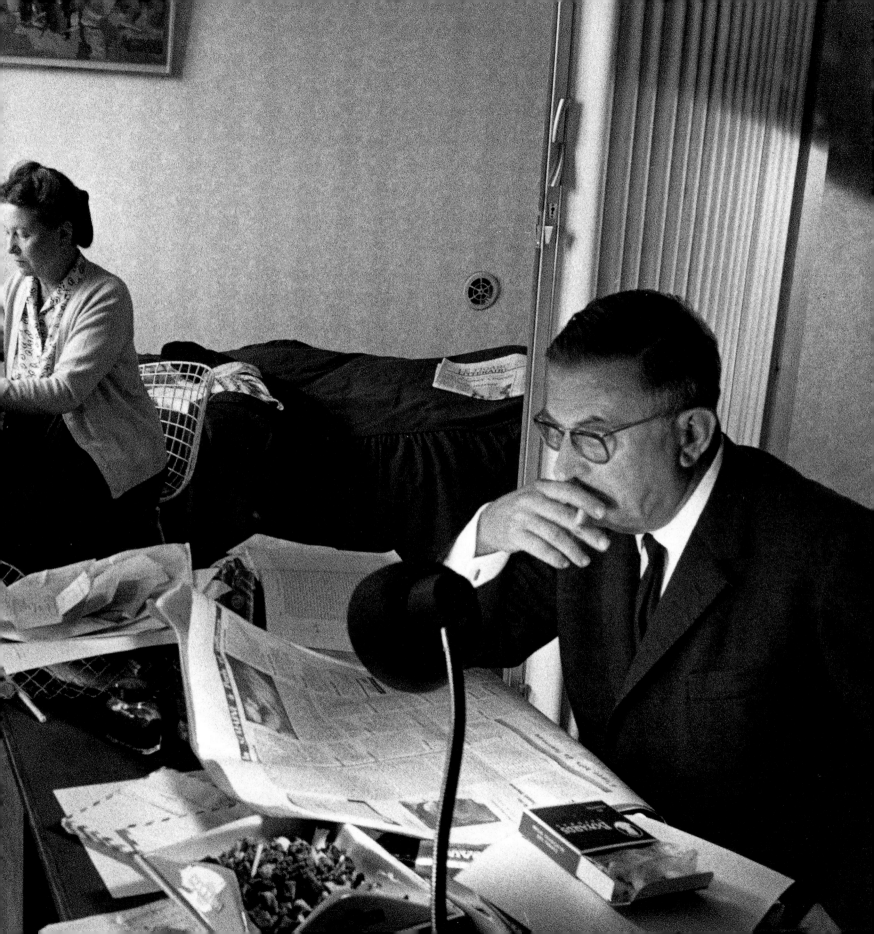

Novelist Françoise Sagan hard at work. The author of *Bonjour tristesse* is able to work anywhere—in a hotel or on the corner of a table. Décor is of no consequence. With her eyes firmly fixed on her portable typewriter, absorbed in her work, she is surrounded by the bare essentials.

Winston Churchill's desk in his house in Kent (facing page). The various objects—a Sèvres porcelain bust of Napoleon by Antoine-Denis Chaudet, photographs, a silver box, glasses, a stapler—leave little room for writing on this highly personal desk.

work surface, modeled on Disraeli's. It was an ingenious system, with a very wide lectern for writing on, low shelves and a raised shelf for books. In her youth Virginia Woolf used to write standing at an architect's drawing board, with a pen which she would dip into green ink. But the number of writers who work standing up has always been small. François Nourissier inquired mischievously whether the choice of a standing posture revealed that the writer was suffering from excessive admiration for Victor Hugo, compression of the spinal column or a bad case of piles.

The writers who work in hotel bedrooms are a dying breed, but fortunately not yet completely dead. And there are still writers who write in cafés, such as Nathalie Sarraute, or who scribble frantically in small notebooks which they carry with them everywhere, in the streets, squares and subways. One day, while riding on a train, Jean Cocteau, in the absence of any kind of paper, ended up writing in Jean Marais's address book: "Words come to me in a rush, in big chunks, and if I don't get them out I wouldn't be able to write anything further."

While Marguerite Yourcenar was professor of French in the United States, she did not write for the best part of ten years. In 1949 she was sent an old trunk that she had left behind in Switzerland. It contained an early manuscript of *Mémoires d'Hadrien* which she had abandoned twelve years previously. She took a train to Santa Fe and began working on it again. She wrote compulsively for two days on the train, continued in her hotel, and then again on the train during the journey back. In Josyane Savignaud's biography we learn that she never saw herself as an "ivory tower writer," but that all of her books, while they were written "with one foot in erudition and the other in magic," could have been written anywhere.

With the advent of the microcomputer, a fair part of the mythology of the writer is in danger of disappearing. The fact of typing on one's computer gives the author something of the air of a personal assistant. It also means you have to stay close to a plug—unless you invest in a portable, that is, but then you are in danger of looking like an aging executive between flights. In a few years from now will we still find writers who are wholly committed to pencil and paper, and the wastepaper bin? In company offices the smell of freshly sharpened pencils is tending to become a thing of the past, to be replaced by the smell of hot plastic from the computers. The wastepaper bin is likely to vanish too, becoming the virtual wastepaper bin which appears at the bottom right-hand corner of your computer screen.

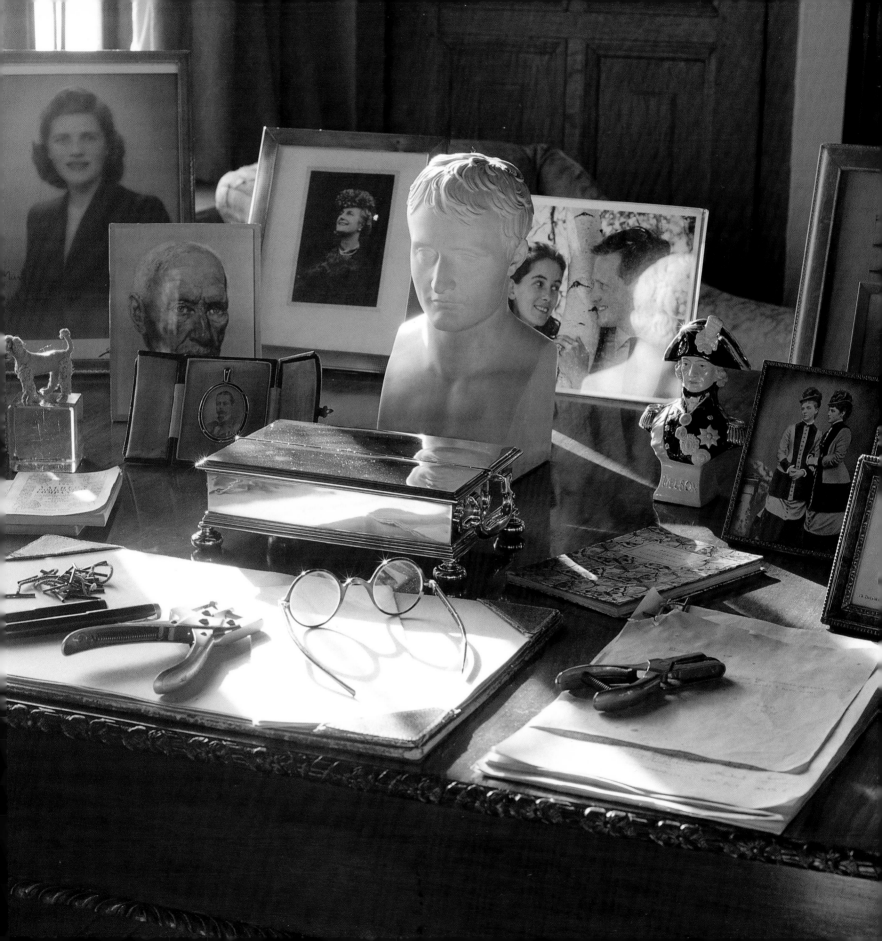

The office of tomorrow

A microcomputer
the size of the book,
a mobile phone, and
your business becomes
virtual. Is the office
as we know it about
to disappear?

In the space of twenty years the computer has completely revolutionized the way we work. Present almost everywhere, it has now come to symbolize the world of work. Here, in the alcoves set up along the corridors of the Ministère des Finances in Paris, the little screen, with its amber glow, keeps watch (preceding double page).

Studies and interviews have confirmed that the office is not always the most suitable place for work. There are too many interruptions and your time is too easily fragmented. Concentration happens more easily elsewhere, such as in your automobile, perhaps, or in your bath.

Has the office become a kind of refuge in a difficult world, particularly in large cities where commuting to work takes up a huge amount of people's time? Every day in Paris approximately 234,000 people travel out beyond the *périphérique* to get to work. At the same time, around 925,000 commuters pour into the city from the suburbs and 100,000 come in from the provinces. These extraordinary statistics were taken from a study of commuting times: in the opinion of one consultant, when people have two or three hours commuting per day, the mere fact of turning up on time in the morning represents such an effort that you should not expect much more from them afterwards. Their day is already more or less finished by the time they have arrived. Conversation tends to focus on news about train cancellations, strikes and traffic jams. The cost—in terms of time, money and physical and mental energy—of all this traveling is well known, but it seems that it is rarely taken

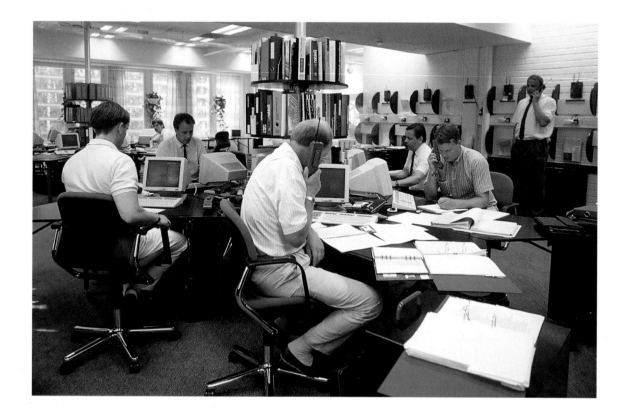

The famous offices of Digital Equipment in Finland, in their "classic" form. Tables, chairs and computers are laid out like petals around revolving storage units. The telephones are portable—a prerequisite for staff mobility, enabling people to work anywhere.

into consideration. Inevitably, the tendency to cling to one's office, even at the cost of thousands of hours of traveling to work, is reinforced in periods of uncertainty, recession and high unemployment.

Work sharing has become a major area of interest in recent years. A CSA survey in 1994 revealed that 77 percent of women in France were in favor of it and 66 percent supported part-time work. Work sharing inevitably means office sharing.

Today corporations are beginning to take an interest in office "flexibility." Early initiatives included the invention of items of furniture on casters, designed so that work could be moved from one room to another. These new furniture systems have not made much headway against the office worker's basic impulse to stay glued to their own work space. There are some things that people will never willingly give up, among them a fixed workstation and a phone. However, the formula of "one person = one room" is beginning to seem rather dated. Increasingly the talk is of space flexibility as well as personnel flexibility.

With the recession, the real estate requirements of companies have been altering. When companies move premises, they do it in the interests of economy and a more efficient use of space. They look for ways of reducing the amount of space they need. In physical terms this often translates into a return to the small, tightly packed, open-plan office, with all the drawbacks discussed above.

SHARED OFFICES

Fortunately there are examples of innovative solutions, such as unallocated desks and office sharing. These are both part of the same trend: to reduce the need for office space by creating practical, communal work spaces. But they are also symptomatic of other concerns: interchangeability of personnel; avoidance of the tendency among staff to become desk-bound; and finally the imposition of new ways of working. This represents perhaps the final stage before the "virtual office."

The head of one management consultancy went even further: "When I see somebody producing a replica of his home environment in his office, complete with children's drawings and photographs, I think to myself that if he can't survive eight hours a day without photos of his kids, there must be something wrong. For me, the office should be a place of communication and exchange between colleagues, not a juxtaposition of individuals in a décor more appropriate to their private lives."

In order to encourage space sharing, companies have invented the concept of unallocated work space. While not yet commonplace in the business world, it already has a name: "hot-desking" or in France the SBF, or *sans bureau fixe*. It is a small office, generally closed off, equipped with the very latest in technology, which members of staff book for an hour or a day at a time, like booking into a hotel room. They take it in turns, each going in with their little trolley of personal effects. You are expected to leave the room as you would like to find it.

Office space at Digital Equipment covered 150,000 square yards in 1994 and represented one third of the company's overheads. The idea was to reduce this cost by 30 percent over a two-year period by creating unallocated work spaces. Each employee sets themselves up wherever the fancy takes them, with their portable computer and mobile phone. The same thing is happening at IBM. Each employee has a work space, but not their own office, so that the company's five thousand "nomads" (60 percent of its total workforce) "free themselves from the time and space of work." You only gain entry to these spaces with the right computer access code.

Bossard Consultants, a firm employing eight hundred people, is trying a variation on this practice: in this company almost nobody has desks as such, since the office furniture consists simply of tables, chairs and electrical sockets for laptop computers. It is a case of first come first served. And in the evening you had better not forget your pen or an important file—anything that is left on the tables is automatically thrown out. Those are the rules of the game. The top of each shelving unit slopes to prevent any transgression. This is one way of combating the tendency towards "cocooning" and apathy that lurks in all of us. There is no question of being able to settle down in one's office for the day. A good consultant is a consultant who is out on the job and the amount of time spent sitting down must be kept to a minimum.

A second solution, which has the merit of simplicity (at least as an idea), is desk sharing. This works on the principle of musical chairs. The last person in the line does not get a chair and so loses. In the business world this takes the form of an office shared between two or even four people. This presupposes an organized and disciplined use of time. You cannot have four people all wanting a desk at the same time. IBM is experimenting with this at the present time, using some of their staff as guinea pigs. Company studies on how time is used show that IBM sales representatives spend 30 percent of their time with clients, 12 percent traveling and only 24 percent in the office.

SEDENTARY AND NOMADIC EMPLOYEES

The unallocated work space, or desk pooling, is directed principally at "nomads"—in other words people who spend much of their time outside the office. The gap is growing between "sedentary" and "nomadic" staff. Some staff may be given the opportunity to work partly from home, but others will always be prisoners of their phones and computers. Their presence will be required in the office to deal with visitors, arrange appointments and keep filing up to date. The nomads are freer. And these "nomads," do not only refer to sales representatives going out to see clients. For example, in the French Conseil d'État, individual councillors do not have private offices as such, but have access to libraries, where they can work when the need arises. The "nomad's" office is a temporary space, used for a few hours or a few days each month. The most innovative solutions are being developed in companies with large numbers of "nomads," but these tend to be rather unfair on the sedentary workers, who are treated only to advances in ergonomics. In this sphere things are becoming rather elaborate, with wrist-rests, footrests, copy-holders so that documents can be placed at screen height and swiveling supports for monitors. The overall aim is to improve the interface between man and machine. San Francisco was the first city to promulgate municipal laws on the use of personal computers in 1990, with requirements for non-reflecting screens, free-standing and adjustable keyboards, and screens which were adjustable in terms of position and height. Despite these developments, sedentary workers are still stuck in front of their computers with their personalized mouse mats.

However, beyond the expertise of the ergonomists and the provision of better lighting and more suitable furniture, what really needs rethinking is the way departments function, general organization and the work of each individual.

There is a second tendency in office layout which goes against the current of this "depersonalization" by creating tiny but private "combi-offices," the kind of office one might have at home. The accent is on comfort and the need to be able to shut oneself away or meet with other people. Here the overall environment is crucial for the development of a different kind of office life. The combi-office is a space that is tiny and functional, a monk-like cell equipped with modern technology, a space which, despite its small size, one person can appropriate.

Other rooms are provided for receiving visitors and meeting with colleagues. The combi-office is a place for reflection and meditation. In order to save space, storage units are set above head height and telephones and even the computer may be suspended. It is all highly practical—you do not have to stoop any more—but it is very much like a kitchen-laboratory. This form of organization requires the user to leave his office periodically, to look for a file, attend a meeting or relax in the corridor. If the surrounding spaces are large and well laid out, it all functions very well.

Euro-RSCG, a Parisian public relations agency, recently moved to new premises in Levallois, abandoning private individual offices of between sixteen and eighteen square yards, in favor of monk-like cells of a mere eight square yards. These cells go hand in hand with large communal meeting spaces designed to provide, as the company's president J. Séguéla puts it, "Both stimulation of the brain and solitary concentration."

THE OFFICE AS CLUB

Other companies equally concerned to economize office space have rethought their organization and the way they function, and have radically changed their work environment by creating layouts that are sometimes modeled on the private house.

The most famous example, mentioned above, is Digital Equipment in Espoo, Finland, created in 1988. The same room is used by different people for a variety of purposes. In the view of the project's architect, Arto Kukkasniemi, there is no one single way of working but several and the work environment needs to be a source of stimulation for all. For example, there is a living room or lounge, which is equipped with comfortable armchairs. These chairs can be reclined until they are almost horizontal and are fitted with large wings in order to provide a degree of privacy. They resemble seats in the first-class section of an aircraft. Staff work wherever they like, with their portable phones, computers and storage units, the latter two mounted on casters. An employee's chosen space might be in a corner, for privacy, or near colleagues so that they can all work together. Electricity is supplied via braided colored wiring suspended from the ceiling. There are some rooms which are entirely private, rather like bedrooms in a house, for those who need peace and quiet. Other rooms offer more conventional work spaces, with tables arranged in a star formation around a tall revolving storage unit. Finally

there is the "garden," a room that has greenery and a swing seat for informal meetings, and tables where staff can either have lunch (there is a small kitchen) or work in the more classic sitting position. Francis Dufy, the head of DEGW, a British architectural practice specializing in office design, has long been promoting this kind of layout, which is loosely modeled on the British clubs of the nineteenth century, on the grounds that it promotes efficiency and creativity.

Why should a conference room need to look like a conference room when a lounge area can serve just as well? It is said that Marcel Bich, the inventor of the Bic biro (and in passing let us hail the Bic, which entered offices in the 1950s) and disposable lighters, always remained standing during meetings and never invited his colleagues to sit down, to avoid meetings going on for ever! Editorial meetings of the daily *Le Monde* sometimes proceed on the same principle.

Some companies provide real kitchens, complete with fridge, and a shower room where people can change after jogging. However they do not usually go to the extent of providing full-blown locker rooms or truly comfortable furnishings such as sofas, swing seats and hammocks.

The offices of Digital Equipment in their unconventional form. This large blue lounge area, with its comfortable seating, has a relaxed, informal atmosphere. You can either work on your own, at a computer on a small table, or meet with colleagues. This is an office which, contrary to appearances, is functional as well as convivial.

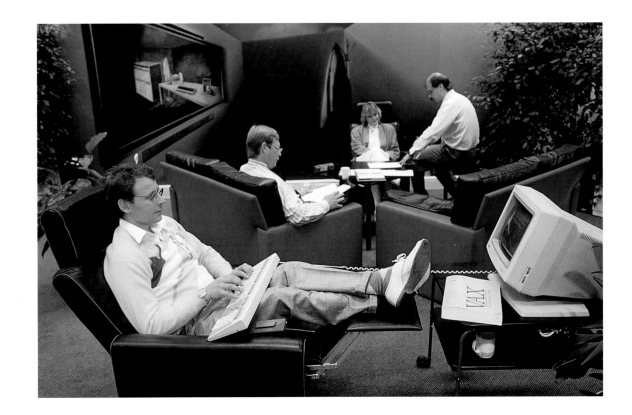

The reception area of the Playboy company in Beverley Hills, designed by Sam A. Cardella. There is a subtle interplay, emphasized by the lighting, between the cutaway patterns of the ceiling, the openings in the wall and the patterning on the floor. The curves of the counter and the small low chairs with fluted legs are a nod in the direction of art deco.

The British architect Sir Norman Foster designed this spectacular scheme in Duisburg, Germany (facing page). The oblong shape of the building and large windows give this room the feel of an ocean liner. Long work tables, arranged in star formation around a majestic "keel," and the minimalist lighting, seeming to fall from the sky, highlight the curves.

If the company is sufficiently large, it may turn itself into a small town, complete with apartments, private work spaces, facilities for group work, restaurants, a gymnasium, cafés, a post office, a tourist office (reception), a "town square" and gardens. There is usually a glazed "street" or central atrium which serves as the backbone of the building. Major corporations will also have a kindergarten, a doctor's surgery, a travel agency, financial services and a variety of other facilities such as newspaper kiosks and dry cleaners.

Denis Ettinghoffer, management consultant and creator of the "virtual company," has been propounding the idea of "business hotels." In French these are known as *Centres d'affaires et de services partagés* (CASP). They provide offices and meeting rooms that are available to everybody, and which can be used for several hours or days at a time by either groups or individuals. This type of office originated in the United States and is now quite widespread, although the French tend to view it with caution. The professional classes happily use secretaries and switchboard operators, but they prefer a space of their own in which to practise.

DIFFERENT KINDS OF OFFICES

There are many examples of original office layouts among architects, designers, fashion designers and other creative professionals. Because of their training and their tastes, people working in these fields tend to appreciate unusual work spaces. But perhaps there is an additional reason for their liking such unconventional environments. Their particular way of working could be explained by their approach to work in general. Generally speaking creative people tend to work in groups, sharing thoughts and bouncing ideas off each other. This way of working implies a different use of space, a greater mental and physical freedom, and the abandonment of conventional symbols of hierarchy. In such situations, power shifts from one person to another as the project develops and becomes more concrete. Things are in a state of permanent flux, with everyone saying what they think about this or that idea or sketch and all accepting group criticism of their personal projects. In the classic cellular type of office—small rooms leading off either side of a corridor—such a synergy would be impossible.

Finally, some offices conceal an unsuspected imagination and creativity. The French newspaper *Libération*, for example, moved into a

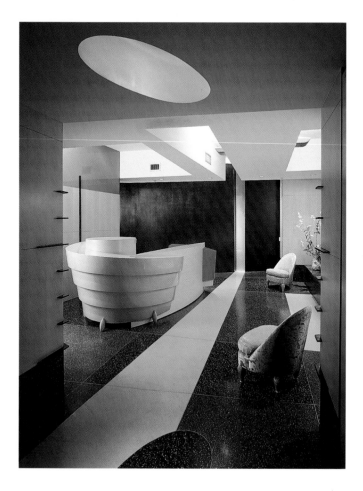

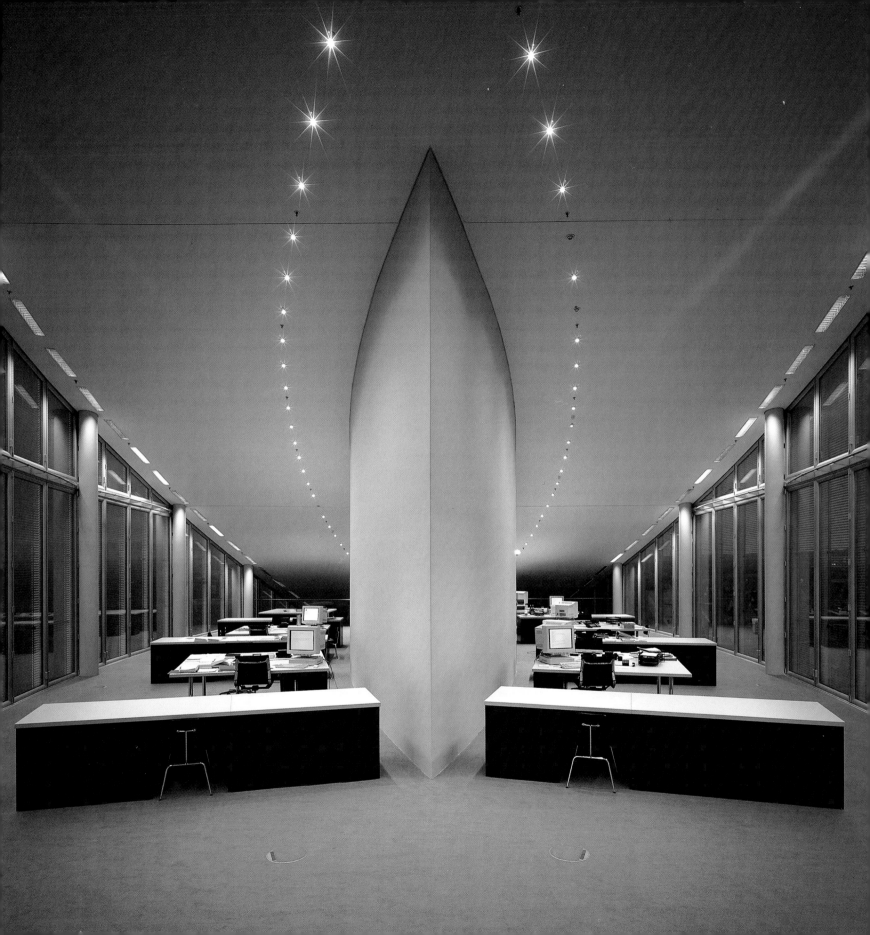

"The role of the architect is to transform society and take it forward, to give people a desire to discover new ways of living and working." In 1994 the architect and designer Gaetano Pesce created an extraordinary office for the Chiat-Day public relations agency in

As you enter the reception area you are hit by a volcanic red and orange floor, on which there are marks to guide you. The cupboard doors behind the fiberglass reception desk suggest the profiles of giant faces. The lights resemble sheep stuck to the ceiling (left).

Computers are enclosed in ultralight metal structures, carefully protected with colored, down-filled quilting and mounted on wheels. They function as cocoons, enabling people to work in peace (below).

There are a variety of different types of door, some with grilles, some padded, and some in the shape of bottles. Equally unexpected are the multicolored fiberglass chairs and tables, which are mounted on springs and look like weird insects (facing page).

New York. The décor has more in common with a children's kindergarten or a university campus than a traditional office.

building that was a working garage, although the cars were not on the same level as the offices. The ground plan for the newspaper's offices was identical to that of the floors occupied by the cars. A (pedestrian) ramp links the various levels. The offices, which are average in size, are laid out in open-plan style, with or without glass-paneled partitions. The layout is classic, designed to accommodate a large concentration of people. There are computers everywhere. Paperwork litters tables, chairs, side tables and cupboards, and even the floor. There are a number of TV sets, which may be on or not, depending on the time of day. An atmosphere of concentration and tension reigns. Agraph Look, a design and public relations agency, has also moved into a garage—this time disused—in the 15th *arrondissement* in Paris. The original entry ramp has been preserved intact.

Not surprisingly, the wildest offices are to be found in New York City. The offices of Chiat-Day advertising and public relations agency, for example, designed in 1994 by the Italian architect Gaetano Pesce, are exuberant, but never gratuitously so. The architect's unusual choices were arrived at after careful consideration of the requirements of the 120–150 employees. It is an extraordinary environment, predominantly red, with doors in the shape of bottles or question marks, or, occasionally, padded. The reception area (where employees come to collect their mail and their mobile phones) has an alcove in the shape of a pair of large red lips. There are no individual offices, nor is there any paperwork. There is an open space, with a library and areas where you can use the fax or your computer or phone. The cafeteria serves as both a work space and meeting place, with chairs made of colored fiberglass mounted on springs, also designed by Gaetano Pesce. To reduce noise, computers are concealed behind ingenious mobile screens which consist of an ultralight steel mesh structure mounted on casters and covered in padded material. There is no visible hierarchy, yet this is an extremely dynamic company which creates advertising campaigns for the likes of Apple, Coca-Cola and Nike. There are also projection rooms and specific rooms reserved for each client. The layout represents an overall space saving of about 30 percent.

"Architecture nowadays just sends you to sleep! I want to stimulate people, put them into an optimistic frame of mind, give them energy for their work . . ." said Gaetano Pesce. For Jay Chiat, the question is no longer of knowing where you are going to sit when you arrive at the office, but of knowing what job you are going to be doing. It is to be

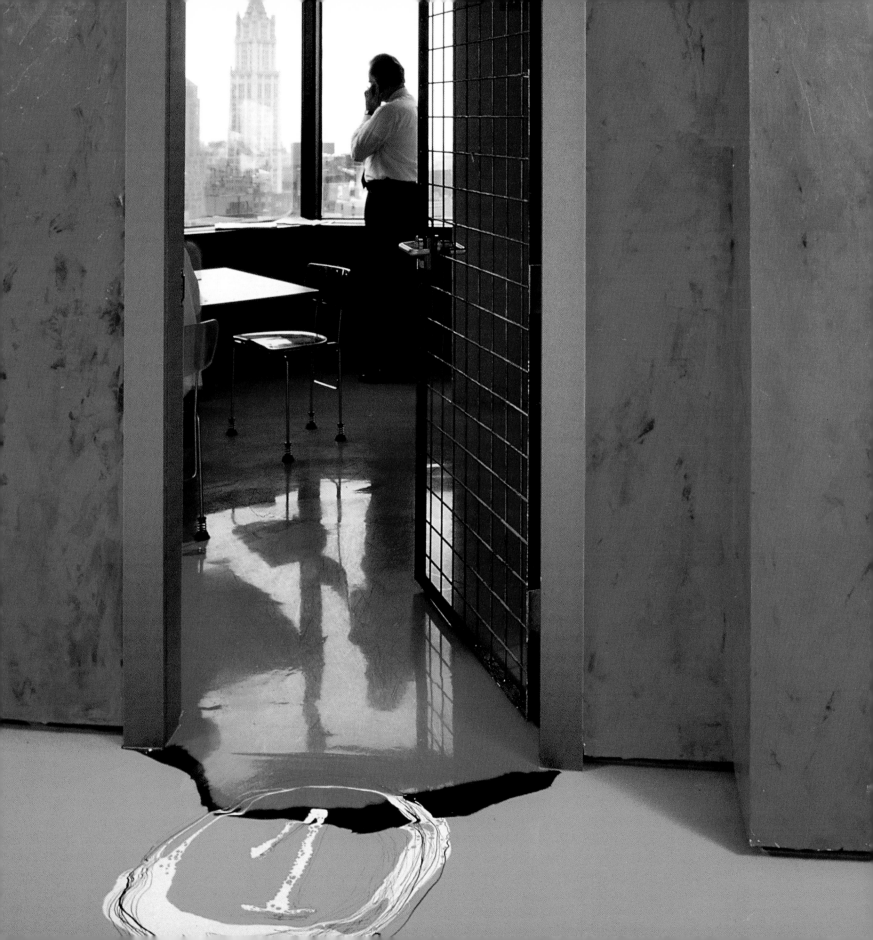

hoped that this exemplary and successful approach is adopted, adapted and copied elsewhere, and that it will become a reference point for the late 1990s, in the same way that Centraal Beheer and Digital Finland were before it.

When there are no clients to propose creating extraordinary environments, architects sometimes embark on projects of their own. For example, two architects set up their practice on a working river barge called the "Sycomore," which still has its engine and wheelhouse intact. The boat has two levels, linked by a staircase. The upstairs consists of a reception area, a filing area and a library for the consultation of documents and small meetings standing up. Downstairs there is a drawing office, where they each have a drawing board and a small retractable desk. The wood and chrome creates a distinctive décor. Another architectural practice moved into an old Parisian bathhouse, preserving many of the building's original features.

The Frankfurt showroom of Knoll International, designed by Studios Architecture (below). It consists of a huge space divided by massive beams and crossbars in untreated wood, with a ceiling of folded perforated metal. This sophisticated décor is designed to enhance the furniture on show.

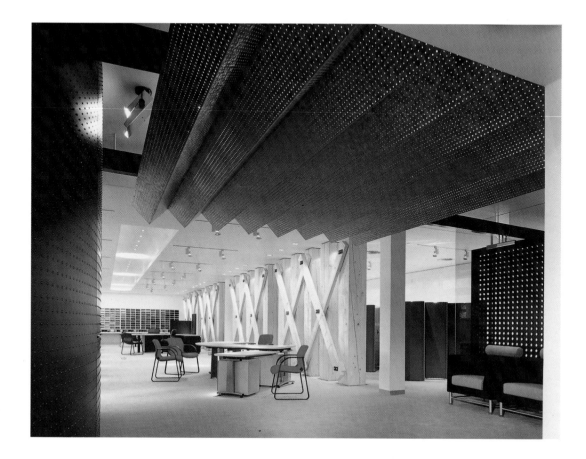

Architect François de Ménil's design for the offices of *Esquire* magazine in New York highlights the building's industrial origins (facing page). The white concrete and pipes have been left exposed, lit by simple neon lighting. A translucent partition provides the finishing touch for the décor of this loft-office.

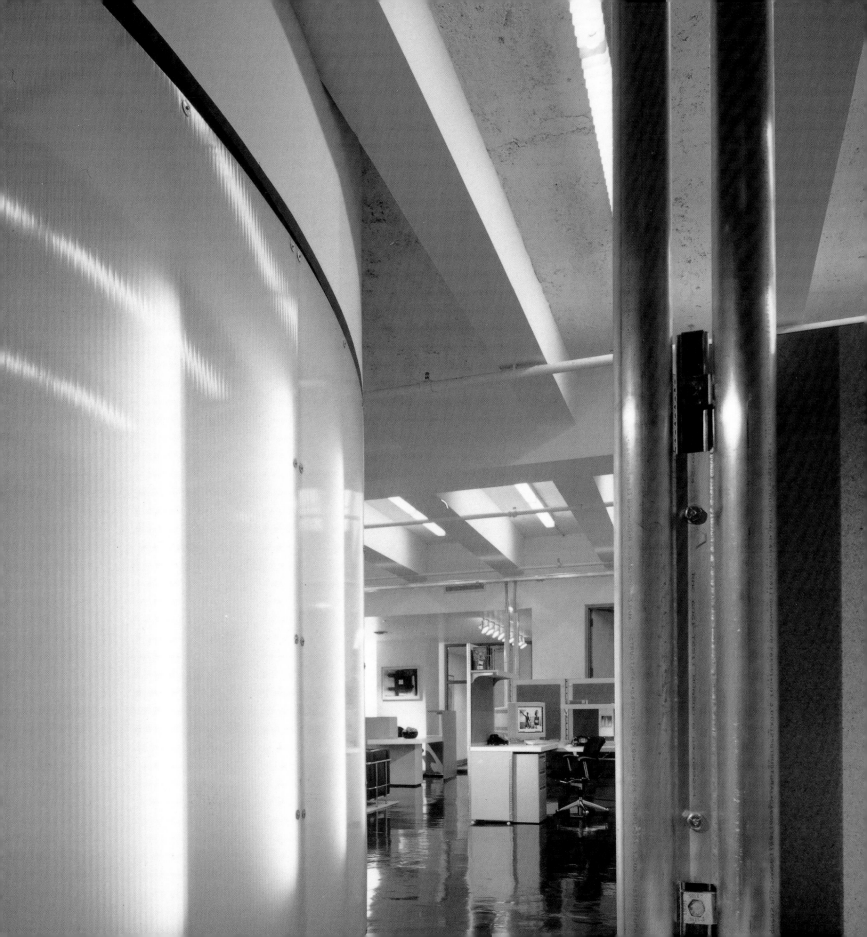

VIRTUAL OFFICES

The rapid development of new communications technology (multimedia, the Internet and information highways) will necessarily have important repercussions on the world of work and, by extension, on the design of the workplace.

It is no longer a question of trying to imagine the likely office of the year 2000, but of creating entirely new kinds of offices. The experts concur in forecasting the emergence of responsibility by process and not by job. A new way of working will develop built around a chain of operations, involving several people in a network. This will require (even more than is the case at present) the setting up of groups of people who work together on a project.

Will this take place in the classic type of company, or in the "virtual" company? At the simplest level, one can expect a greater flexibility in the workplace and the disappearance of the classic one-person office. Work teams will come together around a project for a few weeks or months at a time. These teams will need small individual work spaces, but, more importantly, a number of specially equipped "project rooms," rather like the private meeting rooms or "brand rooms" in certain advertising agencies. There the documentation and all the elements necessary for the creation of a project for a given sponsor are brought together into one single communal space. Also one imagines that in a few years from now there will be less paperwork, and therefore less need for cupboards.

For some people tomorrow's office will involve the elimination of the desk, as proclaimed by Denis Ettinghoffer: "As an unmoving traveler, the firm must be present everywhere in a virtual sense in order best to manage its resources, expertise, products and clients. We have become the 'terminal-men' of a wired, connected society, in which our time is split up between private lives and professional lives with no borders to separate them. We are also 'electronic nomads,' crazy zappers in a world of work which is spread across multiple locations and multiple tasks."

For advocates of the virtual corporation, the present-day organization of work is enormously wasteful, because managers and sales representatives spend less than 30 percent of their time at their desks. Sedentary workers can perfectly well work from home, so the company no longer needs offices. From time to time the staff are brought together in large meetings and the circuit is complete. This is perhaps a slightly exaggerated view, one which neglects the importance of human relations and conviviality—in short, office life.

In the virtual office the computer takes over from human relations. The computer is already organized like an office (desk, filing cabinet, storage space, wastepaper bin, calculator), but can it provide a replacement for the thousand-and-one details of everyday life?

As a partner, your machine is ideal, docile, attentive and efficient. You write to it, you reply to it, you tidy it, you arrange its files. It has all the advantages and none of the disadvantages of a real person, with their changing moods, intuitions and idea associations. The computer has become the embodiment of danger-free face-to-face relationships. It is a launch pad for relations with the whole wide world, which you control from a little screen. If you get angry with it, you simply switch it off. It is becoming a kind of physical and mental mirror, sometimes almost to the point of caricature. The civilization of technology is overtaking us.

Will contact with other people become a privilege reserved exclusively for management? For some years now executives have had at their disposal various tools for long-distance communication, such as video-conferences and videophones. Yet they still prefer to communicate face to face and do not think twice about taking a plane to meet someone for a couple of hours. Are they the precursors, here, of a strategic vision of the future? Or is it simply their privilege to be able to escape from the office?

The paperless office is, it appears, the shape of things to come: everyone sitting at screens, either in an office or at home, linked up to others, exchanging information. But as communication becomes increasingly abstract, loneliness and isolation also increase. At the moment people are hanging on desperately to this kind of communication: as Philippe Breton, author of a number of books on computers and communication, put it, people are endlessly talking and communicating, but they never actually meet. "However, technology only occupies the amount of space that we give to it."

This explosion of communication has provided whole new areas of research for designers. In 1991 Philippe Starck was predicting the disappearance of the office: "First we are going to have to arrange work spaces like domestic spaces (and vice versa) by providing them with up-to-date tools and appropriate environments." He has since gone further, looking into the possibility of internalizing communications technology so that appliances become artificial appendages to the human body, rather like pacemakers—a nod and a wink, perhaps, to suggest the dangers and contradictions that lie in wait for us in the not-too-distant future.

DESKS OF THE FUTURE

Manufacturers are already marketing the "desks of the future": huge empty tables, with complex systems of integrated but visible cabling looking rather like a backbone. The Ypso system created for Aspa in 1991 is an example.

The office furniture company Roneo is promoting the Freedom Office, designed by W. Muller Deisig. Work surfaces can be repositioned, with the use of clips, at whatever height you like. There are screen supports and desk accessories that can be hung up. You can work sitting down, standing up, face to face, or on your own. The most striking example is the Nomos office system which the Italian office furniture company Techno commissioned from the architect Sir Norman Foster. He gave free reign to his passion for aircraft, designing a system which uses the space between floor and ceiling, as in the pilot's cabin. The work surface is movable and the spiders' legs are reminiscent of a lunar module's feet. It is a jigsaw puzzle which can be assembled in a variety of heights and widths according to need.

The Big Boss Compagnie has been marketing a compact piece of furniture for executives which would not look out of place in a domestic sitting room. It has facilities for work, filing, relaxation and comfort. The back section folds down to form a secretaire, with a hi-fi, shelves, a fridge and a safe. Using a hand-held remote control, you can summon up, as if by magic, a chair which can then be transformed not into a pumpkin but into a comfortable bed, facing a TV. The armrests are fitted with a thousand treasures, such as work surfaces, files, microcomputers and telephones. The bar has not been forgotten, either—it is concealed discreetly behind a sliding door . . . This is an office worthy of James Bond!

Even the choice of names is interesting: after the Freedom and Nomos office systems we have the Tech Survival Kit, created by Philips and Olivetti. This enables the user to work absolutely anywhere (on an ice floe, in the bathroom, or by the side of a swimming pool perhaps). It is a miniaturized mobile workstation, a magic carpet, colored and quilted like a bedspread, which houses all the fundamental necessities: a CD-ROM drive, diskettes, mobile phone, calculator, electronic diary, all with concealed buttons and keyboards. When closed it resembles a large desk diary, or a small pillow. With its bright colors and soft materials it looks more like a household object—an activity center for babies, perhaps—than a piece of office equipment.

This "magic carpet" is aptly named. Designed by Stefano Marzano and Michele De Lucchi, it is a "survival computer," reminiscent of a small child's activity center. It contains an electronic diary, a calculator, a mobile phone, a fax, a computer with an ultra-flat screen and of course a CD-ROM drive. There are no unsightly electrical cables either, because the whole thing will operate by infrared connections.

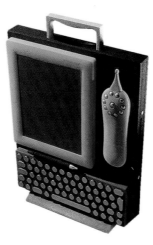

Work spaces have been entirely rethought and rechristened. The Docking Office, for example, makes one think of a well-designed wood-work shop, with a panoply of tools hanging on the wall. It consists of a half-moon keyboard, a chrome-plated device about the size of a dinner plate for reading CD-ROMs and a screen which, needless to say, looks nothing like a screen. There are no wires, as the connections are all infrared. So, whether you are going to a meeting or simply intending to work at an unallocated desk, you come here to put together your "toolbox." At the center of the Docking Office is a "group tool," a kind of reception area, a base for arranging meetings, storing information, working and meeting. It looks nothing like a desk, but more like a large chest with rounded edges, where people meet for a chat. It contains a photocopier, a printer, a fax machine and a paper shredder. Finally there is an "empty room," devoid of furniture and equipped with a wall-mounted videotheque, which replaces the classic office.

The designers Stefano Marzano and Michele De Lucchi insist, "All our projects are realizable in theory." Their aim is to design for the

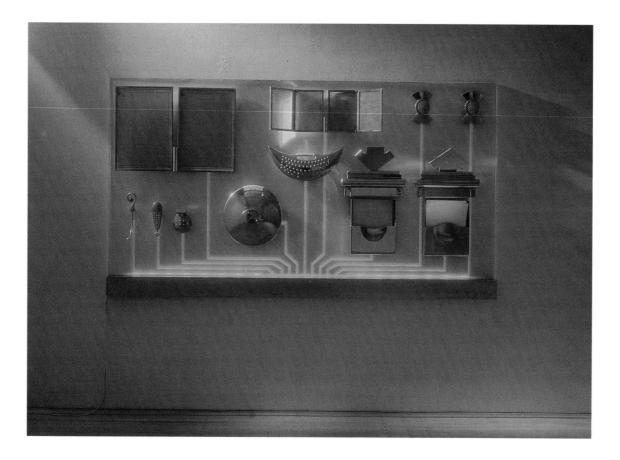

In the office of the future, as imagined by Marzano and De Lucchi, you simply choose the tools that you are going to need for work. Before going to an appointment, you borrow a "toolbox" to transport your computer, which, needless to say, hardly looks like a computer (above).
The storage board of the Docking Office offers a wide range of tools. You simply select the ones you need (left).

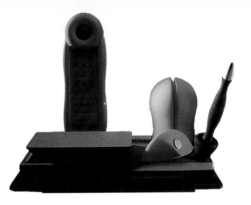

This strange sculpture, called a "communicator," is actually a fax/answering machine/personal computer which enables you to communicate with the whole world.

future by taking human activities, and not products, as their starting point. Future office workers, even those working within the confines of an office building, are effectively going to be nomads. As the journalist Luc Vachez put it when discussing these developments in *Libération*, "The 'cordless' nature of the equipment is matched by the 'rootless' nature of the worker, who effectively becomes a module, an element in a worldwide 'toolbox'."

Rank Xerox is also thinking of tomorrow: their aim is to develop technology which will create a fusion between paper-based information and electronic information. The "electronic desk" is at first sight an ordinary work surface on which you can stack piles of papers and leave personal effects. It is more than that, however. The work surface actually becomes a computer screen. With the aid of cameras, electronic images are projected on to the paper documents on the work surface. The electronic desk reacts to hand signals and reads paper documents when they are placed on it. For example, the prototype enables you to enter figures into a calculator simply by pointing at them on a sheet of paper. You can cut-and-paste on paper without having to use scissors, Scotch tape and a photocopier. Vice versa, a document, laid out with logos and graphics, can be instantly transformed into an electronic document. Working with others without actually having to be in the same place becomes child's play. Work colleagues can all "see" the paper documents on their associates' desks. The aim, say Rank Xerox, is not to improve computers by making it easier for them to access paper documents, but to transform the paper document so that it can benefit from the capacities of the computer. Instead of enabling users to work in the world of computers, their objective is to make computers better adapted to the user's world.

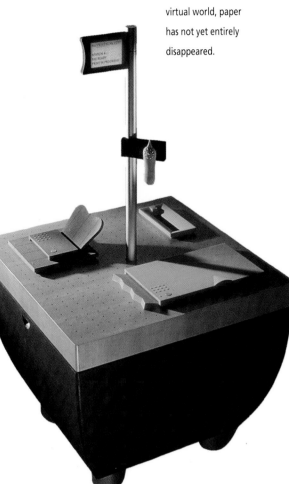

This wooden "group tool" stands at the heart of the Docking Office, a futuristic office scenario (below). Its gentle rectilinear form is designed to encourage conversation. People gather here with their documents to be printed, photocopied, faxed or shredded. In this virtual world, paper has not yet entirely disappeared.

OFFICE MAN

"Office Man exists, we've met him," announced a news magazine in February 1995. Indeed British Telecom has designed a communications console that includes a telephone, videophone, fax machine and computer—nothing extraordinary in that, except that the whole thing is so small it can be worn on your forearm (although we are not told how much the device actually weighs). It is a walking office. It remains to be seen whether businessmen will have the nerve to use it in unlikely places, now that they have got into the habit of using their mobile phones wherever the fancy takes them. Fortunately it is still a bit too big to conveniently use in a restaurant.

Another version has just appeared, produced by the Japanese company NEC. It is the BTC, or Body Top Computer, which does away with the need for phones, diaries, Post-its and filing systems. A small rucksack worn across the stomach, like a kangaroo's pouch, it can be used seated or standing. It contains a screen and keyboard which unfold in front of you. The office is no longer a physical place but a fact and your address need amount to no more than a phone or fax number.

A slightly different variant is the Porto-Office. It consists of three main parts: on your back a long tube housing the various electronic components; round your stomach a computer with a digital camera; and on your head a pair of headphones and a microphone. It becomes an extension of its operator, who can type on the keyboard, write on the touch-sensitive screen, take photographs or speak into the microphone. And the computer will record, reply and advise.

THE MOBILE OFFICE

The mobile office is not a modern invention. As we have seen, the scribes invented it more than five thousand years ago. Nearer to our own times, in its aristocratic version, it might have been a rosewood Louis XVI coach secretaire made in 1738. A flap with a secret catch opens to reveal small drawers and an adjustable paper filing system. However it would be hard to adapt it to modern technology. The nomads have won and the twenty-first century will be the century of the mobile office. It already exists, in a variety of forms. In 1989, for example, the young French architect Roman Claquin designed a simple, light, discreet version in the form of hand luggage. It is a suitcase

Here we have an ultralightweight version of tomorrow's working world: a "man-office" as imagined by British Telecom. This tiny communications console is equipped with a phone, videophone, fax and computer. Extremely easy to use, and designed to be worn on the right or left arm, it would still take nerve to use it in public . . . and a pretty strong forearm too.

which can be transformed into a traveling desk by means of retractable telescopic legs. In 1990 the designers Bernard Byk and Hervé Juhel exhibited at the Salon des Artistes Décorateurs their Alaska series, a combined desk and seat that folds up into a suitcase. In the same vein, we have the Tulip Case, a totally self-contained suitcase incorporating a computer, printer, software and modem, as well as a lid which can hold papers and pens.

Finally we have the ecological version, with the American bicycle-office. "With his Dataspace, packed with electronics and weighing 264 kilograms, Mr Roberts can either work or talk with clients via a built-in microphone. His cycle helmet has an ultrasound device enabling him to move cursors on a miniature screen. There are keys incorporated into the handlebars for typing, a number of microprocessors and large aerials built into his bike trailer, and solar panels to provide energy. All this enables him to edit a periodical and to communicate via satellite with thousands of correspondents. This VTT device enables Steve to move around at (very) slow speeds in the United States, giving lectures on mobile communication systems."

The ordinary version—the automobile with chauffeur—can be seen in big cities or waiting around at airports. The car provides an alternative space for the modern executive: a phone, or phones (there is no stopping progress), a fax, a laptop computer, files on his or her knees, or on a fold-down table, a drinks cabinet with a fridge, an optional television and air conditioning.

People who do not have chauffeurs drive around with clipboards fixed next to the steering wheel, and notepads and biros hanging from a chain. A small pocket dictating machine and a "hands-free" phone obviate the need for contortions and reduce the likelihood of accidents.

In its larger format, this becomes the office-bus. Politicians in the United States use these as a way of combining mobility with comfort. It is a traveling office, or, to be more precise, a small mobile company, offering facilities for receiving people, for doing private work and for having meetings. John Madden, an American sports correspondent for CBS, has for many years used a Greyhound bus kitted out as a traveling office. Needless to say it has all the facilities necessary for work and communication, but it also has a small kitchen, a shower room and a proper bedroom.

A regional councillor in the Paris conurbation, who was having trouble with some of his colleagues, no longer holds his sessions in local town halls, but borrows a camper from one of his friends every week.

The classic, perennial version of the mobile office is the executive

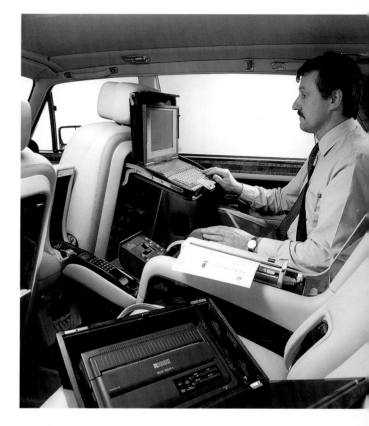

This hand-stitched office, courtesy of Rolls Royce, is every executive's dream. It has deep leather-upholstered seats with armrests, an elm-burr décor and a handy fold-down table and is equipped with a telephone, a computer and a fax machine.

train (first class only, of course). The famous "Rubens," which used to provide an early-morning service between Brussels and Paris, has, alas, become an ordinary TGV. Nevertheless it is still a splendid sight, this modern open-plan office packed with an army of identically dressed businessmen, absorbed in their work, buried in files or tapping away on their laptops (at speeds that leave something to be desired) in religious silence and totally ignoring the passing landscape.

There are also the "executive suites" at big airports—a slightly more sophisticated version of the mobile office, because here you have to have a business-class or first-class ticket to gain access, not to mention earplugs to protect you from the latest form of urban pollution, namely several people sitting side by side all using their mobile phones at the same time.

We have become accustomed to the price war between airlines, which then developed into a comfort war. Now there is a new battle, with the office-at-your-seat. This gives you a video screen, together with a phone, a socket for a portable computer and the possibility of sending faxes to anywhere in the world. One company offers the facility not only of phoning out and faxing, but also, the height of luxury, receiving incoming calls.

Apparently President Bush loved working on his Boeing 747, which was specially fitted out for a staff of seventy people, with meeting rooms, offices, a restaurant and private spaces. At a more modest level, the private jets of certain executives are still all equipped with small tables, phones, faxes and computers.

But in the absence of an airplane, a boat will do just as well. The Greek shipping magnate Aristotle Onassis had a yacht with forty-two telephones, which enabled him to manage his business interests all around the world—often stark naked, by all accounts.

And then there are those who have work to do, but, for various reasons, no office in which to do it. They use public places—cafés, libraries, the lobbies of big hotels—and also other people's offices. Some use hotel bedrooms, like the art publisher who, according to *Libération* in March 1995, lives and works in hotel rooms. He is one of the world's nomadic workers and, instead of a registered office, he has a fax, phone and table in his bedroom. His hotel room is his office and the hotel switchboard serves as his secretary and receptionist—a rather original lifestyle. However, luxurious living has been dying out since the days of Coco Chanel, who lived in a suite at the Ritz for forty years. There are fewer and fewer people with the financial means to stay in a big hotel all year round, using the services of its extensive and competent staff to run their affairs.

In recent years the mobile phone has revolutionized things. It means that absolutely anywhere can be treated as an office, either by the person phoning or the person who is being phoned. When you ring someone, they might even be in the bath, you would never know.

One journalist, for example, takes up summer residence on a bench in a Parisian park. A mobile phone and a notebook computer make it possible to turn this place (which is more or less deserted, except on Wednesdays when children are off school) into an original office. Perhaps chlorophyll helps the concentration.

THE DEMISE OF THE OFFICE?

Is the office destined for extinction? The answer is obviously yes if we are referring to the individual eighteen-square-yard office as such. But not the office as used by a group of people working on a common project. It is possible that corporate offices will no longer be just a series of individual rooms and meeting rooms, but will offer open, non-individualized work spaces designed to encourage the human interaction that is so important in the world of work.

The office may become a new kind of collective space, rather like the British clubs of yesteryear, with a quiet library, a bar, and comfortable soft chairs where people can conduct their business. Or perhaps it will be more along the lines of a family hotel, with an inglenook, lounges for reading and writing, games rooms and relaxation facilities (with or without table tennis and table football).

Finally, the office of the future may also draw on the monastery, which, in the eyes of some historians, was the original model for the development of the modern enterprise, and which will offer identical private work cells for everyone, as well as reception areas, libraries, spaces for thought and contemplation and workshops where things can be made.

The fact that we are moving out of our offices, becoming nomads, and working increasingly at computer screens suggests that we ought to be completely rethinking our lifestyle. We should be inventing new balances between work and private life, now that physical space no longer separates the two, imposing a particular way of doing things. And here we are not talking merely of a way of life adapted to the office, but a way of life in the broadest sense.

Guide to the office

This directory contains the names and addresses of manufacturers of office furniture, accessories and decorative materials, interior designers and architects, and useful organizations. It is not by any means a comprehensive list, but it does include nearly all of those mentioned in the book.

OFFICE FURNITURE

UNITED KINGDOM

AHREND LIMITED
Hogarth Business Park, Burlington Lane, London W4 2TX
Tel.: 0181-747 8383
Ahrend, a Dutch company, manufactures a range of six office systems all with a contemporary styling using steel, plastic and wood finishes. They are also suppliers of office seating made by other companies, notably Wilkhahn.

ANTOCKS LAIRN
Cressex Business Park, Lancaster Road, Cressex, High Wycombe HP12 3HZ
Tel.: 01494 465454
Antocks' reception furniture, three ranges of tables and seventeen ranges of swivel chairs are all designed in-house. The Kion chair, designed in 1993, is an unusual combination of beech and steel frame construction.

ARCHIUTTI
1-2 Mead Business Centre, Mead Lane, Hertford, Herts. SG13 7BJ
Tel.: 0992 503313
Italian-based manufacturer of office systems and executive furniture. Veneers used for the latter include walnut, cherry wood and rosewood. Archiutti also has a range of design classics, such as coffee tables by Eileen Gray and Le Corbusier lounge furniture.

BIANCHI FURNITURE TRADERS
Manley House, 2 High View, Hitchin, Herts. SG5 2HZ
Tel.: 01462 433130
Bianchi specializes in classic Italian furniture and supplies seating by Fian, Alivar and Salotti.

BOLTE UK LTD
31a Bruton Place, Berkeley Square, London W1X 7AB
Tel.: 0171-629 1550
Bolte UK is a subsidiary of a German manufacturer of office systems. The top range is Paso, designed by Edgar Zülch, a flexible system made from alloy, steel, particle board, laminate and veneer which can be reconfigured easily. The complementary screening is "cable managed" to allow lights to be fitted. Bolte's striking Contour chairs have curved legs made from oval tubing.

BOSS DESIGN LTD
117 Wolverhampton Street, Dudley, West Midlands DY1 3AL
Tel.: 01384 241628
This company specializes in office seating and has a wide range of chairs.

CARSON OFFICE FURNITURE SYSTEMS
29–31 Great Portland Street, London W1N 5DD
Tel.: 0171-436 1771
A wide selection of desks, storage units, cupboards, partitions and screens are made by this British manufacturer. Styling ranges from the contemporary to the more classic. The company also offers a space planning service.

CITYSPACE UK LTD
The Tram Shed, 32 Rivington Street, London EC2A 3LX
Tel.: 0171-729 4116
The Cityspace Group is an importer and distributor of North American office furniture, notably storage cabinets by Office Speciality, which come in forty-one heights, three widths and a vast range of interior options and finishes, and furniture systems by SMED, who also custom-build in wood. Cityspace also has a technical department which provides drawing and space planning services and project management.

ENVIRONMENT
31, Lisson Grove, London NW1 6UV
Tel.: 0171-258 0600
Environment are distributors for Kartel, specializing in chairs and tables made from steel and plastic. They offer a range of office accessories, such as bins, planters and mail trays.

ERGONOM
365 Euston Road, London NW1 3AR
Tel.: 0171-387 8001
Distributors of Unifor, the Italian manufacturer of office systems, storage furniture and partitions, and Wilkhahn seating.

FANTONI UK LTD
Alexandra House, Alexandra Terrace, Guildford, Surrey GU13 1DA
Tel.: 01483 306992
Italian office furniture manufacturer and MDF specialist, geared towards specifiers. They offer twelve ranges, including an executive range. Particularly striking is the curvaceous XS, designed by Michel Burkhardt and Mario Broggi.

FLEXIFORM BUSINESS FURNITURE LTD
1392 Leeds Road, Bradford BD3 7AE
Tel.: 01274 656013
Flexiform manufacture a variety of storage units and desking systems, including a wooden executive range. Of note is their modular storage system and their mobile storage units.

GORDON RUSSELL
High Street, Broadway, Worcestershire WR12 7AD
Tel.: 01386 858483
This British firm, which began making furniture in the 1930s, is now part of Steelcase Strafor. The emphasis is on wood, mainly oak, cherry and beech, and the firm makes everything from desking systems to storage units, screens and bookcases.

GESIKA
7/9 King Henry Terrace, Sovereign Court, The Highway, London E1 9HE
Tel.: 0171-522 0005
German manufacturer of office systems, storage walls, screen systems and reception units. The LIM system is particularly flexible and was designed partly with homes and small offices in mind.

GIRSBERGER GMBH OFFICE SEATING
Business Design Centre, 52 Upper Street, London N1 0QH
Tel.: 0171-288 6142
Swiss-German chair manufacturers. There are eight basic designs, available in different fabrics and a variety of configurations. The Contact chair features the firm's patented "Pondomat" mechanism which enables the chair to adjust automatically to the user.

HABITAT
The Heals Building, 196 Tottenham Court Road, London W1
Tel.: 0171-631 3880
Habitat offers everything you need to furnish your home office: desks in a variety of styles, worktops mounted on trestles, shelving units, storage cabinets, anglepoise lamps, computer desks and swivel chairs.

HERMAN MILLER
149 Tottenham Court Road, London W1P 0JA
Tel.: 0171-388 7331
One of the most illustrious names in office furniture. The company offers two versions of its Action Office and another office system called Ethospace. One of its most notable recent products is the Aeron chair, designed by Bill Stumpf and Don Chadwick, made from recycled aluminum, fiberglass, steel and fabric. A descendant of the original office chair designed by Charles Eames, the design is a rigorous application of ergonomics.

IKEA LTD
2 Drury Way, North Circular Road, London NW10 0TH
Tel.: 0181-451 5566
Ikea offers a range of inexpensive and practical items of office furniture, such as desks, computer trolleys, swivel chairs and storage units.

INTERIOR ELEMENTS LTD
Unit 6, Great West Trading Estate, Great West Road, Brentford, Middlesex TW8 9DN
Tel.: 0181-569 7559
Suppliers of various ranges of desking systems, seating and carpets. Manufacturers include Haworth, Gordon Russell, Office Corp and Comforto. The company also offers a comprehensive consultative service, from space planning and drawing to installation.

KINGSLEY COOKE
Unit BZ, Newton Business Park, Talbot Road, Newton, Hyde SK14 4UQ
Tel.: 0161-367 9150
Manufacturer of desks, screens, storage units and bookcases. The styling is contemporary and materials used include steel and laminates with mahogany and cherry wood.

KNOLL INTERNATIONAL
1 East Market, Lindsay Street, Smithfield, London EC1A 9PQ
Tel.: 0171-236 6655
Knoll was founded in 1938 by Hans G Knoll. Under Hans and his wife, Florence Knoll, an architect and designer, the company grew rapidly in the post-war years. Knoll sells some of the landmark furniture designs of the 1950s: Eero Saarinen's Tulip chairs, Harry Bertoia's steel wire chair, Mies van der Rohe's Barcelona chair and Marcel Breuer's Wassily chair, in addition to designs by Florence Knoll, Ettore Sottsass and Frank Gehry.

KÖNIG+NEURATH
K+N International (Office Systems) Limited, King House, 38 Croydon Road, Beckenham, Kent BR3 4BJ
Tel.: 0181-658 2247
This German company manufactures desks, storage units and partitions. The Media desk system, made from steel and cast aluminum with beech ply tops finished in melamine or natural wood, is fitted with additional surfaces for computer screen and telephone and a round side table for meetings, while the

Synchrona desk can be easily adjusted for height and angle.

LAMB MACINTOSH
415-416 Montrose Avenue, Slough Trading Estate, Slough SL1 4TP
Tel.: 01753 522369
Manufacturers of desks, screens, workstations, mobile pedestals and filing cabinets. The firm also offers an interior design service, which covers every aspect of space planning and décor.

LAPORTA
The Hop Exchange, 24 Southwark Street, London SE1 1TY
Tel.: 0171-403 1616
Distributor of Italian office systems by Trau Press and Olivetti Synthesis.

MARCATRÉ LTD
143-149 Great Portland Street, London W1N 5FB
Tel.: 0171-436 1808
Marcatré's range of furniture includes, notably, Territorio designed by Perry A. King and Santiago Miranda.

MARTELA PLC
Rooksley, Milton Keynes, MK13 8PD
Tel.: 01908 667418
Finnish manufacturer of desks, chairs, storage units and partitions. In keeping with the traditions of contemporary Scandinavian design, wood is the principal material, generally beech or birch.

NARBUR OFFICE FURNITURE
12 Cardinal Close, Meltham, Huddersfield HD7 3BL
Tel.: 01484 852717
French company offering a range of systems, screens and storage units. Their A+B range features reversible desktops.

NEWSTYLE FURNITURE LTD
Crossways Business Centre, Alconbury Hill, Alconbury, Weston, Huntingdon, Cambridgeshire PE15 5JH
Tel.: 01480 457373
Newstyle markets office furniture manufactured in Spain and Norway, although some of the

furniture is designed in Britain. They offer a total of fifteen office systems and can also provide a full space planning, CAD, 3D and installation service.

PRESIDENT OFFICE FURNITURE LTD
Lincoln House, Old Parkbury Lane, Colney Street, St Albans AL2 2DX
Tel.: 01923 857211
President design, manufacture and distribute a wide range of furniture. Of particular interest is the Kyo system, featuring "umbilical" elements which are claimed to offer exceptional freedom and flexibility in reconfiguring; it also includes a petal table suitable for the nomadic or "drop-in" worker and adjustable "service columns".

RDS SOLUTIONS
The Basement, 35 Alfred Place, London WC1E 7DP
Tel.: 0171-637 5224
British manufacturer of office chairs and tables for conference rooms and boardrooms. They are also agents for the Spanish company Akaba.

RON ARAD ASSOCIATES
62 Chalk Farm Road, London NW1
Tel.: 0171-284 4963
Ron Arad and his small team of designers specialize in expensive, custom-made furniture, which is made in their workshops near Como in Italy. He has designed a modular seating system for Moroso, shelving for Fian and has worked with Vitra and Kartel.

ROUND OFFICE
The Quadrangle, 49 Atlanta Street, London SW6 6TU
Tel.: 0171-385 6008
Swedish company specializing in executive office furniture and counters. Round Office have been making the same range since the 1970s, with a choice of curved or straight-sided desks.

SCOTT HOWARD
211 Picadilly, London W1V 9LD
Tel.: 0171-437 5792
Dealers for USM (Swiss), Planmöbil (German), ICF (Italian) and Pledge (British). In

addition to a range of desking systems, they offer the Marcabet storage system and a selection of signage and display furniture.

SOTHEBY'S
34-35 New Bond Street, London W1
Tel.: 0171-493 8080
Sotheby's auctions provide the opportunity to acquire exceptional items of antique office furniture.

SQUIREWOOD OFFICE FURNITURE LTD
Shaftsbury House, Shaftsbury Road, Edmonton N18 1SW
Tel.: 0181-807 2294
British manufacturer offering five ranges of office systems and a selection of pedestals, partitions and filing cabinets. Wood is the principal material used, in particular maple, beech, oak and walnut.

STEELCASE STRAFOR
Newlands Drive, Poyle, Berkshire SL3 0DX
Tel.: 01753 680200
The Steelcase Company, now Steelcase Strafor, has manufactured the famous furniture designed by Frank Lloyd Wright for the S.C. Johnson and Son company since 1939 (see page 42). The company provides a comprehensive consultative service for clients.

TECNO UK
19 New Bond Street, London W1
Tel.: 0171-629 0258
Italian manufacturer offering a huge range of products, including Sir Norman Foster's famous Nomos office system, with glass top and steel legs (see page 81), Gae Aulenti's executive range, Jean-Michel Wilmotte's Topo Modo and Ronald Cecil Sportes' latest anodized chair, as well as furniture by Riccardo Bofill.

THE CONRAN SHOP
Michelin House, 81 Fulham Road, London SW3
Tel.: 0171-589 7401
In addition to its range of furniture and accessories for the home, The Conran Shop sells a variety of items for the office:

desks, chairs, shelving, clothes trees and storage cabinets. Designs are bought from all over the world and include such classics as Charles Eames's chair and ottoman, which he designed for Herman Miller in 1956.

VECTOR
Raleigh Road, Bedminster, Bristol BS3 1QU
Tel.: 0117 953 2000
Vector has twenty-one different lines of high-quality office chairs.

VITRA LTD
13 Grosvenor Street, London W1X 9FB
Tel.: 0171-408 1122
For nonconformists Vitra offers new solutions for the workplace, with, notably, the Metropol system by Mario Bellini and Dieter Thiel (see page 124), the Spatio executive desk by Antonio Citterio or the "baroque" desk by Borek Sipek (page 69). Their second office system is Antonio Citterio's Ad Hoc (see page 68). Vitra's large selection of chairs includes classic designs by Charles Eames.

VOKO (UK) LTD
South Bank Business Centre, Ponton Road, London SW8 5BL
Tel.: 0171-627 2727
German manufacturer of office furniture, one of the largest in Europe. Voko offers fourteen desking ranges. Great emphasis is placed on ergonomic and anthropometric considerations. The company also offers space planning and 3D studio facilities.

WILKHAHN LTD
The Old Showhouse, Watermill Way, Merton Abbey Mills, London SW19 2RD
Tel.: 0181-542 9343
German manufacturer of office seating and conference tables.

UNITED STATES

ACME OFFICE GROUP
540 Morgan Avenue, Brooklyn, NY 11222
Tel.: 718-387-0995
New York manufacturer of office system furniture and trading desk manufacturer.

AMTICO DESIGN FLOORING
200 Lexington Avenue, Suite 809, New York, NY 10016
Tel.: 212-545-1127
Design flooring systems for commercial applications. Amtico flooring is inspired by natural products and comes in a wide range of designs.

AURORA SYSTEMS ERGONOMIC ENVIRONMENTS INC.
21640 North 14th Avenue, Phoenix, Arizona 85027
Tel.: 602-581-0070/800-216-0649
A flexible ergonomic keyboard support system.

ERGO SYSTEMS INC.
71 George Street, East Hartford, CT 06108
Tel.: 860-282-9767
Ergo Systems is a manufacturer of articulating monitor and keyboard arms, mousepads, CPU holders, footrests and freestanding workcenters.

FILTERFRESH
215 West 40th Street, New York, NY 10018
Tel.: 212-391-4343
Filterfresh manufacture drink dispensing machines which provide coffee or hot chocolate at the touch of a button.

FLEX-Y-PLAN INDUSTRIES INC.
6960 West Ridge Road, Fairview, PA 16415
Tel.: 800-450-0552
Flex-Y-Plan offer a range of seating, systems furniture, modular furniture and ergonomic accessories.

FULLER CONTRACT ACCESSORIES CORP.
Seaview Industrial Park, 64 Seaview Boulevard, Port Washington, NY 11050
Tel.: 516-625-1350
Fuller specializes in office accessories like desk-top leather, metal and plastic, conference room accessories, clocks, coat hooks, hangers, carafes/ice buckets, wastebaskets, planters, ash/trash receptacles, umbrella stands.

GLOBAL INDUSTRIES
17 W. Stow Road, Marlton,
NJ 08053
Tel.: 800-220-1900
Global offers a large variety of
ergonomic seating, desks, files,
tables, modular furniture and
panel systems.

**GODREJ GROUP
COMPANIES/MERCURY
MANUFACTURING CO. INC.**
624 South Grand Avenue, Suite
#2500, Los Angeles, CA 90017
Tel.: 213-627-4680
Offering steel office furniture as
storage systems, filing systems
and desks, as well as safes and
security equipment such as fire-
resistant filing cabinets.

GORDON INTERNATIONAL
200 Lexington Avenue,
New York, NY 10016
Tel.: 212-532-0075
Gordon International
manufactures seating for offices,
public areas and residential
applications in Bauhaus
and contemporary styles in metal
and wood.

HAMILTON SORTER COMPANY
3158 Production Drive,
Fairfield, Ohio
Tel.: 513-870-4400
Manufacturer of a complete line
of office furniture, ergonomic
workstations and modular panel
systems, available in a variety of
laminate colors.

HERMAN MILLER INC.
855 East Main Avenue, Zeeland,
MI 49464-0302
Tel: 616-654-8600
(See United Kingdom)

**HIGH POINT FURNITURE
INDUSTRIES**
1104 Bedford Street,
High Point, NC 27263
Tel.: 910-431-7101
High Point Furniture is a supplier
of freestanding office casegoods
and seating, including executive
desks, computer workstations,
storage units, bookcases and
conference tables. Their seating
collection includes ergonomic,
contemporary and traditional side,
arm and swivel chairs. They also
make a flexible reception series.

INSTOCK OFFICE FURNITURE
M&A United Sales Associates
Inc., 3 Ethel Boulevard, Wood
Ridge, NJ 07675
Tel.: 201-507-0700
Instock carries a complete line
of office furniture from systems
to back room furniture lines.
Lines represented include Albind,
Daysi, D&E Wood, Jeffrey Craig,
LMO, Nightingale and
Multiaction by Van Haucke.
The company provides
an installation service.

THE IRONMONGER INC.
122 W. Illinois St., Chicago,
IL 60610
Tel.: 312-527-4800
Modern European hardware
including lever handles and
locksets for commercial and
residential specification, with
design by Philippe Starck, Dieter
Rams, Jasper Morrison, Hans
Hollein and many others.

JG FURNITURE SYSTEMS INC.
114 S. Front Street, Quakertown,
PA 18951-9002
Tel.: 215-538-5800
JG Furniture Systems
manufactures wood office
furniture including panel systems,
modular desk systems, casegoods,
tables and office seating.

JOFCO
PO Box 71, Jasper, IN 47546
Tel.: 800-23JOFCO
JOFCO sells quality wood office
furniture and seating in traditional
and contemporary styling.

K.O.H. DESIGN INC.
575 Broad Street, Bridgeport,
CT 06604
Tel.: 203-336-1334
K.O.H. manufactures a track-
system with sliding visual aids
incorporating projection screens,
easels, whiteboards, etc. for
conference/training rooms.

KWIK-FILE INC.
500 73rd Avenue N.E.,
Minneapolis, MN 55432
Tel.: 612-572-1980
Kwik-File's range includes
Marcabet Cabinets, a line of
storage/filing units and Mailflow
Systems, a complete line of
mailroom furniture.

LMO/LABOR METAL ORDEC
1501 E. Hallandale Beach
Boulevard, #132 Hallandale,
FL 33009
Tel.: 305-456-2568
LMO supplies European designs
in modular office furniture, home
office, filing cabinets and office
seating, including high-end and
executive office furniture and
chairs.

**LEVENGER: TOOLS FOR
SERIOUS READERS**
420 Commerce Drive, Delray
Beach, FL 33445
Tel.: 1-800-544-0880/407-276-
2436
Levenger has progressed from
making "serious lighting for
serious readers" to making good
reading chairs, strong bookcases
and "hard to find" library
furniture.

M2L
305 East 63rd Street, 11th floor,
New York, NY 10021
Tel.: 212-832-8222
M2L's range includes an
executive desk chair by
Cadsana/M2L, designed by Vico
Magistretti, as well as executive
side chairs by Cadsana/M2L and
Gigno Seating designed by
Pierluigi Gianfranchi.

MAYLINE COMPANY
619 N. Commerce Street,
Sheboygan, WI 53081
Tel.: 414-457-5537
Mayline manufactures height-
adjustable computer support
workstations, desking systems,
filing systems and drafting
equipment.

MCDONALD PRODUCTS
Smith Metal Arts, 2685 Walden
Avenue, Buffalo, NY 14225
Tel.: 716-684-7200
McDonald offer a range of desk
accessories, panel accessories,
wastebaskets, planters, litter
receptacles, coat-hooks, magazine
racks, clocks and signage.

METIER
4333 Shreveport Highway,
Pineville, LA 71360
Tel.: 318-640-8170
Metier produces a range of desks
and tables with adjustable work

surfaces. As the desking systems
and tables are free-standing, they
can be retrofitted into existing
fixed work surface workstations,
offering unlimited ergonomic
upgrade solutions.

MILLER DESK INC.
1212 Lincoln Drive, High Point,
NC 27262
Tel.: 910-886-7061
Casegoods, wood veneer,
laminates, traditional,
contemporary and lounge seating
can all be found at Miller desk.
They specialize in ergonomic
seating and seating designed for
big and tall individuals.

MOD-SYSTEMS INC.
PO Box 585, Greer, SC 29652
Tel.: 803-879-29652
Organized, time-saving paper
storage cabinets; legal and letter
size; color-coded for quick
retrieval, various sizes available.

**MULTISORT™ MAIL AND
DOCUMENT FURNITURE
SYSTEMS**
International Office Products
Cooperative (IOPC), 2172 B
River Road, Greer, SC 29650-
4504
Tel.: 803-848-0062
IOPC introduces MultiSort™, a
modular Swiss furniture system
offering superior aesthetics and
flexibility for organizing the
contemporary workstation and
mail center environment.

OFFICE FURNITURE HEAVEN
22 West 19th Street,
New York, NY 10011
Tel.: 212-989-8600
Office Furniture Heaven buys
and sells quality used and close-
out furniture and systems from
manufacturers such as Knoll,
Bernhardt and Gunlocke.

OPENINGS
40 West Howard, Pontiac,
MI 48342
Tel.: 800-335-7380
Openings provides Total door
systems which can be retrofitted
to any frame.

PLAN HOLD INTERNATIONAL
17421 Von Karman
Avenue, Irvine, CA 92714

Tel.: 800-634-7081
New Modular Options
modular stacking lateral files,
high-density mobile track
systems, media and
standard overfiles and Oxford
Pendaflex mobile files
and lateral files.

QFI/QUAKER FURNITURE INC.
PO Box 1973, Hickory,
NC 28603
Tel.: 704-322-1794/800-356-
5732
Quaker is a manufacturer of
office seating and tables, with
custom finish matching.

SAINBERG & CO INC.
63-20 Austin Street,
Rego Park, NY 11374
Tel.: 718-897-7000
The finest quality leather
and wood desk accessories,
custom conference room
accessories, custom leather
work and gold-tooled leather
table tops.

SMITH AND WATSON
305 East 63 Street,
New York, NY 10021
Tel.: 212-355-6515
Designers and manufacturers
of reproduction eighteenth
and nineteenth-century English
and custom-made furniture.

SMITH METAL ARTS
2685 Walden Avenue, Buffalo,
NY 14225
Tel.: 716-684-7200
Desk accessories, panel-mounted
accessories, wastebaskets, litter
receptacles, recycling receptacles,
planters, signage, magazine racks
and clocks.

STAPLES, INC.
100 Pennsylvania Avenue,
Framingham, MA 01701-9328
Tel.: 508-370-8500/1-800-333-3330
Staples opened its first office
superstore in May 1986 aimed at
providing the same discounted
prices to the small businessperson
that previously had been available
only to large corporations.
Staples discounts its office
supplies from 30–70 percent,
offering over 6,400 brand name
office products. They also run a
mail order service.

THE BOLING CO.
108 West Third Street,
Siler City, NC 27344
Tel.: 919-663-2400/800-942-6546
Manufactures a complete line
of medium priced wood
furniture, including casegoods,
desks and credenzas, seating
and tables.

THE HARTER GROUP
400 Prairie Avenue,
Sturgis, MI 49091
Tel.: 616-651-3201
Harter offers ergonomically
designed task, managerial,
executive, guest and conference
room seating.

THE KNOLL GROUP
105 Wooster Street, New York,
NY 10012-3808
Tel.: 212-343-4001
(See United Kingdom)

THE TAYLOR CHAIR COMPANY
75 Taylor Street, Bedford,
Ohio 44146
Tel.: 216-232-0700
This 180-year-old company
manufactures wood office
seating, desks, credenzas and
conference tables for
municipalities, financial, legal,
insurance and healthcare
applications.

THOS. MOSER CABINETMAKERS
72 Wrights Landing,
Auburn, ME 04711
Tel.: 207-784-3332
Thos. Moser make durable
wooden furniture.

ULTRAGLAS INC.
9186 Independence Avenue,
Chatsworth, CA 91311
Tel.: 818-772-7744
Sculpted, embossed, molded art
glass for: divider screens, doors,
entry systems, handrails, walls,
windows, lighting and signage
offering privacy with light
transmission.

UNITED MARKETING INC.
14th & Laurel Street, PO Box
870, Pottsville, PA 17901-0870
Tel.: 717-622-7715
United Marketing offers fire-safe
steel, seamless aluminum and
fiberglass waste receptacles, urns
and planters.

WILKHAHN INC.
150 East 58th St.,
New York, NY 10155
Tel.: 212-486-4333
Wilkhahn Inc. manufactures
high-quality furniture for
the contract and residential
markets, including seating
and tables for offices, conference
rooms, reception areas
and lobbies.

CANADA

ALB INDUSTRIES LTD
8024 Leonard de Vinci,
Montreal, Quebec,
H1Z 3R6
Tel.: 514-593-4548
ALB offers a complete line of
lateral files, vertical files, storage
cabinets, lockers and laminated
case goods.

EVANS CONSOLES INC.
1930 Maynard Road SE, Calgary,
Alberta, T2E 6J8
Tel.: 403-291-4444
Designer and manufacturer of
modular computer consoles,
specializing in the trading desk
industry as well as data
processing, transportation,
telecommunications and electric
utilities.

KRUG FURNITURE INC.
421 Manitou Drive, Kitchener,
Ontario, N2C 1L5
Tel.: 519-748-5100
Krug's manufactures a range
of office furniture.
The company's Millennium
Series includes wall unit,
desk with bow top, executive
seating, guest chairs,
and conference table.

MODERCO, INC.
115 DeLauzon, Boucherville,
Quebec J4B 1EZ
Tel.: 514-641-3150
Moderco manufactures acoustical
folding partitions.

NIGHTINGALE INC.
2301 Dixie Road, Mississauga,
Ontario L4Y 1Z9
Tel.: 905-896-3434
Nightingale is a manufacturer of
ergonomic chairs that conform to,
and support, the body.

FRANCE

AIRBORNE
Phone 49 48 91 31 for retail
outlets.
Manufacturer of the Kvadrat desk
by Jean-Louis Berthet designed
(see page 113).

ÉCART INTERNATIONAL
111 Rue Saint-Antoine,
75004 Paris
Tel.: 42 78 88 35
Since 1979, interior designer
Andrée Putman has been famous
for her re-editions of furniture by
certain prewar designers, such as
the best-selling chair by Robert
Mallet-Stevens, the wrought-iron
pedestal table by Pierre Chareau,
lamps by Mariano Fortuny and the
satellite-mirror by Eileen Gray.
Putman is also interested in
young designers such as Paul
Mathieu, Michael Ray and
Patrick Naggar.

MACÉ
For retail outlets, phone 45 72 24
88. Daniel Linguanotto and Yves
Macé offer the Galileo collection
in walnut and American cherry
wood for those who work at
home, designed by Irena Rosinski
(page 119) and an elegant new
shelving system, Vinci, designed
by Pagnon and Pelhaitre.

THE CONRAN SHOP
117 Rue du Bac, 75007 Paris
Tel.: 42 84 10 01
(See United Kingdom)

NÉOTÙ
25 Rue de Renard, 75004 Paris
Tel.: 42 78 96 97
Created in 1985, this gallery
organizes regular expositions
presenting the work of major
French designers such as Martin
Székély, Olivier Gagnère,
Mattia Bonetti and Elizabeth
Garouste. The gallery also has
expositions devoted to younger
talents such as Kristian Gavoille,
Éric Schmitt and Vincent
Beaurin.

KNOLL INTERNATIONAL
268 Boulevard Saint-Germain,
75007 Paris
Tel.: 47 05 74 65
(See United Kingdom)

MARCATRÉ
5 Rue Scribe, 75009 Paris
Tel.: 49 24 92 06
A selection including Achille
Castiglioni's Solone table, Mario
Bellini's "planet office" and his
recent Extra Dry range, a
lightweight, modular desk in
brightly colored panels.

MOBILIER INTERNATIONAL
162 Boulevard Voltaire,
75011 Paris
Tel.: 44 64 12 12
Includes, among others,
the superb triangular Concord
desk, designed by Jean-Louis
Berthet and Denis Vasset,
and the Interface system,
designed by Marc Alessandri
and Asymétrie.

STEELCASE STRAFOR
134 Boulevard Haussmann,
75008 Paris
Tel.: 45 62 72 83
(See United States)

TECNO
242 Boulevard Saint-Germain,
75007 Paris
Tel.: 42 22 18 27
(See United Kingdom)

VITRA
40 Rue Violet, 75015 Paris
Tel.: 45 75 59 11
(See United Kingdom)

STORAGE AND ORGANIZATIONAL SYSTEMS

UNITED KINGDOM

ALLSTEEL EUROPE
Innsbruck House, 9-11 Garden
Walk, London EC2A 3EQ
Tel.: 0171-613 4000

KRUEGER INTERNATIONAL (UK) LTD
Holborn Tower, 137 High
Holborn, London WC1V 6PL
Tel.: 0171-404 7441

RAILEX SYSTEMS
The Wilson Building, 1 Curtain
Road, London EC2A 3JX
Tel.: 0171-377 1777

THE MAINE GROUP
Facility Group, Riverside
Gallery, 2, O&N Metropolitan
Wharf, Wapping Wall,
London E1 9SS
Tel.: 0171-480 7642

UNITED STATES

MERIDIAN INC.
18558 171st Avenue, PO Box
530, Spring Lake, MI 49456
Tel.: 616-847-7674

FRANCE

FAYOLLE
7 Rue de Médicis,
75006 Paris
Tel.: 43 54 80 29

LIGHTING

UNITED KINGDOM

ARTEMIDE GB LTD
323 City Road, London
EC1V 1LJ
Tel.: 0171-833 1755
Distributes, among other designs,
the famous Tizio lamp by Robert
Sapper (page 116) and the
astonishing Cricket by Riccardo
Blumer.

CONCORD LIGHTING LTD
Avis Way, Newhaven, East
Sussex BN9 0ED
Tel.: 01273 515811
Showroom: 174 High Holborn,
London WC1
Tel.: 0171-497 1400
British manufacturer of
commercial lighting. They have a
range of uplighters, downlighters,
spotlights and track lighting.

ERCO
38 Dover Street,
London W1X 3RB
Tel.: 0171-408 0320
Stella spotlight by Franco Clivio.
Erco manufactures a wide
range of task lamps, spotlights,
downlighters and uplighters.
One of their most notable
recent designs is the Clivio
desk lamp by Franco Clivio,
a striking variation on the
traditional anglepoise lamp.

FLOS
31 Lisson Grove,
London NW1 6VB
Tel.: 0171-258 0600
Italian lighting specialists. Their range includes designs by, among others, Philippe Starck.

GFC LIGHTING LTD
Westminster Business Square,
Durham Street, London SE11 5JA
Tel.: 0171-735 0677
GFC supplies various lines of lighting for the office, including Domilux energy-efficient lighting, lighting by Borens for circulation areas and reception areas and Knight Design uplighters.

THE LONDON LIGHTING CO.
135 Fulham Road,
London SW3
Tel.: 0171-589 3612
The London Lighting Company specializes in modern lighting designs.

LIGHTHOUSE
3 Kinnerton Street, Belgravia,
London SW1
Tel.: 0171-235 2166
Lighthouse has a range of office lighting designs.

computer use, indirect and wall mount lighting fixtures with energy efficiency and panel-mounted task and ambient lighting systems.

NORA LIGHTING
5400 W. Jefferson Boulevard,
Los Angeles, CA 90016-3716
Tel.: 800-686-6672
Nora Lighting manufactures track lighting for high tech design and architectural applications.

TECH LIGHTING
2542 N Elston, Chicago,
IL 60647
Tel.: 312-252-0008
Low-voltage halogen lighting systems.

WALDMAN LIGHTING CO.
9 West Century Drive, Wheeling,
IL 60090
Tel.: 708-520-1060
Waldman manufactures ergonomic office task lighting.

FRANCE

ARTEMIDE
6-8 Rue Basfroi, 75011 Paris
Tel.: 43 67 17 17
(See United Kingdom)

UNITED STATES

CENTURY LIGHTING INDUSTRY
40-22 College Point Boulevard,
Flushing, NY 11354
Tel.: 718-939-1198
Manufacturer and importer of contemporary designer lamps, travel/battery operated lamps, and track lighting. Exclusive distributor of energy-saving fluorescent bulbs.

INDUSTRIE UND DESIGN LICHT INC.
Plexus Corp., 475 N. Cleveland Avenue, St Paul, MN 55104
Tel.: 612-644-4900
Manufacturers of alulite, a special kind of low-voltage illumination.

LUXO CORPORATION
36 Midland Avenue, Port
Chester, NY 10573
Tel.: 914-937-4433
Luxo manufactures task lights, ergonomic lighting products for

THE FILOFAX CENTRE
21 Conduit Street, London W1
Tel.: 0171-499 0457
Specialists in personal organizers.

THE GENERAL TRADING COMPANY
144 Sloane Street, London
SW1X 9BL
Tel.: 0171-730 0411
Stationery, Filofax.

ITALIAN PAPER SHOP
11 Brompton Arcade,
London SW3
Tel.: 0171-589 1668
Florentine paper and marbled paper from the Netherlands.

LEFAX
28-32 Shelton Street,
London WC2
Tel.: 0171-836 1977
Personal organizers in various leathers and vinyl.

MUJI
26 Great Marlborough Street,
London W1V 1HB
Tel.: 0171-494 1197
No-name products.

PAPERCHASE
213 Tottenham Court Road,
London W1
Tel.: 0171-580 8496
Paper boxes, stationery.

PENCRAFT
91 Kingsway, London WC2
Tel.: 0171-405 3639
Pens by Mont Blanc, Parker, Waterman and Sheaffer.

SMYTHSON OF BOND STREET
44 New Bond Street, London W1
Tel.: 0171-629 8558
Notepads, ledgers, and Florentine marbled paper.

UNITED STATES

Manufacturers:
FABER/CASTELL CORPORATION
Four Century Drive,
Parsippany, NJ 07054
Tel.: 201-539-4111
Pens, pencils, leads, erasers, ink, drafting and engineers supplies, markers and Higgins inks, staplers, adhesives and sheet protectors.

DESK ACCESSORIES AND STATIONERY

UNITED KINGDOM

Retailers:
ALFRED DUNHILL OF LONDON LTD
30 Duke Street,
London SW1Y 6DL
Tel.: 0171-499 9566
Fine desk accessories.

AMERICAN RETRO
165 New Bond Street,
London W1
Tel.: 0171-734 3477
Decorative items for the home.

ASPREY
165 New Bond Street,
London W1
Tel.: 0171-493 6767
Desk accessories.

LETTS OF LONDON
60 Arkay Drive,
Hauppauge, NY 11788
Tel.: 516-435-0700/800-342-7437
Manufacturer of bound diaries, appointments books, leather and business accessories.

PARKER PEN USA LTD
1400 N Parker Drive,
Janesville, WI 53545
Tel.: 608-755-7000
Manufacturer of fountain pens, ball pens, mechanical pencils, markers, desk sets and accessories.

PENTEL OF AMERICA, LTD
2805 Columbia St.,
Torrence, CA 90509
Tel.: 310-320-3831
Manufacturer of pens, inks, markers, art materials.

RIS PAPER COMPANY
4511 33rd Street, Long Island
City, NY 11101
Tel.: 718-392-8100

Retailers:
BACKER & KOOBY INC.
1204 Madison Avenue, New
York, NY 10128
Tel.: 212-369-8308
High quality office supplies, fountain pens.

HEARTFELT
436 Cortland Avenue,
San Francisco, CA 94110
Tel.:415-648-1380

IL PAPIRIO
1021 Lexington Avenue, New
York, NY 10021
Tel.: 212-288-9330
Hand-modeled Florentine paper and imported Italian desk accessories.

KATE'S PAPERI
561 Broadway,
New York, NY 10021
Tel.: 212-941-9816
8 West 13 Street,
New York, NY 10011
Tel.: 212-633-0570
High quality paper, stationery, wrapping and office accessories.

PAPERCHASE
861 Santa Cruz Avenue, Menlo
Park, CA 94025

Tel.: 415-322-9074
Art-oriented stationery and desk-related items.

PAPER JAZZ
858 NW Wall, Bend, OR 97701
Tel.: 541-389 8460

THE SHARPER IMAGE
900 Madison Avenue,
New York, NY 10021
Tel.: 212-794-4974
This gift store sells a variety of office accessories, such as electronic organizers and microcassette recorders, as well as a selection of pens.

PIER 17
89 South Street Seaport,
New York, NY 10038
Tel.: 212-693-0477
4 West 57 Street,
New York, NY 10019
Tel.: 212-265-2550
Creative desk games, accessories and work diversions.

FRANCE

CARTIER
51 Rue François-Ier, 75008 Paris
Tel.: 40 74 61 85
A luxurious range of office artefacts: a crystal ink-pot with polished-/ground-crystal stopper, small art deco-style clocks, leather diaries and many pens.

CASSEGRAIN
422 Rue Saint-Honoré,
75008 Paris
Tel.: 42 60 20 08
A selection of beautiful objects, paper, pens, and office accessories (page 119), including a spectacular range in leather.

DANESE
At Xanadou, 10 Rue Saint-Sulpice, 75006 Paris
Tel.: 43 26 73 43
Enzo Bari, Bruno Munari, Achille Castiglioni are some of the leading designers whose products are sold here (ashtrays, wastepaper bins, paper knives, etc.).

HERMÈS
24 Faubourg Saint-Honoré,
75008 Paris
Tel.: 40 17 47 17

Renowned store which has a range of desk accessories and diaries, but also its Pippa range and folding furniture designed by Réna Dumas. The store also sells a delightful little folding travel desk in solid pear wood.

PUIFORCAT
22 Rue François Ier, 75008 Paris
Tel.: 47 20 74 27
2 Avenue Matignon, 75008 Paris
Tel.: 45 63 10 10
Silver-plated or wooden art deco or modern desk accessories: letter-holders, pencil pots, in-boxes, frames, magnifying glasses, and silver pens. Particularly striking is the sober, masculine Kigoma range.

OFFICE DÉCOR

UNITED KINGDOM

BARRALETS OF EALING LTD
51a Pitshanger Lane, Ealing, London W5 1RH
Tel.: 0181-997 0576/7
Floral and plant displays; tropical plants and interior landscaping; design and installation.

BURMATEX
Victoria Mills, The Green, Ossett, West Yorkshire WF5 0AN
Tel.: 01924 276333
Burmatex offers an extensive range of contract carpets in a variety of colors and textures.

CITY PLANT LIFE
18c Selsdon Road, South Croydon CR2 6PA
Tel.: 0181-688 9401
Tropical plant displays for offices.

COMMERCIAL FLOORING SERVICES
Suite 9, 2nd floor, Widmore Road, Bromley, Kent
Tel.: 0181-466 7673
Commercial specialists.

HATEMA (UK) LTD
Unit 7, St Pancras Commercial Centre, 63 Pratt Street, London NW1 0BY
Tel.: 0171-482 4466
Hatema UK has a wide range of products from wallcoverings to carpets.

KIRKSTONE QUARRIES LTD
Skelwith Bridge, Nr. Ambleside, Cumbria LA22 9NN
Tel.: 015394 33296
Kirkstone is an unusual British stone of volcanic origin. It can be used for work surfaces, decorative details, interior flooring, planters and signage.

MURASPEC
79-89 Pentonville Road, London N1 9LW
Tel.: 0171-278 0161
Muraspec carries a large range of wallcoverings, in an array of designs, colors, contrasts and tones.

THE LONDON PLANT COMPANY
14 Horselydown Lane, London SE1
Tel.: 0171-407 5204
Office plant displays.

MMH CONTRACTS LTD
Unit AO2, Tower Bridge Business Square, Clements Road, London SE1
Tel.: 0171-237 4270
Business and commercial flooring.

OFFICE LANDSCAPING
7 Park Street, London SE1
Tel.: 0171-357 6401
Interior and exterior plant displays.

VESCOM (UK) LTD
Witan Court, 274 Witan Gate West, Central Milton Keynes MK9 1EJ
Tel.: 01908 696222
Vescom specializes in wallcoverings.

UNITED STATES

ATLAS CARPET MILLS, INC.
2200 Saybrook Avenue, Los Angeles, CA 90040
Tel.: 800-372-6274
Product line distinguished by combining construction integrity and design aesthetics to achieve carpets with high performance in commercial environments. More than 125 products and 4,000 color choices.

BASF CORPORATION
475 Reed Road,

NW Dalton, GA 30720
Tel.: 706-259-1200
Products and services especially suited to commercial floor coverings and upholstery. Specializing in solution-dyed nylons and carpet recycling programs.

BENTLEY MILLS INC.
14641 E Don Julian Road, City of Industry, CA 91746
Tel.: 800-423-4709/212-463-0606
Manufactures mid to high-end commercial carpeting available in broadloom, six foot and carpet tile, with a variety of backing options.

MILLIKEN CARPET
201 Industrial Drive, La Grange, GA 30240
Tel.: 706-880-5728
Offers a complete line of standard and custom modular carpets plus design and maintenance services.

DESIGN SUPPLY
215 Park Avenue South, Suite 700, New York, NY 10003
Tel.: 212-979-6400
Wholesale distributor of innovative decorative surface materials.

DESIGNWEAVE
407 Park Avenue South, New York, NY 10016
Tel.: 212-686-2993
Manufacturer of commercial carpet products.

MADELYN SIMON AND ASSOCIATES INC.
510 West 34th Street, New York, NY 10001
Tel.: 212-627-7000
Madelyn Simon sells plants, planters, ornaments and flowers.

MSA INDUSTRIES
349 Allerton Avenue, South San Francisco, CA 94080
Tel.: 415 871 6276
Flooring solutions for people in business, with 27 locations across the country.

TASK FLOORS INC.
21 East 26th Street, New York, NY 10010
Tel.: 212-532-1113

Task Floors provides the architectural and design community with specialty flooring products, such as Fritztile 1/8-in. and 3/8-in. thick terrazzo tile.

TOLI INTERNATIONAL
55 Mall Drive, Commack, NY 11725
Tel.: 800-446-5476
Toli manufactures solid vinyl flooring emulating wood and stone materials.

FRANCE

FLAMMARION 4
17-19 Rue Visconti, 75006 Paris
Tel.: 44 41 19 60
A selection of posters, reproductions and silk-screen prints with every kind of subject.

TOULEMONDE-BOCHART
10 Rue Du Mail, 5002 Paris
Tel.: 40 26 68 83
Carpets by leading designers such as Hilton MacConnico, Andrée Putman and Didier Gomez.

SIGNS
AND PRESENTATIONAL
EQUIPMENT

UNITED KINGDOM

SIGN 2000
Leys Industrial Park, Maidstone Road, Paddock Wood, Kent TN12 6QJ
Tel.: 01892 834383
Specialists in sign and display manufacture and installation throughout Europe.

THE HB SIGN COMPANY
120 Kings Road, Chelsea London SW3 4TR
Tel.: 0171-581 8044
This company provides bespoke signing and a series of modular signing products. It also offers a range of services covering the complete signing process, from strategic design to maintenance.

UNITED STATES

DALE TRAVIS ASSOCIATES
45 West 21st Street, New York, NY 10010
Tel.: 212-243-8373
Dale Travis specializes in high quality architectural signage.

DESIGNER SIGN SYSTEMS
352 Washington Avenue, Carlstadt NJ 07072
Tel.: 201-939-5577
Sign planning, wayfinding, sign systems, interior and exterior signage, hospitality and institutional signage.

LASSITOR INDUSTRIES INC.
22820 l-45 North, Suite 7L, Spring, TX 77373
Tel.: 800-526-6781
Architectural signage and specialties.

SCOTT SIGN SYSTEMS INC.
7524 Commerce Place, Sarasota, FL 34243
Tel.: 800-237-9447
A complete source for signs and wayfinding systems that will complement and enhance the interior of your buildings. Standard products, custom capabilities and complete systems comply with ADA requirements.

SYSTEM 2/90 INC.
5510 33rd Street, SE Grand Rapids, MI 49512
Tel.: 616-949-4310/800-777-4310
System 2/90 offers a modular system of interior and exterior architectural signage providing flexibility in size, color, materials and style. The system is expandable and changeable.

REMOVALS

UNITED KINGDOM

BEAVENS OF LONDON
Unit 4, Sylvan Grove Industrial Park, Sylvan Grove, London SE15 1PD
Tel.: 0171-732 2602

MICKELBOROUGHS
16 Crayford High Street, Crayford, Kent
Tel.: 0171-493 4165

VANGUARD GROUP LTD
Offices and machinery
removal company
188 Westferry Road, Milwall,
London E14
Tel.: 0181-998 8888

UNITED STATES

**MCB/RELOCATION
MANAGEMENT CORPORATION
OF AMERICA**
360 Lexington Avenue,
Suite 800, New York, NY 10017
Tel.: 212-599-5220

FRANCE

BOSSARD CONSULTANTS
14 Rue Jacques-Ibert,
92441 Issy-les-Moulineaux
Cedex
Tel.: 41 08 40 00

EURO RSCG DESIGN
84 Rue de Villiers,
92683 Levallois-Perret Cedex
Tel.: 41 34 34 34

ARCHITECTS

UNITED KINGDOM

**AHRENDS, BURTON
AND KORALEK**
Unit 1, 7 Chalcot Road,
London NW1 8LH
Tel.: 0171-586 4161

ARUP ASSOCIATES
37 Fitzroy Square,
London W1P 6AA
Tel.: 0171-465 5555

DEGW
8 Crinan Street,
London N1 9SQ
Tel.: 0171-239 7777

**JOHN WINTER
AND ASSOCIATES**
80 Lamble Street,
London NW5 4AB
Tel.: 0171-267 7567

**MICHAEL HOPKINS
AND PARTNERS**
27 Broadley Terrace,
London NW1 6LG
Tel.: 0171-724 1751

**MICHAEL WILFORD
& PARTNERS**
8 Fitzroy Square,
London W1P 5AH
Tel.: 0171-388 6188

**NICHOLAS GRIMSHAW
AND PARTNERS LTD**
1 Conway St., Fitzroy Square,
London W1P 5HA
Tel.: 0171-631 0869

**RICHARD ROGERS
PARTNERSHIP**
Thames Wharf, Rainville Road,
London W6 9HA
Tel.: 0171-385 1235

RICK MATHER ARCHITECTS
123 Camden High Street,
London NW1 7JR
Tel.: 0171-284 1727

SHEPPARD ROBSON
77 Parkway, London NW1 7PU
Tel.: 0171-485 4161

**SIR NORMAN FOSTER
AND PARTNERS**
Riverside 3, 22 Hester Road,
London SW11 4AN
Tel.: 0171-738 0455

TERRY FARRELL AND COMPANY
The Old Aeroworks, 17 Hatton
Street, London NW8 8PL
Tel.: 0171-258 3433

**THE FITZROY ROBINSON
PARTNERSHIP LTD**
77 Portland Place,
London W1N 4EP
Tel.: 0171-636 8033

TROUGHTON MCASLAN
202 Kensington Church Street,
London W8 4DP
Tel.: 0171-727 2663

YRM
Architects and Planners,
24 Britton Street,
London EC1M 5NQ
Tel.: 0171-253 4311

UNITED STATES

**BRENNAN BEER GORMAN
ARCHITECTS**
515 Madison Avenue,
New York, NY 10022
Tel.: 212-888-7663

**BUTLER ROGERS BASKETT
ARCHITECTS, PC**
381 Park Avenue South,
New York, NY 10016
Tel.: 212-686-9677

M. CASTEDO, ARCHITECT, PC
307 Seventh Avenue,
Suite 2406, New York,
NY 10001
Tel.: 212-255-4111

**DAVID LLOYD MARON,
ARCHITECT**
130 Madison Avenue,
New York, NY 10016-7026
Tel.: 212-889-1480

FOX & FOWLE ARCHITECTS
22 West 19th Street,
New York, NY 1011
Tel.: 212-627-1700

**GENSLER & ASSOCIATES,
ARCHITECTS**
1 Rockefeller Plaza, Fifth Floor,
Suite 500, New York,
NY 10020
Tel.: 212-492-1400

**KOHN PEDERSEN FOX
ASSOCIATES, PC**
111 West 57th Street,
New York, NY 10019
Tel.: 212-977-6500

**LUDWIG MICHAEL
GOLDSMITH, AIA**
192 Lexington Avenue,
New York, NY 10016
Tel.: 212-77-3595

**MARTIN E. RICH,
ARCHITECT, PC**
2112 Broadway (406),
New York, NY 10023
Tel.: 212-580-1746

PAI COBB FREED & PARTNERS
600 Madison Avenue,
New York, NY 10022
Tel.: 212-751-3122

**RICHARD DATTNER
ARCHITECT, PC**
Carnegie Hall Studios, 154 West
57th St., New York, NY 10019
Tel.: 212-247-2660

STEVEN HOLL ARCHITECTS
435 Hudson Street,
New York, NY 10014
Tel.: 212-989-0918

SWANKE HAYDEN CONNELL
295 Lafayette Street,
New York, NY 10012
Tel.: 212-226-9696

**SKIDMORE, OWINGS
& MERRILL**
220 East Street, New
York, NY 10017
Tel.: 212-309-9500

**THE PHILLIPS JANSON GROUP,
ARCHITECTS, PC**
112 West 42nd Street,
New York, NY 10036
Tel.: 212-768-0800

FRANCE

PAUL CHEMETOV
4 Square Masséna, 75013 Paris
Tel.: 45 82 85 48

NOUVEL ET CATTANI
4 Cité Griset, 75011 Paris
Tel.: 43 38 92 72

CLAUDE PARENT
94 bis Rue de Longchamp,
92200 Neuilly
Tel.: 47 22 20 24

RENZO PIANO
34 Rue des Archives,
75004 Paris
Tel.: 42 78 00 82

INTERIOR DESIGNERS

UNITED KINGDOM

BDG/MCCOLL
24 St John Street,
London EC1M 4AY
Tel.: 0171-490 1144

CD PARTNERSHIP
22 Shad Thames,
London SE1 2YU
Tel.: 0171-403 8899

**CONCEPT OFFICE
INTERIORS**
162 Kennington Road,
London SE21
Tel.: 0181-670 8046

DIN ASSOCIATES
32 St Oswalds Place, Vauxhall,
London SE11 5UE
Tel.: 0171-582 0777

EVA JIRICNA ARCHITECTS LTD
7 Dering St, London W1R 9AB
Tel.: 0171-629 7077

RODNEY FITCH & CO
Porters South, 4 Crinan Street,
London N1 9UE
Tel.: 0171-409 0117

UNITED STATES

**BERGER RAIT DESIGN
ASSOCIATES, INC.**
20 Exchange Place,
New York, NY 10005
Tel: 212-742-7000

**LINEA THREE DESIGN GROUP
ARCHITECTS**
220 East 23rd Street,
New York, NY 10011
Tel.: 212-889-9600

FRANCE

MARC ALESSANDRI
4 Avenue Adrien-Hébrard,
75016 Paris
Tel.: 45 27 27 44

MARC BERTHIER
141 Boulevard Saint-Michel,
75005 Paris
Tel.: 43 26 49 97

RÉNA DUMAS
5 Rue du Mail, 75002 Paris
Tel.: 42 60 04 82

ISABELLE HEBEY
13-15 Rue Villehardouin,
75003 Paris
Tel.: 42 72 80 79

PASCAL MOURGUE
34 Rue de Lappe, 75011 Paris
Tel.: 43 55 86 11

ANDRÉE PUTMAN/ÉCART
111 Rue Saint-Antoine,
5004 Paris
Tel.: 42 78 88 354

TRIBEL
68 Allée D.-Milhaud, 75013 Paris
Tel.: 40 18 32 69

JEAN-MICHEL WILMOTTE
68 Rue du Faubourg-Saint-
Antoine, 75012 Paris
Tel.: 43 42 50 00

CONSULTANTS

UNITED KINGDOM

MORGAN LOVELL
16 Noel Street,
London W1V 4DA
Tel.: 0171-734 4466

UNITED STATES

**CORPORATE ASSET
MANAGEMENT**
280 Summer Street, Boston,
MA 02210
Tel.: 617-439-4229

FRANCE

ÉLISABETH PÉLEGRIN-GENEL
17 Rue des Francs-Bourgeois,
75004 Paris
Tel.: 42 72 80 72

MAGAZINES, JOURNALS AND OTHER PUBLICATIONS

UNITED KINGDOM

ARCHITECTURAL REVIEW
EMAP Construct, 151 Rosebery
Road, London EC1R 4QX
Tel.: 0171-506 6725

BLUEPRINT
Christchurch House,
35 Cosway Street, NW1 5NJ
Tel.: 0171-262 2622

FX
ETP Ltd, Halford House, Coval
Lane, Chelmsford, Essex CM1 1TZ
Tel.: 01245 491717

UNITED STATES

**THE COMMERCIAL DESIGN
NETWORK**
Miller Freeman Inc., One Penn
Plaza, New York, NY 10119
Tel.: 212-714-11300
CDN, a marketing partnership of
*Contract Design, Facilities Design
and Management* and
Architectural Lighting magazines

reaches a combined audience of
100,000 architects, interior
designers, facilities managers and
corporate end-users. *Contract
Design* is focused exclusively on
commercial interior design and
architecture. *Facilities Design and
Management* is aimed at top
facilities and business executives
responsible for their corporate and
institutional environments.
Architectural Lighting contains
information on lighting
commercial and residential spaces.

INTERIOR DESIGN® MAGAZINE
249 West 17th Street,
New York, NY 10011
Tel.: 212-463-6707

METROPOLIS MAGAZINE
177 East 87th Street,
New York, NY 10128
Tel.: 212-722-5050

ORGANIZATIONS

UNITED KINGDOM

ARCHITECTURAL ASSOCIATION
34 Bedford Square, London WC1
Tel.: 0171-636 0974

**ROYAL INSTITUTE FOR BRITISH
ARCHITECTS**
66 Portland Place,
London W1N 4AD
Tel.: 0171-580 5533

UNITED STATES

**AMERICAN CENTER FOR
DESIGN**
233 East Ontario Street,
Suite 500, Chicago, IL 60611
Tel.:312-787-2018

**AMERICAN INSTITUTE OF
ARCHITECTS (AIA)**
1735 New York Avenue,
NW, Washington, DC 20006
Tel.: 202-626-7300
Chapters in NYC, San Mateo
County, Baltimore

**AMERICAN INSTITUTE
OF ARCHITECTS/NEW YORK
METRO CHAPTER**
200 Lexington Avenue,
New York, NY 10016
Tel.: 212-683-0023

**AMERICAN INSTITUTE OF
ARCHITECTURE STUDENTS (AIAS)**
Department of Architecture,
1206 University of Oregon,
Eugene, OR 97403-1206
Tel.: 503-346-3656

**AMERICAN SOCIETY
OF INTERIOR DESIGNERS/NEW
YORK METRO CHAPTER**
200 Lexington Avenue,
Suite 227, New York, NY 10016
Tel.: 212-685-3480

**ARCHITECTURAL LEAGUE
OF NEW YORK**
457 Madison Avenue,
New York, NY 10022
Tel.: 212-753-1722

**AMERICAN SOCIETY OF
INTERIOR DESIGNERS**
1430 Broadway,
New York, NY 10018
Tel.: 212-944-9220

**INTERNATIONAL
FACILITY MANAGEMENT
ASSOCIATION**
Greenway Plaza, 11th Floor,
Houston, TX 77046
Tel.: 713-623-4362

**INTERNATIONAL
FURNISHINGS AND DESIGN
ASSOCIATION**
PO Box 580045,
Dallas, TX 75258
Tel.: 214-747-2406

**INTERNATIONAL
ASSOCIATION OF LIGHTING
DESIGNERS (AECNET)**
18 East 16th Street,
New York, NY 10003
Tel.: 713-623-4362

**INTERNATIONAL INTERIOR
DESIGN ASSOCIATION**
127 East 59th Street,
New York, NW 10022
Tel.: 212-421-1950/212-874-3779

**OFFICE PLANNERS
AND USERS ASSOCIATION**
Box 11182, Philadelphia, PA 19136
Tel.: 215-335-9400

**SOCIETY OF AMERICAN
REGISTERED ARCHITECTS**
1245 S Highland Avenue,
Lombard IL 60148
Tel.: 708-932-4622

**SOCIETY OF INDUSTRIAL
AND OFFICE REALTORS**
777 14th Street NW,
Washington DC 20005
Tel.: 202-383-1150

FRANCE

VIA
29-37 Avenue Daumesnil,
75012 Paris
Tel.: 46 28 11 11

OFFICE TECHNOLOGY

UNITED KINGDOM

APPLE COMPUTERS UK
6 Roundwood Avenue,
Stockley Park, Uxbridge,
Middlesex UB11 1BB
Tel.: 0181-659 1199

BASF PLC
BASF House, 151 Wembley Park
Drive, Wembley, Middlesex
HA9 8HQ
Tel.: 0181-908 3188

**BROTHER INTERNATIONAL
EUROPE LTD**
Brother House, Tame Street,
Guide Bridge, Audenshaw,
Manchester M34 4SE
Tel.: 0113 306531

CANON UK
Canon House, Manor Road,
Wallington, Surrey SM6 0AJ
Tel.: 0181-773 3173

DELL UK COMPUTER CORP LTD
Millbank House, Western Road,
Bracknell, Berkshire RG12 1RW
Tel.: 1344 860456

DIGITAL EQUIPMENT CO. LTD
Digital Park, Imperial Way,
Reading, Berkshire RG2 0TE
Tel.: 1734 868711

EPSON UK
Campus 100, Maylands Avenue,
Hemel Hempstead,
Herts. HP2 7EZ
Tel.: 01442 61144

HEWLETT-PACKARD LTD
Cain Road, Bracknell,
Berkshire RG12 1HN
Tel.: 01344 360000

IBM UK LTD
76 Upper Ground,
London SE1 9PZ
Tel.: 0171-202 3000

KONIKA
Konika House, Miles Gray Road,
Basildon, Essex SS14 3AR
Tel.: 01268 534444

MICROSOFT LTD
Microsoft Place, Winnersh
Triangle, Workingham,
Berkshire RG11 5TP
Tel.: 1734 270001

MITA UK
Mita House, Hamm Moor Lane,
Addlestone, Weybridge,
Surrey KT15 2SB
Tel.: 01932 858266

RANK XEROX LTD
Parkway, Marlow,
Buckinghamshire SL7 1YL
Tel.: 1628 890000

RICOH UK
Ricoh House, 1 Plane Tree
Crescent, Feltham,
Middlesex TW13 7HG
Tel.: 0181-751 6611

UNISYS CORPORATION
Bakers Court, Bakers Road,
Uxbridge UB8 1RG
Tel.: 1895 237137

UNITED STATES

APPLE COMPUTER, INC.
One Infinite Loop,
Cupertino, CA 95014
Tel.: 408-996-1010

**AT&T BUSINESS
COMMUNICATION SERVICES**
1301 Avenue of the Americas,
New York, NY 10019
Tel.: 212-841-4610

**BASF CORPORATION
INFORMATION SYSTEMS**
35 Crosby Drive,
Bedford, MA 01730
Tel.: 617-271-4000/800-383-4600

**BROTHER INTERNATIONAL
CORPORATION**
Vantage Ct., 200 Cottontail Lane,
Somerset, NJ 08875-6714
Tel.: 908-356-8880

CANON USA, INC.
One Canon Plaza,
Lake Success, NY 11042
Tel.: 516-488-6700/800-OK-
CANON

**COMPAQ COMPUTER
CORPORATION**
2055 State House 249,
Houston, TX 7707-2698
Tel.: 713-370-0670/800-231-0900

COMPUSA
14951 N Dallas Pkwy,
Dallas, TX 75240
Tel.: 214-982-4000/800-332-9263

**DELL COMPUTER
CORPORATION**
9505 Arboretum Boulevard,
Austin, TX 78759-7299
Tel.: 512-338-4400/800-289-3355

**DIGITAL EQUIPMENT
CORPORATION**
146 Main Street, Maynard,
MA 01754-2571
Tel.: 509-493-5428

EPSON AMERICA, INC.
20770 Madrona Avenue,
Torrance, CA 90503
Tel.: 310-782-0770/800-298-3776

HEWLETT-PACKARD COMPANY
3000 Hanover St.,
Palo Alto, CA 94304-1185
Tel.: 415-857-1501/800-752-0900

**INTERNATIONAL BUSINESS
MACHINES CORPORATION
(IBM)**
Old Orchard Road,
Armonk, NY 10504
Tel.: 914-765-1900

**KONICA BUSINESS MACHINES
USA, INC.**
500 Day Hill Road,
Windsor, CT 06095
Tel.: 203-683-2222

MICROSOFT CORPORATION
One Microsoft Way,
Redmond, WA 98052 6399
Tel.: 206-882-8080

MITA COPYSTAR AMERICA, INC.
225 Sand Road,
Fairfield, NJ 07004 0008
Tel.: 201-808-8444

OFFICE DEPOT, INC.
2200 Old Germantown Road,
Delray Beach, FL 33445
Tel.: 407-278-4800/800-937-3600

RICOH CORPORATION
Five Dedrick Place, West
Caldwell, NJ 07006
Tel.: 201-882-2000/800-63-
RICOH

UNISYS CORPORATION
Township Line & Union Meeting
Road, PO Box 500, Blue Bell,
PA 19424
Tel.: 215-986-4011

WORDPERFECT CORP.
1555 N Technology Way,
Orem, UT 84052
Tel.: 801-225-5000/800-872-9933

XEROX CORPORATION
PO Box 1600, 800 Long Ridge
Road, Stamford, CT 06904
Tel.: 203-968-3000/800-832-6979

LIST OF INTERNET
WEBSITES

ARCH-ONLINE NY
http://www.arch-online.com/
e-mail: webmaster@arch-
online.com/
Tel.: 212-274-0928
Fax: 212-274-9580
Modem: 212-274-9430
Serves and promotes architectural
and design professionals

primarily in the northeast region
of the US. They provide valuable
resource materials online,
including information concerning
New York metropolitan area
organizations and their events.
Arch-Online NY will serve
as the index to professional
organizations, companies,
related services and resources
in the NY area.

AEC ACCESS
http://www.interlog.com/~bhewli
tt/index/html
Architecture; engineering;
building construction; interior
design; landscape architecture;
urban planning; and home
ownership image galleries.

**AEC INFOCENTER'S BUILDING
PRODUCT LIBRARY**
http://www.aecinfo.com
Concrete, masonry, steel, plastic,
insulation, waterproofing,
roofing, siding, doors, windows,
hardware, paint, carpet, tile,
drywall, appliances, elevators,
plumbing, heating, air-
conditioning, electrical, lighting.

**AEC INFONET: ARCHITECTURE,
ENGINEERING, BUILDING
CONSTRUCTION**
http:www.inforamp.net/ıaec/

AECNET
http://www.aecnet.com
Electronic resource network
of architecture, engineering
and construction.

**AMERICAN INSTITUTE
OF ARCHITECTS (AIA)**
http://www.aia.org/

**AMERICAN INSTITUTE OF
ARCHITECTURE
STUDENTS/OREGON (AIAS)**
http://gladstone.uoregon.edu

**ARCHITECTURAL LEAGUE
OF NEW YORK**
http://www.arch-online.com/
organ/arleag.htm

ARCHIWEB
http://www.archiweb.com/
ArchiWeb is a new media which
will exchange information
relating to architecture on the
Internet.

**ART AND ARCHITECTURE
ARCHIVE**
http://english-www.hss.cmu.edu/
Art.html
A collection of writings and
layouts in classical and
postmodern architecture.

**ASSOCIATION OF COMPUTER
AIDED DESIGN IN
ARCHITECTURE (ACADIA)**
http://www.clr.toronto.edu/ORG/
ACADIA/HOME.HTML

SHOWS

UNITED KINGDOM

INTERBULD
National Exhibition Centre
(NEC), Birmingham
Contemporary furniture and
building products.

WORKPLACE
Grand Hall, Olympia,
London W14
Annual show of workplace
technology and office furniture.

GERMANY

**COLOGNE INTERNATIONAL
FURNITURE FAIR**
KölnMesse, Messeplatz 1,
D-50679 Köln
Tel.: (221) 821-2574

The largest European office
furniture trade fair.

UNITED STATES

INTERPLAN
PO Box 939,
New York, NY 10108-0939
Tel.: 212-869-1300

ORGATEC 96
Cologne International Trade Fairs
Inc., 40 West 57th Street, 31st
Floor, New York, NY 10019
Tel.: 212-974-8835
Orgatec '96 will help visitors
with export, trade and travel
information.

FRANCE

BUREAU CONCEPT EXPO
Parc des Expositions de Paris,
Porte de Versailles, Paris
Tel.: 40 76 45 00

SICOB
(Salon International
de la Communication et de
l'Organisation du Bureau)
Organized by the Comité
des Expositions de Paris,
55 Quai A.-Le Gallo, BP 317,
92107 Boulogne-Billancourt
Tel.: 49 09 60 00

MUSEUMS

DESIGN MUSEUM
Butlers Wharf, Shad Thames,
London SE1 2YD
Tel.: 0171-403 6933

VITRA DESIGN MUSEUM
Charles Eames Strasse 1,
79 576 Weil am Rhein,
Germany
Tel.: 76 2 70 22 00

Adler, Laure. *Les femmes politiques*. Paris: Le Seuil, 1993.

Bachelard, G. *La Poétique de l'espace*. Paris: Quadrige, PUF, 1957.

Bailey, Stephen. *Offices*. London: Butterworth Architecture, 1990.

Becker, Franklin. *The Changing Facilities Organization*. London: Project Office Furniture plc, 1988.

Bédarida, M., and Milatovis, M. *Immeubles de bureaux*. Paris: Éditions du Moniteur, 1991.

Becker, Franklin. *The Total Workplace*. New York: Van Nostrand Reinhold, 1990.

Berger-Levrault. *L'Empire du bureau 1900-2000*. Nancy: Berger-Levrault, 1984.

Binder, Stephen. *Corporate Facility Planning*. New York: McGraw-Hill, 1992.

Bordass, W., and Leaman, A. "User and Occupant Controls in Office Buildings" in E. Sterling, C. Bieva and C. Collet, eds. *Building Design, Technology and OccupantWell-being in Temperate Climates: Conference Proceedings*. Atlanta: ASHRAE, 1993.

Brandt, Peter B. *Office Design*. New York: Whitney Library of Design, Watson Guptil Publications, 1992.

Brill, Michael, et al. *Using Office Design to Increase Productivity*, 2 vols. Buffalo: Workplace Design and Productivity, 1984.

Brill, Michael. *Now Offices, No Offices, New Offices: Wild Times in the World of Office Work*. Toronto: Tekmon, 1994.

British Council for Offices. *Specification for Urban Offices*. Reading, 1994.

Building Research Establishment BREEAM/New Offices. *An Environmental Assessment for New Office Designs*. Watford: BRE Publications, 1993.

Camard, F. *Ruhlmann*. Paris: Éditions du Regard, 1983.

Campbell-Cole, B., and Benton, T., eds. *Tubular Steel Furniture*. London: The Art Book Company, 1979.

Caplan, R. *The Design of Herman Miller*. New York: Whitney Library of Design, 1976.

Clarke, A.C. *Profiles of the Future*. London: Pan, 1973.

Claude, J., ed. *Créer des epaces de bureau*. Paris: Nathan, 1982.

Courteline, G. *Messieurs les ronds-de-cuir*. Paris: Flammarion, 1921.

Cowan, P., et al. *The office. A Facet of Urban Growth*. London: Heinemann Educational Books Ltd., 1969.

Craig, M. *Office Workers' Survival Handbook: A Guide to Fighting Health Hazards in the Future*. London: BSSRS, 1981.

Dalco, F. *Kevin Roche*. London: The Architectural Press, 1986.

De Sola Pool, I., ed. *The Social Impact of the Telephone*. Cambridge: The MIT Press, 1977.

Drexler, A. *Charles Eames. Furniture from the design collection*. New York: Museum of Modern Art, 1973.

Droste, M., and Ledewig, M. *Marcel Breuer*. Berlin: Taschen, 1992.

Duffy, F. *Office Landscaping. A new approach to office planning*. London: Anbar Publications Ltd, 1969.

Duffy, F. "Office furniture" in *The Architectural Review*, pp. 366–370. London: June 1979.

Duffy, F. "Offices, an escape from banality" in *The Architectural Review*, pp. 31–35. London: November 1983.

Duffy, F., Cave, C., and Worthington, J., eds. *Planning Office Space*. London: The Architectural Press, 1986.

Duffy, F., and Henney, A. *The Changing City*. London: Bulstrode Press, 1990.

Eley, J. "Intelligent Buildings" in *Facilities*, vol. 4, no. 4, April 1986, pp. 4-10.

Eley, J. "The Green Office: Policy and Practice" in *Facilities*, vol. 7, no. 5, May 1989, pp. 16-17.

Eley, J., and Marmot, A.F. *Understanding Offices*. London: Penguin Books, 1995.

Ettinghoffer, D. *L'Entreprise virtuelle : les nouveaux modes de travail et leurs incidences sur l'espace de bureau de demain*. Paris: Odile Jacob, 1993.

Fischer, G.N. *Psychologie des espace de travail*. Paris: Armand Colin, 1989.

Giedion, Siegfried. *Mechanization Takes Command*. London and New York: W W Norton & Company, 1969.

Giroud, F. *La Comédie du pouvoir*. Paris: Fayard, 1977.

Gorman, F., and Brown, C., eds. *The Responsible Office*. Streatley-on-Thames: Steelcase Strafor/Polymath Publishing, 1990.

Handy, C. *The Empty Raincoat*. London: Hutchinson, 1994.

Harris, David A., et al. *Planning and Designing the Office Environment*. New York: Van Nostrand Reinhold, 1991.

Hartkopf, V., et al. *Designing the Office of the Future: The Japanese Approach to Tomorrow's Workplace*. New York: Van Nostrand Reinhold, 1991.

Hillier, W., and Hanson, J. *Social Logic of Space*. Cambridge: Cambridge University Press, 1984.

Johnson Gross, K., and Stone, J. *Desk*. London: Thames and Hudson Ltd, 1994.

Kleeman, W.B., Jr. *Interior Design in the Electronic Office: The Comfort and Productivity Payoff*. New York: Van Nostrand Reinhold, 1991.

Klein, Judy Graf. *The Office Book*. New York: Facts on File, 1982.

Knobel, Lance. *Office Furniture. Twentieth Century Design*. New York: E. P. Dutton, 1987.

Laing, A. "Desk Sharing: The Politics of Space" in *Facilities*, vol. 8, no. 7, July 1990, pp. 12-19.

Leaman, A. "Designing for Manageability" in *Building Services*, March 1993.
Leaman, A. "Discomfort and Complexity" in *Architects' Journal*, October 1993.

Lipman, J. *Frank Lloyd Wright and the Johnson Wax Buildings*. London: The Architectural Press, 1986.

Lloyd, B. *Offices and Office Work: The Coming Revolution*. London: Staniland Hall, 1990.

Loewy, R. *Never Leave Well Enough Alone*. New York: Simon & Shuster, 1951.

Lovatt-Smith, Lisa. *Intérieurs parisiens*. Cologne: Taschen, 1994.

Marberry, S. *Color in the Office*. New York: Van Nostrand Reinhold, 1994.

Marmot, A.F. "Flexible Work" in *Facilities*, vol. 10, no. 11, November 1992, pp. 20-22.

Marmot, A.F. "Managing Empty Space" in *Facilities*, vol. 10, no. 9, September 1992, p. 6.

Mole, J. *Brits at Work*. London: Brealey, 1992.

Page, Marian. *Furniture Designed by Architects*. New York: Whitney Library of Design, 1980.

Pile, John F. *Open Office Planning*. New York: Whitney Library of Design, 1978.

Prémoli-Droulers, F. *Maisons d'écrivains*, préface de Marguerite Duras. Paris: Éditions du Chêne, 1994.

Probst, R. *The Office. A Facility Based on Change*. Zeeland: Herman Miller, 1968.

Pulgram, William L., and Stronis, Richard E. *Designing the Automated Office*. New York: Whitney Library of Design, 1984.

Rappoport, J.E., Cushman, R.F., and Daroff, K., eds. *Office Planning and Design: Desk Reference*. New York: John Wiley and Sons, 1992.

Rayfield, J.K. *The Office Interior Design Guide*. New York: John Wiley and Sons, 1994.

RiceBrydone Limited. *The Corporate and Professional Office: Organization and Design*. New York: Harper and Row, 1983.

Riley, T., ed. *Frank Lloyd Wright: Architect*. London: Thames and Hudson Ltd, 1994.

Rollin, André. *Ils écrivent où? quand? comment?* Paris: Mazarine, 1986.

Rybczynski, Witold. *The Most Beautiful House in the World*. Penguin Book, 1989.

Saphir, Michael. *Planning the New Office*. New York: McGraw-Hill, 1978.

Sembach, K.J. *Henry Van de Velde*. Paris: Hazan, 1989.

Sottsass, Ettore, Jr. "When I was a child" in *MANtransFORMS*. Washington, DC: Smithsonian Institution, 1976.

Sundstrom, E. *Workplaces: The Psychology of the Physical Environment in Offices and Factories*. Cambridge: Cambridge University Press, 1986.

Szenasy, Susan S. *Office Furniture: The Office Book Design Series*. NewYork: Facts on File, 1984.

Vischer, J. *Environmental Quality in Offices*. New York: Van Nostrand Reinhold, 1989.

Wankum, A. *Layout Planning in the Landscaped Office*. London: Anbar Publications Ltd, 1969.

White, J.R., eds. *The Office Building: From Concept to Investment Reality*. Chicago: Counselors of Real Estate, 1993.

Wilk, C. *Frank Lloyd Wright, The Kauffmann Office*. London: Victoria and Albert Museum, 1993.

Williams, B. *Facilities Economics*. Bromley: Building Economics Bureau, 1995.

Wilson, A. *Are You Sitting Comfortably?* London: Optima Books, 1994.

Wilson, S. *Premises of Excellence: How Successful Companies Manage Their Offices*. London: Herman Miller, 1985.

Wineman, J.D., ed. *Behavioural Issues in Office Design*. New York: Van Nostrand Reinhold, 1986.

Zeldin, T. *France, 1848-1945*, vol. I. Oxford: Oxford University Press, 1973.

PICTURE CREDITS

ACKNOWLEDGMENTS

First I would like to thank Ghislaine Bavoillot, the author's true guardian angel, all the Flammarion team, in particular Claire Lamotte, as well all those who kindly responded to my questions and allowed me into their offices.

I would also like to thank Dominique Pélegrin and Laurence Salmon as well as Francis Andriveau, Jacques Beer Gabel, Isabelle Behaghel, Andrée Bel, Cabinet Benoit, Philippe Breton, Paul Cuchet, Sophie Debure, Pierre-Olivier Drège, Catherine Doyard, Jacques Flat, Michel Francony, Charles Gancel, Michèle Gendreaux Massaloux, Isabelle Hebey, D. Maréchal and P. Joly, Laurent Mauduit, Jean Meunier, Alice Morgaine, Pascale Piquet, and Jean Prémesnil.

The Publisher is extremely grateful to all those who helped to find interesting and original offices: above all Piera Peroni in Milan who first thought of the idea in the offices of her magazine *Abitare*; Terence Conran in London, José Alvarez in Paris, as well as everyone who granted the Author and photographers access to their offices, and in particular Thomas Elamrami, Mr. Amor, Patrick Raynal, Louis Audibert and Mme Stern.

Finally the Publisher would like to thank Élisabeth Pélegrin-Genel who took time out from a busy schedule to work on an illustrated book, and Danièle Mazingarbe who introduced the Publisher to the Author. Thanks are also due to the team who worked to produce this book: Marc Walter, Ruth Eaton and Sabine Greenberg, Christian Sarramon and Safia Bendali, Olivier Canaveso and Barbara Kekus, Marguerita Mariano and Nelly Morin, Claire Lamotte and Véronique Manssy, Sophie Alibert and Elsa Tardif.